TASCHEN

KÖLN LISBOA LONDON NEW YORK PARIS TOKYO

D1501146

contemporary german photography

edited by markus rasp

preface by ulf erdmann ziegler

preface

I. For many years our way of looking at photographs was obscured by the legend of the "decisive moment". What this really meant was reducing photographic space to an anecdote. But photographers – and with them the public – have freed themselves from this narrow fixation. Now people marvel at the gigantic tableaus of Gilbert & George, assay the nuances of a Walker Evans print, and know what to make of a complex visual book like the latest from Richard Prince.

Photographers are no longer men with grey lab aprons, biological extensions of their paraphernalia. Often they are not men at all, but women, and they have learned their trade at colleges. They read the novels of Roddy Doyle or the writings of Vilém Flusser, they know something about Warhol's Factory or about Kieslowski's films, and they watch MTV or flick through *L'uomo Vogue*. Some take pictures with enormous cameras, others with tiny ones.

Among German photographers, Wolfgang Tillmans is a good example, even though – or perhaps precisely because – he lives in London. He shoots still lifes, portraits, nudes, cityscapes and genre scenes. Ten years ago people would have said: he does not know what he is trying to do. Meanwhile the work of this young photographer has become popular. His pictures are read metaphorically: the yellow tomatoes recall the pedantic still lifes of Irving Penn, but they also speak of the seclusion of the studio. The half-naked friends stand for their desires, but also for the fact that it is good to have friends. The diary is the assignment book. Fashion is whatever you choose to wear. The pictures are freighted with ambivalences.

When the Swiss American Robert Frank began shooting films in the late fifties, he had already produced the seminal photographic work of the 20th century:

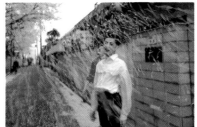

Nan Goldin: Honda Brothers w/falling cherry blossoms, 1994
Die Honda-Brüder unter fallenden Kirschblüten
Les frères Honda sous une pluie de fleurs de cerisier

vorwort

I. Der Blick auf Photographien war lange verstellt durch die Legende vom „entscheidenden Augenblick". Damit war eigentlich gemeint, den photographischen Raum auf eine Anekdote zu beschränken. Aber die Photographen haben sich von dieser engen Fixierung frei gemacht, und mit ihnen das Publikum. Es bestaunt die gigantischen Tableaus von Gilbert & George, begutachtet die Feinheiten eines Prints von Walker Evans und weiß komplexe visuelle Bücher zu entschlüsseln, wie die von Richard Prince.

Die Photographen sind nicht mehr Männer in grauen Kitteln, biologische Verlängerungen ihres Geräteparks. Häufig sind es gar keine Männer, sondern Frauen, und ihr Handwerk haben sie in Hochschulen gelernt. Sie lesen die Romane von Roddy Doyle oder die Schriften von Vilém Flusser, sie kennen Details aus Warhols Factory oder aus den Filmen von Kieslowski. Sie sehen MTV und blättern in der „L'uomo Vogue". Manche photographieren mit riesigen, andere mit winzigen Kameras.

Unter den deutschen Photographen ist Wolfgang Tillmans ein gutes Beispiel – obwohl er in London lebt, oder gerade deshalb. Er photographiert Stilleben, Porträts, Akte, Stadtlandschaften und Genreszenen. Vor zehn Jahren hätte man gesagt: Er weiß nicht, was er will. Jetzt ist die Arbeit des nicht einmal Dreißigjährigen populär. Man liest sie metaphorisch. Die gelben Tomaten erinnern an die pedantischen Stilleben von Irving Penn, aber sie stehen auch für die Abgeschiedenheit des Ateliers. Die halbnackten Freunde stehen für ihre Begierden ein; aber auch dafür, daß es gut ist, Freunde zu haben. Das Tagebuch ist das Auftragsbuch. Was man anhat, ist die Mode des Augenblicks. Die Bilder sind geladen mit Ambivalenzen.

Als der Schweizer Amerikaner Robert Frank Ende der fünfziger Jahre anfing, Filme zu drehen, hatte er das prägende photographische Werk des 20. Jahrhun-

préface

I. Notre façon de regarder la photographie a longtemps été obstruée par le mythe de «l'instant décisif». On sous-entendait par là que l'espace photographique se limitait simplement à une anecdote. Mais les photographes se sont libérés de cette fixation étroite, et avec eux le public. Celui-ci s'émerveille des tableaux gigantesques de Gilbert & George, il donne son avis sur les subtilités d'un tirage de Walker Evans, et il est à même de décrypter la complexité visuelle de certains ouvrages, comme ceux de Richard Prince.

Les photographes ne sont plus des hommes en blouse grise, prolongements biologiques de leur matériel encombrant. Souvent même ce ne sont pas des hommes, mais des femmes, qui ont appris leur métier dans des établissements d'enseignement supérieur. Elles lisent les romans de Roddy Doyle ou les écrits de Vilém Flusser, elles sont incollables sur la Warhol's Factory et sur les films de Kieslowski. Elles regardent MTV et feuillettent «L'uomo Vogue». Certaines utilisent de très gros appareils, d'autres des appareils minuscules.

Parmi les photographes allemands, Wolfgang Tillmans est très représentatif – bien qu'il vive à Londres, ou peut-être justement pour cela. Ses photographies sont des natures mortes, des portraits, des nus, des paysages urbains et des scènes de genre. Il y a dix ans on aurait dit: il ne sait pas ce qu'il veut. Entre-temps, le travail de ce photographe qui n'a même pas trente ans est devenu populaire. On le lit d'une façon métaphorique: les tomates jaunes font penser au formalisme des natures mortes d'Irving Penn, mais elles suggèrent également le côté insulaire du studio. La semi-nudité des amis manifeste leurs désirs, mais aussi le fait que c'est bien d'avoir des amis. Le journal intime, le «cher cahier», est le carnet de commandes. Ce que l'on porte sur soi, c'est la mode du moment. Les images sont chargées d'ambivalence.

Lorsque le Suisse Américain Robert Frank a commencé à tourner des films à la fin des années cinquante, il avait déjà produit cette œuvre qui devait marquer

The Americans, even today one of the best photo books ever made. It is the result of his journeys through America, but it is not travel photography. It shows the hotheads and the cools cats, the bored rich and grumbling poor, the shoebox houses and automobile dinosaurs, the living and the dead. In one photo we see a car's headlights shining, and behind the windscreen a woman with a boy. It is the last picture of the series. The woman is Frank's wife Mary and the boy his son Pablo. And this is just how far photographs can take you, that you journey through the state of mind of a country and suddenly realize who you are travelling with.

Such monumental projects were not without precedent. One thinks of Atget and the way he systematized the facades and entrances of old Paris, or of August Sander, who wanted to turn the strata of German society into a group of photographic portfolios. All of which brings us to the fundamental question: should the task be to photograph objects or people? Robert Frank's America fused people and things, the observer and the observed, portraying a country in a photographic language for the first time. A whole country.

The more closely photographers after Frank looked around them, the stranger did society appear to them: a zombieland to Diane Arbus, a sinister gallery of parallel signs and gestures to Gary Winogrand, and a Piranesi-like interweaving of shadows, walls, text and figures to Lee Friedlander.

These were author-photographers whom the Museum of Modern Art helped make famous. In retrospect it seems remarkable that they all stuck to black-and-white photography as an instrument for capturing the strangeness of contemporary society. Above all, however, they had broken out of the straitjacket of fash-

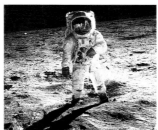

Neil Armstrong: Edwin "Buzz" Aldrin on the moon, 1969
Edwin „Buzz" Aldrin auf dem Mond
Edwin «Buzz» Aldrin sur la lune

dert schon abgeliefert: „Die Amerikaner", auch jetzt noch eines der besten Photobücher, die es gibt. Es ist das Ergebnis seiner Reisen durch Amerika, aber es ist keine Reisephotographie. Es zeigt die Hitzköpfe und die Gleichgültigen, die gelangweilten Reichen und die murrenden Mittellosen, die Haus-Schachteln und die Auto-Saurier, Lebende und Tote. Auf dem letzten Photo der Serie sieht man in den Scheinwerfer eines Autos, erleuchtet, und hinter der Windschutzscheibe eine Frau mit einem Jungen. Die Frau ist Robert Franks Frau Mary und der Junge sein Sohn Pablo. Soweit kann man mit Photographien gehen, daß man den state of mind eines Landes durchquert und plötzlich gewahr wird, wer mit einem reist.

Gigantische Projekte hatte es vorher schon gegeben: Atget, wie er die Fassaden und Eingänge des alten Paris systematisiert hatte. Und August Sander, der die deutsche Ständegesellschaft umbuchen wollte in ein Konvolut photographischer Mappen. Womit die Basisfrage gestellt ist: Soll man die Dinge photographieren oder die Menschen? Franks Amerika verschmolz die Dinge und die Menschen, den Beobachter und die Gesehenen, und zeigte damit erstmals in einer photographischen Sprache ein Land. Ein ganzes Land.

Je genauer die Photographinnen und Photographen nach Frank sich umsahen, desto fremder war ihnen die Gesellschaft: ein Zombieland bei Diane Arbus, ein unheimliches Kabinett paralleler Zeichen und Gesten bei Garry Winogrand, ein Piranesi-mäßiges Geflecht von Schatten, Wänden, Schrift und Figuren bei Lee Friedlander.

Das waren die Autorenphotographen, denen das Museum of Modern Art zu Ruhm verholfen hat. Es erscheint im Rückblick eigenartig, daß sie alle an der schwarzweißen Photographie festgehalten haben als einem Instrument, mit dem man die Fremdheit der Gesellschaft, in der man lebt, beschreiben kann. Vor

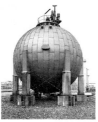

Bernd und Hilla Becher:
Spherical Gas Tank, Wesseling, Cologne (Germany), 1983
Kugel-Gasbehälter
Gazomètre sphérique

toute la photographie du 20e siècle, à savoir «Les Américains», qui au demeurant reste l'un des meilleurs albums photo publiés à ce jour. Ce livre est le résultat de ses voyages à travers l'Amérique, mais ce n'est pas de la photographie de voyage. Il montre les têtes brûlées et les indifférents, l'ennui des riches et l'expression renfrognée de ceux qui sont dans le besoin, les maisons-boîtes et les voitures-dinosaures, des vivants et des morts. Sur une photo, on voit l'intérieur du phare allumé d'une voiture, et derrière le pare-brise, on aperçoit une femme et un petit garçon. C'est la dernière image de la série. La femme est Mary, sa femme, et le garçon son fils Pablo. La photographie va si loin qu'elle permet de traverser l'état d'esprit d'un pays et tout à coup de se rendre compte de l'identité de la personne qui accompagne le photographe.

Des projets d'ampleur, il y en avait déjà eu avant: Atget et sa façon systématique de photographier les façades et les passages du vieux Paris. Et August Sander, qui voulait transformer la société allemande et ses différentes classes en un dossier compartimenté de planches photographiques. Ce qui pose la question fondamentale de savoir si l'on doit photographier les gens ou les choses. L'Amérique de Robert Frank était une vision fusionnelle des choses et des gens, de celui qui regarde et de ceux qui sont vus: c'était la première fois qu'on montrait un pays, un pays tout entier, à travers un langage photographique.

Plus les hommes et les femmes photographes, après Frank, regardaient autour d'eux, et plus ils se sentaient étrangers à la société, qui chez Diane Arbus devenait un pays de zombies, chez Garry Winogrand un inquiétant cabinet de signes et de gestes parallèles et chez Lee Friedlander un réseau d'ombres, de murs, d'écrits et de figures entrelacés dignes de Piranèse.

C'étaient les auteurs-photographes à la renommée desquels a contribué le Museum of Modern Art. Rétrospectivement, il peut paraître étrange que tous, ils s'en soient tenus au noir et blanc en tant qu'instrument permettant de rendre l'étrangeté de la société dans laquelle on vit. Mais surtout, ils s'étaient déta-

ion photography, out of the press photographer's repetitive alternation of double-page spread, supporting picture etc. – they made exhibitions and books.

II. From the perspective of the painter's studio, the question of whether one is "still doing black and white" or is "already using colour" sounds rather ridiculous. But in the age of mass reproduction the distinction is a crucial one. Indeed it would be possible to use this criterion to provide an account of 20th century visual culture. The difference is hardly less momentous than that between driving and flying – which is not to say one is better than the other. All the same, there is a distinction. Seen from the point of view of the music video, the difference is retrospective: to use black and white is to quote from the past, whereas to leap to colour is to leap into the present. But this only applies when both media are available, and it is one of the ironies of the status quo that almost all moving-image equipment is "already using colour" (with the exception of many security systems) while the still image remains chained to good old black and white, like the farmer to his field. Readers of German local newspapers may be regaled with twee front-page colour photos at Christmas and Easter, but their everyday fare will remain black and white until the next millenium.

It has always been the consumer goods industry which has wanted colour. The first colour pictures in the illustrated magazines were the covers, because the cover is printed on the same sheet as the back page, and this was financed, for example, by a perfume house. As early as the 1930s Paul Outerbridge was photographing muted colour still lifes and interiors for *House Beautiful*. Because with colour it is difficult to balance contrasts, at first colour was used in a domestic context. In the fifties even Irving Penn's colour photos were kitchen still lifes. Of all things colour, which was surely predestined to make a perfect rendering of

allem jedoch waren sie ausgebrochen aus den Kompromissen der Modephotographie, aus dem Rhythmus von Aufmacher, Aufmacher, Nebenbild und Nebenbild der Reportage: Sie machten Ausstellungen und Bücher.

II. Vom Maleratelier aus gesehen klingt das Problem ein bißchen lächerlich: ob man „noch schwarzweiß" oder „schon Farbe" macht. Aber im Zeitalter der Reproduzierbarkeit kommt es darauf an. Man könnte die visuelle Kultur des 20. Jahrhunderts anhand dieses Kriteriums beschreiben. Der Unterschied ist nicht geringer als Fahren und Fliegen – wobei in dem Fall ja auch nicht gesagt ist, was besser ist. Aber es ist ein Unterschied.

Vom Musikvideo aus gesehen ist der Unterschied historisch: Wer Schwarzweiß benutzt, zitiert die Vergangenheit, und der Sprung in die Farbe meint fast immer den Sprung in die Gegenwart. Das gilt aber erst in dem Moment, wo alle Mittel zur Verfügung stehen, und es gehört zu den Ironien des Status quo, daß fast sämtliche Systeme mit bewegten Bildern „schon Farbe" machen (mit Ausnahme der meisten Security-Videoschleifen), während das stehende Bild der soliden Technik des schwarzweißen Rasters verhaftet ist wie der Bauer dem Acker. Auch wenn die vielen deutschen Lokalzeitungen ihre Leser zu Ostern und Weihnachten mit betulichen Farbaufmachern beglücken, wird es beim täglichen Schwarzweiß bleiben bis ins nächste Jahrtausend.

Es ist immer die Konsumgüterindustrie, die Farbe gewollt hat. Die ersten farbigen Bilder der Illustrierten waren die Cover, weil das Cover auf demselben Bogen gedruckt wird wie die Rückseite, und die wurde finanziert zum Beispiel vom Hersteller eines Parfüms. Schon in den dreißiger Jahren photographierte Paul Outerbridge gedämpft farbige Stilleben und Interieurs für „House Beautiful". Weil man mit Farbe Kontraste schwer ausgleichen kann, war sie zunächst domestiziert: Selbst bei Irving Penn, in den fünfziger Jahren, sind die farbigen Bilder Küchenstilleben. Gerade die Farbe, die doch prädestiniert ist, die Welt

Joachim Brohm: Gelsenkirchen, 1990

chés des compromis de la photographie de mode, du rythme gros titre, gros titre, photo annexe, photo annexe du reportage: ils faisaient des livres et des expositions.

II. Vu de l'atelier du peintre, le problème se pose en des termes un peu ridicules: est-ce que l'on fait «encore du noir et blanc» ou «déjà de la couleur». Mais à l'ère de la reproductibilité, cette différence a une importance décisive. Ce critère pourrait à lui seul servir à une description de la culture du 20e siècle. La différence n'est pas de moindre envergure que celle qui sépare la voiture de l'avion (quoiqu'en ce cas, il ne soit pas dit lequel est le meilleur). Mais la différence est là.

Vue de la vidéo musicale, cette différence a des connotations d'ordre historique: utiliser le noir et blanc revient à citer expressément le passé, alors que faire le saut dans la couleur est presque toujours synonyme de faire le saut dans le présent. Mais ceci ne vaut qu'à partir du moment où tous les moyens sont réunis, et ce n'est pas la moindre des ironies du statu quo que presque tous les systèmes d'images animées, à l'exception des bandes vidéo de surveillance, fassent «déjà de la couleur», tandis que l'image fixe reste solidement attachée au schéma du noir et blanc comme le paysan à son champ. Même si, à Pâques et à Noël, la foultitude des journaux locaux allemands s'empresse de faire le bonheur de ses lecteurs en leur servant des manchettes en couleur, c'est tout de même le noir et blanc qui, dans le prochain millénaire, continuera de prévaloir dans les pages des quotidiens.

C'est toujours l'industrie des biens de consommation qui a voulu la couleur. Les premières photos en couleur des magazines étaient les couvertures, parce que la couverture est imprimée sur la même feuille que la quatrième de couverture qui elle, était financée disons par une marque de parfum. Dès les années trente, Paul Outerbridge utilisait des couleurs délicates dans les natures mortes et les intérieurs qu'il photographiait pour «House Beautiful». Du fait que la couleur

the world, was reduced to commercial niches. The first important news photo in colour is from the astronaut Neil Armstrong and shows his colleague Edwin Aldrin taking his first steps on the moon.

III. During the 1980s the Federal Republic of Germany was a poor rich country. Wealth was not so dramatically redistributed there as in the USA or in England: German society was not to such a degree divided into haves and have-nots. But ideas were in short supply, and there was a certain loss of impetus. Helmut Kohl became chancellor, while Faßbinder had already left the stage. It was all not without logic. At the time scant attention was paid to the self-taught Berlin photographer Michael Schmidt, but it is now clear that in his gloomy shots of West Berlin he recognized with a telling indistinctness a certain loss of imagination, a brooding in false security.

He was one of the photographers who in 1986 took part in an exhibition in Essen entitled "Remains of the Authentic". These photographers believed that they were living in posthistory, at a time when history had been arrested or frozen. Accordingly, photographic signs are downplayed, diminished to the milky traces of industrial fossilization which Joachim Brohm made out in the Ruhr area. Here the effects of mining contrasted with the desolation of social structure brought on by joblessness.

Those brave souls who at the time nevertheless ventured into the Ruhr area, perhaps to study photography at the Folkwangschule located in Essen, required strong nerves. One of them was Angela Neuke, who in 1980 took up a professorship in Essen and immediately recognized the possibilities of the colour lab

Robert Frank: US-Interstate 90, on the way to Del Rio, Texas, 1956
US-Bundesstraße 90, unterwegs nach Del Rio
La route 90, en route vers Del Rio

lückenlos abzubilden, war reduziert auf kommerzielle Nischen. Das erste wichtige Nachrichtenphoto in Farbe stammt von Neil Armstrong, dem Astronauten, und zeigt seinen Kollegen Edwin Aldrin bei seinen ersten Schritten auf dem Mond.

III. Die Bundesrepublik Deutschland war in den achtziger Jahren ein armes reiches Land. Die Mittel wurden nicht so rabiat umverteilt wie in den USA oder in England, von einer Zweidrittelgesellschaft konnte damals keine Rede sein. Aber die Ideen wurden rar, die Impulse ließen nach: Helmut Kohl wurde Kanzler, während sich Faßbinder anschickte abzutreten, das hatte seine Logik. Dem photographischen Autodidakten Michael Schmidt in Berlin hat man damals nicht viel Aufmerksamkeit geschenkt, aber jetzt ist klar, daß er eine bestimmte Reduktion der Phantasien, ein Brüten in falscher Sicherheit in seinen düsteren Photographien aus West-Berlin mit der nötigen Unschärfe erkannt hat.

Er war einer der Photographen, deren Arbeiten 1986 in einer Ausstellung in Essen gezeigt wurden, die „Reste des Authentischen" hieß. Man glaubte, in der Geschichte nach der Geschichte – der Posthistoire – zu leben, in einer Art historischer Arretierung. Deshalb wurden die Signale heruntergefahren, bis zu den milchigen Spuren industrieller Versteinerung, die Joachim Brohm im Ruhrgebiet ausmachte. Dort kontrastierten die Folgen des Bergbaus mit der Verödung der sozialen Struktur durch Unterbeschäftigung.

Wer damals trotzdem ins Ruhrgebiet kam, um an der Folkwangschule Photographie zu studieren, mußte gute Nerven haben. Das galt auch für Angela Neuke, die 1980 in Essen eine Professur übernahm und die Möglichkeiten der frisch installierten Farblabors sofort erkannt hat. Parallel mit Martin Parr in England entdeckte sie die Technik, mit mittelformatigen Kameras zu photographieren und die Szene durch das Blitzlicht aufzuhellen. Diane Arbus hatte etliche Por-

Lee Friedlander: New York City, 1964

permet difficilement d'adoucir les contrastes, on en a fait d'abord un usage domestique: même chez Irving Penn, les photos couleur des années cinquante sont des natures mortes de cuisines. Bien que prédestinée à restituer le monde dans son intégralité, la couleur se trouvait paradoxalement réduite et enclavée dans des niches à vocation commerciale. La première photo de presse en couleur digne de ce nom a été prise par Neil Armstrong, le cosmonaute. Elle représente son collègue Edwin Aldrin marchant pour la première fois sur la lune.

III. Dans les années quatre-vingt, la riche République Fédérale d'Allemagne était un pays pauvre. La redistribution des moyens ne se faisait pas de façon aussi brutale qu'aux Etats-Unis ou en Angleterre, et on ne pouvait pas vraiment parler de société des deux tiers. Mais les idées se faisaient rares, les impulsions s'essoufflaient: Helmut Kohl devenait chancelier, tandis que Faßbinder envisageait d'abandonner le cinéma, ce qui en soi se défendait. On n'a guère prêté attention à l'époque au photographe autodidacte berlinois Michael Schmidt, mais il est clair à présent que ses photographies de Berlin-Ouest, avec leur côté noir et leur nécessaire absence de définition, ont su reconnaître une certaine réduction au niveau de l'imaginaire collectif.

Il fut l'un des photographes exposés dans une exposition qui eut lieu à Essen en 1986, intitulée «Reste des Authentischen» (Restes d'authenticité). On croyait vivre dans une histoire d'après l'histoire, la post-histoire, dans une sorte d'arrêt de l'histoire. C'est la raison pour laquelle on en a enfoui tous les signaux, jusqu'aux traces laiteuses de fossilisation industrielle que Joachim Brohm avait repérées dans la Ruhr. Le contraste entre les conséquences de l'industrie minière et la désertification de la structure sociale due au sous-emploi y était en effet frappant.

Mais si on voulait quand même venir dans la Ruhr pour étudier la photographie à la Folkwangschule, il fallait avoir les nerfs solides. Angela Neuke elle-même en a fait l'expérience, qui prit une chaire de professeur en 1980 et ne tarda pas à se rendre compte des immenses possibilités qu'offrait le tout nouveau labo-

freshly installed there. Parallel to Martin Parr in England, she discovered the technique of using medium-format cameras to photograph scenes brightened up with flash. Diane Arbus had made numerous portraits in this manner, and Weegee had already splendidly demonstrated the merits of flash in his shots of fresh murder victims down in the canyons of Manhattan. Translated into colour, the result meant an incomparable freedom of movement. Henceforward the "decisive moment" was no longer borrowed from the choreography of classical ballet. Sociologist Michael Rutschky called the eighties a "journey through awkwardness", and the new photography recorded this.

IV. Flashback: Robert Frank travels through the land, only to find – when he turns round – his own family. With the last picture in *The Americans*, Frank anticipates the possibility of making your particular journey through life into an object of description. And this is the essence of beatnik literature, of rock and roll, of the hippie enclaves (notwithstanding Vietnam). In his first film, *Pull My Daisy*, Frank incorporated the New York scene into an abstruse play. His film about the Rolling Stones went so deep into the register of depravity that the band still refuses to release the negative to this day. What remained of him and his family – not much – Frank later issued as a gruesome video.

Life in pop culture is no guidebook to a happy existence, but it sharpens the sense of whether life is worth living. The stage of political life is shrinking, while the stage of everyday life is wired-up. And already society no longer seems alien; rather you are part of it. Accordingly, pop culture must make its own documentary of itself. The film about the Woodstock festival is part of that.

Angela Neuke: Geneva, 1985
Genf
Genève

träts in dieser Art gemacht, und Weegee hatte die Vorzüge des Blitzlichts an den frisch Ermordeten in den Schluchten Manhattans bereits blendend illustriert. Auf Farbe übertragen, ergab sich eine äußerste Freiheit der Bewegung. Der entscheidende Augenblick war spätestens danach nicht mehr von der Choreographie des klassischen Balletts geborgt. Eine „Reise durch das Ungeschick" hat Michael Rutschky die achtziger Jahre genannt; und so war diese Photographie des Politischen auch gemeint.

IV. Robert Frank, der durch das ganze Land reist, und als er sich schließlich umwendet, seine eigene Familie sieht: Mit dem letzten Bild in „Die Amerikaner" nimmt Frank die Möglichkeit vorweg, den selbstgewählten Lebensweg zum Gegenstand der Beschreibung zu machen. Und das ist ja die Essenz der Beatnikliteratur, des Rock'n'Roll, der Hippieenklaven trotz Vietnam.

In seinem ersten Film, „Pull My Daisy" hat Frank die New Yorker Szene einem abstrusen Schauspiel einverleibt; sein Film über die Rolling Stones hat so tief ins Register der exzentrischen Sause gegriffen, daß die Band das Negativ des Films heute noch nicht herausgegeben hat. Was von ihm und von seiner Familie übrigblieb – nicht viel – hat Frank in einem späteren Video gruselig zur Ansicht gebracht.

Das Leben in der Popkultur ist keine Anleitung zum Glücklichsein, aber es schärft den Sinn dafür, ob das Leben lohnt. Die Bühne der Politik schrumpft, und die Bühne des Alltags steht unter Strom. Und schon ist die Gesellschaft nicht mehr fremd, sondern man ist selbst ein Teil von ihr. Deshalb muß die Popkultur sich selbst auch so gut dokumentieren, angefangen mit dem Film über das Festival von Woodstock.

In den Photographien von Nan Goldin gibt es keine schwarzen Verstärkerboxen, aber das Leben, von dem sie lebt, wäre nicht denkbar ohne Rock'n'Roll. Man

Paul Outerbridge: Tools with Blueprint, 1938
Werkzeug mit Entwurfszeichnung
Outils avec croquis

ratoire couleur. Parallèlement à Martin Parr en Angleterre, elle découvrit la technique de la photographie en moyen format et l'utilisation du flash. Diane Arbus avait fait quelques portraits de cette manière et Weegee, en photographiant juste après leur mort des personnes qui venaient d'être assassinées dans les coupe-gorge de Manhattan, avait déjà su tirer un brillant parti du flash. La transposition dans la couleur donnait lieu à une extrême liberté de mouvement. Après eux, et même avant, l'instant décisif n'avait plus rien à emprunter à la chorégraphie du ballet classique. Un «voyage dans la maladresse», c'est en ces termes que Michael Rutschky a parlé des années quatre-vingt; et c'est aussi dans cet esprit que s'inscrivait cette photographie du politique.

IV. Robert Frank, qui a voyagé dans tout le pays et qui, quand il finit par regarder autour de lui, voit sa propre famille ... Cette dernière image des «Américains» anticipe l'attitude qui consiste à faire de la vie qu'on s'est choisie un objet de description. Et ça, c'est exactement l'essence de la littérature beatnik, du rock and roll, des enclaves hippies contre la guerre au Viêtnam. Dans son premier film «Pull My Daisy», Frank a assimilé la scène new-yorkaise à un spectacle confus; son film sur les Rolling Stones va si loin dans l'excentricité de la beuverie que le groupe refuse aujourd'hui encore de sortir le négatif du film. Quant à ce qui reste de lui et de sa famille, c'est à dire pas grand-chose, Frank l'a montré plus tard dans une vidéo qui donne la chair de poule.

Vivre dans la culture pop n'est pas en soi recette de bonheur, mais cela aiguise la sensibilité à la question de savoir si la vie vaut d'être vécue. La scène politique s'atrophie, celle du quotidien est sous tension. Et déjà la société n'est plus un corps étranger: on fait partie d'elle. C'est la raison pour laquelle la culture pop doit produire des documents sur elle-même, ce qu'elle a commencé de faire avec le film sur le festival de Woodstock.

Dans les photographies de Nan Goldin, il n'y a pas d'amplis noirs, mais la vie dont elle vit ne serait pas concevable sans le rock and roll. On y est passager de l'interlope, habitant de la nuit, on se retrouve embarqué dans des trains, reflété dans des salles de bains mondaines, couverts de bleus dans des lits fripés. Bref,

In Nan Goldin's photographs we see no banks of loudspeakers or amplifiers, and yet the life from which she lives would be unthinkable without rock and roll. People are passengers in the underworld, denizens of the night, travelling in trains, reflected in chic bathrooms, beaten black and blue in rumpled beds: a work from which contemporary photographers have learned that everything, no matter how small, repays close attention.

Of course, once sub-culture has established itself as a visual code, it also feeds industry. Or was counter-culture's form not already adapted from pop industry's images? Contemporary photography finds itself caught midway between the forces which create images and those which order them.

V. For many left-wingers in the West, the German Democratic Republic (East Germany) was no more than an abstract ideal, instinctively defended like a bad conscience. In 1989/90 the country was redrawn on the world map of diplomacy, culture, economics and history. In the West viewers sat in front of their TVs and watched in disbelief as older married couples queued up before hastily erected containers to buy porn, ever ready like children to chat to the camera. Meanwhile ever-smiling head-of-state Honecker finally escaped to South America, where he died. The Russian army withdrew, leaving behind contaminated land and crumbling military towns.

The systems to the east had always had something monolithic about them. In retrospect they seemed labyrinthine. Ilya Kabakov gave visual expression to this in his installations, much acclaimed in the West. West Germany had seen itself as organic, heterogeneous, couched in rational hierarchies. Now it slipped into the role of conqueror, its weapon the Deutschmark.

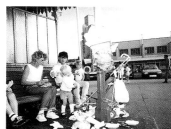

Martin Parr: New Brighton, undated

ist Passagier der Unterwelt, Bewohner der Nacht, unterwegs in Zügen, gespiegelt in mondänen Bädern, blau geschlagen in zerfurchten Betten: das Protokoll der Gegenkultur, wörtlich genommen, von Boston bis Berlin. An ihrem Werk haben die zeitgenössischen Photographen gelernt, daß kein Ding so gering ist, daß es nicht lohnen würde, es genau zu betrachten.

Etabliert sich die Subkultur als visueller Code, speist sie selbstverständlich auch die Industrie. Oder war der Entwurf der Gegenkultur nicht den Bildern der Popindustrie bereits nachempfunden? Die zeitgenössische Photographie befindet sich in der Schwebe zwischen den Kräften, die Bilder hervorbringen, und den Kräften, die Bilder bestellen.

V. Die DDR war für viele Linke im Westen „das bessere Deutschland" gewesen, ein nur noch papiernes Ideal, das man reflexhaft in Schutz nimmt wie das eigene schlechte Gewissen. 1989/90 wurde Ostdeutschland auf der Weltkarte der Diplomatie, der Kultur, der Ökonomie und der Geschichte neu verzeichnet. Im Westen saß man vor dem Fernseher und sah ungläubig ältere Ehepaare vor eiligst aufgestellten Containern mit Pornoware Schlange stehen, wie Kinder jederzeit zum Gespräch mit der Kamera bereit. Der immer lächelnde Staatsratsvorsitzende entkam schließlich nach Südamerika, wo er starb. Die russische Armee zog ab und hinterließ verseuchte Gelände und bröckelnde Kasernenstädte.

Die Systeme des Ostens hatten immer etwas Monolithisches gehabt; retrospektiv zeigten sie sich als labyrinthisch. Ilya Kabakov hat das mit seinen im Westen gefeierten Installationen bildlich zum Ausdruck gebracht. Der Westen sah sich selbst als organisch, heterogen, gebettet in nachvollziehbare Hierarchien. Jetzt rutschte er in die Rolle des Eroberers, die Waffe die D-Mark.

le procès-verbal de la contre-culture, au sens propre, de Boston à Berlin. Les photographes contemporains ont appris à son école qu'il n'existe aucune chose, si infime soit-elle, qui ne mérite d'être regardée avec attention.

Si d'un côté l'underground s'établit en tant que code visuel, de l'autre il alimente bien évidemment l'industrie. Mais le projet de la contre-culture n'était-il pas déjà lui-même inspiré par les images de l'industrie pop? La photographie contemporaine oscille en réalité entre les forces productrices d'images et celles qui en sont commanditaires.

V. Pour beaucoup de gens de gauche à l'Ouest, la R.D.A. avait été «la meilleure des Allemagnes», formulation qui ne recouvrait plus rien qu'un idéal de papier que l'on défend avec l'automatisme de la mauvaise conscience. En 1989/90, on a redessiné sur le planisphère diplomatique, culturel, économique et historique les contours de l'Allemagne de l'Est. A l'Ouest, installé devant son téléviseur, on regardait incrédule des couples d'un certain âge faire la queue, des articles pornographiques à la main, devant des containers érigés à la hâte, de la même façon qu'on voyait des enfants toujours prêts à dialoguer avec la caméra. Le président du Conseil d'Etat, avec son éternel sourire, avait fini par s'enfuir en Amérique du Sud, où il mourut. L'armée russe se retirait en laissant derrière elle des terrains contaminés par la radioactivité et des cités-casernes.

Les systèmes de l'Est avaient toujours eu quelque chose de monolithique; ils se sont avérés rétrospectivement des labyrinthes. C'est ce qu'Ilya Kabakov a exprimé de façon plastique à travers ses installations, qui connaissent un grand succès à l'Ouest. La vision que l'Ouest avait de lui-même était celle d'un organisme hétérogène, encadré par une hiérarchie accessible à tout un chacun. Il glissait à présent sur une pente qui lui faisait endosser le rôle du conquérant, avec pour arme le Deutsche Mark.

Those aged fifteen to thirty at the time had grown up thinking that history was what the school books stated. Now they were overtaken by a cataclysm. Almost all of them had to come to terms with the fact that they had not been granted the power to turn recent history into politics. But in turn this made them as observers free. If it was possible to overcome the old redundant order of things, they would have to transform themselves back into the autodidacts of their biography. Some are doing this, for others it is asking too much of them.

VI. The title page continues to be printed on the same sheet as the commercial back page. The world of luxury and fashion has acquired considerable powers. Who, one might rightly ask, brought the wall tumbling down – Ronald Reagan or Michael Jackson? The president might have had the superweapon, but the popstar had the supercode.

It is not just in the East that state authority has lost authority, but also in the West. The privatization of state utilities, especially in the UK, has weakened the authority of the state. Social themes have reverted to society – witness the British cinema of, say, Stephen Frears or Mike Leigh.

Germany's position in all this is a singular one. On the one hand it must directly address the problem of the Communist legacy. On the other it suffers from a deep-seated fear of the new. The schmalzy German pop song is making a comeback, with its oom-pah-pah rhythm and its platitudes. And the German public cannot get enough of the mindless German cinema comedies about singles and their pseudo-problems.

Contemporary photographers remain relatively unaffected by the struggles within the institutions or by the media's mania for revelation. They work not only

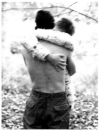

Wolfgang Tillmans: Alex & Lutz, Bournemouth, 1992

Die damals Fünfzehn- bis Dreißigjährigen waren aufgewachsen mit der Perspektive, daß Geschichte das war, was im Schulbuch stand. Jetzt waren sie von einer Zeitenwende überrascht worden. Sie mußten sich, fast alle, damit abfinden, daß ihnen keine Definitionsmacht zugestanden wurde für die Fortsetzung der jüngsten Geschichte in Politik. Das wiederum macht sie als Beobachter frei. Wenn es möglich ist, die untauglichen Schemen zu überwinden, müssen sie sich in Autodidakten ihrer Biographie zurückverwandeln. Manche tun das, von anderen ist das zuviel verlangt.

VI. Daß die Titelseite auf demselben Bogen gedruckt wird wie die kommerzielle Rückseite, gilt als Regel weiter. Die Welt des Luxus und der Moden hat erhebliche Kräfte auf sich gezogen: Wer, darf man mit Recht fragen, hat die Mauer ins Wanken gebracht – Ronald Reagan oder Michael Jackson? Der eine hatte vielleicht die Superwaffen, der andere aber den Supercode.

Die Staatsgewalt hat nicht nur im Osten an Gewalt verloren, sondern auch im Westen. Der Ausverkauf der Staatsbetriebe, in England vor allem, hat die Autorität des Staates geschwächt. Die gesellschaftlichen Themen sind an die Gesellschaft zurückgefallen: Das sieht man im englischen Kino etwa von Stephen Frears und Mike Leigh.

Deutschland ist da in einer eigenwilligen Position. Einerseits muß es sich mit der Bewältigung des kommunistischen Erbes direkt befassen. Andererseits gibt es eine tiefsitzende Angst vor dem Neuen. Der deutsche Schlager kehrt zurück, mit seinem Schunkelrhythmus und seinen Plattitüden, und das deutsche Kinopublikum liebt die dusseligen deutschen Komödien über Singles mit Scheinproblemen.

Die zeitgenössischen Photographen bewegen sich relativ frei von den Kämpfen in den Institutionen. Sie sind nicht berührt von der aggressiven Bekenntnis-

Ceux qui à l'époque avaient entre quinze et trente ans avaient été élevés dans l'idée que l'histoire, c'était ce qui était écrit dans les manuels scolaires. Ils s'étaient laissés surprendre par un de ses tournants. Presque tous, ils ont dû prendre leur parti de ce qu'on ne leur avait inculqué aucune notion, aucune faculté de définition qui aurait permis à l'histoire récente de trouver un prolongement dans la politique. Mais d'un autre côté, cela leur confère une liberté d'observation absolue. S'ils ont la possibilité de dépasser des schémas qui ne sont plus pertinents, ils devront alors se retransformer en autodidactes de leur propre biographie. Certains le font, mais à d'autres, c'est trop demander.

VI. Le fait que la couverture et le dos du magazine, investi par la publicité, soient imprimés sur la même feuille, est toujours de mise aujourd'hui. Le monde du luxe et de la mode a tiré à lui des forces considérables. On est en droit de se demander lequel, de Ronald Reagan ou de Michael Jackson, a fait vaciller le mur. L'un avait peut-être les superarmes, mais l'autre le supercode.

Mais il n'y a pas qu'à l'Est que l'Etat a perdu de son pouvoir. A l'Ouest, la liquidation des entreprises publiques a, surtout en Angleterre, considérablement affaibli son autorité. Les problèmes sociaux connaissent une recrudescence dont le cinéma anglais, celui de Stephen Frears ou de Mike Leigh par exemple, se fait l'écho.

L'Allemagne se retrouve à cet égard dans une position particulière. Il lui faut d'une part s'employer à gérer l'héritage communiste. Mais elle a d'autre part une peur viscérale du nouveau. Le «tube» allemand revient en force avec son rythme pompier et ses clichés, et le public allemand aime voir au cinéma les stupides comédies allemandes où il est question de célibataires et de leurs faux problèmes.

Les photographes contemporains font preuve d'une certaine liberté de manœuvre par rapport aux querelles qui secouent les institutions. Ils ne sont pas tou-

as the authors and implementers of their projects, but also finish them in the colour lab and often even act as their own producers – only a few of the picture series in this book have been commissions, and some of the projects are ongoing.

The variety of options might be described as a spectrum between two poles. On the one hand there is the Tillmans-type option, to *feed objets* trouvés from one's own personal surroundings into a universal atmosphere, where we are not really dealing with the person of the photographer, but with every conceivable *ambiance* attributable to an "I". On the other hand there is the option taken by Bernd and Hilla Becher, who address things, the made, the framework of civilization, with a probing meticulousness. The "I" is concealed in the anonymity of the apparatus, and the work is like a dictionary that one can raid down the years without ever stopping to ask who wrote it.

Photographers are lucky in that there is no theoretical superstructure that would rest heavily on them. Nobody expects of them a geopolitical blueprint or a new theory of the subject. Part of a massive transformation, signals beam forth from German contemporary photography which do not yet belong to the canon. To this extent the "decisive moment" could be rehabilitated as Now.

Common to all these photographic positions is that the photographers address the particular. This particular, however, is drawn from the great stream of consciousness. Assembled in dense rapid succession, the stream depicts itself. It is in the nature of the stream of consciousness that it discloses not forms, but energies.

Ulf Erdmann Ziegler

Michael Schmidt: Untitled, undated
Ohne Titel
Sans titre

sucht der Medien. Sie betätigen sich nicht nur als Autoren und Macher ihrer Projekte, sondern vollenden sie auch im Farblabor, und zudem sind sie oft ihre eigenen Produzenten – wenige der Bildserien in diesem Buch sind Aufträge gewesen, und manche der Projekte dauern noch an.

Die Vielfalt der Optionen könnte man als Spektrum beschreiben, zwischen zwei Polen. Auf der einen Seite gibt es die Option wie bei Tillmans, Fundstücke der eigenen Lebenswelt in ein universales Fluidum einzuspeisen. Es geht dabei nicht wirklich um die Person des Photographen, sondern um alle denkbaren Ambientes, die einem „Ich" zugeschrieben werden können. Auf der anderen Seite gibt es die Option von Bernd und Hilla Becher, die sich mit forschender Akribie den Dingen, dem Gemachten, dem Regelwerk der Zivilisation zuwenden. Das „Ich" verbirgt sich in der Anonymität des Apparats. Das Werk ähnelt einem Lexikon, das man über Jahre plündern kann, ohne sich jemals zu fragen, wer es geschrieben hat.

Es erweist sich von Vorteil, daß der theoretische Überbau der Photographie nicht schwer auf den Bildautoren lastet. Niemand erwartet von Photographen einen geopolitischen Entwurf oder eine neue Theorie des Subjekts. Als Teil einer gewaltigen Transformation, leuchten aus den zeitgenössichen deutschen Photographien Signale, die noch nicht zum Kanon gehören. Insofern könnte man den „entscheidenden Augenblick" rehabilitieren, als Jetzt.

Was alle photographischen Positionen verbindet, ist, daß die Photographen das Partikulare benennen. Aber dieses Partikulare ist aus dem großen Bewußtseinsstrom geschöpft. In dichter Folge montiert, bildet er sich ab. Es liegt in der Natur des stream of consciousness, daß er keine Gestalt offenbart, sondern Energien.

Ulf Erdmann Ziegler

Michael Schmidt: Untitled, undated
Ohne Titel
Sans titre

chés par cette frénésie avec laquelle les médias se jettent sur tout ce qui ressemble à une déclaration. Ils ne font pas seulement œuvre d'auteurs et de réalisateurs de leurs projets, ils les parachèvent dans le laboratoire couleur, et de plus, ils sont souvent leur propre producteur – parmi les séries de cet ouvrage, très peu ont été réalisées sur commande, et un grand nombre de ces projets sont aujourd'hui encore en cours de réalisation.

On pourrait qualifier cette pluralité d'options de spectre à deux pôles. D'un côté, il y a l'option qui consiste, comme chez Tillmans, à alimenter un fluide universel de choses trouvées dans son propre environnement. Ce n'est pas véritablement la personne du photographe qui entre ici en ligne de compte, mais la somme de toutes les atmosphères susceptibles de relever de la constitution d'un «moi». De l'autre, il y a l'option de Bernd et Hilla Becher, qui s'attachent à rechercher minutieusement les rouages d'une civilisation à travers les choses et les réalisations humaines. Le «moi» se dissimule derrière l'anonymat de l'appareil, et l'œuvre ressemble à une encyclopédie que l'on éplucherait des années durant sans jamais se demander qui l'a écrite.

Le fait que le poids de la superstructure théorique de la photographie ne se fasse pas sentir sur les auteurs des images s'avère un avantage. Personne n'attend d'un photographe qu'il élabore un schéma géopolitique ou une nouvelle théorie du sujet. La photographie allemande contemporaine émet des signaux qui, s'ils participent d'un gigantesque processus de transformation, n'en ont pas encore pour autant valeur de canon. C'est en ce sens, celui d'un «maintenant», que l'on pourrait réhabiliter l'«instant décisif».

Ce qui fait le lien entre toutes ces attitudes photographiques, c'est le fait que les photographes savent nommer le particulier. Mais ce particulier lui-même puise dans le courant de conscience général, et il se dessine à la faveur d'un montage serré. Il est dans la nature du courant de conscience de révéler non des formes, mais des énergies.

Ulf Erdmann Ziegler

stefan bungert *Thuringia, views of cities and countryside*

When the German Democratic Republic (GDR) still existed, I only knew it from traveling across its territory on my way to West Berlin. I had never visited the GDR before reunification, my only impressions were gained while driving along the transit road to West Berlin: unfriendly border guards, intimidating border installations, and the orders never to leave the Autobahn. Then there were the views through the car windows: the long, straight stretches of road, sometimes a glimpse into a Trabi (short for "Trabant", a cheap East German car). Those views through the glass panes conjured such an impression of distance that the GDR seemed more foreign to me than even the most far away places that I had ever visited. The photographs published in this book were taken in the Gera and Werra valleys several years after the infamous Berlin wall came down. Both are places in the state of Thuringia. This time I was no longer a transit traveler. I find myself in the center of Germany. I gaze upon my own, but still foreign land. Gera was an important economic center during the GDR era. It suffered massive unemployment after reunification. Its external appearance changed hardly at all during the years after reunification. The effects of socialism are still evident everywhere. On the other hand, the villages in the region of the Werra river seemed like a living recreation of my parents' childhood during the period of the late forties and early fifties. Local farmers, with their own kind of opposition against socialism, sought to preserve old structures, to retain a little private land and cattle of their own. This tradition survives in the Werra valley to this very day.

Thüringen, Ansichten von Stadt und Land **Als die DDR noch existierte, kannte ich sie nur als Transitreisender. Ich bin vor der Wende nie in die DDR gereist, meine einzigen Erfahrungen machte ich auf der Transitstrecke nach West-Berlin: einschüchternde, unfreundliche Grenzbeamte, angsteinflößende Grenzanlagen und dazu die Anweisung, nicht die Autobahn zu verlassen. Dann der Blick durch das Autofenster, mal auf die schnurgerade Strecke, mal in einen Trabi hinein. Der Blick durch die Scheiben hielt eine solche Distanz, daß die DDR mir fremder als jedes noch so ferne Land vorkam, in das ich je gereist war. Die in diesem Buch veröffentlichten Bilder sind mehrere Jahre nach der Maueröffnung in Gera und im Werra-Tal entstanden. Diesmal bin ich kein Transitreisender mehr. Ich befinde mich in der Mitte von Deutschland. Ich blicke in das eigene und trotzdem noch fremde Land. Gera war zu Zeiten der DDR ein wichtiger Wirtschaftsstandort. Nach der Wende herrscht hier eine große Arbeitslosigkeit. Das äußere Erscheinungsbild hat sich seit 1989 kaum verändert. Die Spuren des Sozialismus sind noch überall sichtbar. Die dörflichen Regionen an der Werra erinnert mich an eine lebendig gewordene Schilderung der Kindheit meiner Eltern, die Zeit der späten vierziger und frühen fünfziger Jahre. Die Bauern versuchten hier in einer Art Opposition gegen den Sozialismus alte Strukturen zu wahren, ein wenig eigenes Land und Vieh zu behalten. Diese Tradition hat sich im Werra-Tal bis heute gehalten.**

Thuringe, vues urbaines et rurales Ma seule connaissance de la R.D.A., du temps où elle existait encore, était celle d'un voyageur en transit. Je ne suis jamais allé en R.D.A. avant la chute du mur, la seule expérience que j'en avait me venais de l'itinéraire de transit qui me menait à Berlin-Ouest: c'était celle de douaniers intimidants et rébarbatifs, de postes de douane terrifiants, avec en plus l'interdiction de quitter l'autoroute. Ne restait plus alors qu'à fixer à travers le pare-brise la route si droite qu'elle semblait tracée au cordeau, à moins d'entrevoir de façon fugace l'intérieur d'une Trabant. La matérialité de la vitre induisait une telle distance entre le regard et la R.D.A. que celle-ci me semblait plus étrangère que le plus lointain des pays dans lesquels j'avais voyagé. Les photographies publiées dans ce livre ont été prises plusieurs années après l'ouverture du mur, à Gera et dans la vallée de la Werra, deux endroits de Thuringe. Cette fois, je ne suis plus en transit. Je me trouve au centre de l'Allemagne. Je regarde ce pays qui est le mien et qui pourtant m'est encore étranger. A l'époque de la R.D.A., Gera était un centre économique important. Depuis le tournant de 1989, le chômage y est considérable. Son aspect extérieur s'est à peine modifié par la suite. Les traces du socialisme sont encore omniprésentes. Les villages qui longent la Werra en revanche me font penser à une illustration vivante de l'enfance de mes parents, c'est-à-dire de l'époque où, à la fin des années quarante et au début des années cinquante, les paysans opposaient une sorte de résistance au socialisme en essayant de maintenir les structures anciennes et de garder par-devers soi un peu de terrain et de bétail. Cette tradition de la vallée de la Werra est toujours de mise aujourd'hui.

Stefan Bungert was born in Mühlheim (Ruhr) in 1965, graduated from high school in 1985, studied communication design with a major in photography from 1987 to 1994 at Essen Polytechnic University; became a freelance photojournalist in Hamburg with work published in Spiegel Special, ADAC Special, Greenpeace; member of the Bilderberg agency since 1996; in 1994 was awarded the second prize in the Porsche Design Competition in Seville, completing in the same year a dissertation on *Thuringia, views of cities and countryside*. Stefan Bungert lives in Hamburg.

Stefan Bungert, 1965 geboren in Mülheim/Ruhr; 1985 Abitur; 1987–1994 Studium Kommunikationsdesign an der Universität Gesamthochschule Essen, Schwerpunkt Photographie; seit 1994 freier Photojournalist in Hamburg, Publikationen in Spiegel Special, ADAC Special, Greenpeace; seit 1996 Mitglied bei Bilderberg; 1994 zweiter Preis, Porsche Design Wettbewerb, Sevilla; 1994 Diplomarbeit *Thüringen, Ansichten von Stadt und Land*. Stefan Bungert lebt in Hamburg.

Stefan Bungert, né en 1965 à Mülheim (Ruhr); 1985 baccalauréat; 1987–1994 études de design et de communication à la Université Gesamthochschule (université intégrée) de Essen, spécialisation photographie; depuis 1994 photojournaliste indépendant à Hambourg, publications dans le Spiegel Special, ADAC Special, Greenpeace; depuis 1996 membre de l'agence Bilderberg; 1994 deuxième prix du concours Porsche Design, Séville; 1994 travail de fin d'études, *Thuringe, vues urbaines et rurales*. Stefan Bungert vit à Hambourg.

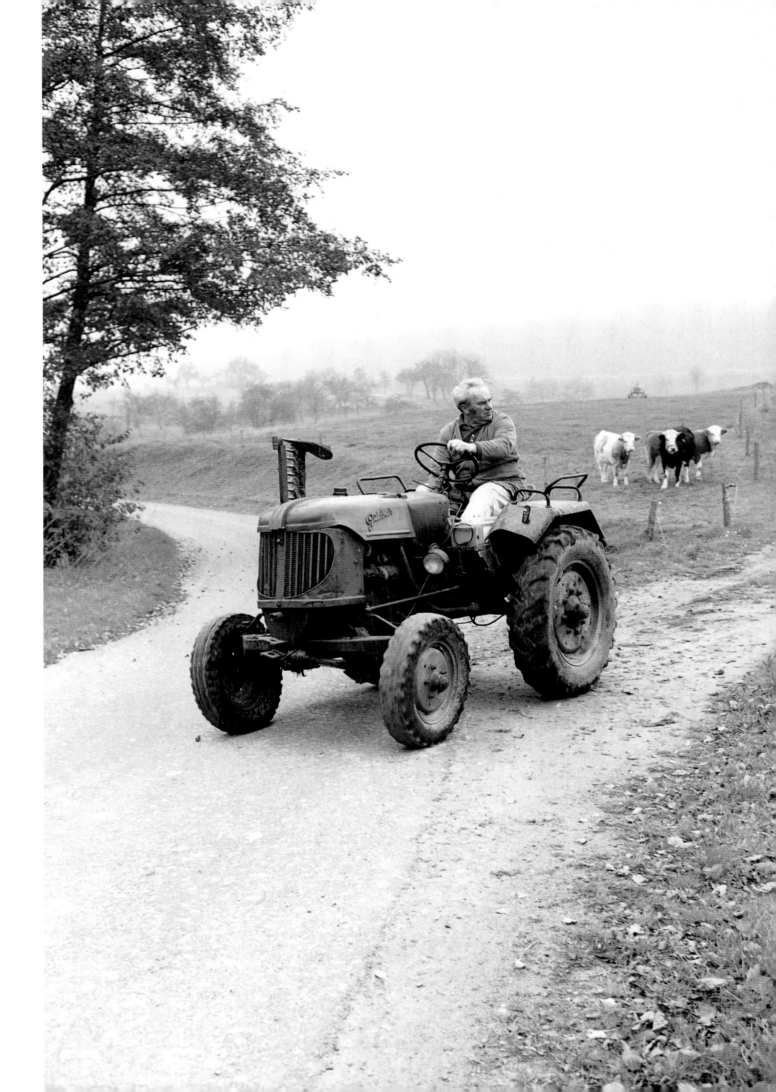

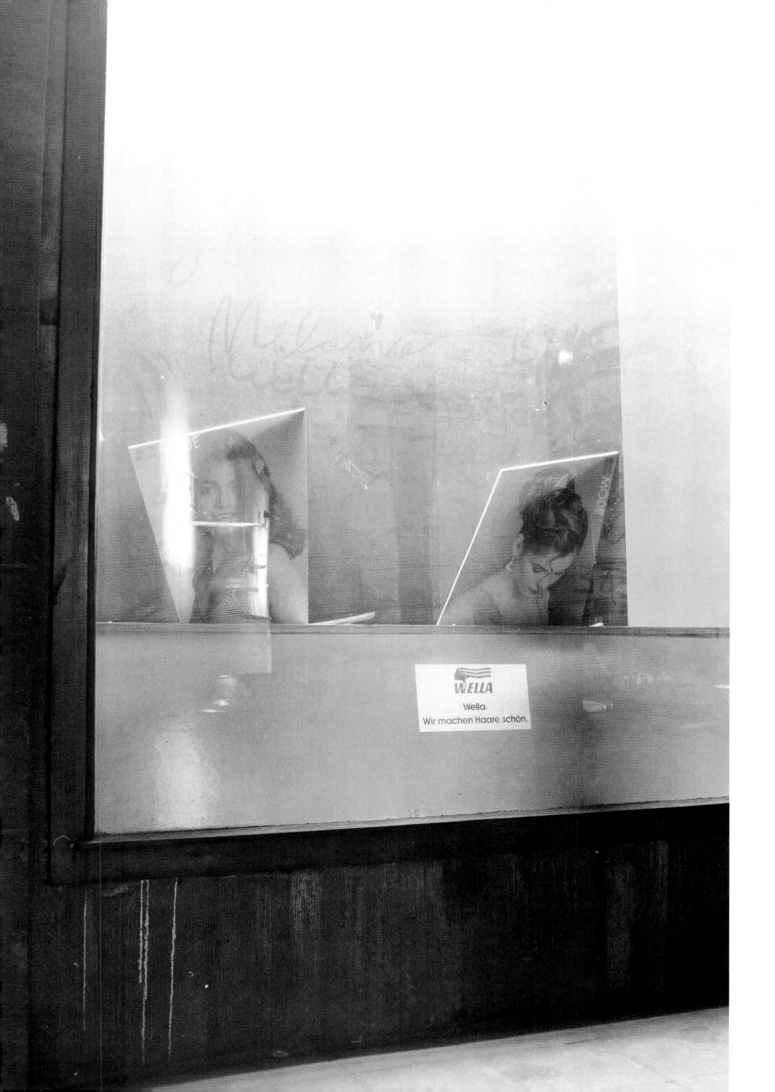

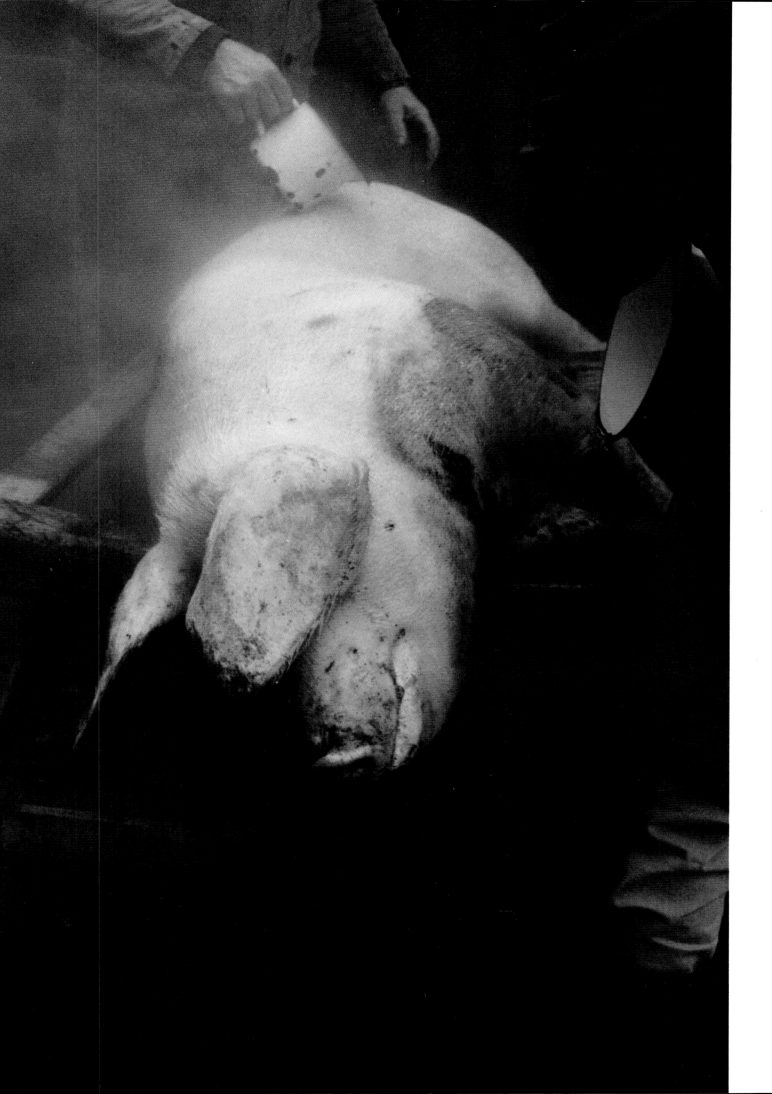

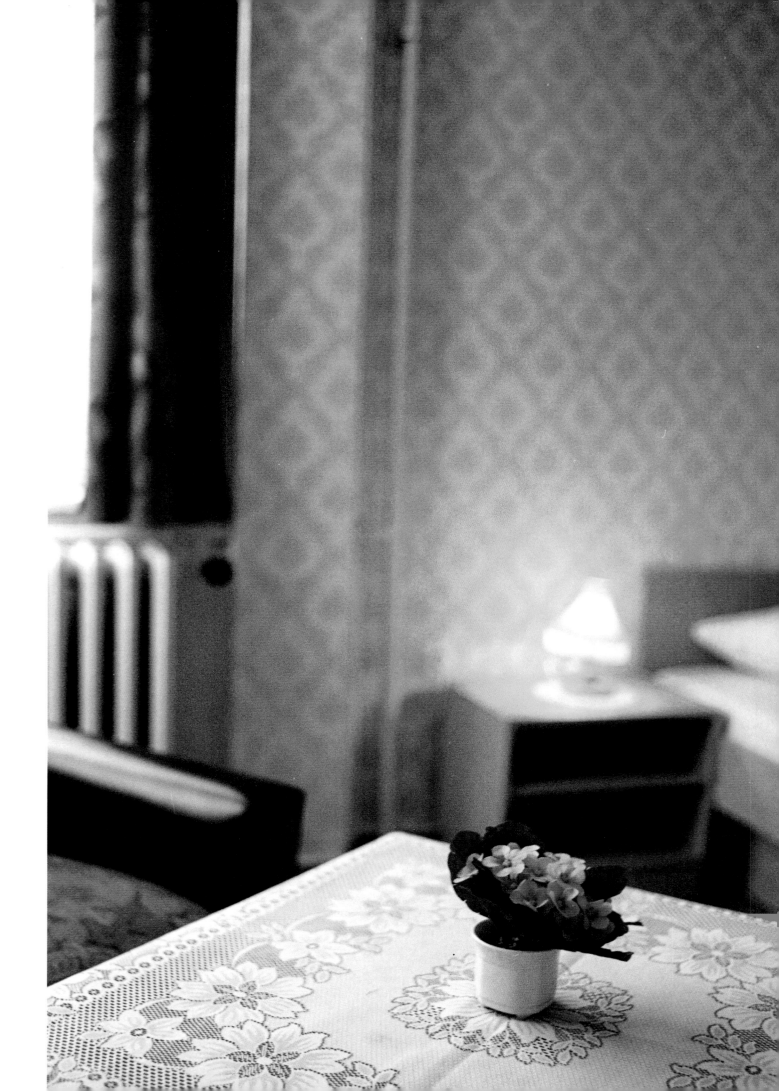

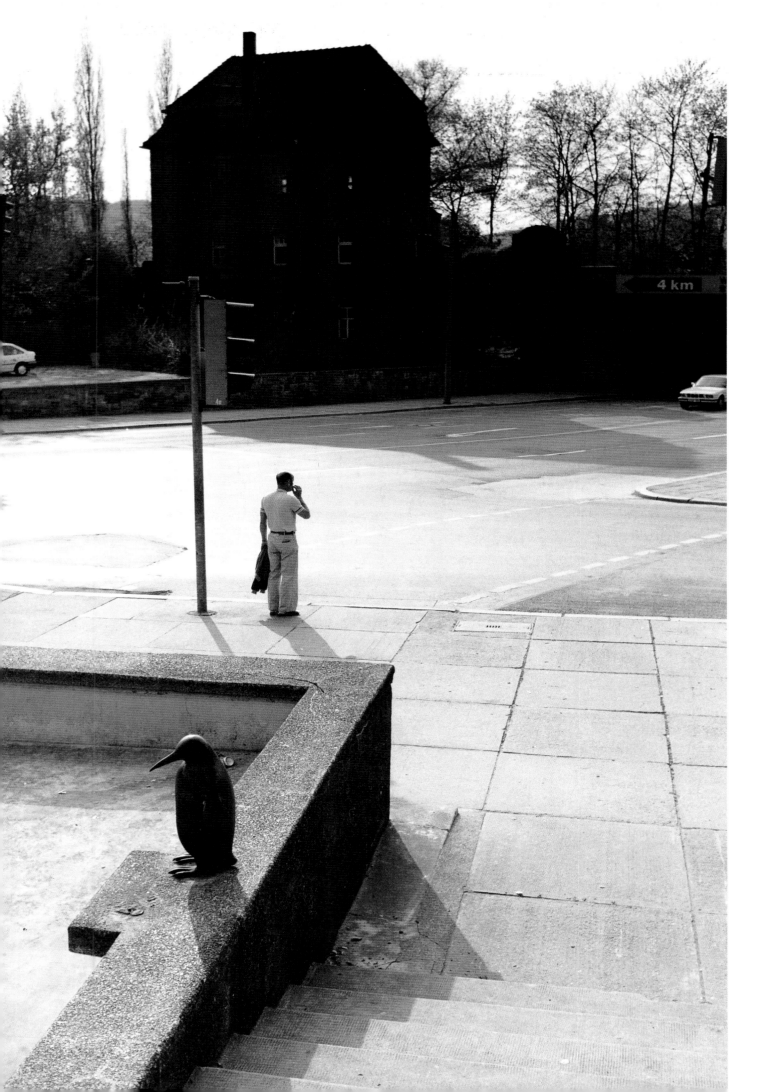

with just one sentence: I like pictures that have a double theme – the richness of what can be depicted and the limits of depictability.

Nur ein Satz zu meiner Photographie: Mir gefallen Bilder, die ein doppeltes Thema haben – die Fülle des Abbildbaren und die Grenzen der Abbildbarkeit.

Ma photographie en une phrase: Me plaisent les images qui ont un double sujet, la profusion des objets reproductibles et les limites de la reproductibilité.

Katharina Bosse was born in Turku, Finland in 1968; 1988–1994 studied photo-design at the Bielefeld Technical College; 1994–1995 DAAD scholarship in the USA; solo exhibitions: 1993 *Partly Red*, Tallinn (Estonia); 1995 *From inside/from outside*, New York; 1996 *Von außen/von innen*, Munich; group exhibitions: 1991 *Babylon - Architecture and photography*, Bielefeld (catalog); 1992 Photo – Biennale Rotterdam; 1995 *One to six – recent photography on architecture*, Aberdeen, Scotland; 1995 *Surroundings*, Kassel (catalog); 1996 *Kunstzeit*, Bochum; since 1991 work published in: Pakt Mono Box, Camera Austria, Kunstforum, Phototechnik International, Der Kunsthandel, Zeit Magazin, Süddeutsche Zeitung Magazin, Merian, Spiegel Special, Time, Fortune, Cosmopolitan, Allegra. Katharina Bosse lives and works in Cologne.

Katharina Bosse, 1968 geboren in Turku/Finnland; 1988–1994 Studium Photo-Design an der Fachhochschule Bielefeld; 1994/95 DAAD-Stipendium USA; Einzelausstellungen: 1993 *Ein Teil Rot*, Tallinn/Estland; 1995 *From inside/from outside*, New York; 1996 *Von außen/von innen*, München; Gruppenausstellungen: 1991 *Babylon – Architektur und Photographie*, Bielefeld (Katalog); 1992 Photo-Biennale Rotterdam; 1995 *One to six – recent photography on architecture*, Aberdeen/Schottland; 1995 *Surroundings*, Kassel (Katalog); 1996 *Kunstzeit*, Bochum; seit 1991 Veröffentlichungen in: Pakt Mono Box, Camera Austria, Kunstforum, Phototechnik International, Der Kunsthandel, Zeit Magazin, Süddeutsche Zeitung Magazin, Merian, Spiegel Special, Time, Fortune, Cosmopolitan, Allegra. Katharina Bosse lebt und arbeitet in Köln.

Katharina Bosse, née en 1968 à Turku (Finlande); 1988–1994 études de photodesign à l'Institut Universitaire de Technologie de Bielefeld; 1994–1995 bourse du DAAD (Deutscher Akademischer Austauschdienst = office allemand d'échanges universitaires) aux USA; expositions personnelles: 1993 *Ein Teil Rot* (Une partie rouge), Tallinn (Estonie); 1995 *From inside/from outside*, New York; 1996 *Von außen/von innen* (De l'extérieur/de l'intérieur), Munich; expositions collectives: 1991 *Babylon – Architektur und Photographie*, Bielefeld (catalogue); 1992 Biennale de photographie de Rotterdam; 1995 *One to six – recent photography on architecture*, Aberdeen, Ecosse; 1995 *Surroundings*, Kassel (catalogue); 1996 *Kunstzeit* (Le temps de l'art), Bochum; depuis 1991, publications dans Pakt Mono Box, Camera Austria, Kunstforum, Phototechnik International, Der Kunsthandel, Zeit Magazin, Süddeutsche Zeitung Magazin, Merian, Spiegel Special, Time, Fortune, Cosmopolitan, Allegra. Katharina Bosse vit et travaille à Cologne.

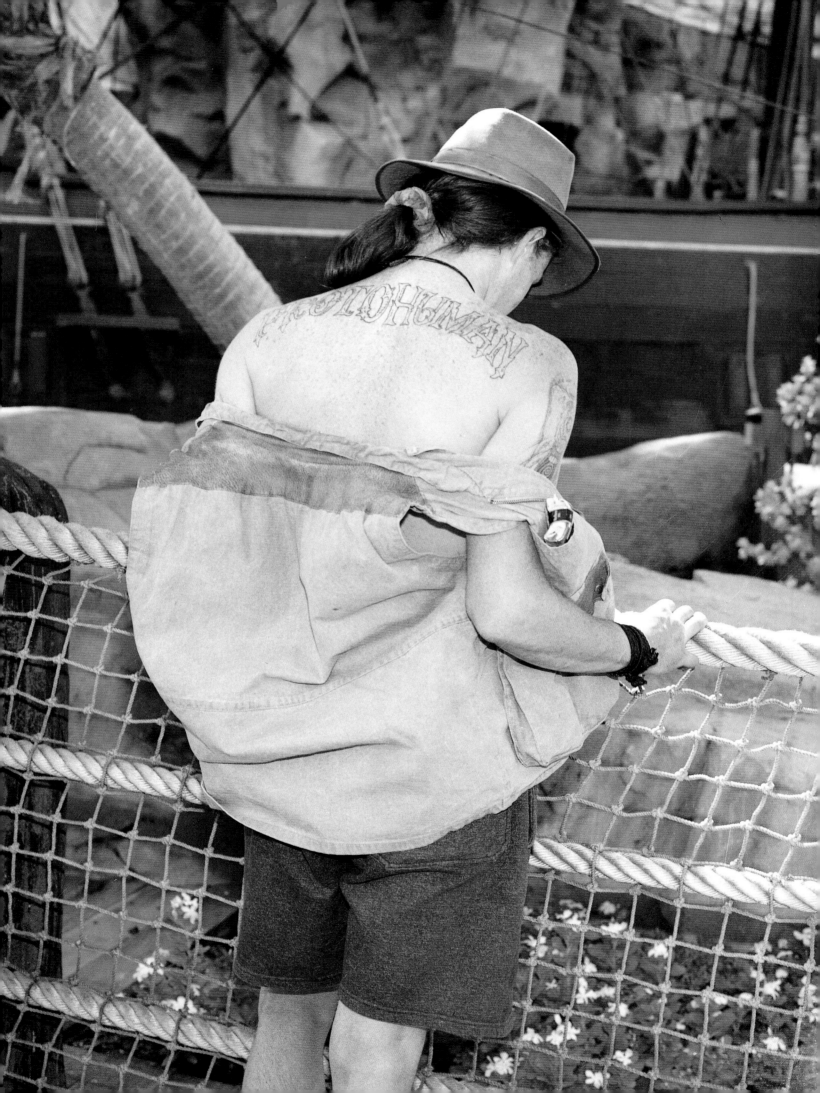

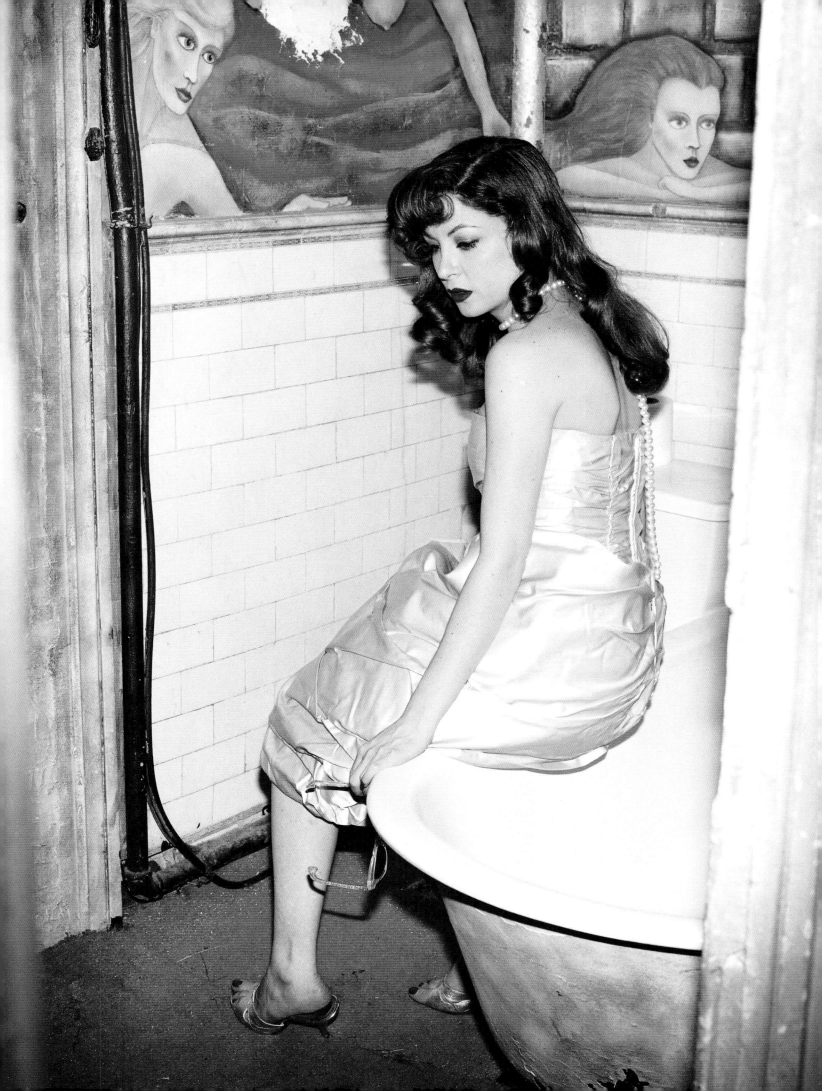

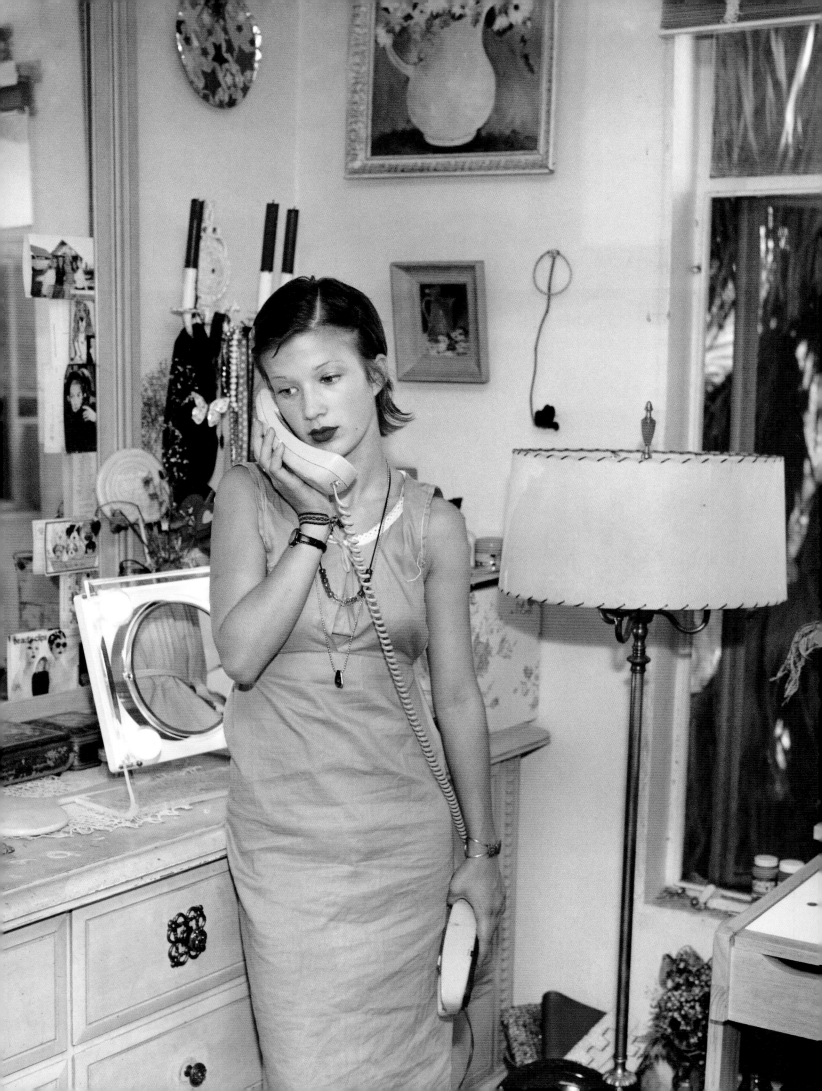

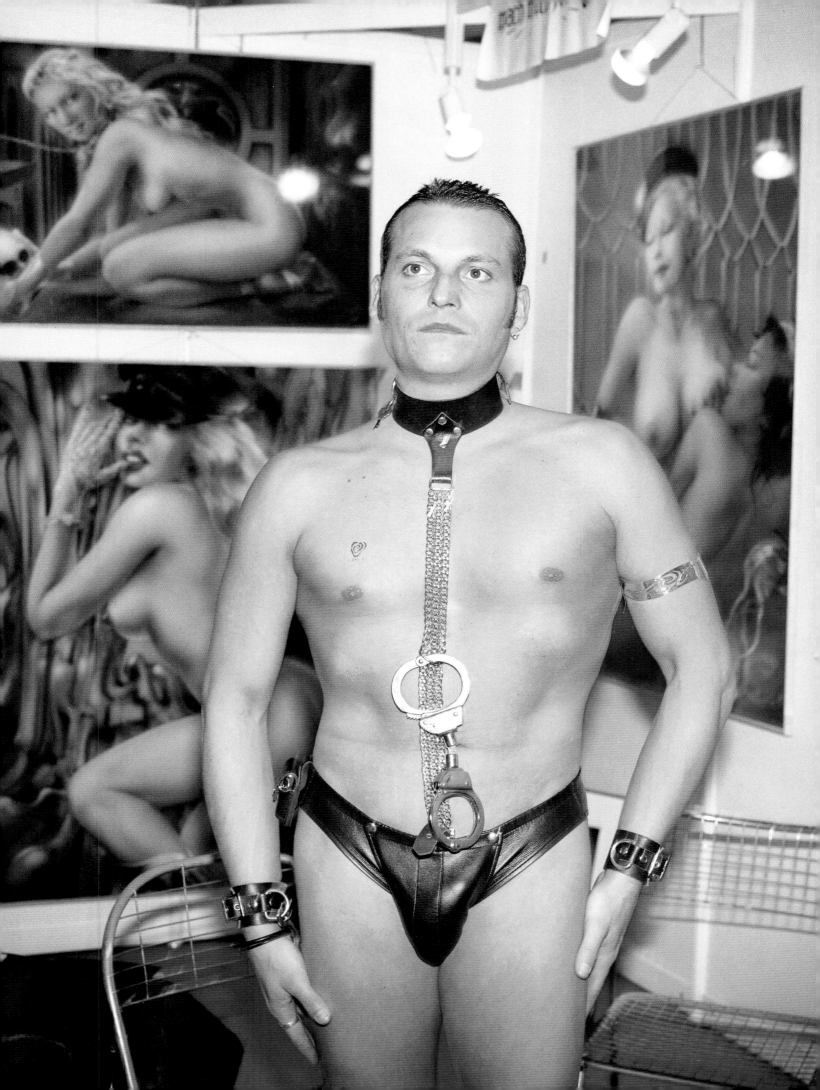

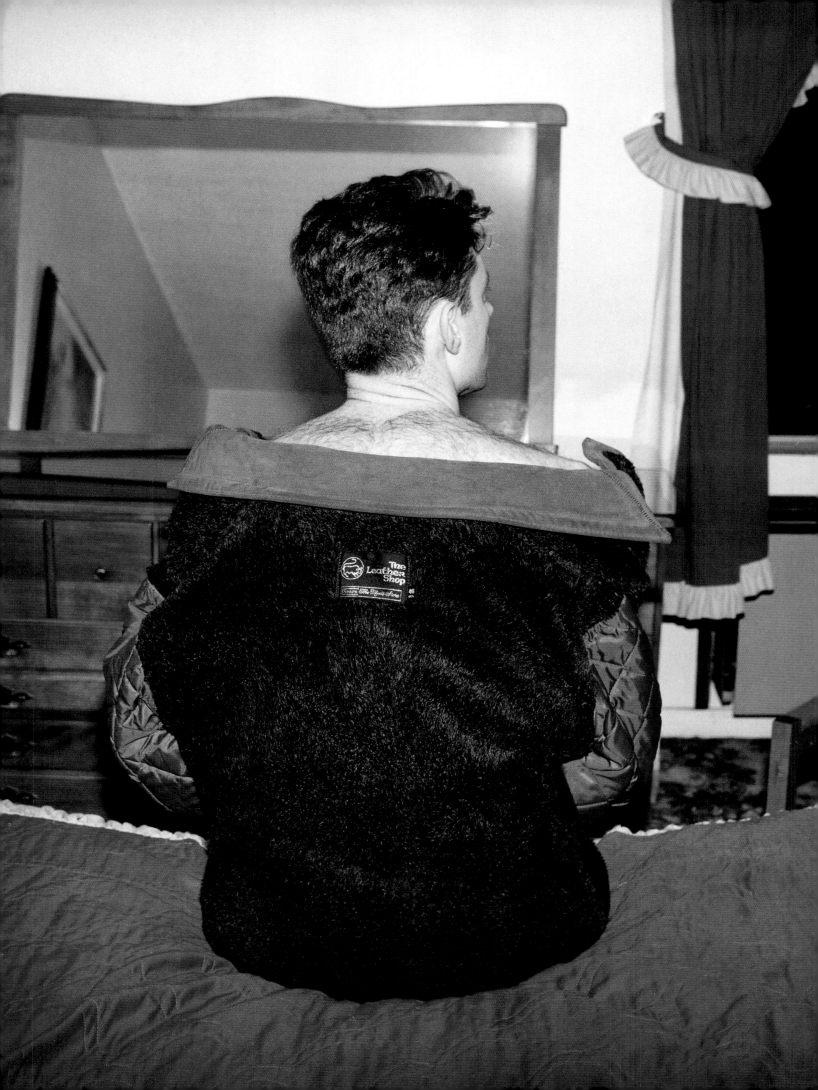

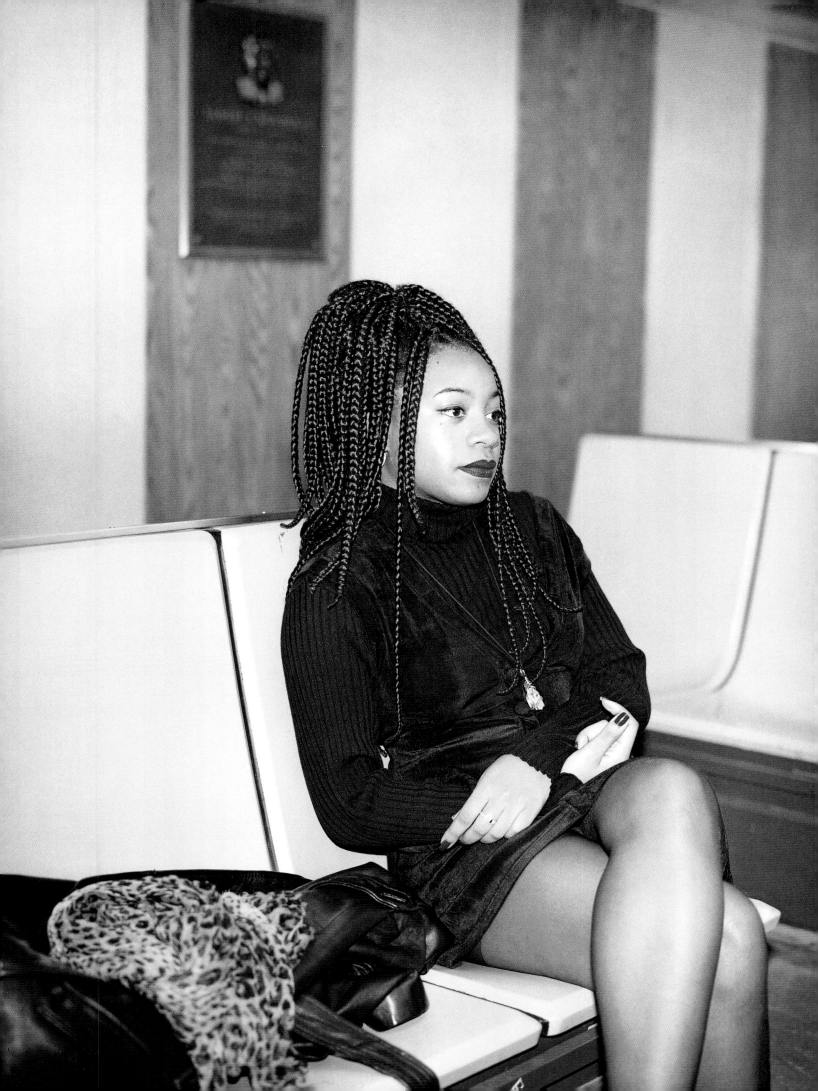

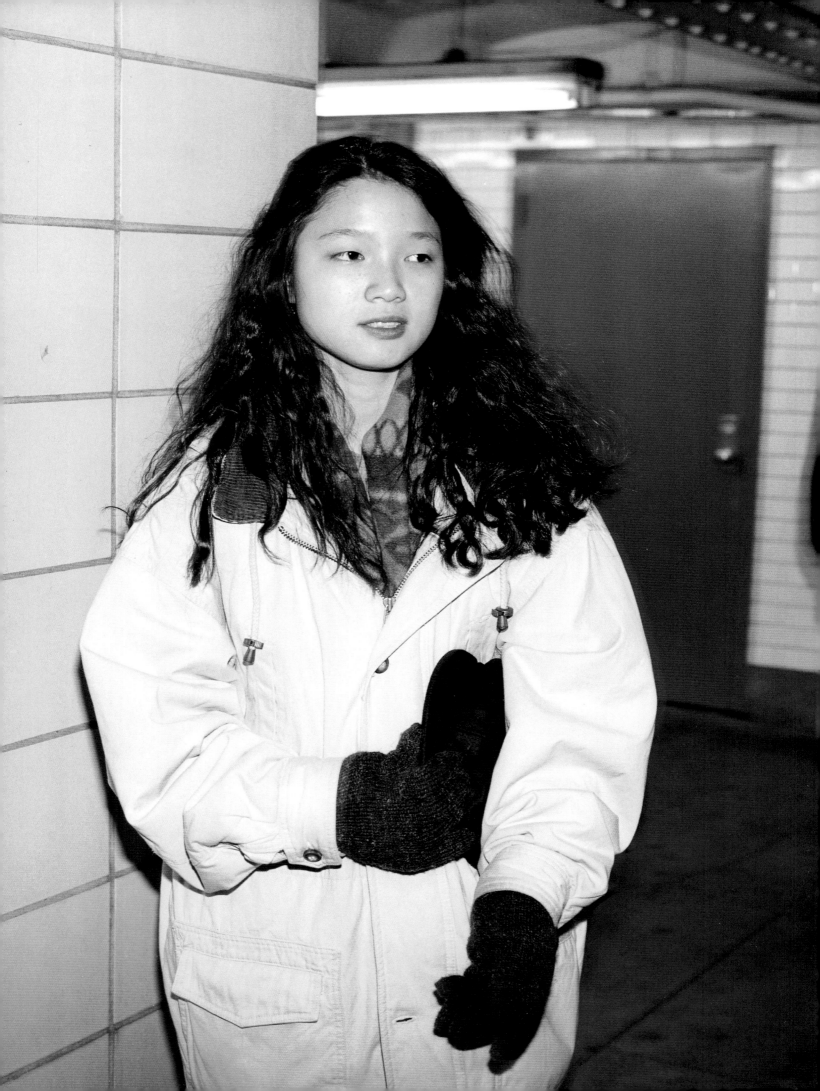

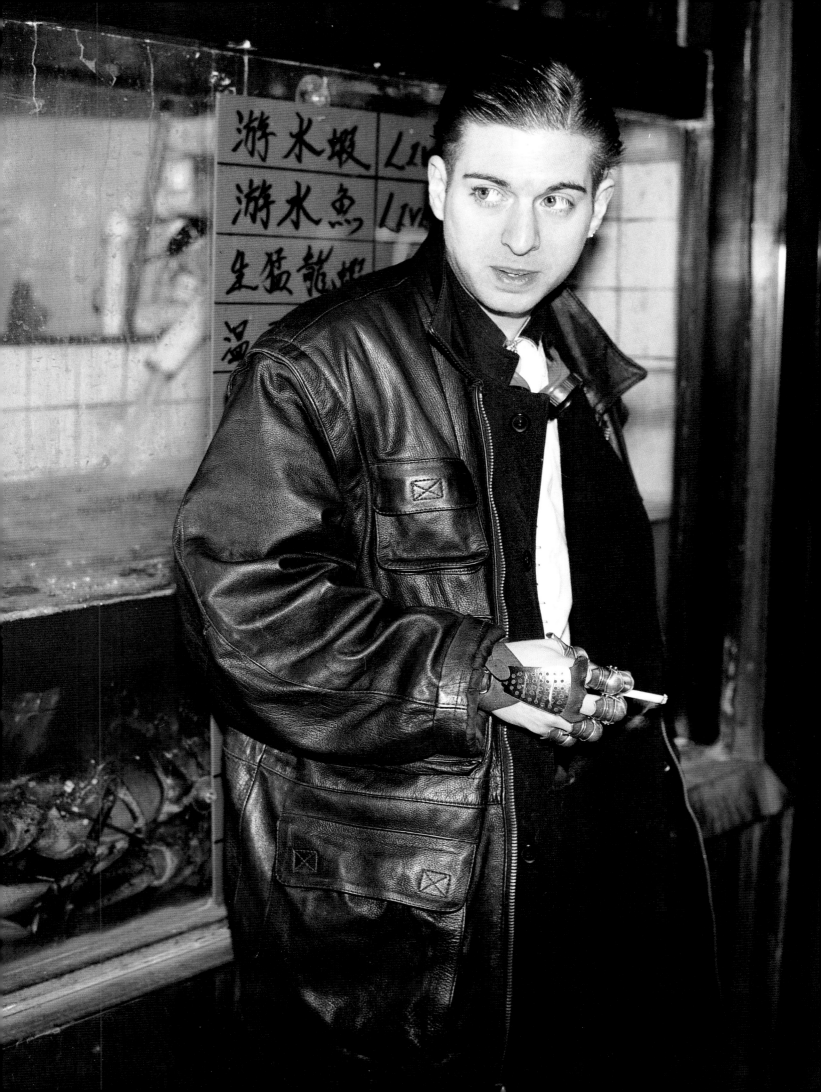

The photographs presented in this book are excerpts from my project *Tokyo – 3 Portfolios*. These three portfolios represent different attempts to describe this metropolis. While in the series that are not shown here I use black-and-white street photography that is spontaneous and full of action, the photos in color are intended to express the calm that I experience in my second home town. This feeling, which originated during my early years in Tokyo, became a strong motivation to stroll through this city and to search my memories. The main aim is to create a counterpoint to the images that meanwhile have been formed in many minds by a one-sided view of this Far Eastern metropolis. Tokyo is subject to constant changes in its appearance. Another reason not to consider this project as finished, but to continue working on it in the years ahead.

Dokumentarphotographie aus Tokyo **Die in diesem Buch vorgestellten Photographien sind meiner Arbeit *Tokyo – 3 Portfolios* entnommen. Diese zeigen verschiedene Ansätze, die Metropole zu beschreiben. Während ich in den hier nicht abgebildeten Serien die Schwarzweiß-Straßenphotographie verwende, die spontan und voller Bewegung ist, sollen die Farbarbeiten die Ruhe ausstrahlen, die ich in meiner zweiten Heimatstadt empfinde. Dieses Gefühl hat sich im Laufe meiner frühen Jahren in Tokio entwickelt und inspiriert mich, durch diese Stadt zu gehen und nach meinen Erinnerungen zu suchen. Es gilt vor allem, einen Gegenpol zu schaffen zu den Bildern, die sich mittlerweile durch eine einseitige Betrachtungsweise dieser fernöstlichen Metropole in vielen Köpfen festgesetzt haben. Tokio ist einem ständigem Wandel seines Erscheinungsbildes ausgesetzt. Ein Grund mehr, diese Arbeit nicht als abgeschlossen zu betrachten, sondern sie in den nächsten Jahren fortzuführen.**

Photographie documentaire de Tokyo Les photographies présentées dans cet ouvrage sont extraites de mon travail *Tokyo – 3 Portfolios*. Ces portfolios sont trois ébauches de descriptions différentes de la métropole. Alors que, dans les séries que l'on ne voit pas ici, j'utilise le noir et blanc pour rendre le mouvement et la spontanéité de la photographie de rue, je veux que les travaux en couleur fassent ressortir cette sensation de calme que j'éprouve dans ma seconde patrie. J'ai développé ce sentiment durant les toutes premières années de mon existence, que j'ai passées à Tokyo, et c'est lui qui m'incite si fortement à marcher dans cette ville à la recherche de mes souvenirs. Il s'agit avant tout de prendre le contre-pied de ces photographies qui se sont imposées à la conscience collective et de proposer une alternative à cette vision unilatérale de la métropole extrême-orientale. L'image que Tokyo donne d'elle-même est en mutation constante. Raison de plus pour ne pas considérer ce travail comme terminé, mais pour au contraire le poursuivre dans les années à venir.

Enno Kapitza was born in Neuss in 1969; spent 8 childhood years in Tokyo, then moved to Munich; 1988 graduated from high school; 1992 worked as an assistant to Achim Bunz; 1992–1995 studied at the College of Photodesign in Munich; 1995 exhibition *Tokyo – 3 Portfolios*, Munich; exhibition *Tokyo – 3 Portfolios*; German Photo Prize, Stuttgart, 1996 became a member of the Bilderberg agency; work published in Süddeutsche Zeitung Magazin, jetzt, Photomagazin, among others. Enno Kapitza lives in Munich.

Enno Kapitza, 1969 geboren in Neuss; während seiner Kindheit und Jugend 8 Jahre in Tokio, dann Umzug nach München; 1988 Abitur; 1992 Assistenz bei Achim Bunz; 1992–1995 Ausbildung an der Fachakademie Photodesign, München; 1995 Ausstellung *Tokyo – 3 Portfolios*, München; Ausstellung *Tokyo – 3 Portfolios*, Deutscher Photopreis, Stuttgart; 1996 Mitglied der Agentur Bilderberg; Veröffentlichungen u.a. in: Süddeutsche Zeitung Magazin, jetzt, Photomagazin. Enno Kapitza lebt in München

Enno Kapitza, né en 1969 à Neuss; enfance et adolescence (8 années) à Tokyo, puis déménagement à Munich; 1988 baccalauréat; 1992 assistant d'Achim Bunz; 1992–1995 formation à l'Académie de Photodesign de Munich; 1995 exposition *Tokyo – 3 Portfolios*, Munich; exposition *Tokyo – 3 Portfolios*, Deutscher Photopreis (prix allemand de Photographie), Stuttgart; 1996 membre de l'agence Bilderberg; publications dans divers magazines dont la Süddeutsche Zeitung, jetzt, Photomagazin. Enno Kapitza vit à Munich.

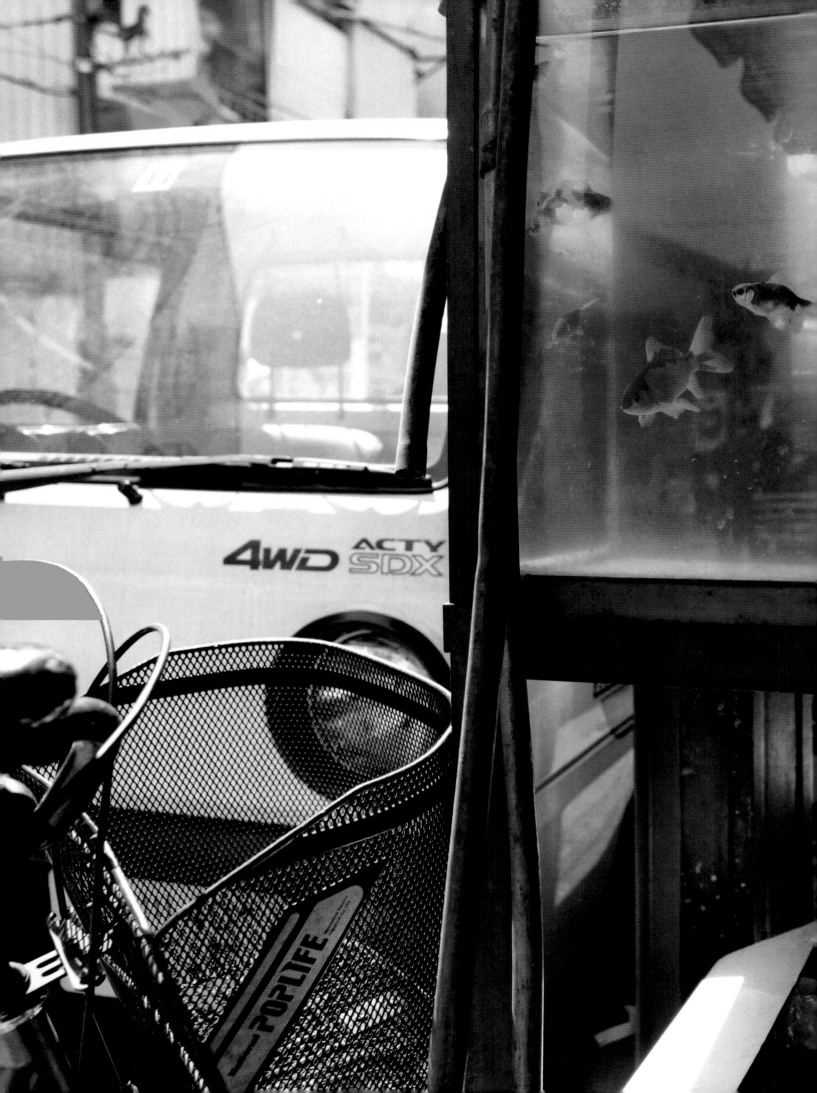

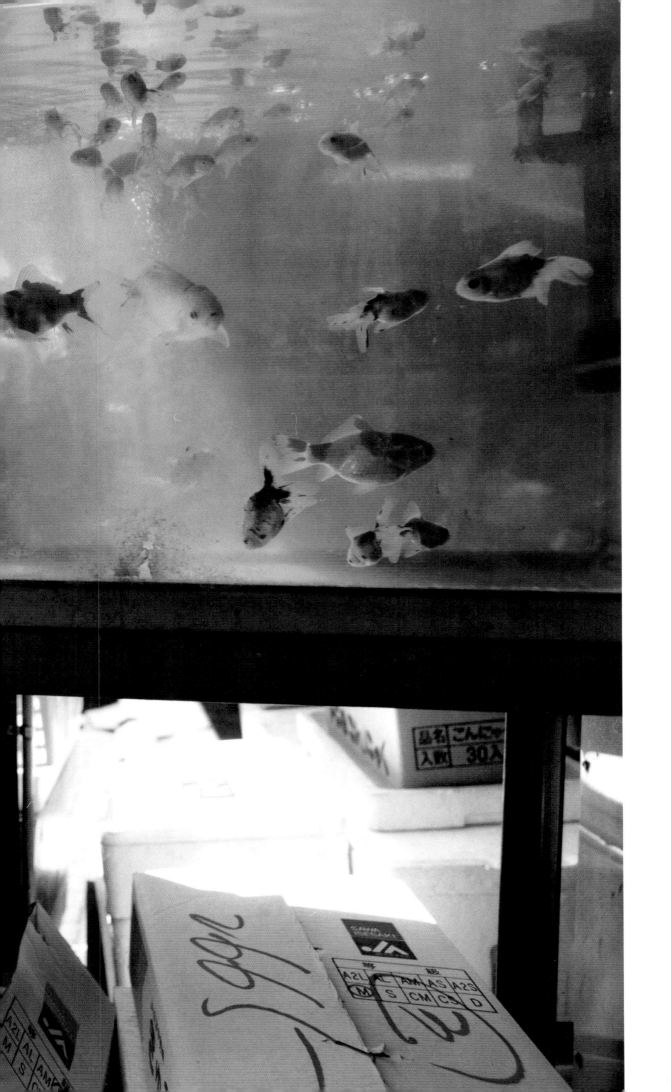

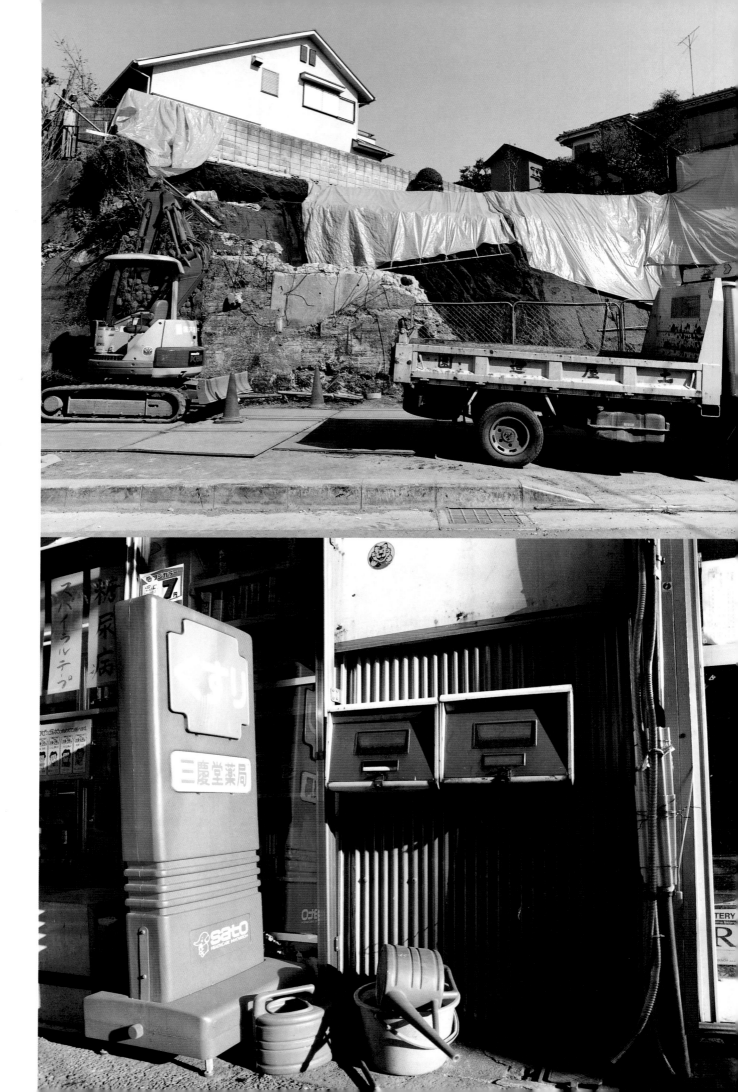

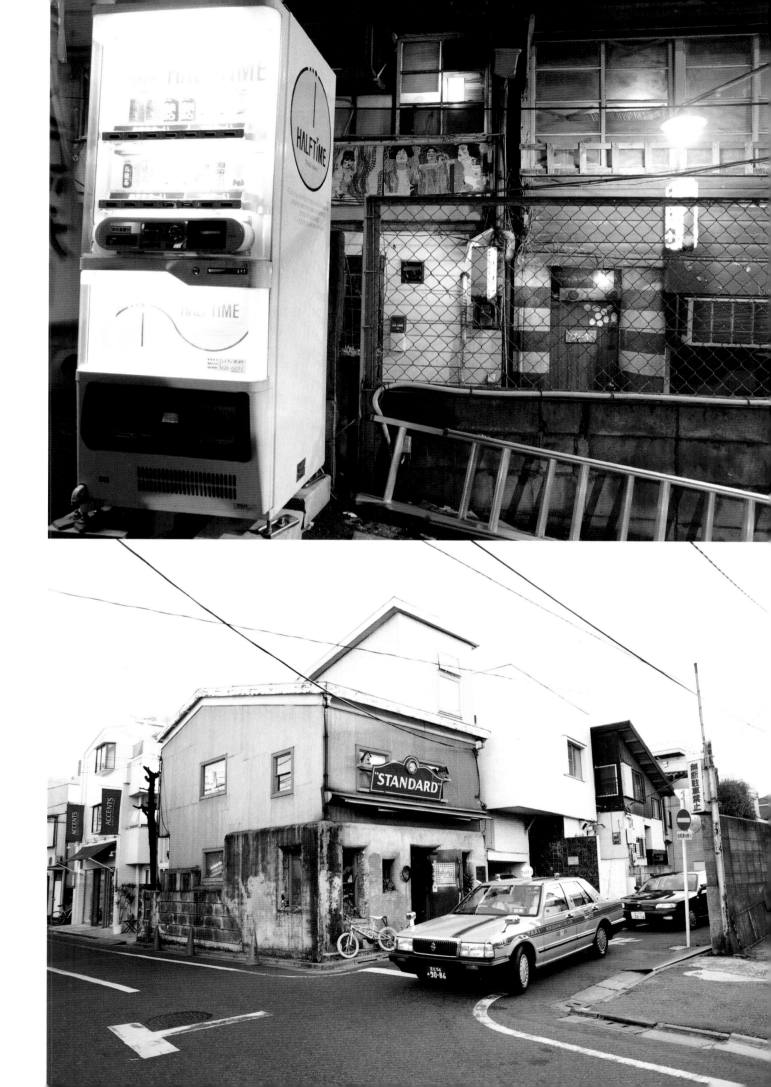

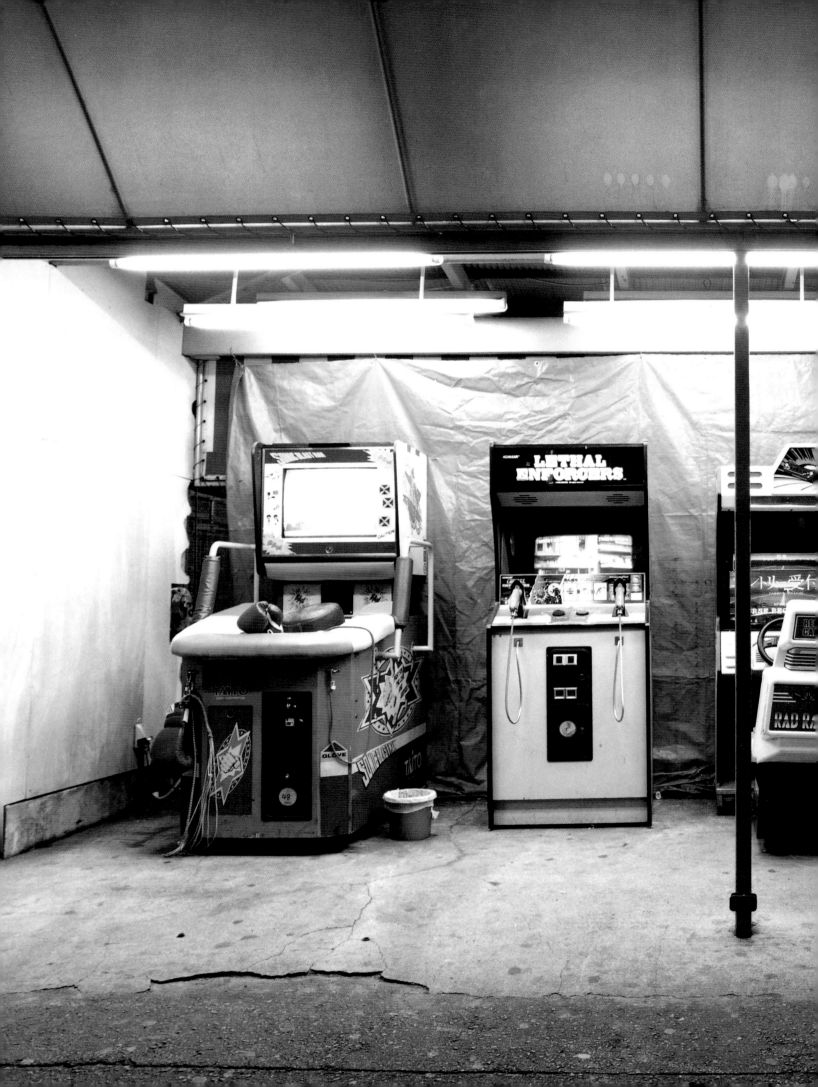

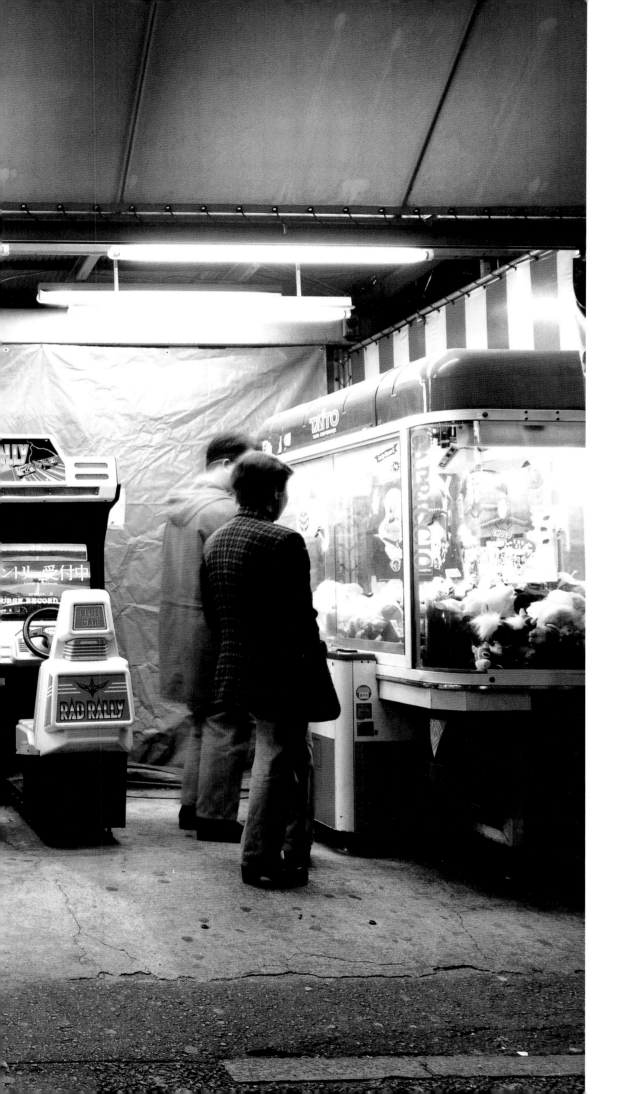

The text for my work reads as follows: "Happiness will eventually come to you too." Glückskeks (Fortune cookie), Munich, March 1996

Der Wille zum Glück, 1995–19... Der Text zu meinen Arbeiten lautet wie folgt: „Das Glück kommt schließlich auch zu Ihnen." Glückskeks, München, März 1996

La volonté de bonheur, 1995–19... Le commentaire que je ferai de mes travaux est le suivant: «Vous aussi, vous finirez par avoir votre part de bonheur.» Glückskeks (Biscuits porte-bonheur), Munich, mars 1996

Armin Smailovic was born in Zagreb (Croatia), in 1968; 1989–1991 Bavarian State College of Photography, Munich; 1992 Grant for Contemporary German Photography sponsored by the Alfried Krupp von Bohlen und Halbach Foundation in Essen; exhibitions: 1993 Folkwang Museum, Essen (catalog); 1994 Robert Doisneau Gallery, André Malraux Cultural Centre, Vandœuvres-les-Nancy; 1994 Basement Gallery of the College of Photodesign, Munich, *Ansichten*, Munich (catalog); 1995 WUK, Vienna; 1996 Künstlerwerkstatt, Munich. Armin Smailovic lives in Munich.

Armin Smailovic, 1968 geboren in Zagreb/Kroatien; 1989–1991 Bayerische Staatslehranstalt für Photographie, München; 1992 Stipendium für Zeitgenössische Deutsche Photographie der Alfried Krupp von Bohlen und Halbach-Stiftung, Essen; Ausstellungen: 1993 Folkwang Museum, Essen (Katalog); 1994 Gallerie Robert Doisneru, Centre Culturel André Malraux, Vandœuvres-les-Nancy; 1994 Kellergalerie der Fachakademie für Photodesign, München; *Ansichten*, München (Katalog); 1995 WUK, Wien; 1996 Künstlerwerkstatt, München. Armin Smailovic lebt in München.

Armin Smailovic, né en 1968 à Zagreb (Croatie); 1989–1991 Ecole Nationale de Photographie de Bavière, Munich; 1992 bourse de la photographie contemporaine allemande de la fondation Alfried Krupp von Bohlen und Halbach, Essen; expositions: 1993 Folkwang Museum, Essen (catalogue); 1994 Galerie Robert Doisneau, Centre Culturel André Malraux, Vandœuvres-les-Nancy; 1994 Galerie en sous-sol de l'Académie de Photodesign de Munich; *Ansichten* (Vues), Munich (catalogue); 1995 WUK, Vienne; 1996 Künstlerwerkstatt, Munich. Armin Smailovic vit à Munich.

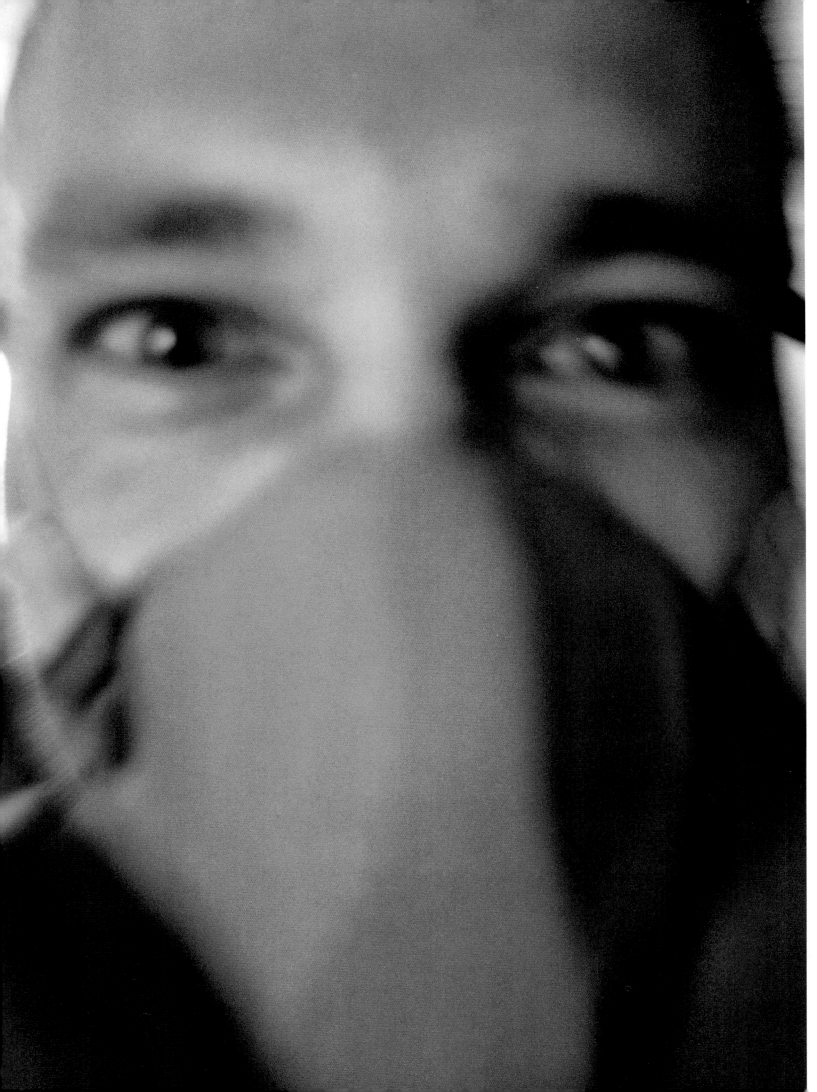

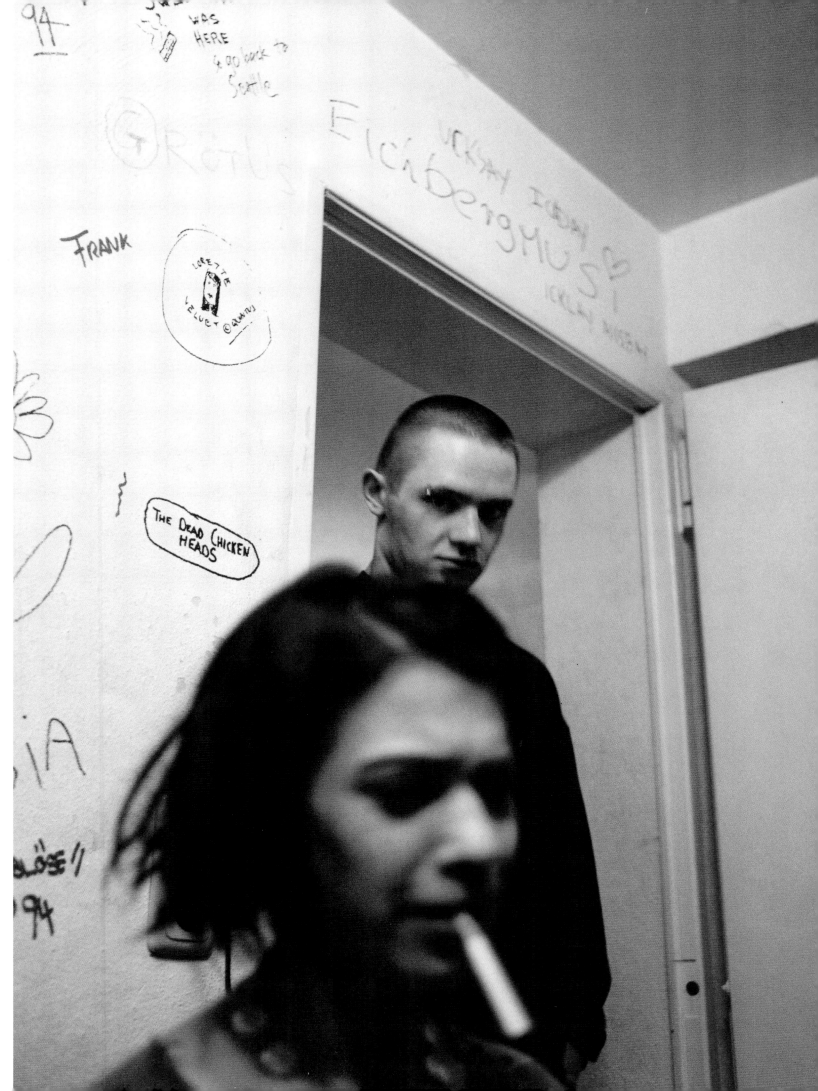

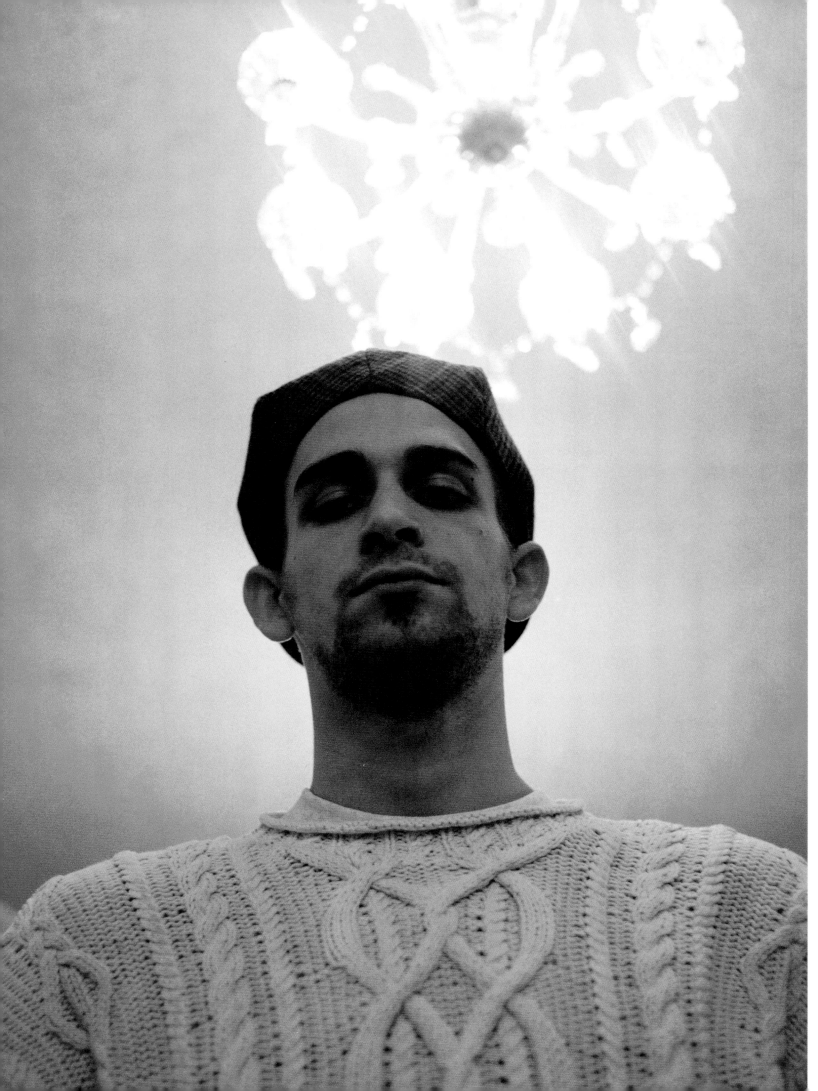

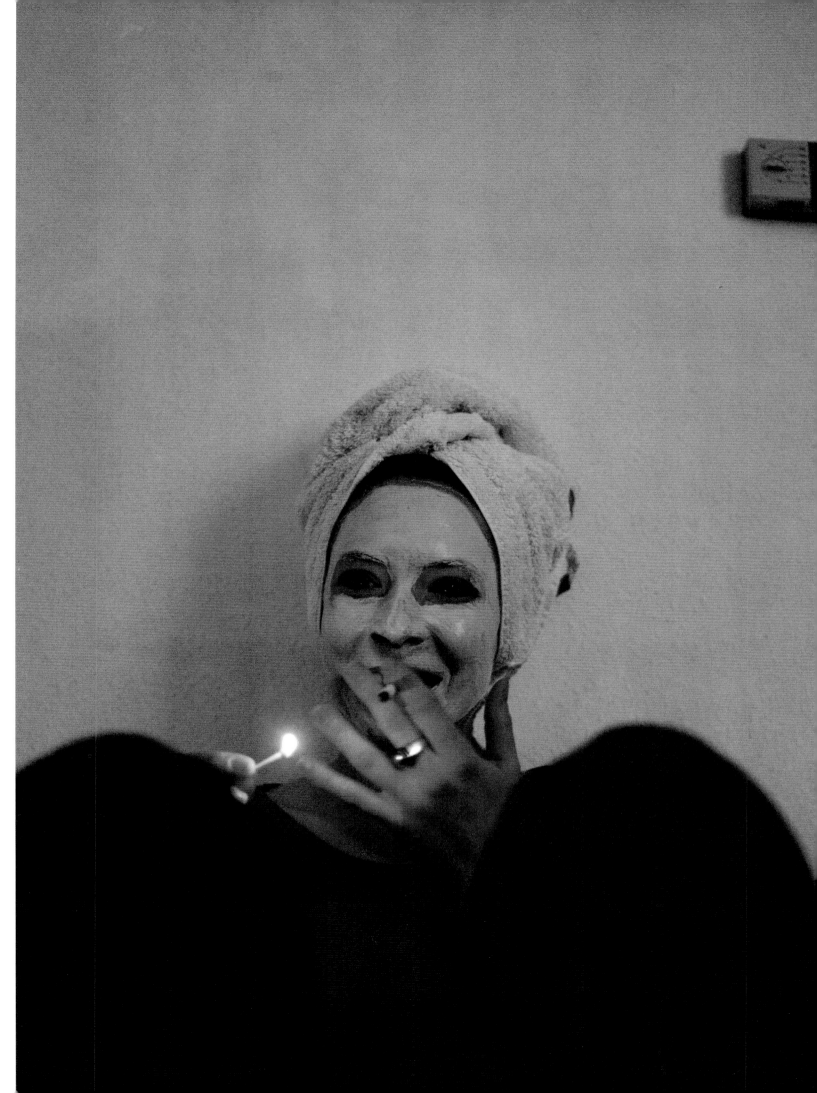

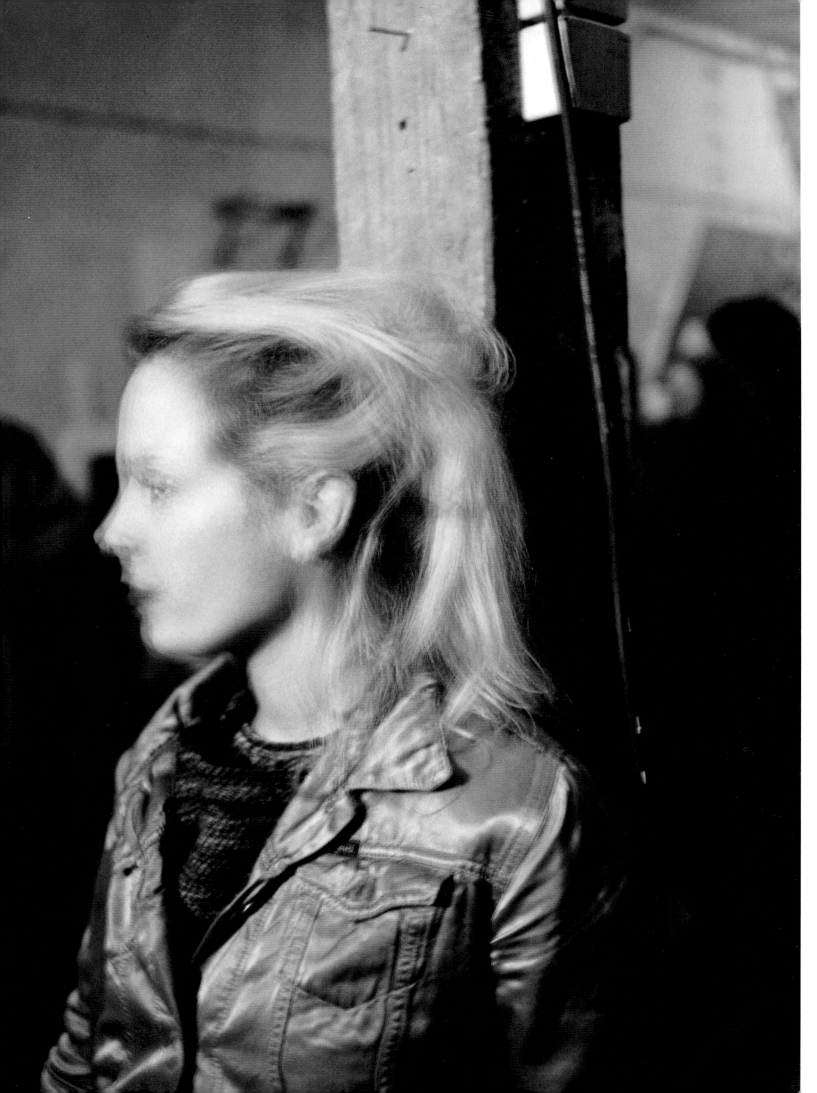

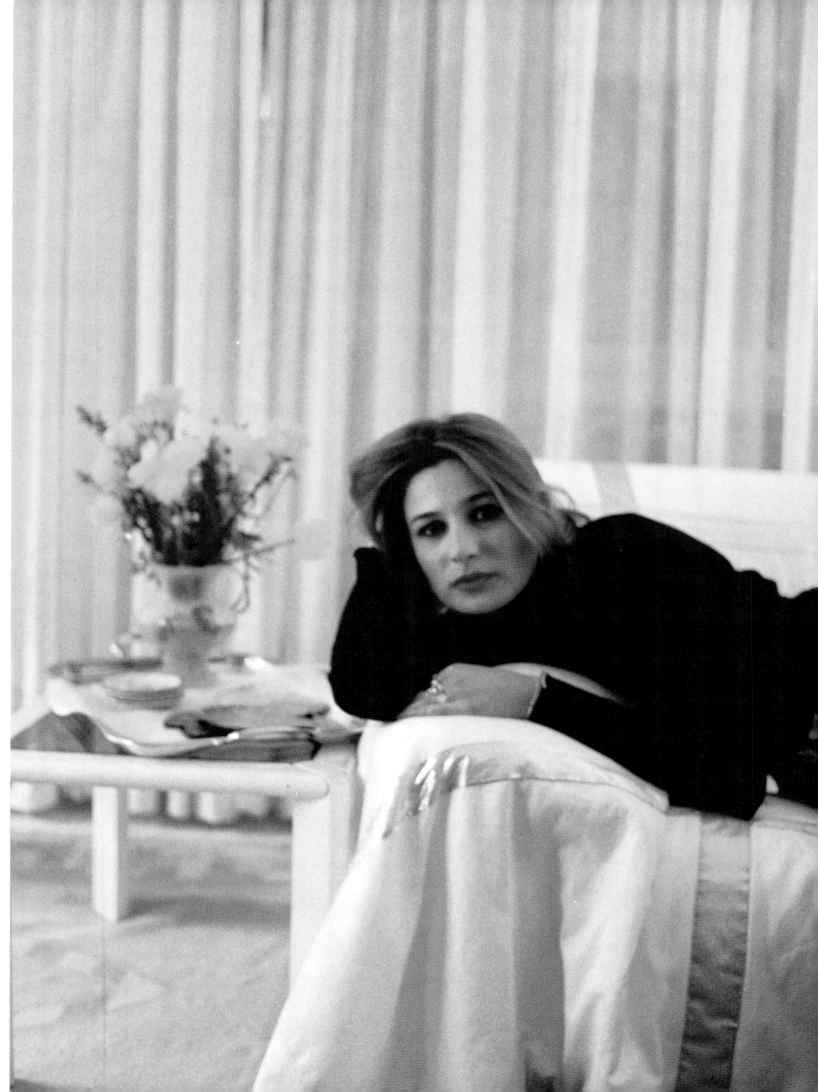

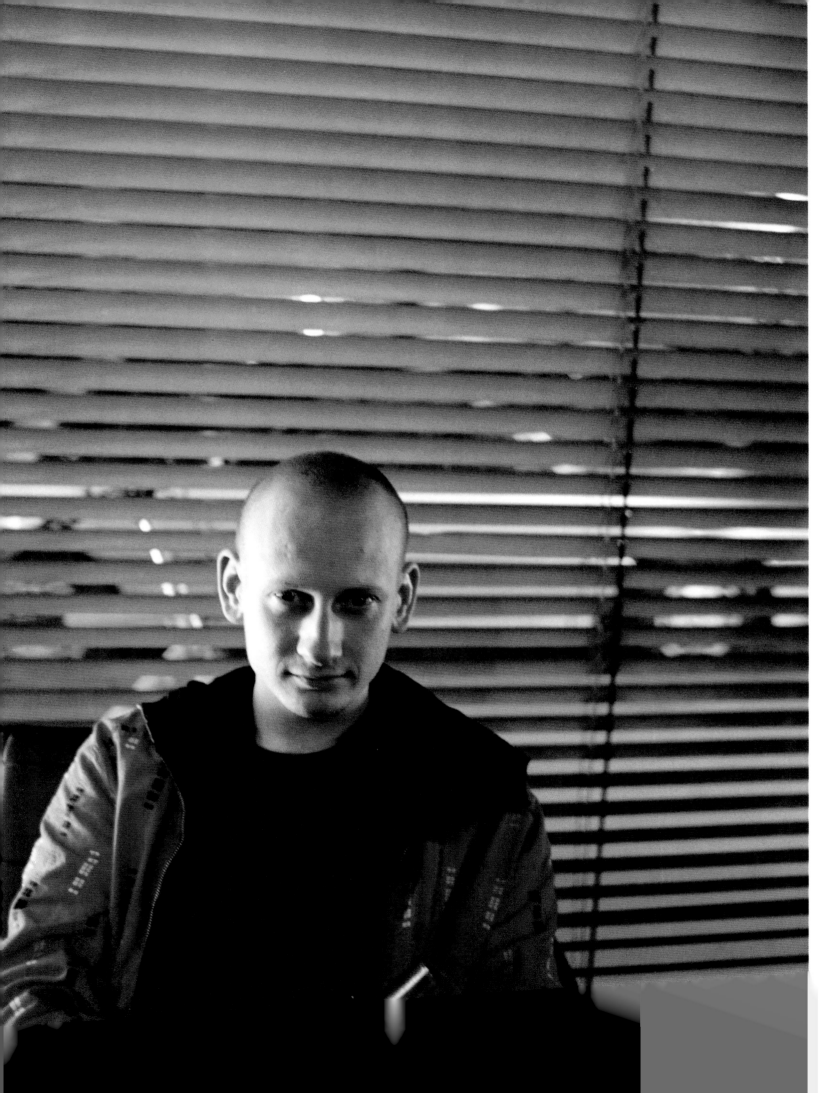

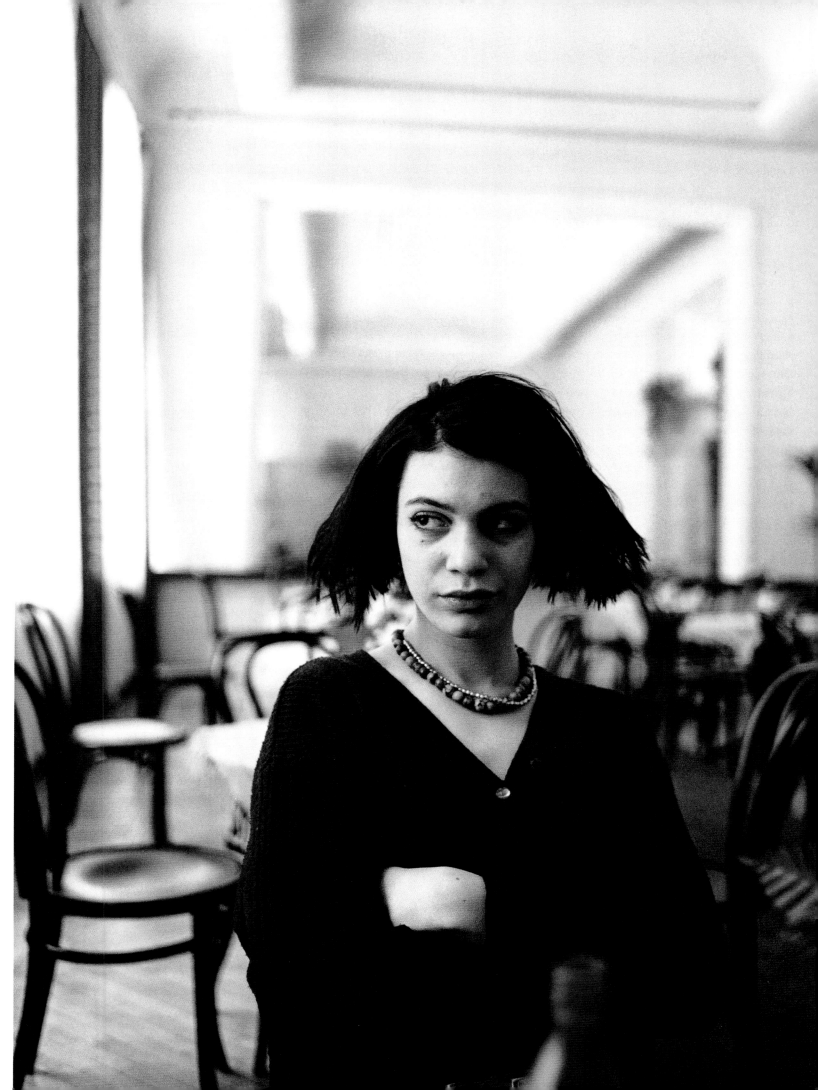

wolfgang bellwinkel *Photographic work on the peace process in Bosnia-Herzegovina*

In the summer of 1995, after a short period of calmness early in the year, the conflict in Bosnia re-ignited. Sarajevo once again came under massive artillery bombardment, and Bosnian Serb troops overran the Žepa and Srebrenica enclaves. Thousands of refugees were massacred and disappeared in mass graves. Thanks largely to the punitive air attacks by NATO, at the end of the year all three warring parties were compelled to come to the negotiating table. On the 14th of December 1995 they signed the Dayton Agreement. Among its main stipulations were the preservation of Bosnia-Herzegovina as a unified state and the right of all refugees to return to their homes. In my project *The daily routine of war*, completed late 1994, I showed people and landscapes during the war years of 1993 and 1994. The new series presented here in the form of excerpts begins in December 1995 and documents the year after Dayton. As the second part of a long-term study, it describes the wounds left by the war and the efforts to convert a war society into a civilian society. I mostly photograph landscapes that mirror both the past as well as the present, and I place them in a provocative relationship with portraits. In this work too, I prefer to direct my attention to ordinary everyday life, this in a country that is in the throes of regaining normal daily routines. This departs from or expands the classic way of depicting wars. What remains is a documentary level that is not exhaustive; my objective is to leave room for the viewer to form associations. The photographic form is that of a photo essay. While the pictures have individual image values, they only attain complete substance in their groupings, through the manner they are sequenced, through reciprocal relationships. The complete project encompasses approximately 30 images and was supported by a grant from the DAAD (German Academic Exchange Service).

Illustrations: 1. Houses in the Krajina; 2. Landscape, Bihac; 3. House in Sarajevo; 4. Tito, Sarajevo; 5. Mass grave near Nova Kasaba; 6. Voting booths, Stolac

Photographische Arbeit zum Friedensprozeß in Bosnien-Herzegovina **Im Sommer 1995, nach einer kurzen Beruhigung zu Beginn des Jahres, eskalierte der Konflikt in Bosnien. Sarajevo stand erneut unter massivem Beschuß, bosnisch-serbische Truppen nahmen die Enklaven Žepa und Srebrenica ein. Tausende von Flüchtlingen wurden umgebracht und verschwanden in Massengräbern. Nicht zuletzt nach den massiven Luftangriffen seitens der NATO wurden Ende des Jahres alle drei Kriegsparteien an den Verhandlungstisch gezwungen. Am 14. Dezember 1995 unterzeichneten sie das Abkommen von Dayton. Zu dessen wichtigsten Vereinbarungen zählen die Erhaltung von Bosnien-Herzegowina als einheitlicher Staat sowie das Recht aller Flüchtlinge auf Rückkehr in ihre Heimatorte. In meiner Ende 1994 abgeschlossenen Arbeit *Die Alltäglichkeit des Krieges* zeigte ich Menschen und Landschaften während der Kriegsjahre 1993 und 1994. Die neue, hier in Ausschnitten vorgestellte Serie beginnt im Dezember 1995 und dokumentiert das Jahr nach Dayton. Als zweiter Teil einer Langzeitstudie erzählt sie von den Wunden, die der Krieg hinterlassen hat, und von den Bemühungen, eine Kriegsgesellschaft in eine zivile zu überführen. Ich photographiere vor allem Landschaften, die gleichsam Spiegelbilder von Vergangenheit und Gegenwart sind, und setze sie in ein Spannungsverhältnis zu Porträts. Auch in dieser Arbeit richte ich meinen Blick vorzugsweise auf das Alltägliche – in einem Land, das sich gerade in einem Prozeß der Wiedergewinnung der Alltäglichkeit befindet. Dadurch wird die Sichtweise der klassischen Kriegsphotographie verlassen bzw. erweitert. Es bleibt eine dokumentarische Ebene, ohne daß sich jedoch die Bilder in ihr erschöpfen; mein Ziel ist es, dem Betrachter Raum für Assoziationen zu eröffnen. Die photographische Form ist die des Photoessays. Obwohl die Bilder durchaus Einzelbildcharakter haben, erschließen sie sich vollständig erst in ihrer Gesamtheit, durch die Art und Weise ihrer Abfolge, durch wechselseitige Bezüge. Die gesamte Arbeit umfaßt etwa 30 Bilder und wurde durch ein Stipendium des DAAD (Deutscher Akademischer Austauschdienst) unterstützt.**

Abbildungen: 1. Häuser in der Krajina; 2. Landschaft, Bihac; 3. Haus in Sarajevo; 4. Tito, Sarajevo; 5. Massengrab bei Nova Kasaba; 6. Wahlkabinen, Stolac

Photographische Arbeit zum Friedensprozeß in Bosnien-Herzegovina Après une brève accalmie début 1995, le conflit reprit de plus belle en Bosnie pendant l'été. Sarajevo fit de nouveau l'objet de tirs groupés, les troupes bosno-serbes prirent les enclaves de Žepa et de Srebrenica. Des milliers de réfugiés furent assassinés et disparurent dans des charniers. C'est surtout grâce aux raids aériens répétés des forces de l'OTAN qu'à la fin de l'année, les trois parties en guerre furent contraintes de s'asseoir autour d'une table. Les négociations aboutirent, le 14 décembre 1995, à la signature des accords de Dayton, dont les points les plus importants sont le maintien de l'intégrité de l'Etat de Bosnie-Herzégovine ainsi que le droit de tous les réfugiés à rentrer chez eux. Dans mon travail *Die Alltäglichkeit des Krieges* (La guerre au quotidien), terminé fin 1994, je montrais des gens et des paysages photographiés en 1993 et 1994, pendant la guerre. Cette nouvelle série, dont on présente ici des extraits, commence en décembre 1995 et se veut un document sur l'année qui a suivi Dayton. Second volet d'une étude de longue haleine, elle témoigne des séquelles de la guerre et du difficile passage à la société civile. Je photographie essentiellement des paysages dans la mesure où ils reflètent en quelque sorte le passé et le présent, et je les confronte aux portraits d'une façon propre à établir entre eux un rapport de tension. Là encore, mon regard se tourne de préférence vers le quotidien, dans un pays qui se trouve justement dans un processus de reconquête de la quotidienneté. L'approche de la photographie de guerre traditionnelle y est abandonnée, ou faire élargie: le point de vue documentaire demeure, sans parvenir cependant à épuiser toute la portée de mon travail. Mon objectif est de proposer au spectateur un espace dans lequel il pourra opérer ses propres associations. La forme est celle de l'essai photographique. Même si, considérées individuellement, les images ont chacune leur spécificité, elles n'acquièrent leur pleine signification que replacées dans leur contexte d'ensemble, dans la façon dont elles se succèdent, dans les rapports qu'elles entretiennent les unes avec les autres. Ce travail compte dans son intégralité quelque 30 photographies. Il a été soutenu par une bourse du DAAD (Office allemand d'échanges universitaires).

Illustrations: 1. Maisons de la Krajina; 2. Paysage, Bihac; 3. Maison à Sarajevo; 4. Tito, Sarajevo; 5. Charnier près de Nova Kasaba; 6. Urnes électorales, Stolac

Wolfgang Bellwinkel was born in Bochum in 1959; 1977 graduation from high school; 1984 studied communication design majoring in photojournalism at the Essen Polytechnic University under Professor Angela Neuke; 1988 worked as a freelance photographer; 1994 dissertation *The daily routine of war*; 1994 publication of the book *Bosnia, War in Europe*, in cooperation with P. M. Schäfer; member of the German Photographic Society; work on the subject of *Vietnam, 20 years after the war*; 1995 assignments for, among others, Süddeutsche Zeitung Magazin, Telegraph Magazine, Zeit Magazin, Details; Membership of Visum; 1996 documentation of the peace process in Bosnia; exhibitions and awards: 1986 *Hausbesetzer* (House squatters), Theater Bochum; 1989 slide presentation on the subject *DDR* (GDR), Rencontres Internationales de la Photographie, Arles, France; *Go West*, Theater Bochum; 1992 *Krieg* (War), Museum Bochum (catalog); 1993 *Wojna*, Stodola Gallery, Warsaw; 1994 *Krieg* (War), prize and exhibition, German Photo Prize (catalog), Stuttgart, Arles and photokina (Cologne); *Die Alltäglichkeit des Krieges* (The daily routine of war), Treppenhaus Gallery, Berlin and National Gallery of Sarajevo; *Fundstücke* (Found objects), 2nd Prize in the Photography as Art Competition, Pforzheim; 1995 Commendation, Otto Steinert Prize; *Die Alltäglichkeit des Krieges* (The daily routine of war), Cologne, Phototage Herten; award winner, BFF (German Association of Freelance Photographers) competition for the best examination work, exhibitions, Stuttgart (catalog); Arles, 1996 *Die Alltäglichkeit des Krieges* (The daily routine of war); award and exhibition, German Photo Prize, Stuttgart; participated in the exhibition *Das Deutsche Auge* (The German Eye), Deichtorhallen Hamburg (catalog). Wolfgang Bellwinkel lives in Bochum.

Wolfgang Bellwinkel, 1959 geboren in Bochum; 1977 Abitur; 1984 Studium Kommunikationsdesign an der Universität Gesamthochschule Essen mit Schwerpunkt Bildjournalistik bei Prof. Angela Neuke; 1988 Tätigkeit als freier Photograph; 1994 Diplomarbeit *Die Alltäglichkeit des Krieges*; 1994 erscheint das Buch *Bosnia, Krieg in Europa* in Zusammenarbeit mit P.M. Schäfer; Berufung in die Deutsche Gesellschaft für Photographie; Arbeit zum Thema *Vietnam, 20 Jahre nach dem Krieg*; 1995 Auftragsarbeiten u. a. für Süddeutsche Zeitung Magazin, Telegraph-Magazin, Zeit Magazin, Details; Mitgliedschaft bei Visum; 1996 Dokumentation des Friedensprozesses in Bosnien; Ausstellungen und Preise: 1986 *Hausbesetzer*, Theater Bochum; 1989 Diapräsentation zum Thema *DDR*, Photofestival, Arles/Frankreich; *Go west*, Theater Bochum; 1992 *Krieg*, Museum Bochum (Katalog); 1993 *Wojna*, Galerie Stodola, Warschau; 1994 Krieg, Auszeichnung/Ausstellung, Deutscher Photopreis (Katalog), Stuttgart, Arles und photokina, Köln; *Die Alltäglichkeit des Krieges*, Galerie Treppenhaus, Berlin und Nationalgalerie, Sarajevo; *Fundstücke*, 2. Preis beim Wettbewerb Photographie als Kunst, Pforzheim; 1995 lobende Erwähnung, Otto Steinert Preis; *Die Alltäglichkeit des Krieges*, Köln, Phototage Herten; Preisträger, BFF-Wettbewerb der besten Examensarbeiten, Ausstellungen, Stuttgart (Katalog), Arles; 1996 *Die Alltäglichkeit des Krieges*, Auszeichnung/Ausstellung, Deutscher Photopreis, Stuttgart; 1996 Ausstellungsbeteiligung, *Das Deutsche Auge*, Deichtorhallen, Hamburg (Katalog). Wolfgang Bellwinkel lebt in Bochum.

Wolfgang Bellwinkel, né en 1959 à Bochum; 1977 baccalauréat; 1984 études de design et de communication à la Universität Gesamthochschule de Essen auprès du professeur Angela Neuke, spécialisation photojournalisme; 1988 travaille comme photographe indépendant; 1994 travail de fin d'études *Die Alltäglichkeit des Krieges*; 1994 parution de l'ouvrage *Bosnia, Krieg in Europa* (Bosnie, la guerre en Europe) en collaboration avec P.M. Schäfer; nomination à la Société Allemande de Photographie; travail sur le thème *Vietnam, 20 Jahre nach dem Krieg* (Le Viêtnam 20 ans après la guerre); 1995 travaux de commande pour entre autres le Süddeutsche Zeitung Magazin, Telegraph-Magazin, Zeit Magazin, Details; membre de Visum; 1996 documentation du processus de paix en Bosnie; Expositions et prix: 1986 *Hausbesetzer* (Squatters), Théâtre de Bochum; 1989 présentation diapo sur le thème *DDR (R.D.A.)*, Rencontres Internationales de la Photographie d'Arles (France); *Go west*, Théâtre de Bochum; 1992 *Krieg* (Guerre), Musée de Bochum (catalogue); 1993 *Wojna*, Galerie Stodola, Varsovie; 1994 *Krieg* (Guerre), récompense/exposition, Deutscher Photopreis (catalogue), Stuttgart, Arles et photokina, Cologne; *Die Alltäglichkeit des Krieges*, Galerie Treppenhaus, Berlin, et Nationalgalerie, Sarajevo; *Fundstücke* (Objets trouvés), 2e prix du concours La Photographie comme Art, Pforzheim; 1995 Prix Otto Steinert avec mention; *Die Alltäglichkeit des Krieges*, Cologne, Journées de la photographie de Herten; lauréat du concours BFF des meilleurs travaux d'examen, expositions, Stuttgart (catalogue), Arles; 1996 *Die Alltäglichkeit des Krieges*, récompense/exposition, Deutscher Photopreis, Stuttgart; 1996 participation à l'exposition *Das Deutsche Auge* (L'œil allemand), Deichtorhallen, Hambourg (catalogue). Wolfgang Bellwinkel vit à Bochum.

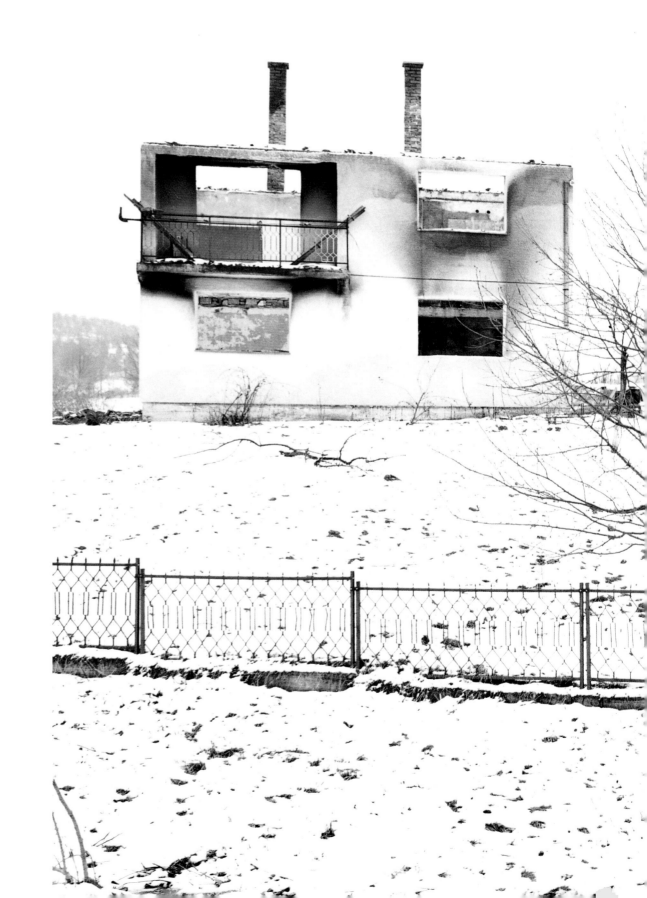

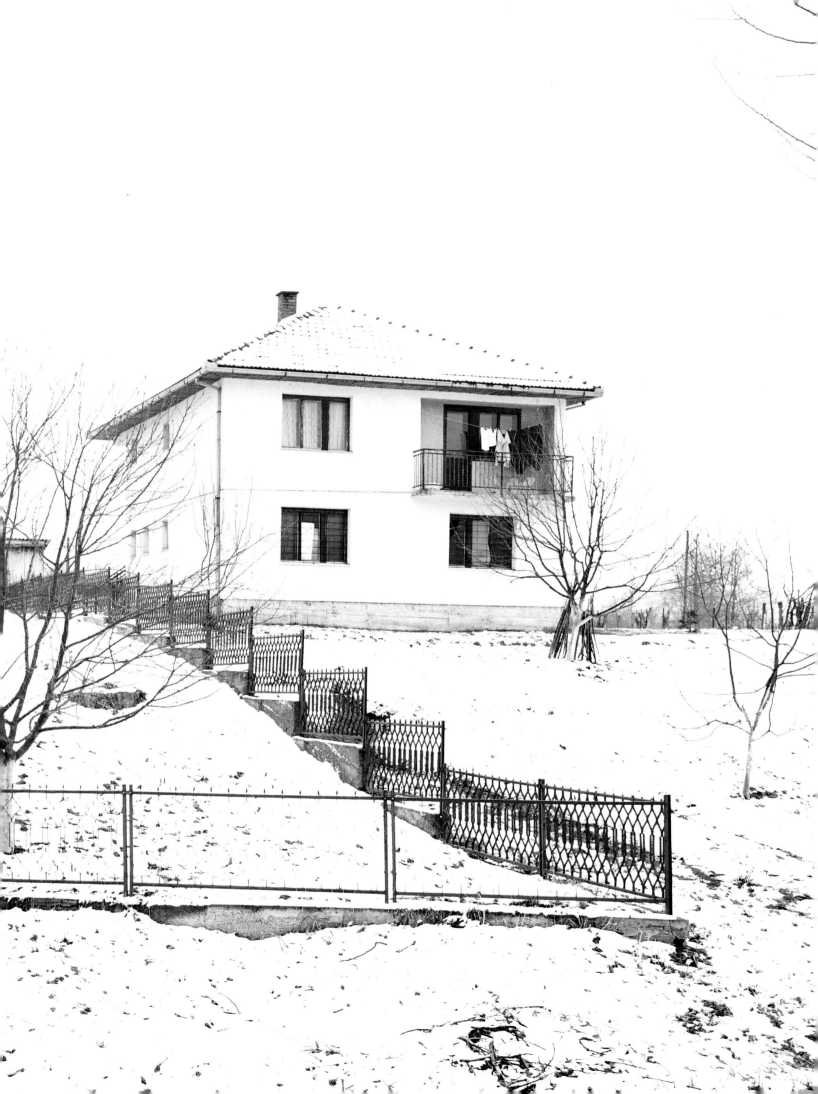

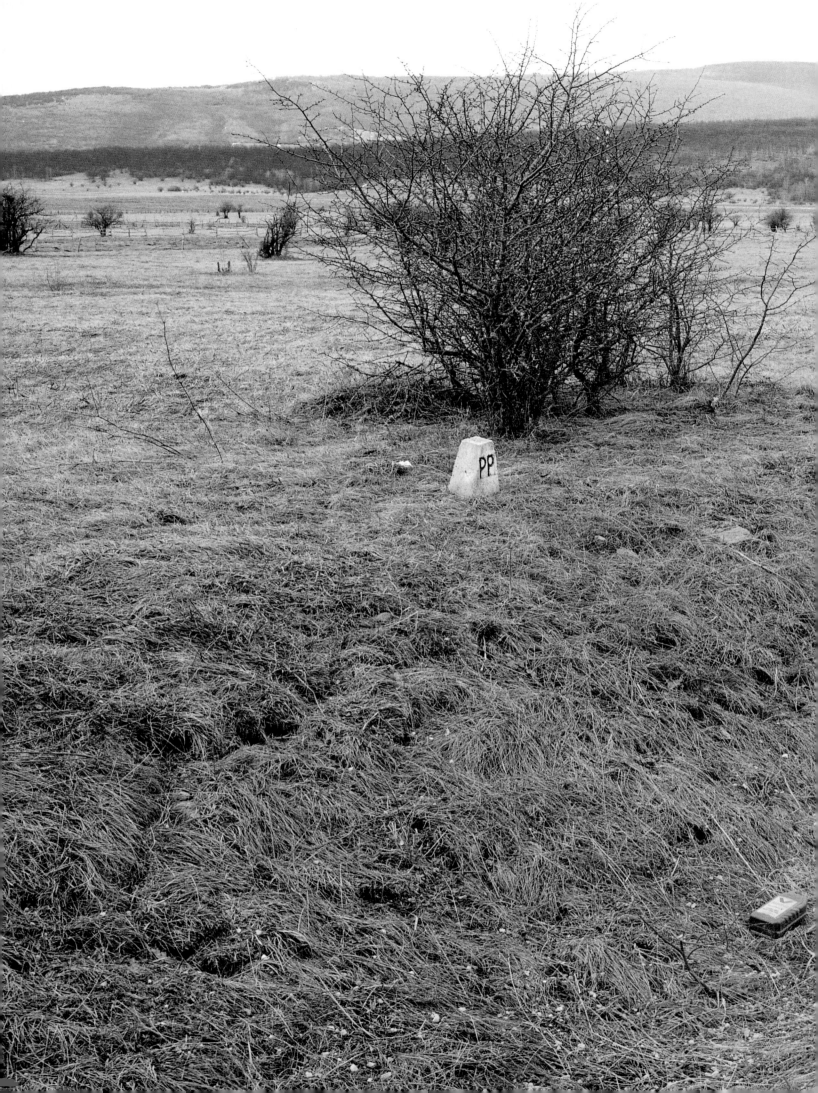

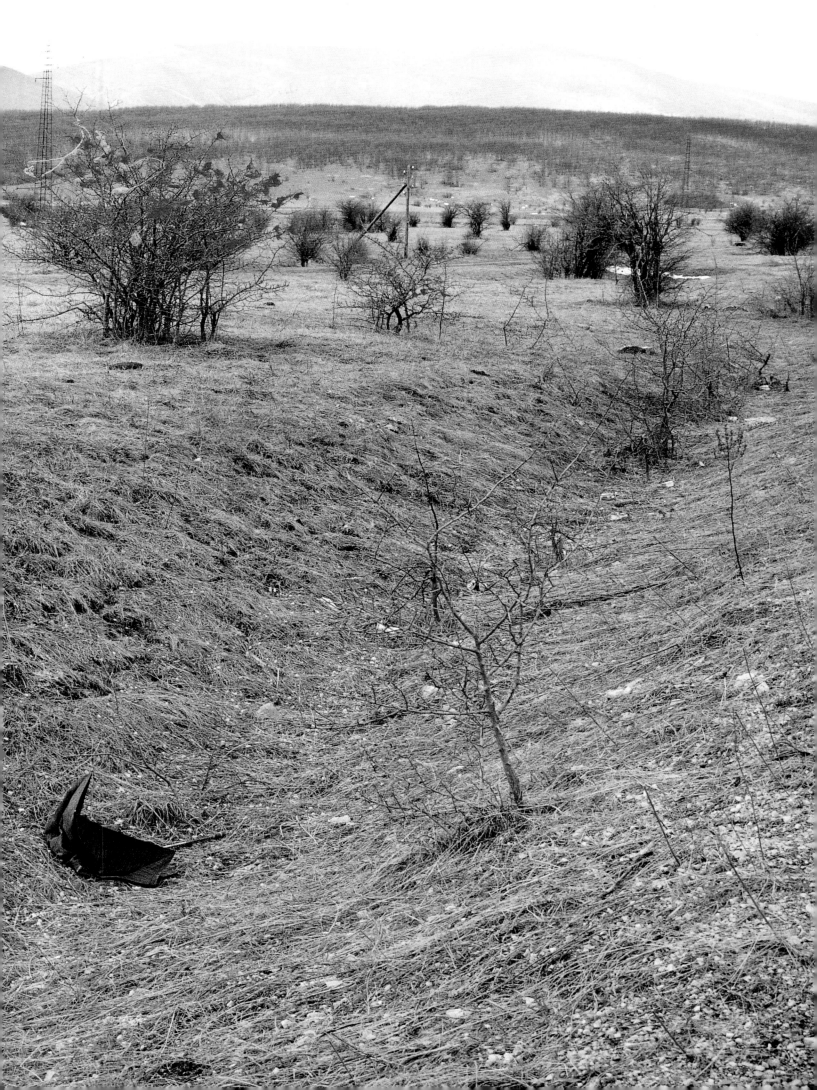

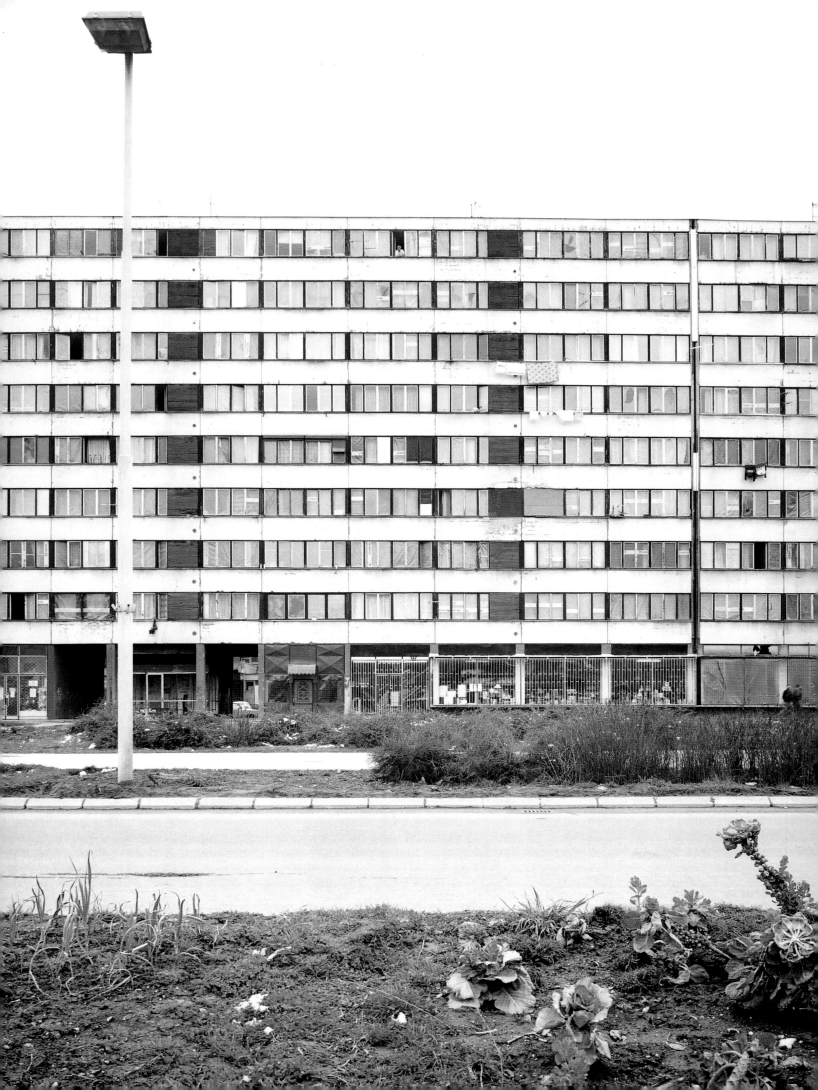

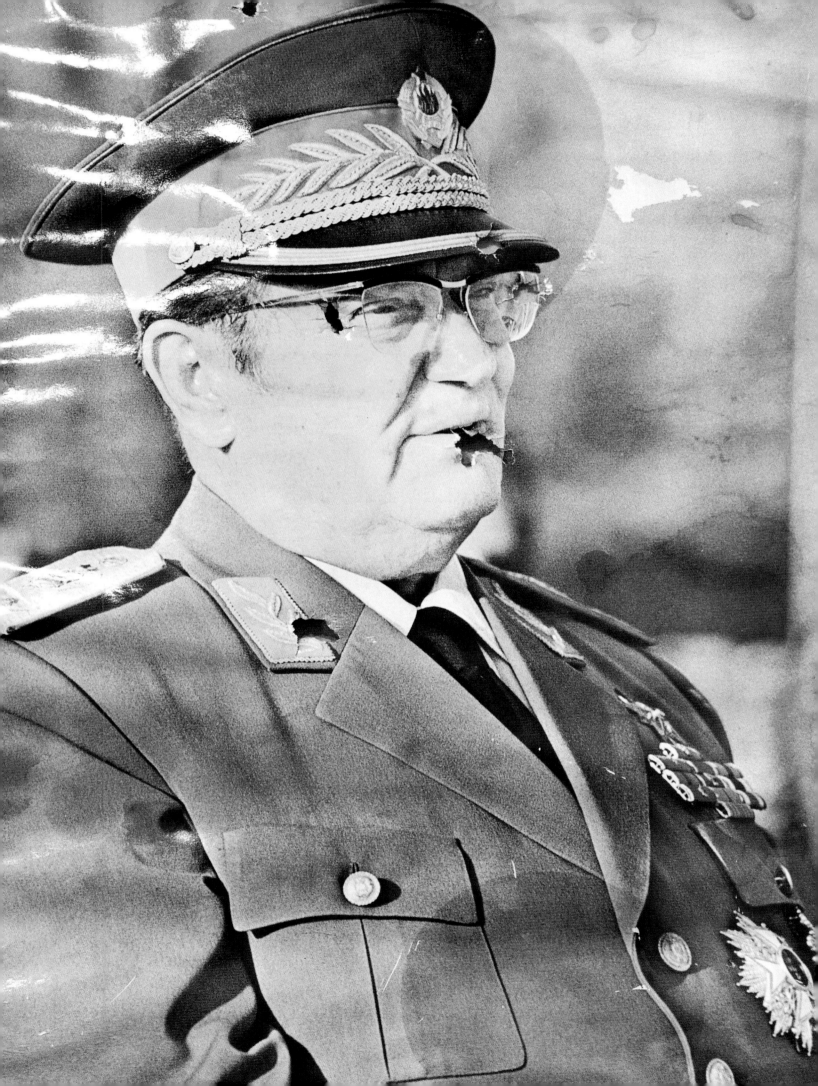

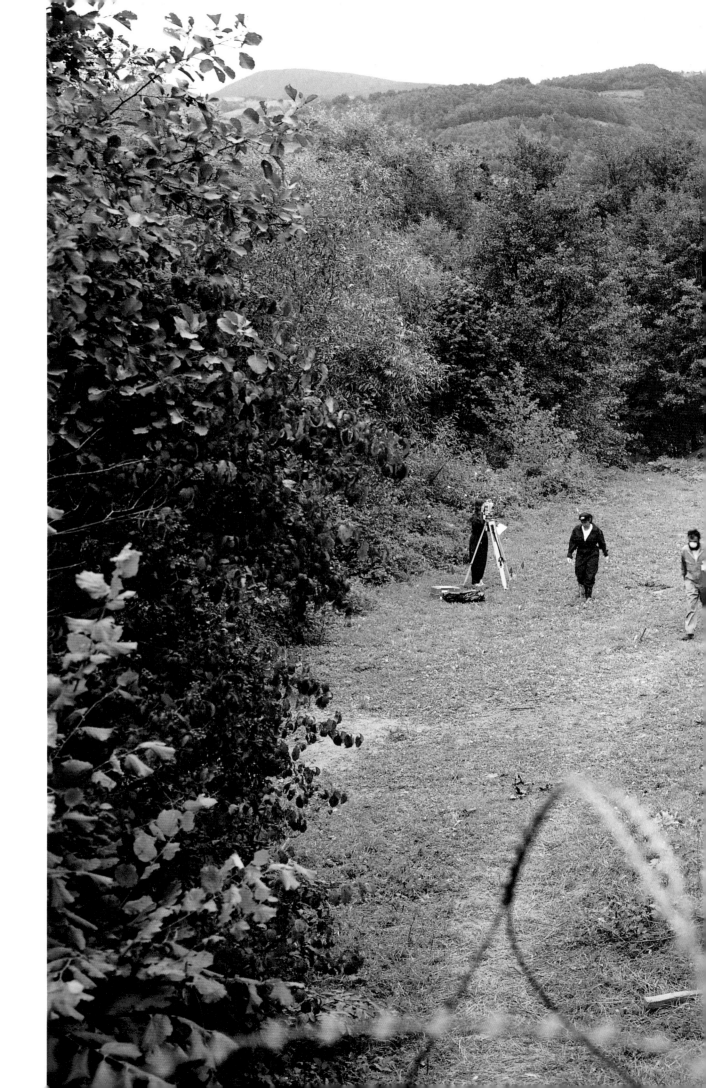

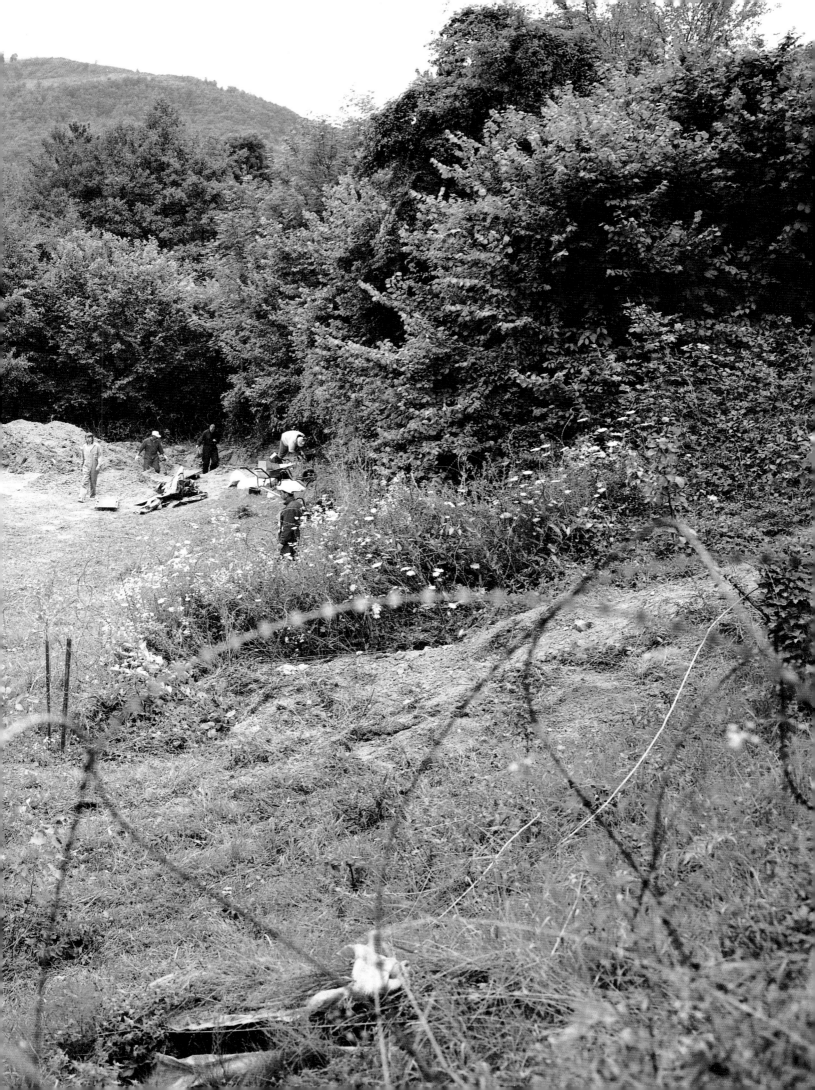

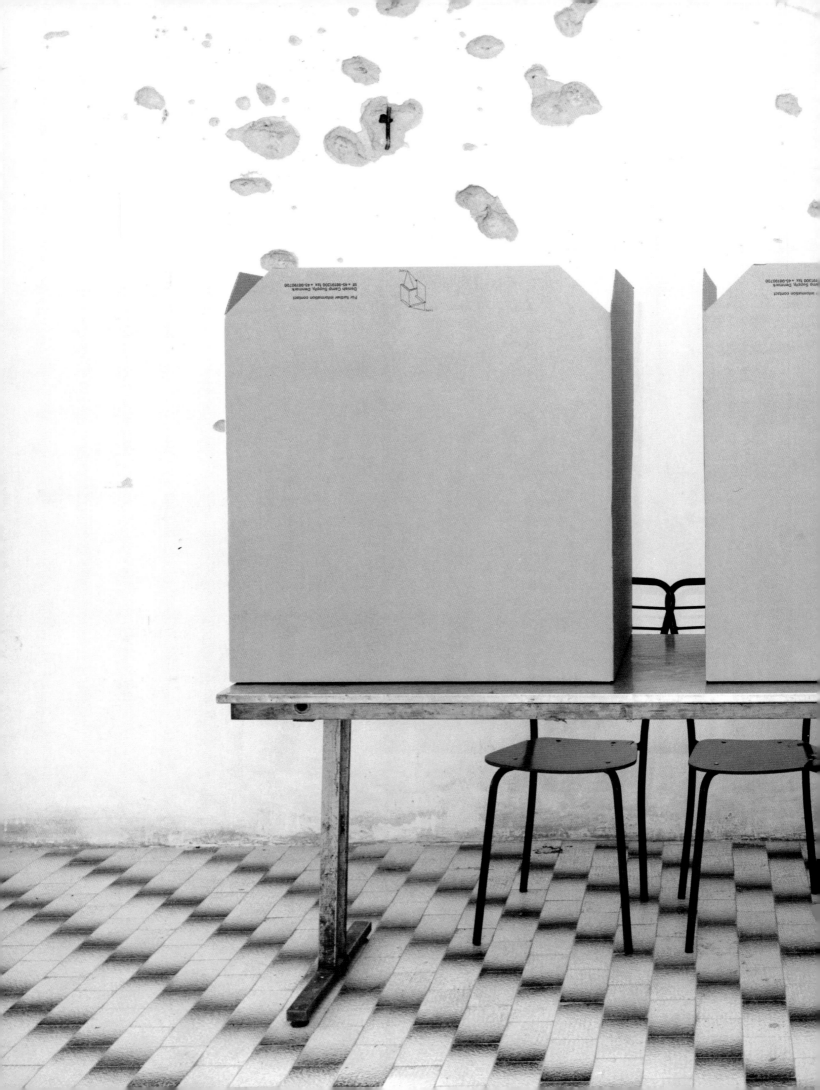

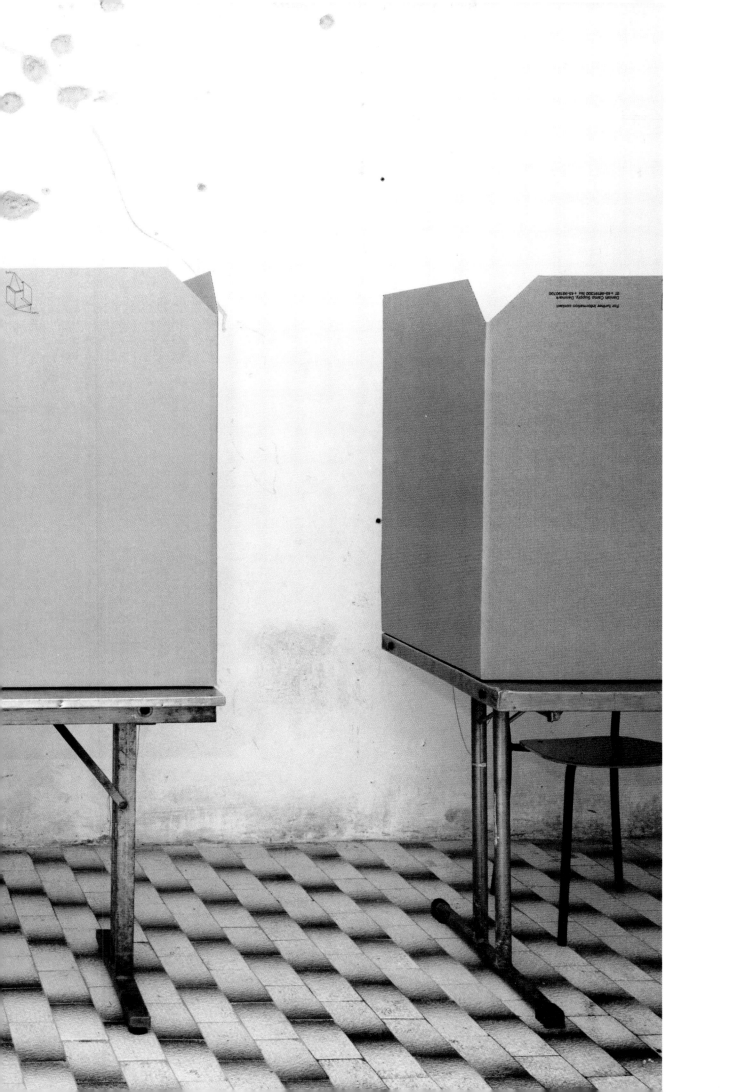

These photographs depict the everyday life of a family with five children. They all live in the Ruhr district, but they could just as well live in other, economically unstable conurbations. Their life is molded like that of many others who know what it means not to find paid work for long periods of time. They all allowed me to accompany them photographically in personal and intimate moments. The basis is our amicable proximity and their trust in opening the doors to their private life to me as an image maker. Thus it is my intention over the years – four and a half years so far – to create both a very personal family album as well as an image of the times in which they live.

Familienbande, 1992–1996 **Die Photographien erzählen vom Alltag einer Familie mit fünf Kindern. Die Familie lebt im Ruhrgebiet und könnte doch auch in anderen strukturveränderlichen Ballungsräumen wohnen. Ihr Leben gestaltet sich wie das vieler anderer, die wissen, was es heißt, wenn lange Zeit keine bezahlte Arbeit zu finden ist. Sie erlaubten mir, sie in persönlichen und intimen Momenten photographisch zu begleiten. Grundlage dafür sind unsere freundschaftliche Nähe und ihr Vertrauen, mir als Bildermacher die Tür zu ihrem Privaten zu öffnen. So will ich über die Jahre – viereinhalb sind es bisher – ein sowohl sehr individuelles Familienalbum entstehen lassen als auch ein Bild der Zeit zeichnen, in der diese Menschen leben.**

Familienbande (Liens familiaux), 1992–1996 Ces photographies racontent la vie quotidienne d'une famille de cinq enfants. Ils vivent dans la Ruhr, mais ils pourraient tout aussi bien habiter n'importe quelle autre agglomération urbaine où l'on observe un changement des structures. Leur existence ressemble à celle de beaucoup d'autres gens, de ceux qui savent ce que cela veut dire que d'être depuis longtemps sans travail, et donc sans argent. Tous, ils m'autorisent à les accompagner dans leur vie personnelle et leurs moments d'intimité par le biais de mon appareil-photo. Ils me font confiance, et c'est sur la base de notre proximité, voire de notre amitié, qu'ils consentent à ouvrir au faiseur d'images que je suis la porte de leur vie privée. C'est ainsi qu'au fil des ans – quatre et demi à ce jour – j'ambitionne de produire quelque chose qui tiendrait tout à la fois de l'intimité de l'album de famille et du portrait de l'époque dans laquelle vivent ces gens.

Andre Zelck was born in Düsseldorf in 1962; he studied communication design at the Essen Polytechnic University, majoring in photojournalism; group exhibitions (a selection): 1993 *Armes, reiches Deutschland* (Poor, rich Germany), Essen Polytechnic University; 2nd prize for young photojournalism, Cologne; Internationale Phototage, Herten; 1994 *Sehwege aus der Romantik* (Ways of seeing from the era of Romanticism), Norden (catalog); 1995 *Gesichter der Industrie* (Faces of Industry), Gelsenkirchen (catalog); 1996 *Zeigung* (Showing), Essen; *Bilderflut* (Flood of Pictures), Herten; solo exhibitions (a selection): 1992 *Ohne Wohnung* (Homeless), Recklinghausen (catalog); 1993 *Ohne Wohnung* (Homeless), Bottrop; 1994 *Ohne Wohnung* (Homeless), Kassel, Polytechnic; *Familienbande* (Family Group), Krefeld; *Wohnbilder* (Residential Pictures), Strasbourg (catalog); 1995 *Familienbande* (Family Group), Berlin *Wohnbilder* (Residential Pictures), Münster; Numerous publishings in newspapers, magazines and professional publications. Andre Zelck lives in Essen.

Andre Zelck, 1962 geboren in Düsseldorf; Studium Kommunikationsdesign an der Universität Gesamthochschule Essen, Schwerpunkt Bildjournalistik; Gruppenausstellungen (Auswahl): 1993 *Armes, reiches Deutschland*, Universität Gesamthochschule Essen; 2. Preis für jungen Bildjournalismus, Köln; Internationale Phototage, Herten; 1994 *Sehwege aus der Romanik*, Norden (Katalog); 1995 *Gesichter der Industrie*, Gelsenkirchen (Katalog); 1996 *Zeigung*, Essen; *Bilderflut*, Herten; Einzelausstellungen (Auswahl): 1992 *Ohne Wohnung*, Recklinghausen (Katalog); 1993 Bottrop; 1994 Kassel, Gesamthochschule; *Familienbande*, Krefeld; *Wohnbilder*, Straßburg, (Katalog); 1995, *Familienbande*, Berlin; *Wohnbilder*, Münster; zahlreiche Publikationen in Zeitungen, Magazinen und Fachpublikationen. Andre Zelck lebt in Essen.

Andre Zelck, né en 1962 à Düsseldorf; études de design et de communication à la Université Gesamthochschule de Essen, spécialisation photojournalisme; Expositions collectives (sélection): 1993 *Armes, reiches Deutschland* (Pauvre, riche Allemagne), Université Gesamthochschule de Essen; 2e prix du Jeune Photojournalisme, Cologne; Journées Internationales de la Photographie, Herten; 1994 *Sehwege aus der Romanik* (Chemins d'une vision de l'art roman), Norden (catalogue); 1995 *Gesichter der Industrie* (Visages de l'industrie), Gelsenkirchen (catalogue); 1996 *Zeigung*, Essen; *Bilderflut* (Flots d'images), Herten; expositions personnelles (sélection): 1992 *Ohne Wohnung* (Sans abri), Recklinghausen (catalogue); 1993 Bottrop; 1994 Kassel, Gesamthochschule; *Familienbande*, Krefeld; *Wohnbilder* (Habitats), Strasbourg (catalogue); 1995 *Familienbande* (Lien familiaux), Berlin; *Wohnbilder*, Münster; nombreuses publications dans des journaux, des magazines et des publications spécialisées. Andre Zelck vit à Essen.

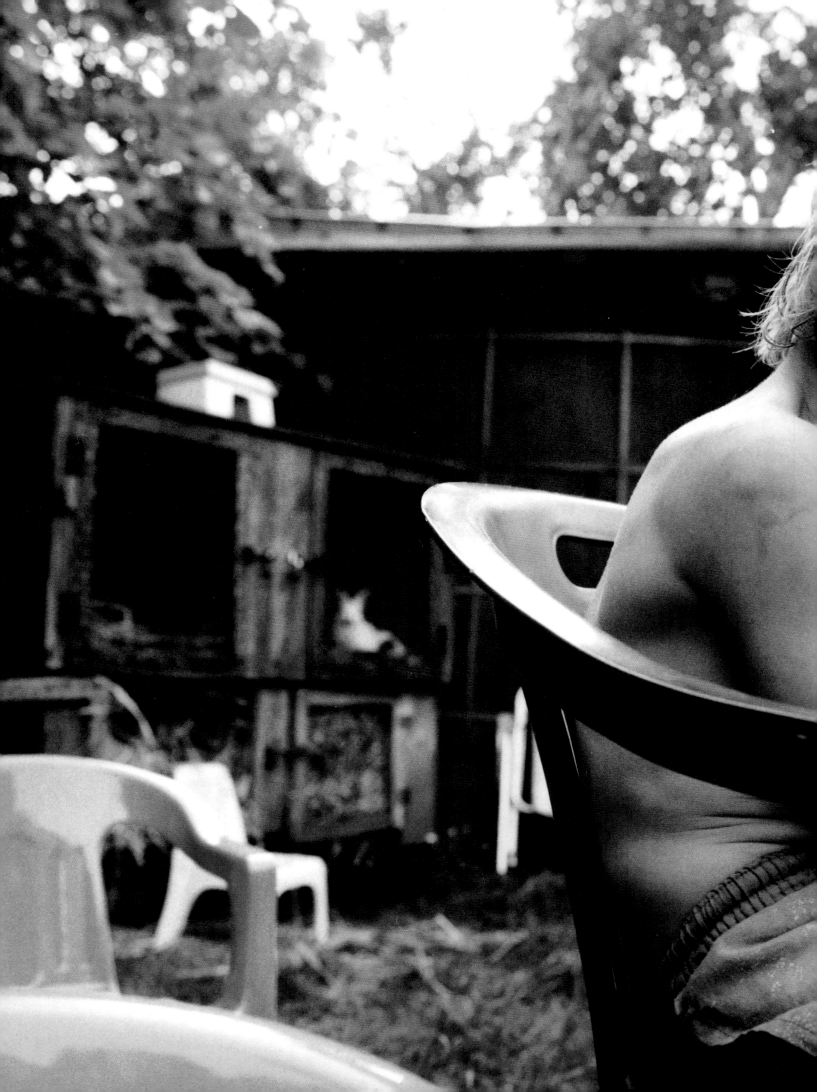

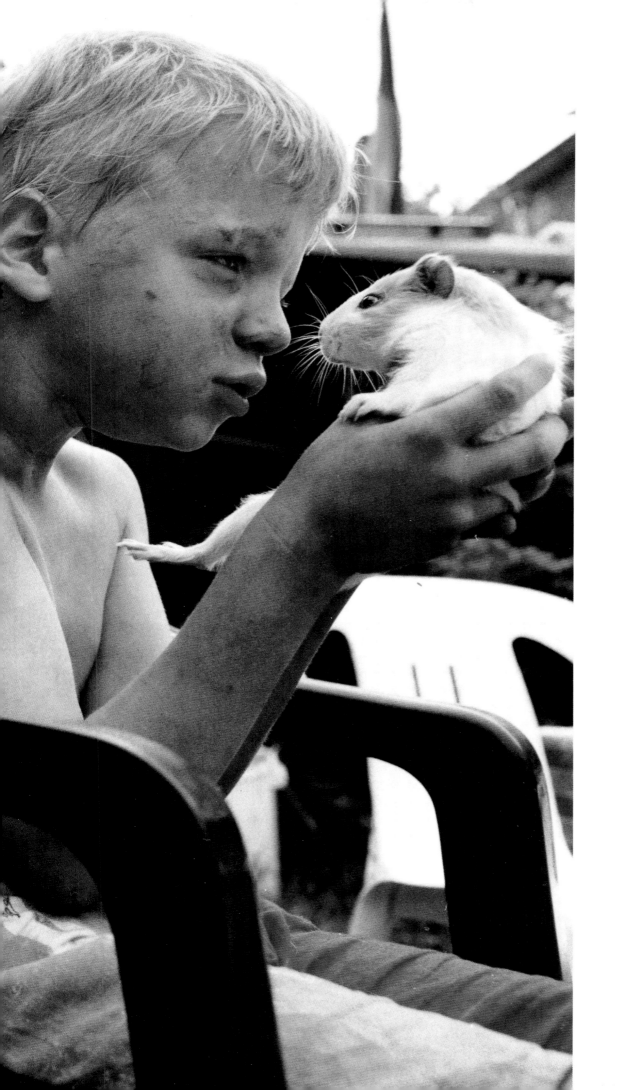

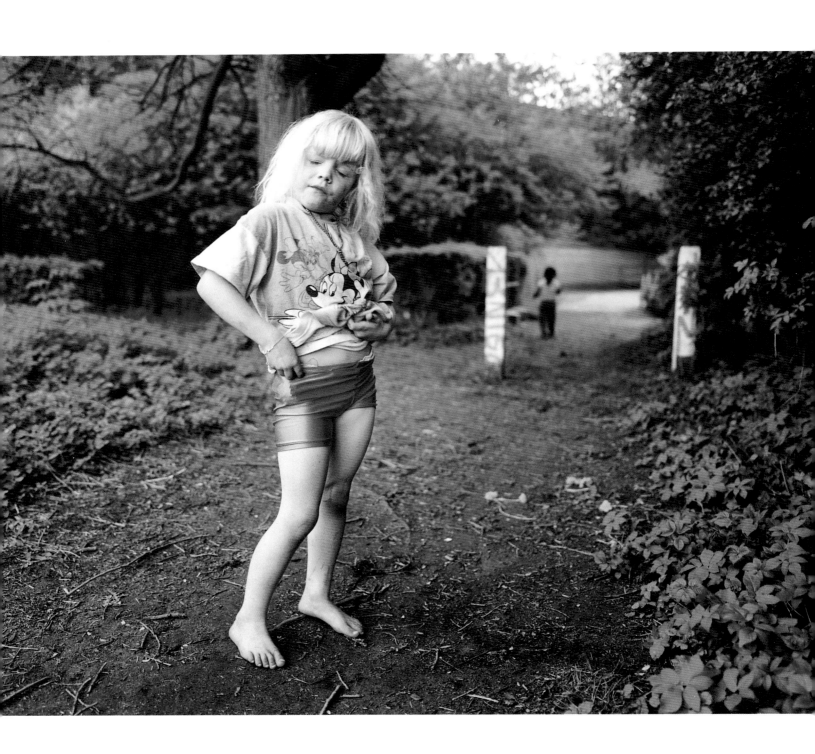

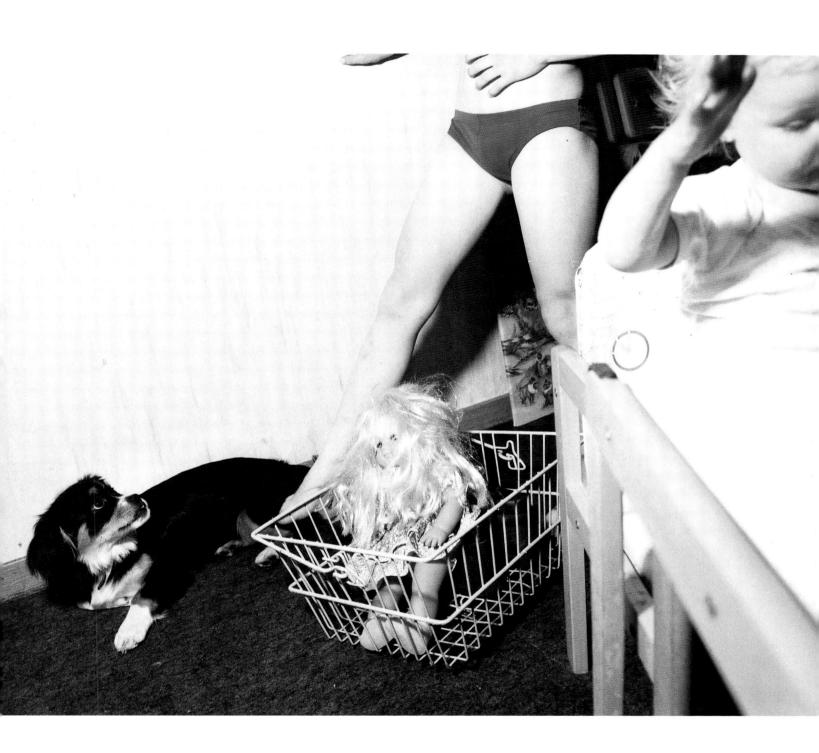

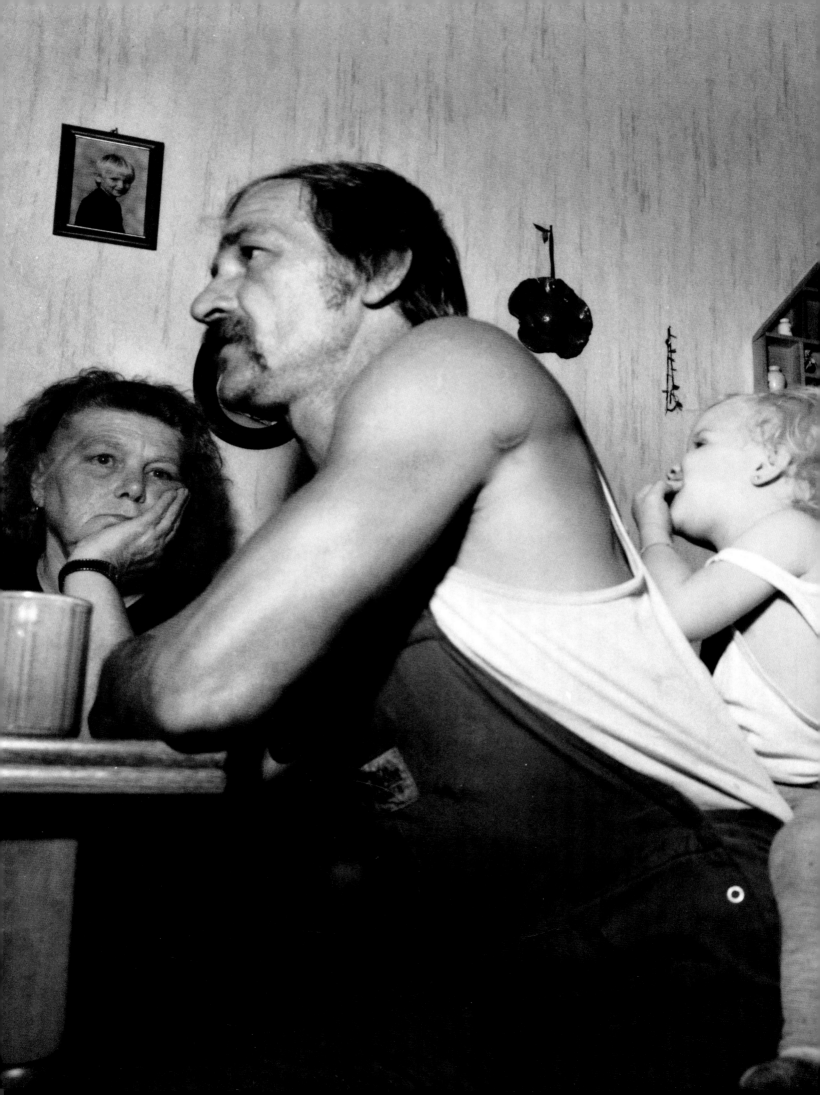

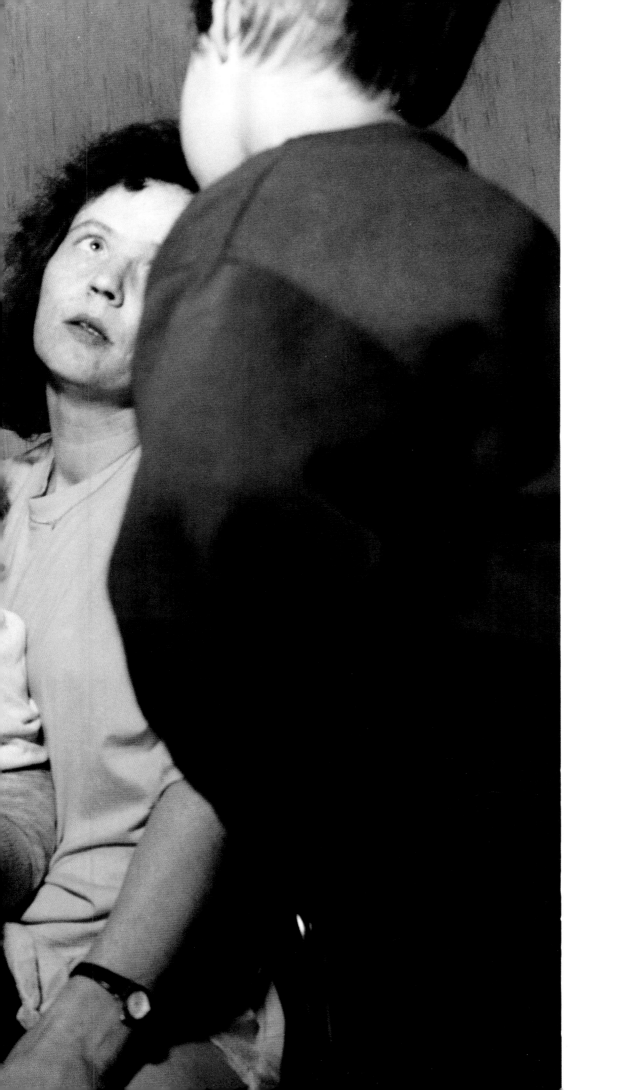

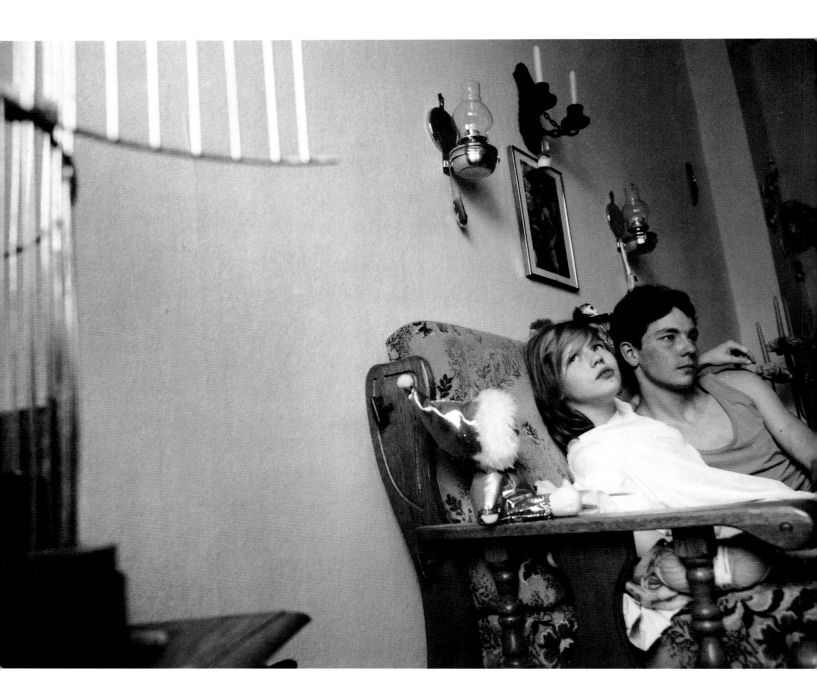

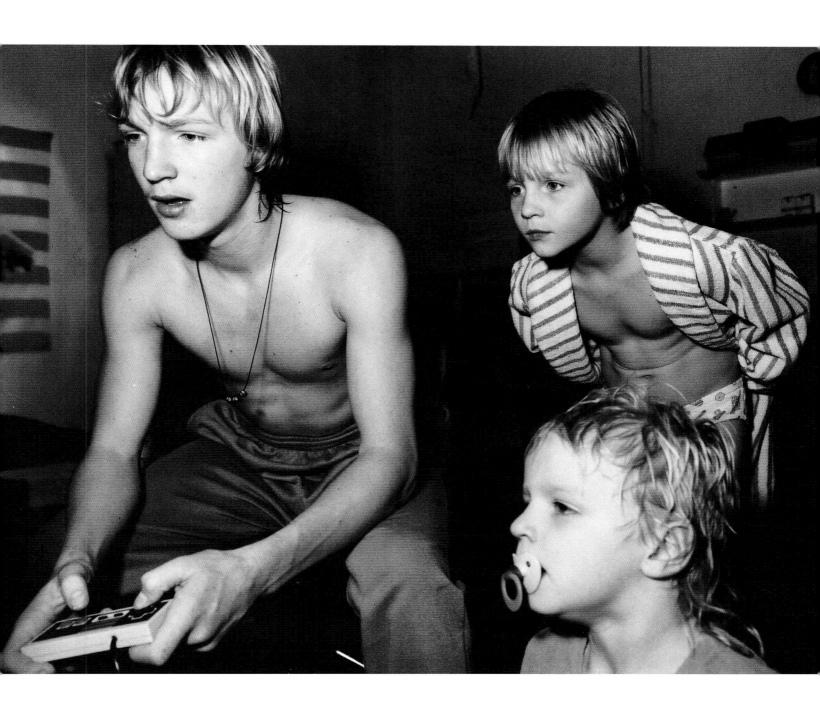

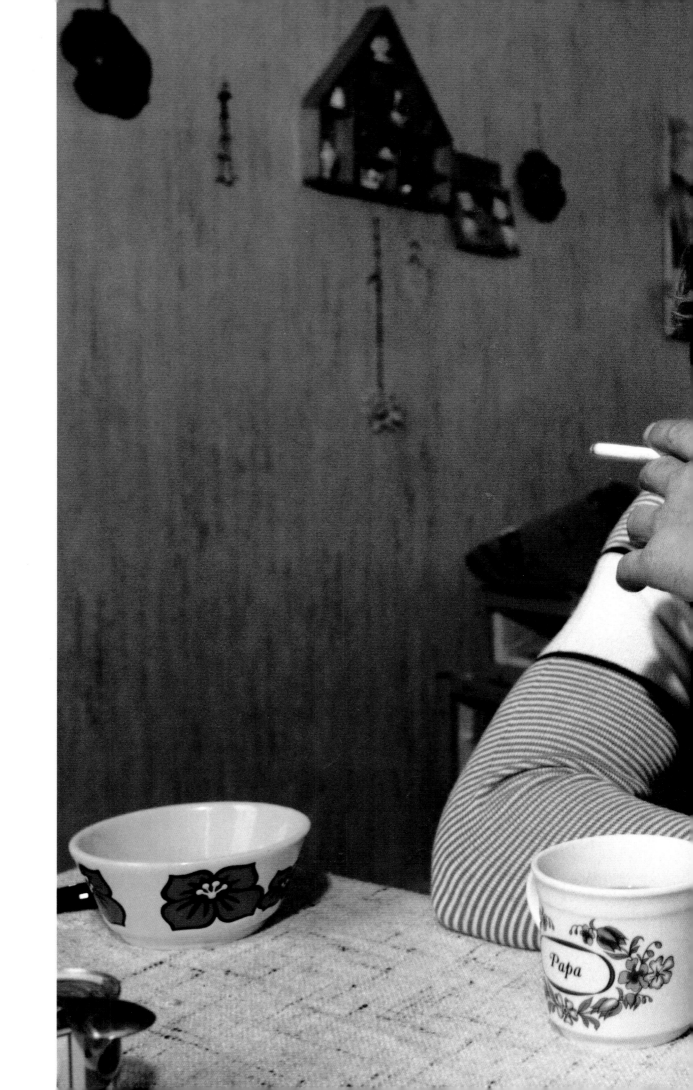

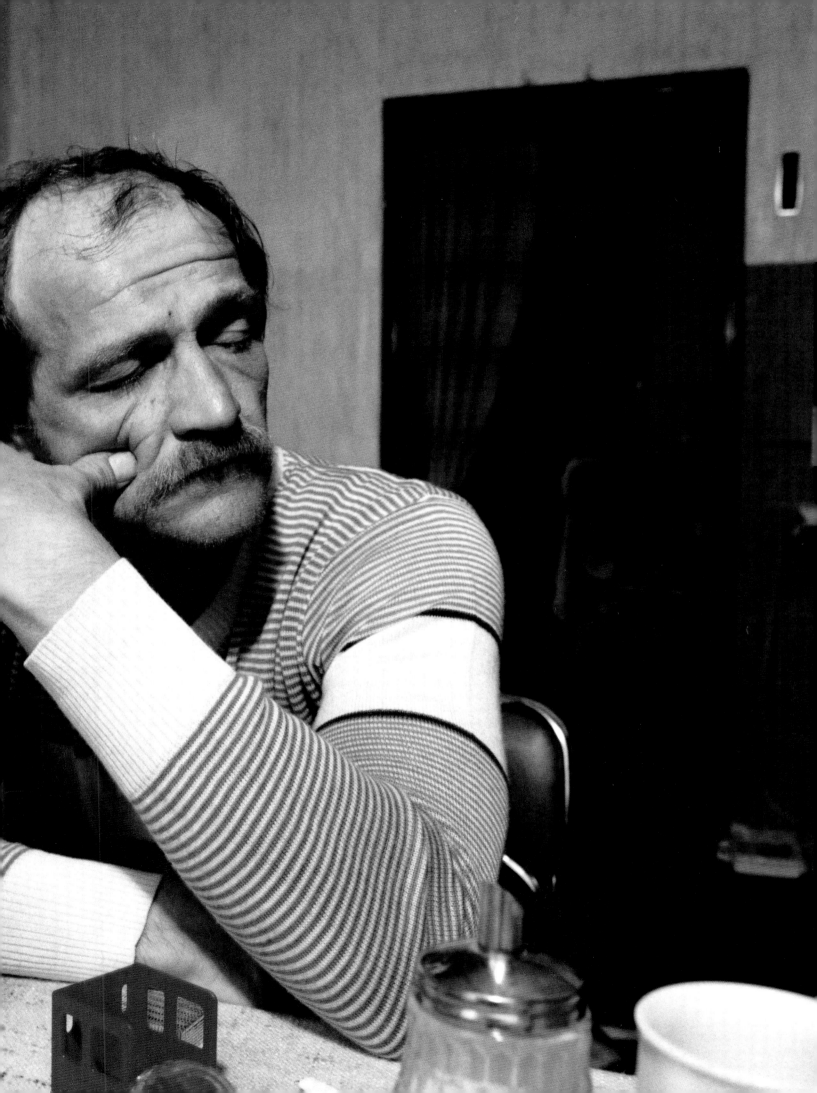

martin fengel I photographed this essay for Tempo in the summer of 1995. In the text, a former junkie talks about his life as an addict. An important part of his story deals with the path between his home in Mönchengladbach (Germany) and the railway stations in nearby Holland, where he purchased his heroin. In order not to illustrate this story with pictures of needles in arms or coarse-grained photographs of emaciated junkies, I wanted to show the path between home and dealer. The contrast between a landscape or places whose exterior appearance does not suggest anything out of the ordinary and the tale told by a junkie who circulates in that space and who consumes drugs there would have constituted an interesting story. Unfortunately the picture editor resigned from the magazine before I delivered my photographs, and only coarse-grained images of emaciated junkies were printed.

Diese Bilder habe ich im Sommer 1995 für Tempo photographiert. Im Text erzählt ein Ex-Junkie von seinem Leben als Suchtkranker. Ein wichtiger Teil seiner Geschichte handelt von dem Weg zwischen seiner Wohnung in Mönchengladbach und den Bahnhöfen in den nahegelegenen Niederlanden, wo er sich Heroin kaufte. Um die Geschichte nicht mit Photos von Nadeln in Armen oder grobkörnigen Aufnahmen, auf denen ausgemergelte Junkies zu sehen sind, zu illustrieren, wollte ich den Weg zwischen Wohnung und Dealer zeigen. Der Kontrast zwischen einer Landschaft oder Orten, die durch ihr Äußeres auf nichts Außergewöhnliches schließen lassen, und der Erzählung eines Junkies, der sich in diesem Umfeld bewegt und dort Drogen konsumiert, hätte eine interessante Geschichte ergeben. Leider verließ die Bildredakteurin vor meiner Bildabgabe die Zeitschrift, und es wurden nur grobkörnige Aufnahmen von ausgemergelten Junkies gedruckt.

J'ai photographié cette histoire pour Tempo pendant l'été 1995. Dans le texte, un ex-junkie raconte sa vie de toxicomane. Son histoire traite pour une large part du chemin qu'il empruntait pour se rendre de son appartement de Mönchengladbach (Allemagne) aux gares hollandaises toutes proches, où il s'achetait de l'héroïne. Refusant d'illustrer cette histoire par des photos d'aiguilles plantées dans des bras ou des images à forte granulation de junkies décharnés, j'ai voulu montrer le chemin entre l'appartement et le dealer. Le contraste entre un paysage, ou des lieux, dont l'aspect ne laisse rien présager d'extraordinaire, et le récit d'un junkie qui se meut dans cet environnement et s'y livre à la consommation de drogues, aurait pu donner lieu à une histoire intéressante. Malheureusement, la rédactrice à laquelle j'ai remis mes photos a quitté le magazine, et seules les photos à forte granulation de junkies décharnés ont été imprimées.

Martin Fengel was born in Munich in 1964; he studied at the Bavarian State College of Photography in Munich and worked in New York as an assistant to, among others, Amy Arbus, Stephan Erfurt, Mary Ellen Mark and Wolfgang Wesener; exhibitions and grants: 1992 *Laim*, Munich; solo exhibition: 1993 Project grant, Hacker-Pschorr Foundation, Munich; 1994 *Rendezvous der Freunde* (Meeting of Friends), Munich; Bayerischer Photopreis (Bavarian Photographic Prize), grant of the Danner Foundation in Munich; *Europa 94*, Moc, Munich; 1995 *Tiere und Pflanzen* (Animals and Plants), Munich, solo exhibition; 1996 *Von hier* (From here), Munich; *Kinder* (Children), Munich Municipal Museum, solo exhibition from the 1994/1995 Bavarian Photo Prize; *Regards sur Dakar* (Views of Dakar), Dakar (Senegal); *18 x 24 Aids Project*, Vienna; *Innere Medizin* (Inner Medicine), Ulm, solo exhibition: *Dadamünchen* (Dada-Munich), Munich. Martin Fengel lives in Munich.

Martin Fengel, 1964 geboren in München; Studium an der Bayerischen Staatslehranstalt für Photographie, München; arbeitete in New York als Assistent u.a. von Amy Arbus, Stephan Erfurt, Mary Ellen Mark und Wolfgang Wesener; Ausstellungen und Stipendien: 1992 *Laim*, München, Einzelausstellung; 1993 Projektstipendium Hacker-Pschorr-Stiftung, München; 1994 *Rendezvous der Freunde*, München; Bayerischer Photopreis, Stipendium der Danner-Stiftung, München; *Europa 94*, Moc, München; 1995 *Tiere und Pflanzen*, München, Einzelausstellung; 1996 *Von hier*, München; *Kinder*, Münchener Stadtmuseum, Einzelausstellung zum Bayerischen Photopreis 1994/95; *Regards sur Dakar*, Dakar/Senegal; *18 x 24 Aids Projekt*, Wien; *Innere Medizin*, Ulm, Einzelausstellung; Dadamünchen, München. Martin Fengel lebt in München.

Martin Fengel, né en 1964 à Munich; apprit la photographie à l'Ecole Nationale de Photographie de Bavière, Munich; travailla à New York comme assistant de, entre autres, Amy Arbus, Stephan Erfurt, Mary Ellen Mark et Wolfgang Wesener; expositions et bourses: 1992 Laim, Munich; exposition personnelle: 1993 bourse au projet de la Fondation Hacker Pschorr, Munich; 1994 *Rendezvous der Freunde* (Rendez-vous des amis), Munich; prix photographie de Bavière, bourse de la Fondation Danner, Munich; *Europa 94*, Moc, Munich; 1995 *Tiere und Pflanzen* (Des animaux et des plantes), Munich, exposition personnelle; 1996 *Von hier* (D'ici), Munich; *Kinder* (Enfants), Münchner Stadtmuseum, exposition personnelle consécutive au prix de photographie de Bavière 1994/95; *Regards sur Dakar*, Dakar, Sénégal, Afrique; *18 x 24 Aids Projekt* (Projet en 18 x 24 sur le sida), Vienne; *Innere Medizin* (Médecine interne), Ulm, exposition personnelle; Dadamünchen (Munich dada), Munich. Martin Fengel vit à Munich.

ulrike myrzik / manfred jarisch

In 1994 and 1996 we traveled to China to create a body of work, unencumbered by time constraints, on the side-effects of modernization in that country. We sought to document our personal perceptions of situations as they were at the moment, casual encounters and scenes on the margins. We could still sense traces of the erstwhile nation of workers and farmers, mostly in rural areas. In its expanding cities, China's vision of the future still struck us as a giant construction site. Traditional residential areas in the centers of cities have to make way for prestigious investment buildings. Economic centers spring up where only a short time ago there were villages. It was not so much the realities which impressed us as the extent and speed of the changes and the consequences of their implementation. We plan to make additional trips to continue our work in the years to come.

1994 und 1996 reisten wir nach China mit dem Ziel, eine zeitlich ungebundene Arbeit über die Begleiterscheinungen der Modernisierung zu realisieren. Wir versuchten, unsere persönlichen Wahrnehmungen der momentanen Situation, zufällige Begegnungen und Szenen am Rand zu dokumentieren. Der frühere Arbeiter- und Bauernstaat war für uns vor allem noch in den ländlichen Regionen spürbar. In den expandierenden Städten nahmen wir Chinas Vision von der Zukunft als überdimensionale Baustelle wahr. Traditionelle Wohnsiedlungen in den Stadtzentren müssen repräsentativen Investitionsbauten weichen. Wirtschaftszentren entstehen, wo eben noch Dörfer waren. Uns beeindruckten weniger die bloßen Tatsachen als die Dimension und Geschwindigkeit der Veränderung und die Konsequenz ihrer Durchführung. In den nächsten Jahren möchten wir auf weiteren Reisen unsere Arbeit fortsetzen.

En 1994 et 1996, nous nous sommes rendus en Chine avec l'intention de réaliser un travail sur les effets secondaires de la modernisation, travail qui dans notre esprit, devait s'effectuer hors de tout contexte temporel. Nous avons essayé de rendre compte de notre perception personnelle de la situation du moment, de rencontres de hasard et de scènes sans importance. C'est surtout dans les campagnes que nous pouvions encore nous faire une idée de ce qu'avait été le premier Etat ouvrier et paysan. Dans les villes en pleine expansion, la vision qu'avait la Chine de son avenir n'était encore pour nous qu'un immense chantier. Des lotissements traditionnels dans les centres-villes doivent céder la place à des immeubles de rapport représentatifs. Des centres économiques naissent là où, il y a encore peu de temps, se trouvaient des villages. Ce ne sont pas tant les faits en eux-mêmes que les dimensions et la rapidité du changement, ainsi que les conséquences qu'il induira nécessairement, qui nous ont impressionnés. Nous voudrions entreprendre de nouveaux voyages au cours des prochaines années, afin de poursuivre notre travail.

Ulrike Myrzik and Manfred Jarisch were both born in 1966; 1990–1993 College of Photodesign, Munich; 1993 began working together; 1996 Reinhard Wolf Prize; 1st Prize in the Linhof Panorama Competition; World Press Photo Master Class; membership of the Bilderberg agency. Ulrike Myrzik and Manfred Jarisch live in Munich.

Ulrike Myrzik und Manfred Jarisch, beide 1966 geboren; 1990–1993 Fachakademie für Photodesign, München; seit 1993 gemeinsame Arbeit; 1996 Auszeichnung Reinhard-Wolf-Preis; 1. Preis Linhof Panorama Wettbewerb; World-Press Photo Masterclass; Mitgliedschaft in der Agentur Bilderberg. Ulrike Myrzik und Manfred Jarisch leben in München.

Ulrike Myrzik et Manfred Jarisch, nés tous deux en 1966; 1990–1993 Académie de Photodesign, Munich; travaillent ensemble depuis 1993; 1996 prix Reinhard Wolf; 1er prix du concours Linhof Panorama; World-Press Photo Masterclass; membres de l'agence Bilderberg. Ulrike Myrzik et Manfred Jarisch vivent à Munich.

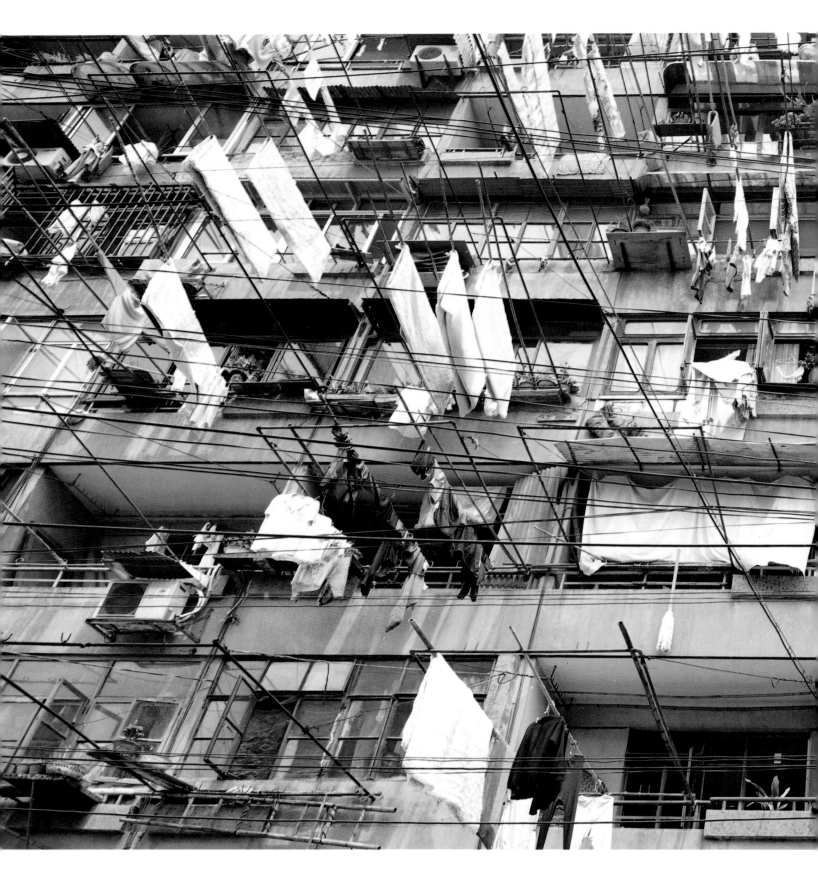

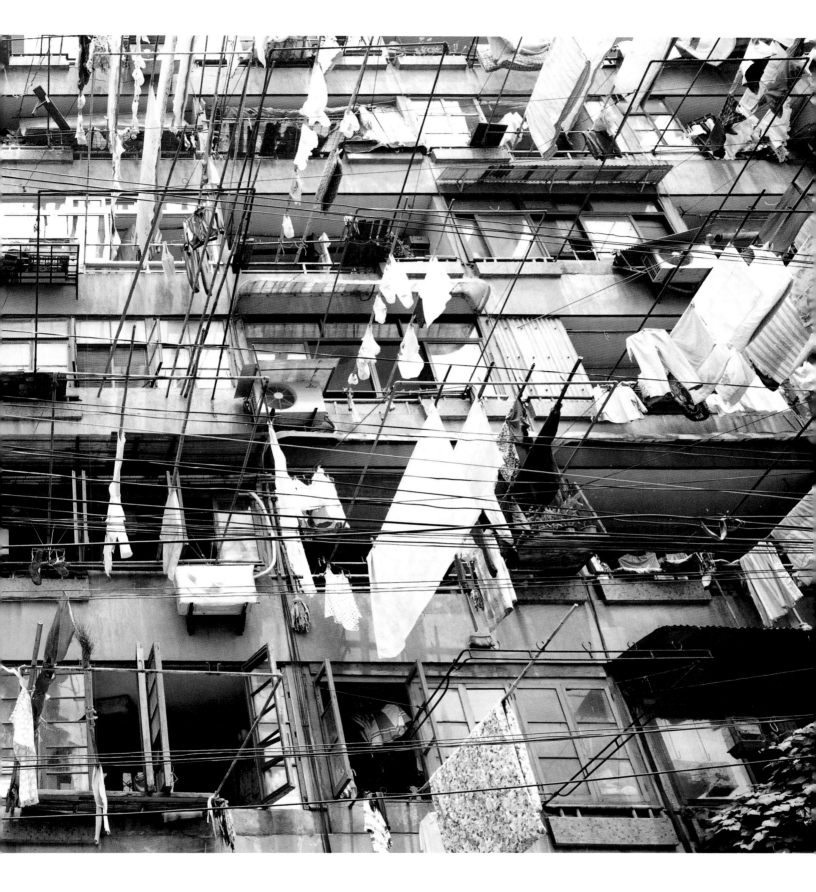

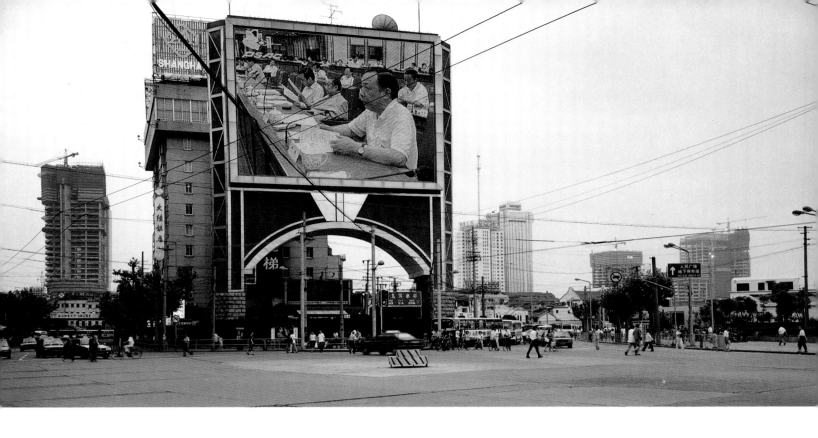

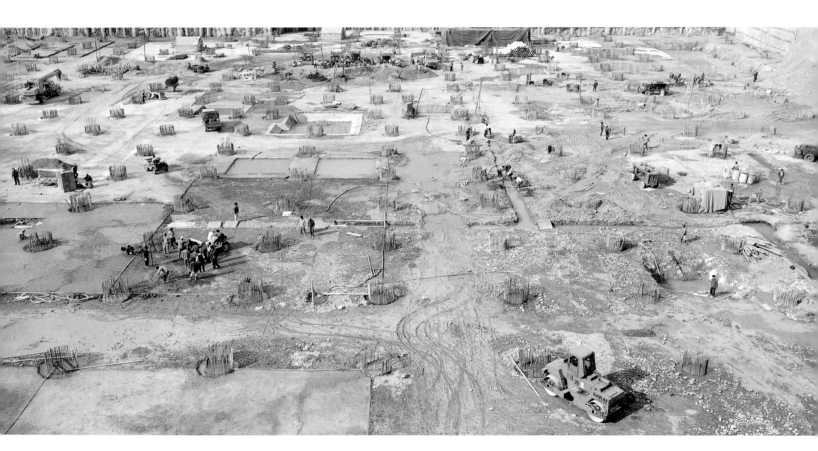

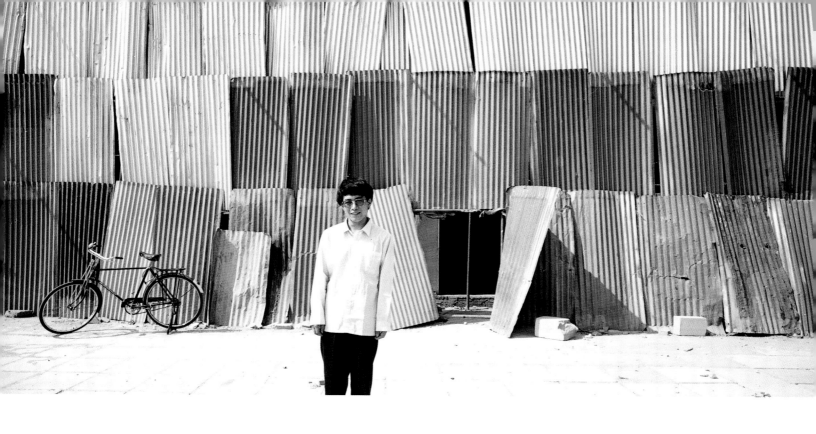
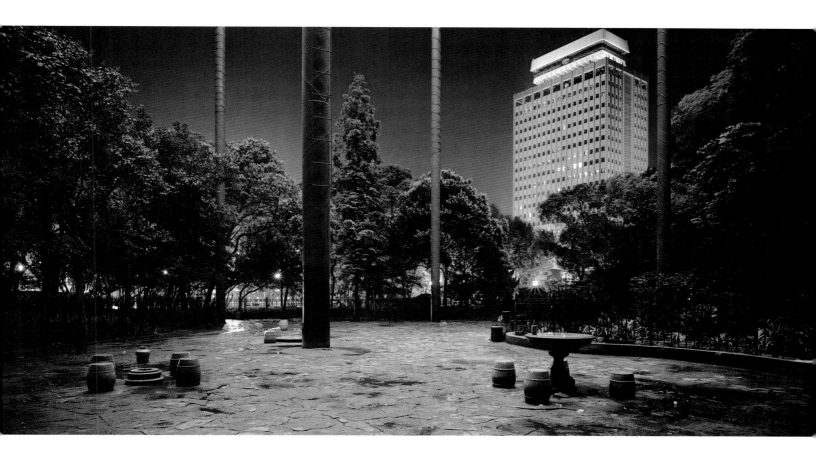

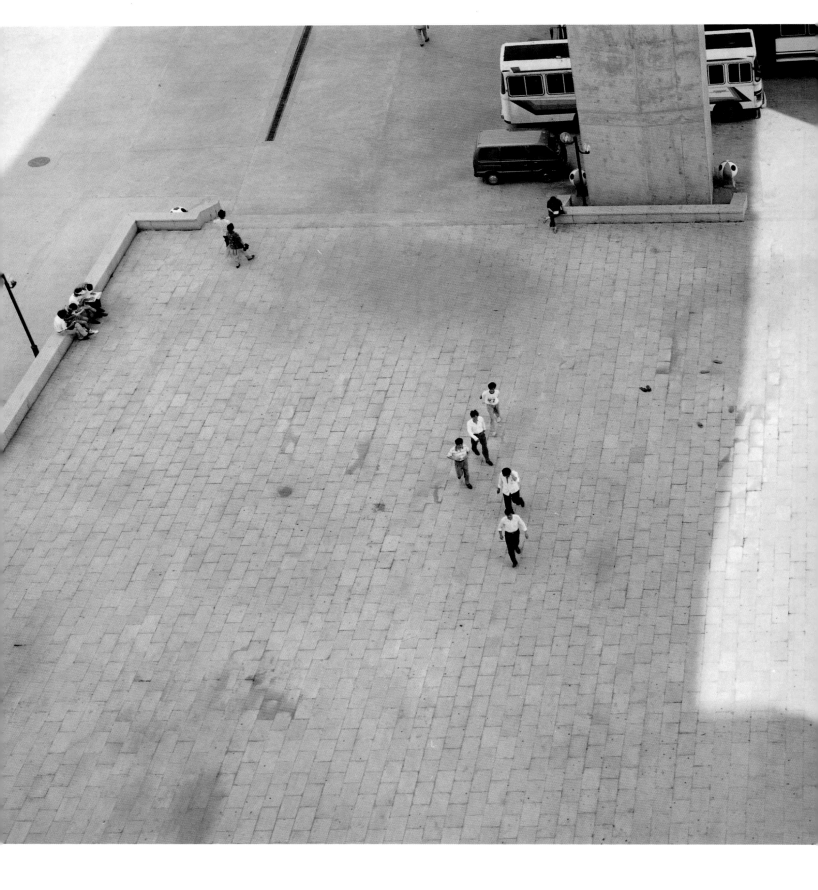

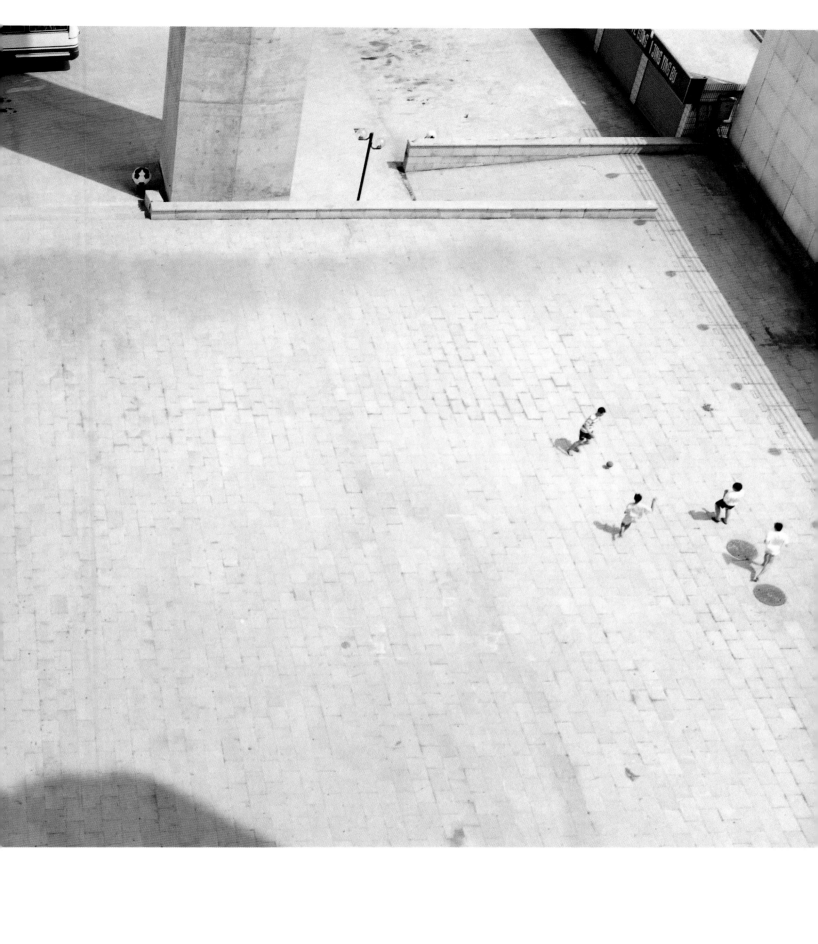

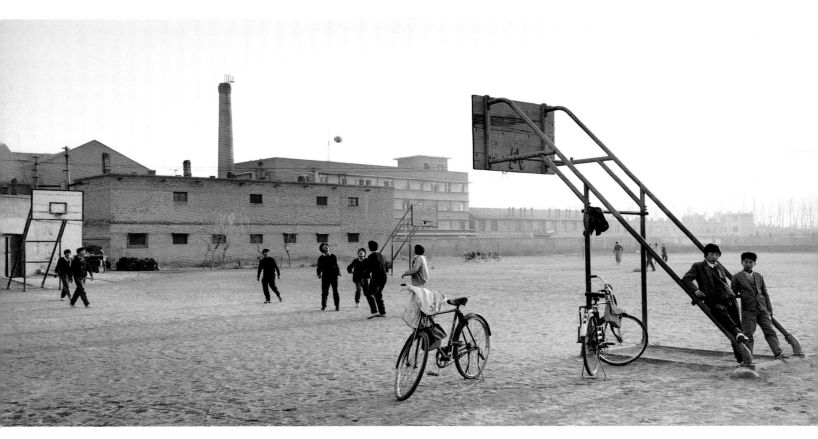

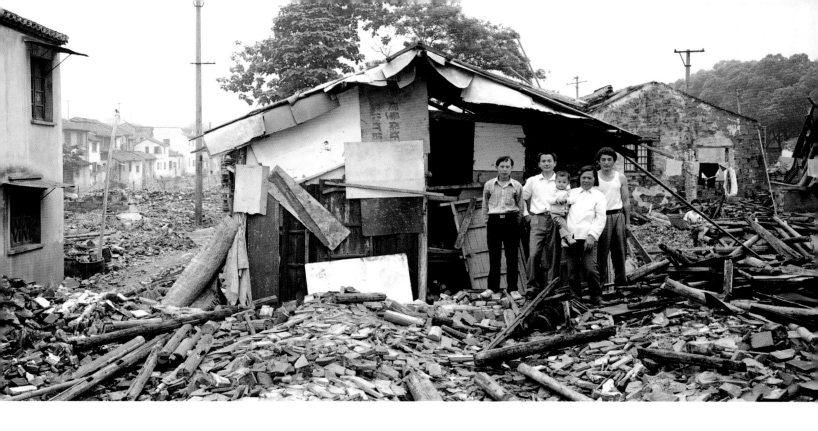

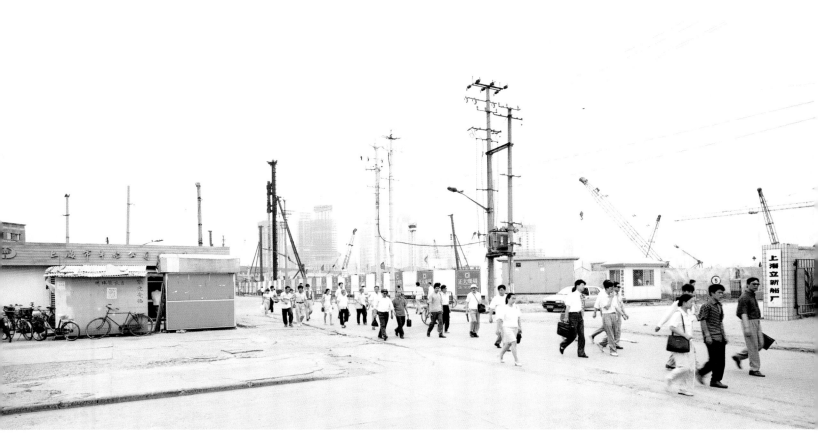

corinna wichmann *London Underground – a city under a city*

The stations are called Leicester Square and Elephant & Castle. But as soon as a passenger has passed through the turnstiles, he or she is swallowed up by the innards of the subway. Escalators descend into somber depths, winding passages snake their way through the underground. The world's oldest subway, called "the Tube", is no place to linger. At rush-hour times, anonymous masses of humanity squeeze themselves through a labyrinth of sparsely illuminated passages. Signs dominate the place, communication takes place only with directional and prohibition signs. In these pictures, people disappear and only silhouettes remain. Natural perception is suspended and orientation is replaced by mirror images. These spaces share no visual communality with the real conditions of the city above ground. Discomfort sets in when bends in the passages continually obstruct the view ahead. These portraits were made during trips. It is crowded inside the carriages, too crowded, and one comes uncomfortably close to fellow passengers. Commuters react by withdrawing into their world of thoughts. Perception is inactivated, the looks are blank. What is, only a few inches away no longer exists when one has withdrawn into one's self. The subway ride is a vacuum filled with the thoughts of the individual. This work was created in London during the spring of 1995.

London Underground – eine Stadt unter der Stadt: **Leicester Square heißen die Stationen und Elephant and Castle. Doch sobald der Passagier die Ticketbarriere hinter sich hat, verschlingen ihn die Eingeweide der U-Bahn: Rolltreppen führen in düstere Tiefen, wurmartige Gänge schlängeln sich durch den Untergrund. Die älteste U-Bahn der Welt, „Tube" genannt, ist kein Platz zum Verweilen. Anonyme Menschenmassen quetschen sich zu Stoßzeiten durch ein Labyrinth von spärlich beleuchteten Wegen. Schilder beherrschen den Ort, kommuniziert wird allein mit Wegweisern und Verbotstafeln. In diesen Photographien verschwinden die Menschen, was bleibt, sind Silhouetten. Die natürliche Wahrnehmung ist aufgehoben, und Orientierung wird ersetzt durch Spiegelbilder. Mit den realen Begebenheiten der oberirdischen Stadt haben die Räume keine visuelle Gemeinsamkeit. Unbehagen macht sich breit, wenn abknickende Gänge immer wieder die Sicht verstellen. Die Porträts sind während der Fahrt entstanden. Im Waggon ist es eng, zu eng, und dem Mitfahrenden kommt man unangenehm nah. Die Reisenden reagieren und ziehen sich zurück in ihre Gedankenwelt. Die Wahrnehmung ist ausgeschaltet, der Blick ist leer. Das Gegenüber, nur wenige Zentimeter entfernt, existiert nicht mehr, wenn man in sich selbst versunken ist. Die U-Bahn-Fahrt ist ein Vakuum, gefüllt mit den Gedanken des Individuums. Diese Arbeit entstand im Frühjahr 1995 in London.**

London Underground – une ville sous la ville: Leicester Square, et puis Elephant and Castle, c'est le nom des stations. Mais dès que le passager a composté son ticket, il est englouti par les entrailles du métro: des escaliers roulants l'emportent dans de sombres abysses tandis que des couloirs sinueux sillonnent l'espace souterrain comme des vers de terre. Le plus vieux métro du monde, dit le «Tube», n'est pas un endroit où l'on s'attarde. Aux heures de pointe, des foules anonymes jouent des coudes pour se frayer un passage à travers un labyrinthe de chemins pauvrement éclairés. Les panneaux sont les maîtres du lieu, on ne communique que par ceux qui indiquent les directions et ceux qui affichent les interdictions. Dans ces photographies, les êtres ont disparu, ce qui reste, ce sont des silhouettes. La perception naturelle n'existe plus, et l'orientation est remplacé par des reflets. Ces espaces n'ont rien de commun, du point de vue visuel, avec les événements réels, ceux qui se passent au-dessus, dans la ville. Le malaise prend pour ainsi dire ses aises quand des couloirs qui vous recroquevillent, vous bouchent constamment la vue. Ces portraits ont été faits durant le trajet. On est à l'étroit dans le wagon, trop à l'étroit, et la promiscuité y est particulièrement désagréable. Les voyageurs réagissent en se retranchant dans leurs pensées. La perception est abolie, et le regard vide. Le vis-à-vis, qui n'est pourtant qu'à quelques centimètres, n'existe plus quand on est plongé en soi-même. Le parcours en métro est un vide rempli des pensées de l'individu. Ce travail a été réalisé début 1995 à Londres.

Corinna Wichmann was born in 1970; 1990–1996 studied photo-design at the Bielefeld Technical College; 1995 stayed in London; 1996 graduation diploma; group exhibitions: 1993 *Mit Licht* (With Light), Gütersloh Art Association; 1994 *Die Seitenstrasse grünt* (The side street greens), Bielefeld; 1995 *London Underground*, Bielefeld; 1996 *Stadt Land Fluß* (City Countryside River), Bielefeld; *Geschichten von der Elbe* (Stories of the Elbe), photokina, Cologne. Corinna Wichmann lives in Bielefeld.

Corinna Wichmann, 1970 geboren; 1990–1996 Studium Photodesign, Fachhochschule Bielefeld; 1995 Auslandsaufenthalt in London; 1996 Diplom; Gruppenausstellungen: 1993 *Mit Licht*, Kunstverein Gütersloh; 1994 *Die Seitenstraße grünt*, Bielefeld; 1995 *London Underground*, Bielefeld; 1996 *Stadt Land Fluß*, Bielefeld; *Geschichten von der Elbe*, photokina, Köln. Corinna Wichmann lebt in Bielefeld.

Corinna Wichmann, née en 1970; 1990–1996 études de photodesign, Institut Universitaire de Technologie de Bielefeld; 1995 séjour à Londres; 1996 diplôme; expositions collectives: 1993 *Mit Licht* (Avec de la lumière), Kunstverein Gütersloh; 1994 *Die Seitenstraße grünt* (La rue latérale verdoie), Bielefeld; 1995 *London Underground*, Bielefeld; 1996 *Stadt Land Fluß* (Ville Campagne Rivière), Bielefeld; *Geschichten von der Elbe* (Histoires de l'Elbe), photokina, Cologne. Corrina Wichmann vit à Bielefeld.

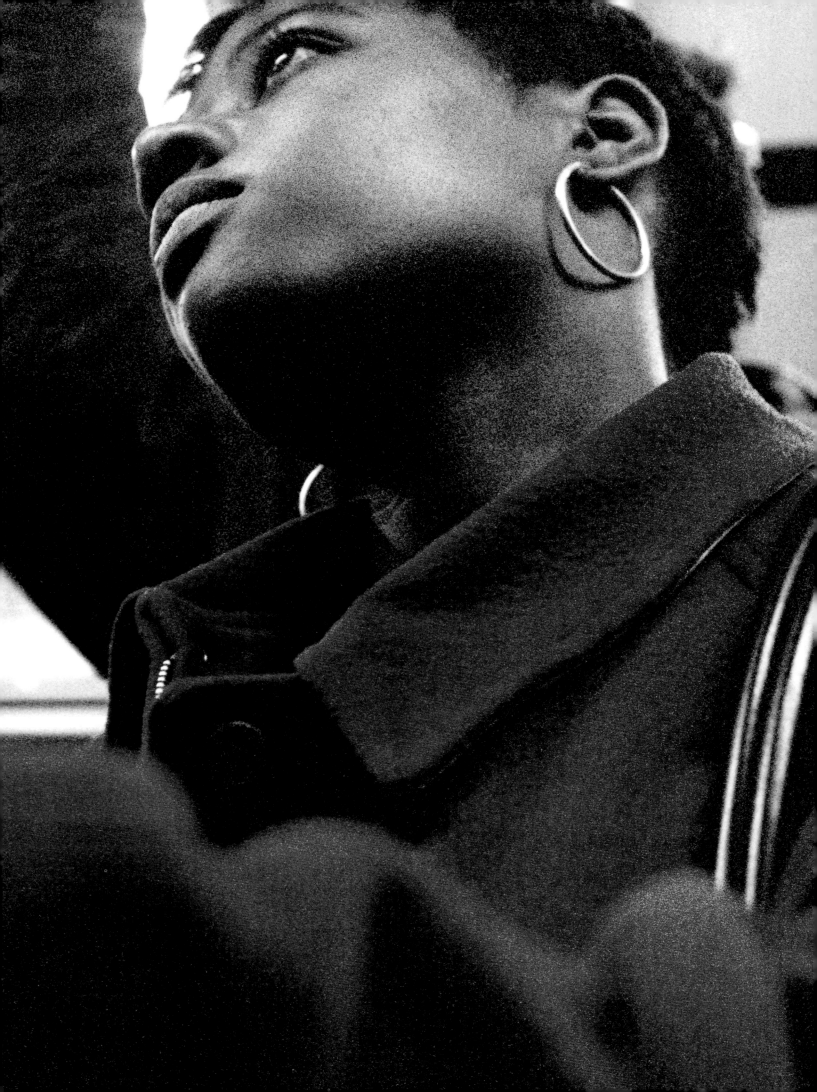

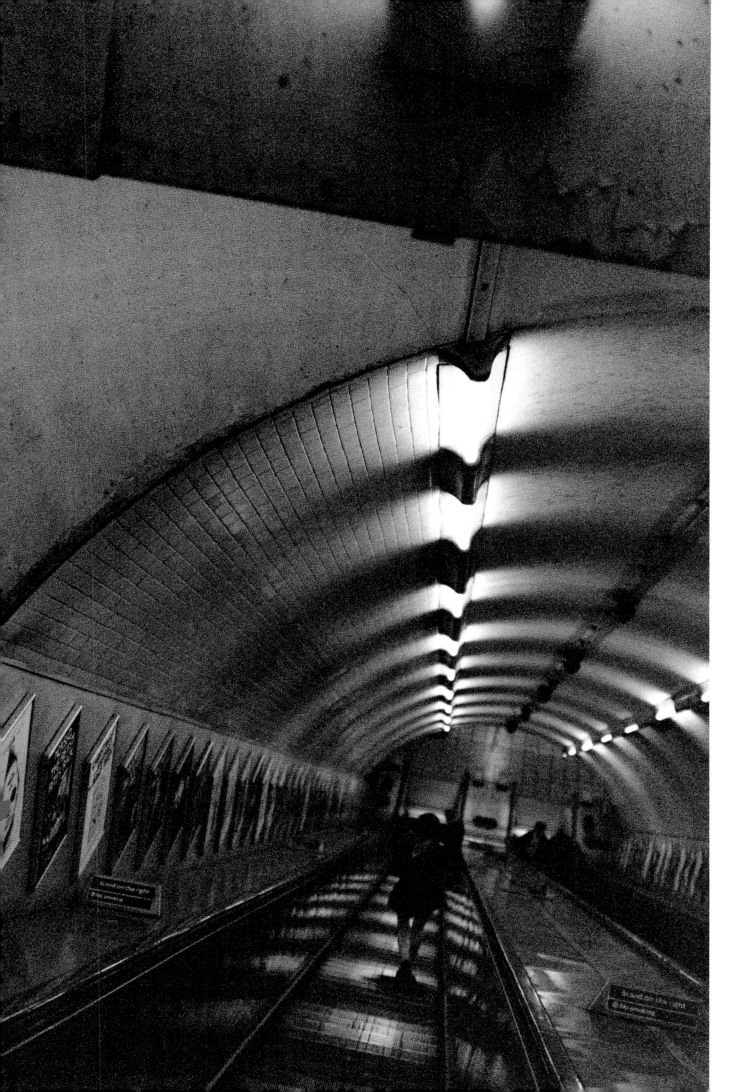

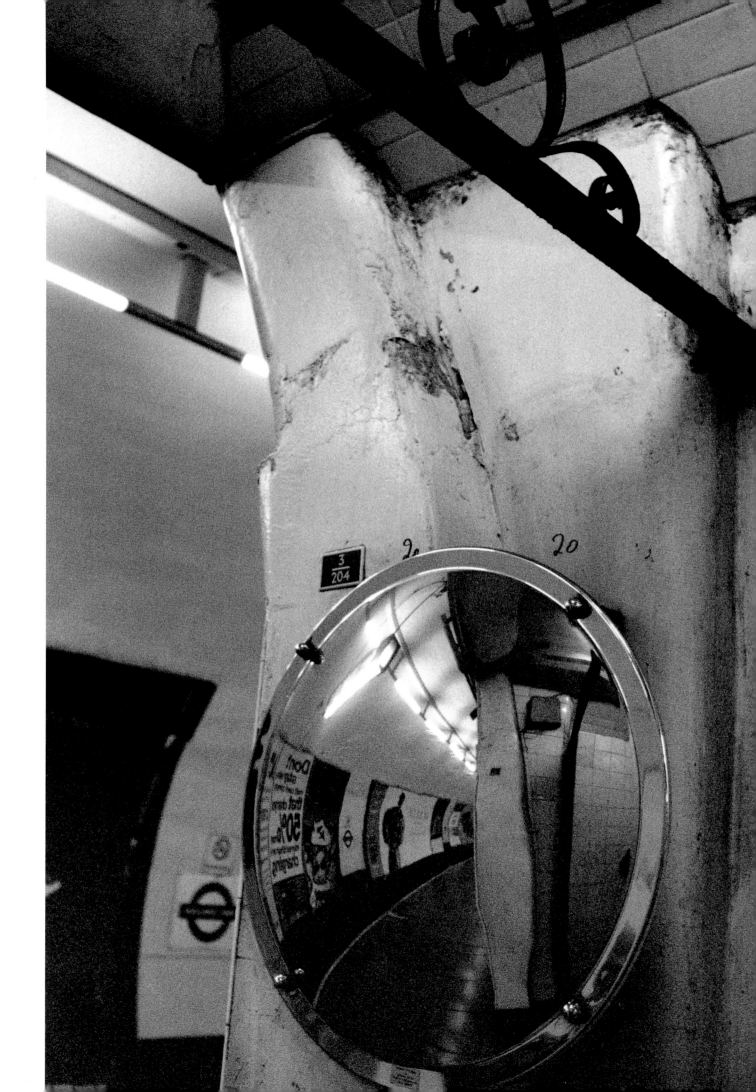

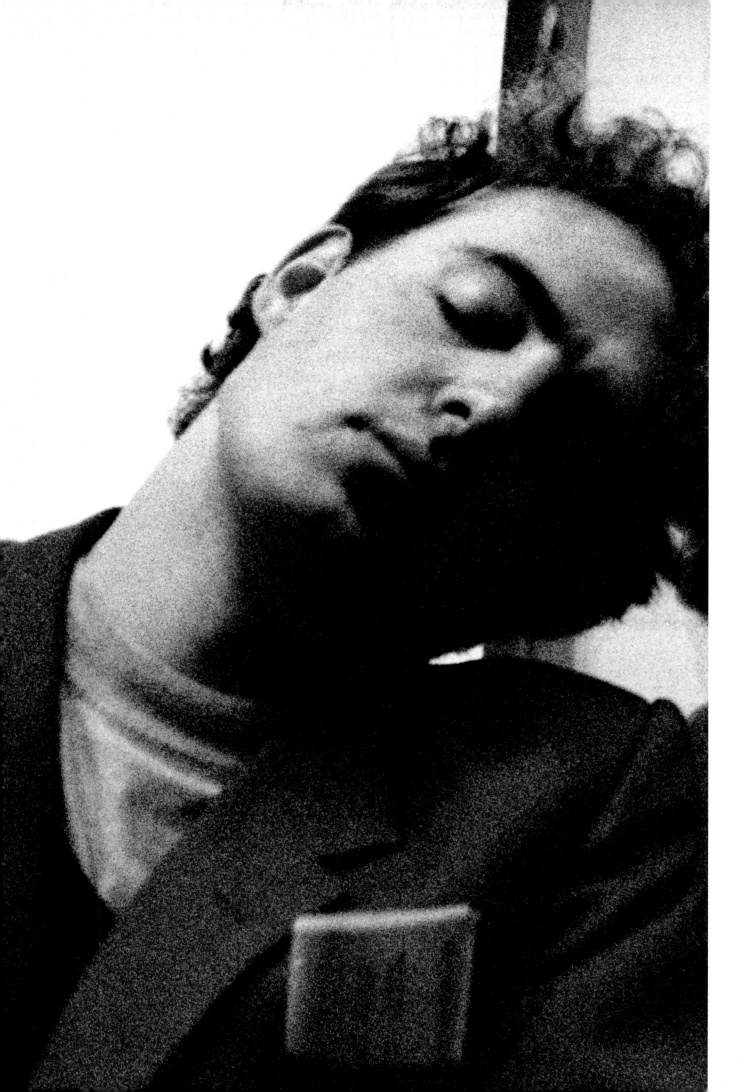

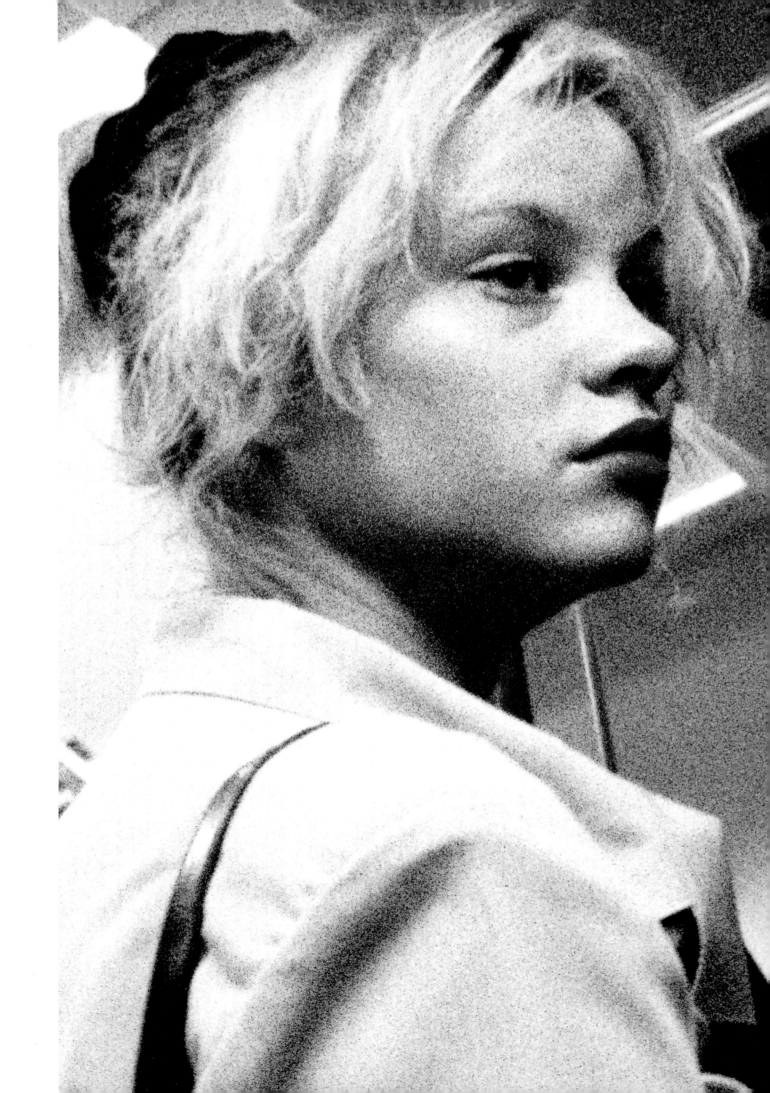

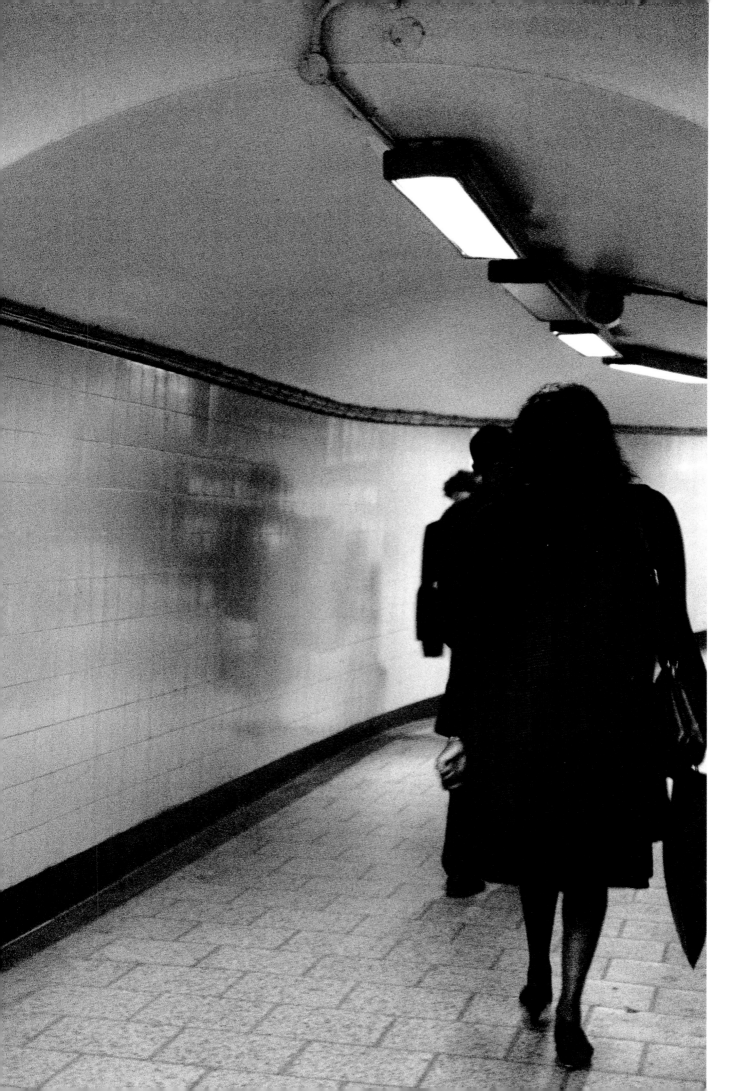

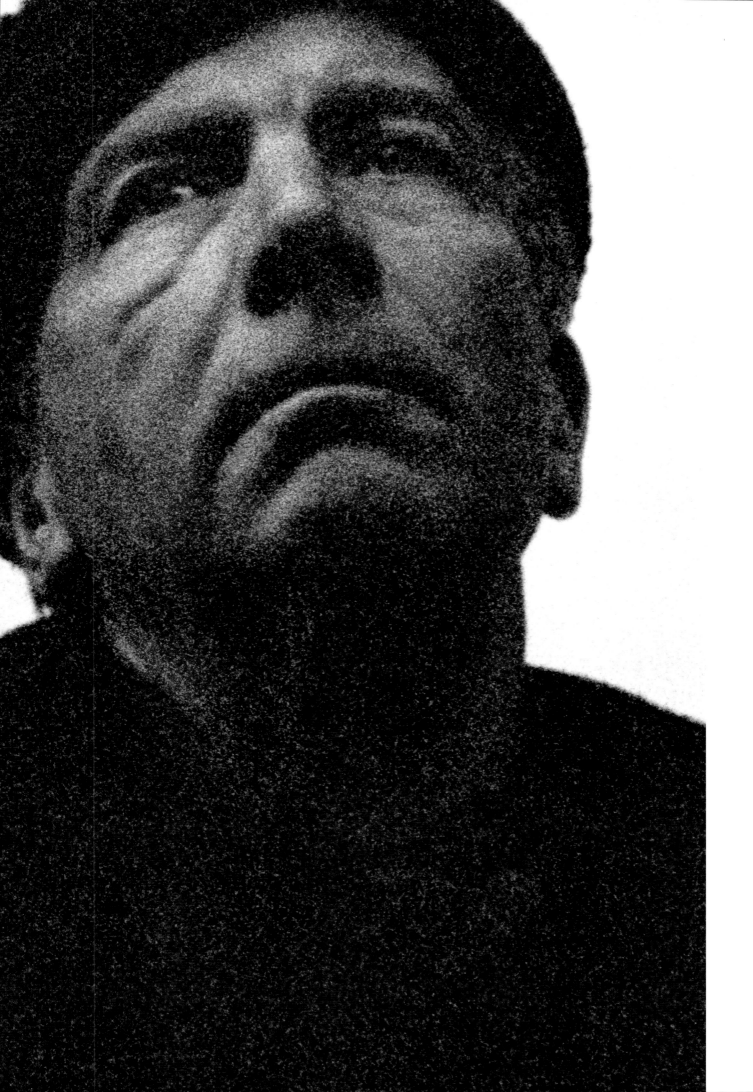

anne eickenberg / peter von felbert

Travel photography continues to be subject to enormous pressures It is expected to tout fabulous geographic attractions, to make one feel close to the unfamiliar, to repeat stale clichés or to brag with curiosities. And it also has to illustrate a text or itself perform like a text. A strenuous and monotonous job in the long run. Especially at a time when one sees more of the world than one can possibly absorb, and when huge amounts of information can be obtained everywhere, travel photography can very well afford to reduce stress and to be ist own relaxed self. Only when it begins to share the experiences of a traveler – i.e. when it does not continually kid itself and us – can it offer more than just pictures of foreign lands, namely pictures of trips. Pictures that pick up something here and there, that inquisitively look out of the bus window, that are occasionally tired and introverted. Pictures that don't always clarify everything, that can also occasionally roam round aimlessly and that can often be both beguiled and confused. Photography too can be in a bad mood or well disposed. Whenever travel photography dares to give preference to personal notes and inaccurate sketches ahead of satisfying the expectations of others, it is justified in feeling self-assured and independent. Only then will we see relaxed and inspiring picture sequences instead of pseudo-informative exotic tidbits.

Reisephotographie ist nach wie vor einer enormen Erwartungshaltung ausgesetzt. Sie soll geographische Spitzenleistungen anpreisen, Nähe zum Fremden suggerieren, abgestandene Klischees nachplappern oder mit Kuriositäten prahlen. Dabei muß sie auch noch Text illustrieren oder sich gleich selbst wie einen verhalten. Auf die Dauer ein anstrengender und eintöniger Job. Gerade in einer Zeit, in der man mehr von der Welt sieht, als man verkraften kann, und in der Unmengen von Informationen überall leicht zu haben sind, kann es sich die Reisephotographie durchaus leisten, Streß abzubauen und ganz unverkrampft sie selbst zu sein. Erst wenn sie die Erfahrungen des Reisenden mitzuteilen beginnt – also sich und uns nicht dauernd etwas vormacht – kann sie mehr bieten als nur Photos fremder Länder, nämlich Bilder vom Reisen. Bilder, die hier und dort etwas aufschnappen, die neugierig aus dem Bus blicken, die zwischendurch müde und gelegentlich in sich gekehrt sind. Bilder, die nicht gleich alles durchschauen, auch einmal ohne Ziel herumstreunen und oft betört und verwirrt zugleich sind. Auch Photographie kann schlecht gelaunt oder gut drauf sein. Jedesmal wenn Reisephotographie den Mut hat, persönliche Notizen und fehlerhafte Skizzen dem Abarbeiten fremder Erwartungen vorzuziehen, kann sie sich selbstbewußt und unabhängig fühlen. Statt scheinbar informativer Exotik-Häppchen sehen wir dann entspannte und inspirierende Bildfolgen.

La photographie de voyage a été de tout temps soumise à une énorme pression. On attend toujours d'elle qu'elle vende de la géographie comme si elle était soumise à une exigence de rendement, qu'elle suggère une certaine proximité de l'étranger, qu'elle perpétue des clichés éculés ou encore qu'elle fasse étalage de curiosités. De plus, il lui faut encore illustrer des textes ou se comporter comme si elle était elle-même un texte. Bref, un boulot à la longue parfaitement pénible et ennuyeux. Mais justement: à une époque où l'on voit du monde plus que ce que l'on est capable d'en supporter, où il est facile de se procurer n'importe où des tonnes d'information, eh bien, à une telle époque, la photographie peut parfaitement se permettre d'en finir avec le stress et, totalement décontractée, d'être enfin elle-même. Ce n'est que quand elle commence à partager le vécu du voyageur, c'est-à-dire quand elle ne se raconte plus et ne nous raconte plus sans arrêt des fadaises, qu'elle est en mesure d'offrir autre chose que de simples photos de pays étrangers: des images du voyage en soi. Des images qui, çà et là, attrapent quelque chose au vol, des images curieuses de ce qui se passe à l'extérieur du bus, des images qui de temps en temps sont fatiguées et à l'occasion songeuses. Des images qui ne comprennent pas tout immédiatement, qui savent aussi vagabonder sans but précis et qui sont souvent envoûtées et déconcertées à la fois. La photographie peut elle aussi être de mauvaise humeur ou au contraire avoir la joie au cœur. Chaque fois que la photographie de voyage a le courage de privilégier les notes personnelles et les esquisses, avec leurs imperfections, aux dépens d'attentes frelatées qui ne sont pas les siennes elle peut légitimement prendre conscience de sa propre valeur et de son indépendance. Au lieu de ces amuse-gueule exotiques que l'on sert sous couvert d'information, ce sont des suites sereines d'images, sources d'inspiration de surcroît, que nous avons alors sous les yeux.

Anne Eickenberg was born in Solingen in 1969; 1985–1986 studied composition and design in Bielefeld; 1987 studied photography and graphic design in Louisville (Kentucky), USA; 1988–1994 studied photo-design at the Bielefeld Technical College; 1992 Founding of the Luks agency; group exhibitions and awards; 1991 Kodak Blitz award; 1992 *Architektur Subjektiv* (Architecture, Subjectively), Heilbronn; 1994 BFF Competition of the best examination works (Bund Freischaffender Fotografen, i.e. Association of Freelance Photographers); *Apartments*, Aarau, Switzerland; *Menschenbilder* (Pictures of people), Cologne; Rencontres Internationales de la Fotografie, Arles, France; 1995 Aenne Biermann Exhibition, Gera; Reinhard Wolf Exhibition, Hamburg; *Deutschland erotisch* (Erotic Germany), Red Box Exhibition, Hamburg; *Skurril art–art skurril*, Hamburg; *Der Mann* (Man), concept and organization of the exhibition, Bielefeld; 1995–1996 *Zeitgenössische deutsche Modefotografie* (Contemporary German Fashion Photography), Bonn, Frankfurt/Main. Anne Eickenberg lives in Hamburg.

Peter Felbert was born in Bonn in 1966; 1986 high school graduation; 1988–1994 studied photo-design at the Bielefeld Technical College; 1992 Founding of the Luks agency; 1993 Grant from the DAAD (German Academic Exchange Service); Solo and group exhibitions: 1990 *DDR Bilder* (Pictures of the German Democratic Republic), Bielefeld; 1992 *Architektur Subjektiv* (Architecture, Subjectively), Heilbronn; 1993 *Haltbar* (Durable), Dortmund; *Bilderberg*, Phototage Herten; 1994 *Amerika gibt es nicht* (There is no America), Bielefeld Technical College; 1996 *Anständige Aussichten* (Decent Views), Bremen. Peter Felbert lives in Munich.

Anne Eickenberg, 1969 geboren in Solingen; 1985/86 Fachoberschule Gestaltung/Design, Bielefeld; 1987 Photographie/Grafikstudium, Louisville (Kentucky), USA; 1988–94 Photodesign-Studium an der Fachhochschule Bielefeld; 1992 Gründung der Agentur Luks; Gruppenausstellungen und Preise: 1991 Auszeichnung, Kodak Blitz; 1992 *Architektur Subjektiv*, Heilbronn; 1994 BFF-Wettbewerb der besten Examensarbeiten; *Apartments*, Aarau/Schweiz; *Menschenbilder*, Köln; Festival international de la photographie, Frankreich; 1995 Aenne-Biermann-Ausstellung, Gera; Reinhard-Wolf-Ausstellung, Hamburg; *Deutschland erotisch*, Red-box-Ausstellung, Hamburg; *Skurril art – art skurril*, Hamburg; *Der Mann*, Konzeption und Organisation der Ausstellung, Bielefeld; 1995/96 *Zeitgenössische deutsche Modephotographie*, Bonn, Frankfurt/Main. Anne Eickenberg lebt in Hamburg.

Peter Felbert, 1966 geboren in Bonn; 1986 Abitur; 1988–94 Photodesign Studium an der Fachhochschule Bielefeld; 1992 Gründung der Agentur Luks; 1993 Stipendium des DAAD (Deutscher Akademischer Austauschdienst); Einzel- und Gruppenausstellungen: 1990 *DDR Bilder*, Bielefeld; 1992 *Architektur subjektiv*, Heilbronn; 1993 *Haltbar*, Dortmund; *Bilderberg*, Phototage Herten; 1994 *Amerika gibt es nicht*, Fachhochschule Bielefeld; 1996 *Anständige Aussichten*, Bremen. Peter Felbert lebt in München.

Anne Eickenberg, née en 1969 à Solingen; 1985/86 études de design à l'Institut Universitaire de Technologie de Bielefeld; 1987 études de photographie et de graphisme, Louisville (Kentucky); 1988–1994 études de photodesign à l'Institut Universitaire de Technologie de Bielefeld; 1992 fondation de l'agence Luks; expositions collectives et prix: 1991 récompense du Kodak Blitz; 1992 *Architektur Subjektiv*, Heilbronn; 1994 concours BFF des meilleurs travaux d'examen; *Apartments*, Aarau, Suisse; *Menschenbilder* (Photos de gens), Cologne; Festival international de la photographie, France; 1995 exposition Aenne Biermann, Gera; exposition Reinhard Wolf, Hambourg; *Deutschland erotisch* (L'Allemagne érotique), exposition Red box, Hambourg; *Skurril art – art skurril* (Art grotesque – grotesque de l'art), Hambourg *Der Mann* (L'homme), conception et organisation de l'exposition, Bielefeld; 1995/96 *Zeitgenössische deutsche Modefotografie* (Photographie de mode contemporaine en Allemagne), Bonn, Francfort/Main. Anne Eickenberg vit à Hambourg.

Peter Felbert, né en 1966 à Bonn; 1986 baccalauréat; 1988–1994 études de photodesign à l'Institut Universitaire de Technologie de Bielefeld; 1992 fondation de l'agence Luks; 1993 bourse du DAAD; expositions personnelles et collectives: 1990 *DDR Bilder* (Images de la R.D.A.), Bielefeld; 1992 *Architektur Subjektiv*, Heilbronn; 1993 *Haltbar* (Solide), Dortmund; *Bilderberg*, Journées de la Photographie de Herten; 1994 *Amerika gibt es nicht* (L'Amérique n'existe pas), Institut Universitaire de Technologie de Bielefeld; 1996 *Anständige Aussichten* (Perspectives correctes), Brême. Peter Felbert vit à Munich.

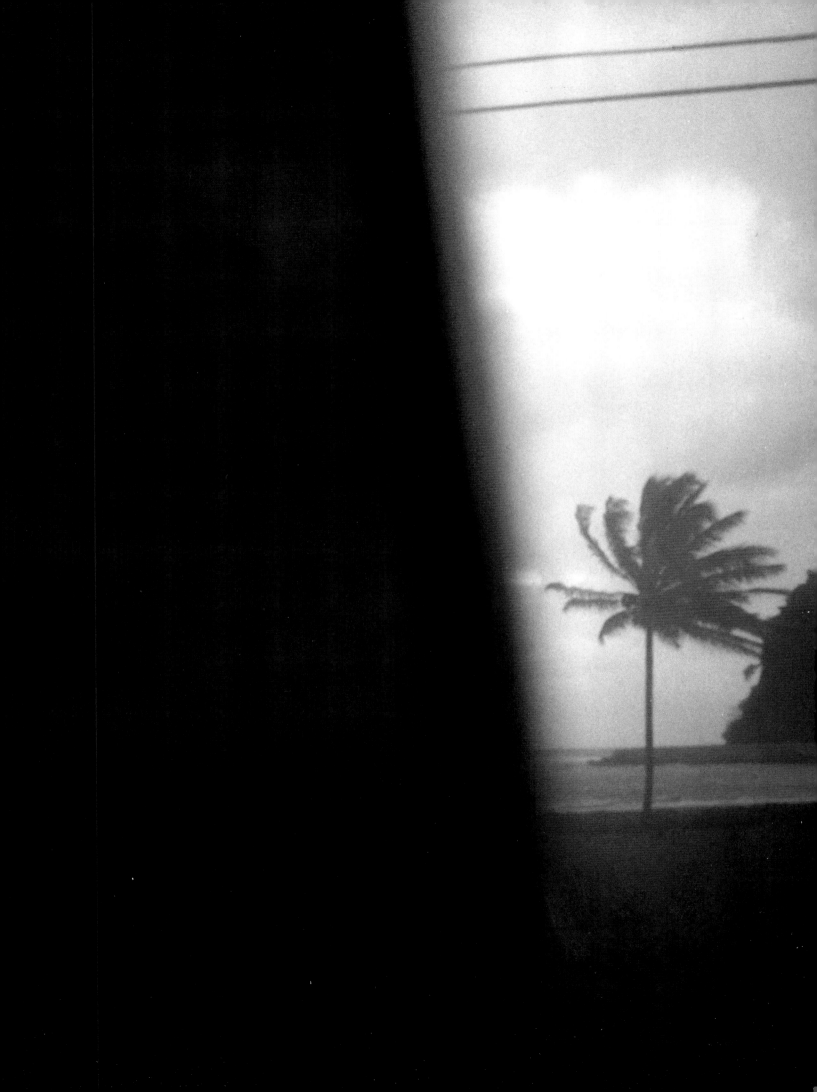

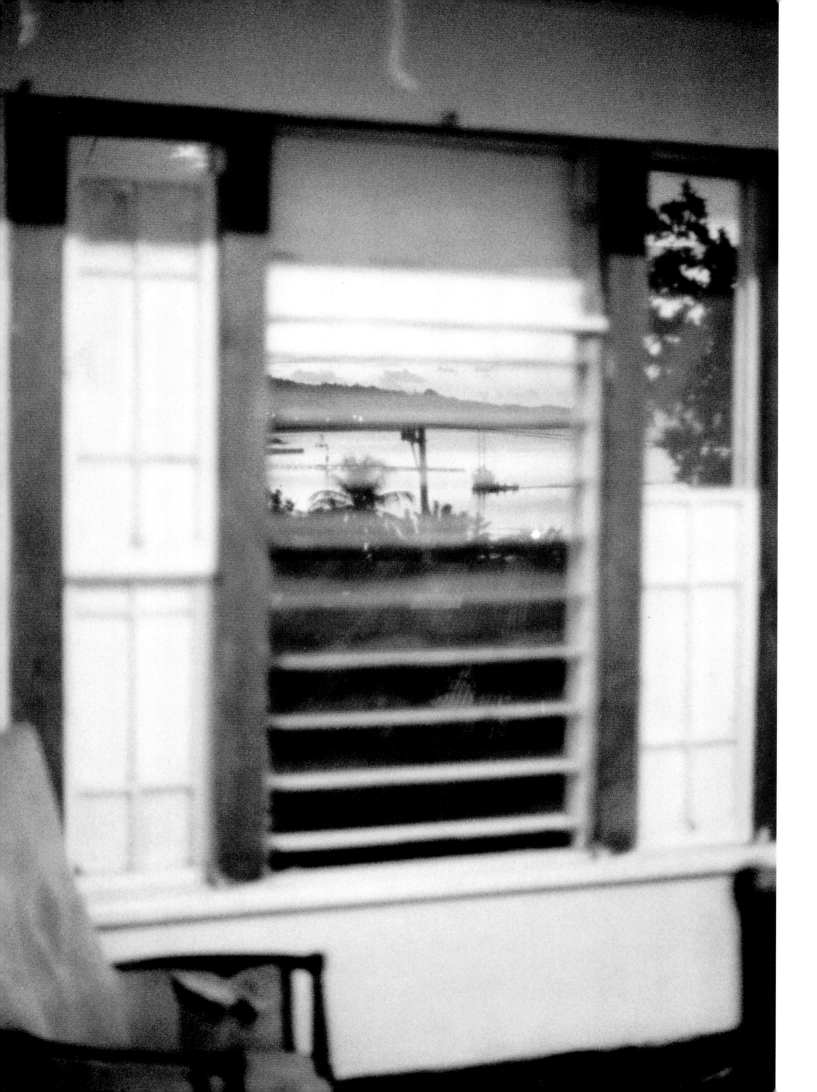

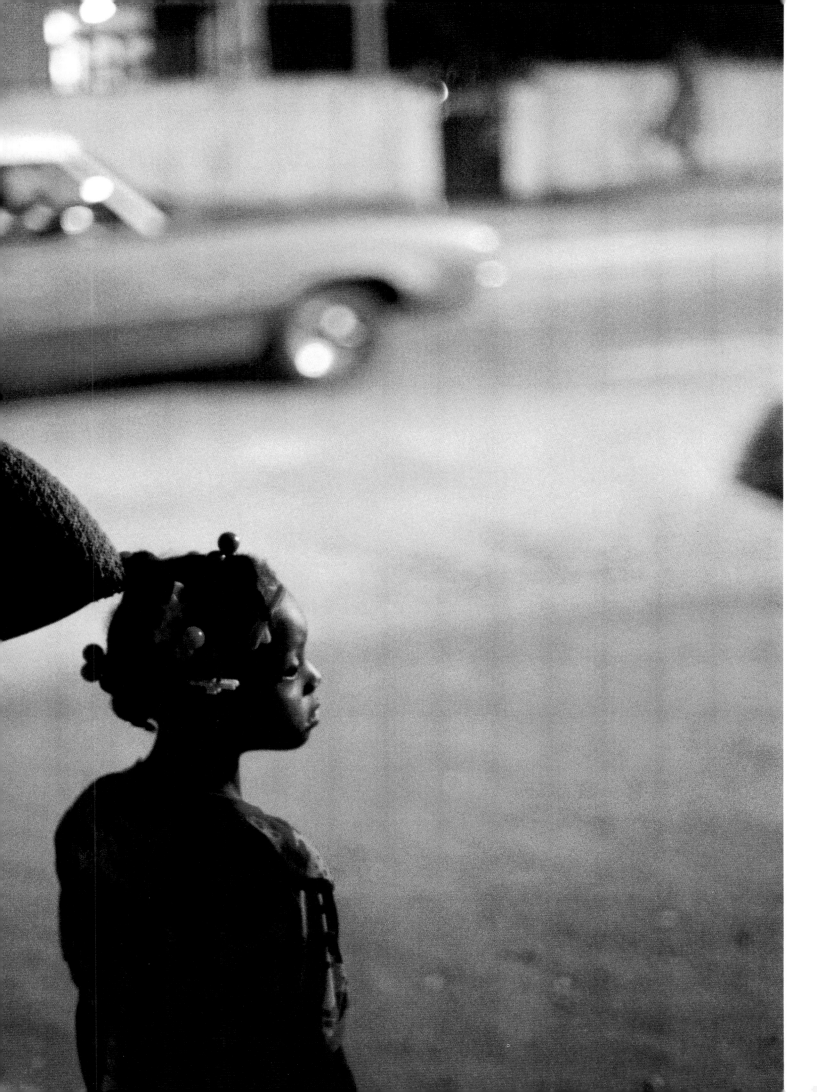

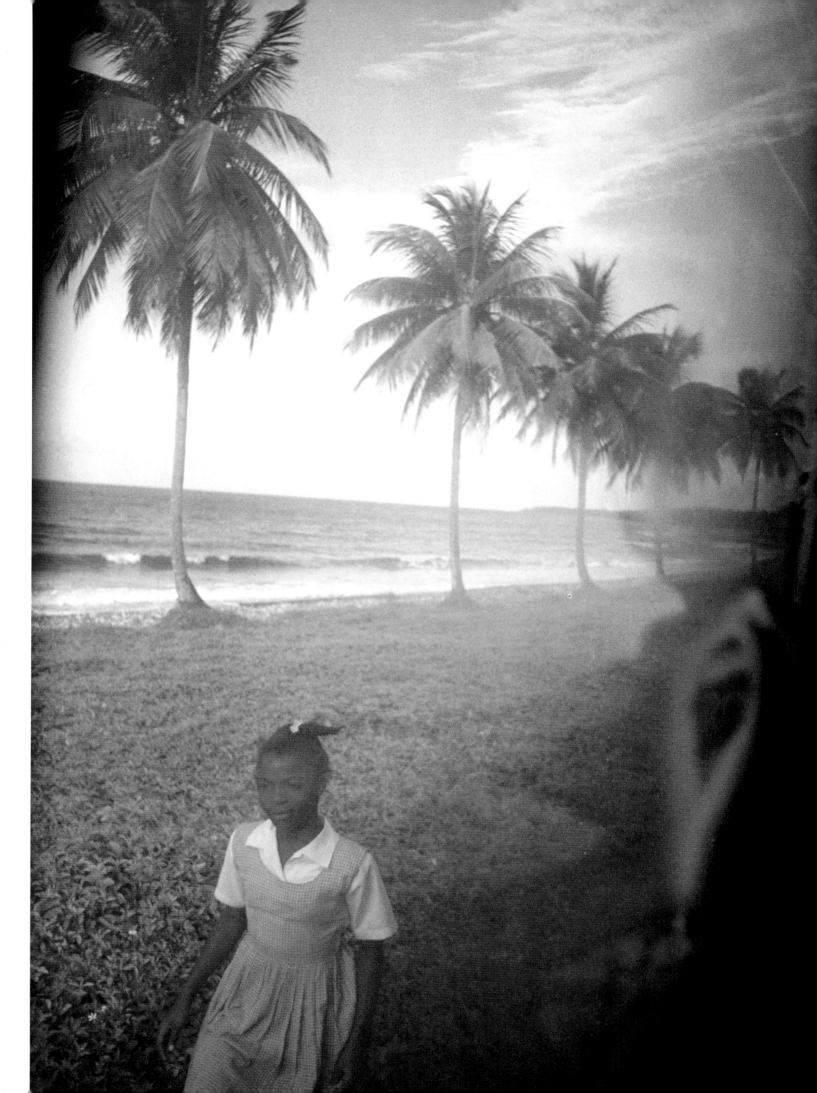

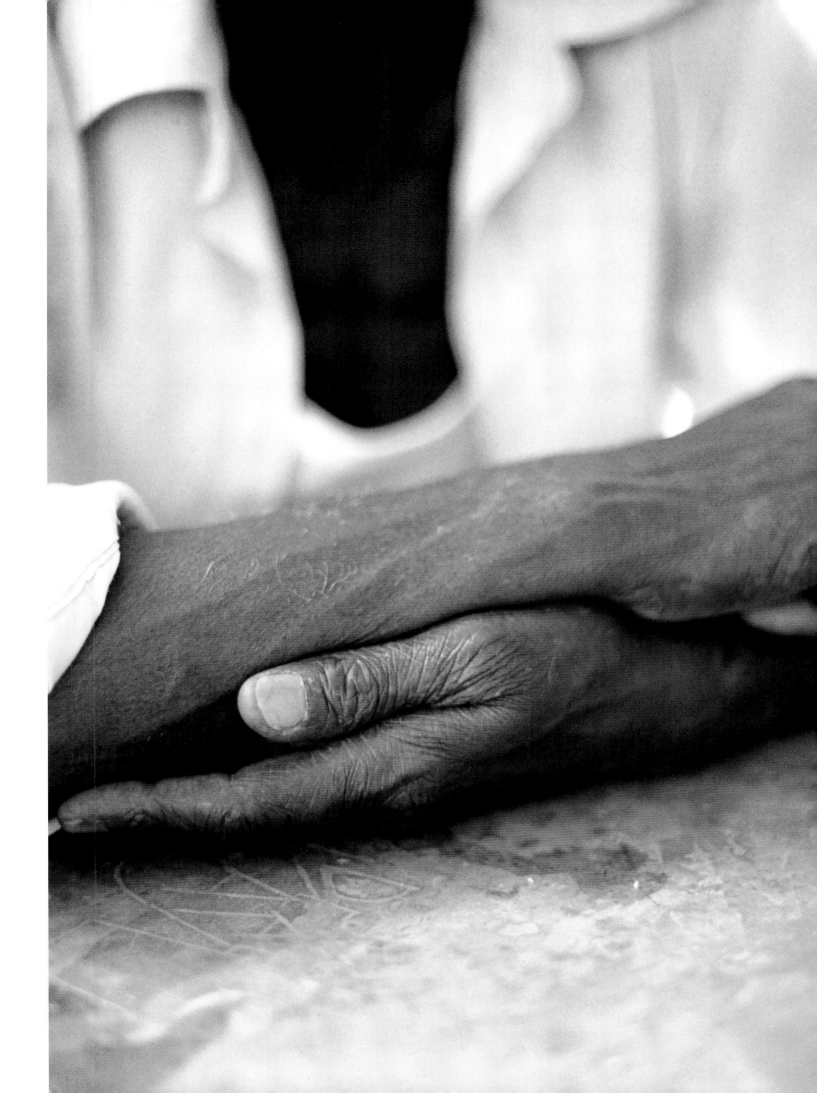

axel boesten / kai-olaf hesse *Between Gardens and Deserts – Dessau, Wittenberg, Bitterfeld*

Winter 1993. Time and space seem here to be subject to other laws. Dessau, Wittenberg, Bitterfeld – cornerstones of a landscape that is a patchwork of railroad tracks, winding rivers, brown coal excavations made by gigantic earthmovers, romantic parks, man-made hills, lines and axes charged with history and random meaning, onetime places of work... its own culture seems to have gone through a compactor. Simulation of beautification and destruction of the landscape sometimes become so compressed in one's own perception that those traces of historical civilization seem to contradict themselves too much to be in any kind of connection with each other. Experience and attempts at abstraction reach their limits, sensible correlations between these places that are so close to each other are no longer conceivable. Landscapes as residual experiences, patterns of the most varied surface changes, in which the past and the tone of the times occasionally seem to surface. But these very patterns could yield information about historical events, and the texture of the surfaces and their specific coloring would allow conjectures about the condition and the content of a society. A focusing of an image as a space for associations and as a symbolization of real as well as impossible contexts? Summer 1996. Transformation of time and space... It still impacts on the landscape and on people with full force. And yet pictures may – if you regard them as photographic metaphors – depict a connection between the past, the present and a (possible) future of this landscape, between document and discourse.

Zwischen Gärten und Wüsten – Dessau, Wittenberg, Bitterfeld **Winter 1993. Zeit und Raum scheinen hier anderen Gesetzen zu unterliegen. Dessau, Wittenberg, Bitterfeld – Begrenzungsmarken einer Landschaft, die von einem Gewebe aus Schienensträngen, Flußschleifen, von Riesenbaggern gefressenen Braunkohlelöchern, romantischen Parkanlagen, künstlichen Bergen, historischen Sichtachsen, zufälligen Sinnachsen, Orten gewesener Arbeit überspannt wird. Die eigene Kulturgeschichte scheint in den Verdichter geraten zu sein. Schein-sein von Schön-sein und Destruktion in der Landschaft verdichten sich in der eigenen Wahrnehmung manchmal so sehr, daß sich jene zivilisationshistorischen Spuren doch zu sehr zu widersprechen scheinen, als daß sie in irgendeiner Beziehung zueinander stehen könnten. Erfahrung und Abstraktionsversuche geraten an ihre Grenzen, sinnvolle Zusammenhänge zwischen diesen so nah beieinanderliegenden Orten sind nicht mehr greifbar. Landschaft als Resterfahrung, Muster unterschiedlichster Überformungen, in denen zuweilen das Gewesene, der Klang der Zeit wiederzukehren scheint. Eben dieses Muster könnte jedoch Auskunft geben über historische Vorgänge; die Beschaffenheit von Oberflächen und deren spezifische Farbigkeit ließen Mutmaßungen über Zustand und Befindlichkeit einer Gesellschaft zu. Eine Bildeinstellung als Raum für Assoziationen und als Versinnbildlichung tatsächlicher wie unmöglicher Zusammenhänge? Sommer 1996. Transformation von Zeit und Raum... Sie trifft noch immer mit voller Wucht auf Landschaft und Menschen. und doch mögen Bilder – versteht man sie als photographische Metaphern – eine Verbindung zwischen Vergangenheit, Gegenwart und (möglicher) Zukunft dieser Landschaft zeichnen, zwischen Dokument und Diskurs.**

Entre jardins et déserts – Dessau, Wittenberg, Bitterfeld Hiver 1993. Ici, l'espace et le temps ... semblent soumis à d'autres lois. Dessau, Wittenberg, Bitterfeld – marches de délimitation d'un paysage tendu d'un tissu de lignes de chemin de fer, de fleuves méandreux, de trous de lignite que dévorent de gigantesques excavatrices, de parcs romantiques, de montagnes artificielles, d'axes visuels qui sont le fait de l'histoire, d'axes signifiants qui sont celui du hasard, de localités où il y a eu du travail ... Histoire et culture locales semblent avoir été passées au rouleau compresseur. Ce vouloir-être-beau, qui tient à la fois de l'être et du paraître, et toute cette destruction opérée dans le paysage, se confondent parfois au niveau de la perception à un point tel que ces traces d'histoire et de civilisation donnent l'impression de trop se contredire pour pouvoir entretenir entre elles un quelconque rapport. L'expérience et les essais d'abstraction atteignent ici leurs limites; tenter d'établir des corrélations sensées entre ces deux localités pourtant si proches n'est plus concevable. Le paysage comme l'expérience de ce qui reste, modèle d'adaptations mimétiques des plus disparates où parfois le ce-qui-a-été semble revenir et le son du temps se faire entendre. Mais peut-être ce modèle pourrait-il justement nous fournir des informations sur les événements historiques, peut-être la texture des strates supérieures, la spécificité de leur coloris nous autoriseraient-elles à émettre des hypothèses sur l'état et la situation d'une société à un moment donné. Une attitude photographique qui serait à la fois espace générateur d'associations et représentation symbolique de corrélations tant effectives qu'impossibles? Eté 1996. Transformation de l'espace et du temps ... Elle continue de fondre de toutes ses forces sur le paysage et sur les gens, au hasard des rencontres. Et pourtant il se pourrait que les images, comprises dans le sens de métaphores photographiques, établissent un lien entre le passé, le présent et l'(éventuel) avenir de ce paysage, entre le document et le discours.

Axel Boesten was born in Rochester (NY), USA in 1968; 1987 high school graduation; 1988–1989 community service; 1989 began studying communication design at the Essen Polytechnic University; 1991 began working as a freelance photographer and as a designer of books and posters; 1992 began project work at the Bauhaus in Dessau; group exhibitions, awards and publications: 1987 award winner in the competition *Stadtlandschaften* (Cityscapes) sponsored by the Science Ministry of the state of North-Rhine Westphalia; 1993–1995 grant for a project at the Bauhaus in Dessau; 1994 award winner in the competition *Photographie als Kunst* (Photography as Art) in Pforzheim; 1996 Book presentation *Bauhaus Dessau – industrielles Gartenreich* (Bauhaus Dessau – industrial garden), Berlin and Bochum; *Zwischen Gärten und Wüsten* (Between gardens and deserts), Krefeld (in cooperation with Kai-Olaf Hesse). Axel Boesten lives in Bochum.

Kai-Olaf Hesse was born in Wittingen in 1966; 1984 freelance photographic assistant; 1985 high school graduation; 1986–1989 photographic apprenticeship in Hamburg; 1988–1990 freelance work at the Bongarts sports press agency in Hamburg; 1989–1994 freelance work at the Westdeutsche Allgemeine Zeitung (a newspaper) and at Foyer in Essen; 1989–1996 studied communication design at the Essen Polytechnic University; group exhibitions, awards and publications: 1983–1984 *Niedersachsen entdecken* (Discover Lower Saxony), exhibitions in Aurich and Wolfsburg; 1985–1986 Deutscher Jugendfotopreis (German Youth Photography Award); 1990 Polaroid Award *Final Art,* Museum of Photography, Brunswick; 19901991 and 1993 *Zeigung* (Showing), Essen Polytechnic University; 1993–1995 working scholarship at the Bauhaus in Dessau; 1995 exhibition at the Bauhaus in Dessau (in cooperation with E. McNeill); 1995 project presentation at the Washington Center for Photography; 1995 Bowling Green University Gallery of Fine Arts; 1996 book presentation Bauhaus Dessau – industrielles Gartenreich (Bauhaus Dessau – industrial garden), Berlin, Bauhaus Dessau; exhibition at the Azur 21 gallery in Krefeld (in cooperation with Axel Boesten). Kai-Olaf Hesse lives in Hankensbüttel.

Axel Boesten, 1968 geboren in Rochester/N.Y., USA; 1987 Abitur; 1988/1989 Zivildienst; seit 1989 Studium Kommunikationsdesign an der Universität Gesamthochschule Essen; seit 1991 Tätigkeit als freier Photograph und Gestalter von Büchern und Plakaten; seit 1992 Projektarbeit am Bauhaus Dessau; Gemeinschaftsausstellungen/Preise/Veröffentlichungen: 1987 Preisträger Wettbewerb *Stadtlandschaften*, Wissenschaftsministeriums, NRW; 1993–1995 Projektstipendium am Bauhaus Dessau; 1994 Preisträger Wettbewerb *Photographie als Kunst*, Pforzheim; 1996 Buchpräsentation *Bauhaus Dessau – industrielles Gartenreich*, Berlin und Bochum; 1996 *Zwischen Gärten und Wüsten*, Krefeld (mit Kai-Olaf Hesse). Axel Boesten lebt in Bochum.

Kai-Olaf Hesse, 1966 geboren in Wittingen; 1984 freie Photoassistenz; 1985 Abitur; 1986–89 Photographenlehre, Hamburg; 1988–90 freie Mitarbeit Sportpresseagentur Bongarts, Hamburg; 1989–94 freie Mitarbeit Westdeutsche Allgemeine Zeitung/WAZ und Foyer, Essen; 1989–96 Studium Kommunikationsdesign an der Universität Gesamthochschule Essen; Gemeinschaftsausstellungen/Preise/Veröffentlichungen: 1983/84 *Niedersachsen entdecken*, Ausstellungen in Aurich und Wolfsburg; 1985/86 Deutscher Jugendphotopreis (DJF); 1990 Polaroid Award *Final art*; 1990 Museum für Photographie, Braunschweig; 1990/91/93 *Zeigung*, Universität Gesamthochschule Essen; 1993–95 Arbeitsstipendium am Bauhaus Dessau; 1995 Ausstellung am Bauhaus Dessau (mit E. McNeill); 1995 Projektpräsentation, Washington Center for Photography (WCP); 1995 Bowling Green University Gallery of Fine Arts; 1996 Buchpräsentation *Bauhaus Dessau – industrielles Gartenreich*, Berlin, Bauhaus Dessau 1996; 1996 Ausstellung Galerie Azur 21, Krefeld (mit Axel Boesten). Kai-Olaf Hesse lebt in Hankensbüttel.

Axel Boesten, né en 1968 à Rochester (NY), USA; 1987 baccalauréat; 1988–1989 service civil; depuis 1989 études de design et de communication à la Universität Gesamthochschule de Essen; depuis 1992, travaille comme photographe indépendant et maquettiste dans les domaines du livre et de l'affiche; depuis 1992, projet au Bauhaus de Dessau; Expositions collectives/prix/publications: 1987 lauréat du concours *Stadtlandschaften* (Paysages urbains), Ministère de la recherche scientifique, NRW; 1993–1995 bourse au projet au Bauhaus de Dessau; 1994 lauréat du concours *Photographie als Kunst* (La photographie comme art), Pforzheim; 1996 présentation du livre *Bauhaus Dessau – industrielles Gartenreich* (Le Bauhaus de Dessau, royaume du jardin industriel), Berlin et Bochum; 1996 *Zwischen Gärten und Wüsten*, Krefeld (en collaboration avec Kai-Olaf Hesse). Axel Boesten vit à Bochum.

Kai-Olaf Hesse, né en 1966 à Wittingen; 1984 assistant-photographe freelance; 1985 baccalauréat; 1986–89 apprentissage de photographe, Hambourg; 1988–90 collaboration freelance à l'agence de presse sportive Bongarts, Hambourg; 1989–94 collaboration freelance à la Westdeutsche Allgemeine Zeitung/WAZ et à Foyer, Essen; 1989–96 études de design et de communication à la Universität Gesamthochschule de Essen; expositions collectives/prix/publications : 1983/84 *Niedersachsen entdecken* (Découvrir la Basse-Saxe), expositions à Aurich et Wolfsburg; 1985/86 prix de la Jeune Photographie Allemande (DJF); 1990 Polaroid Award *Final art*;1990 Museum für Photographie, Braunschweig; 1990/91/93 *Zeigung*, Universität Gesamthochschule de Essen; 1993–95 bourse pour un travail au Bauhaus de Dessau; 1995 exposition au Bauhaus de Dessau (avec E. McNeill); 1995 présentation de projet, Washington Center for Photography (WCP); 1995 Bowling Green University Gallery of Fine Arts; 1996 présentation du livre *Bauhaus Dessau – industrielles Gartenreich* (Le Bauhaus de Dessau, royaume du jardin industriel), Berlin, Bauhaus de Dessau 1996; 1996 exposition à la Galerie Azur 21, Krefeld (avec Axel Boesten). Kai-Olaf Hesse vit à Hankensbüttel.

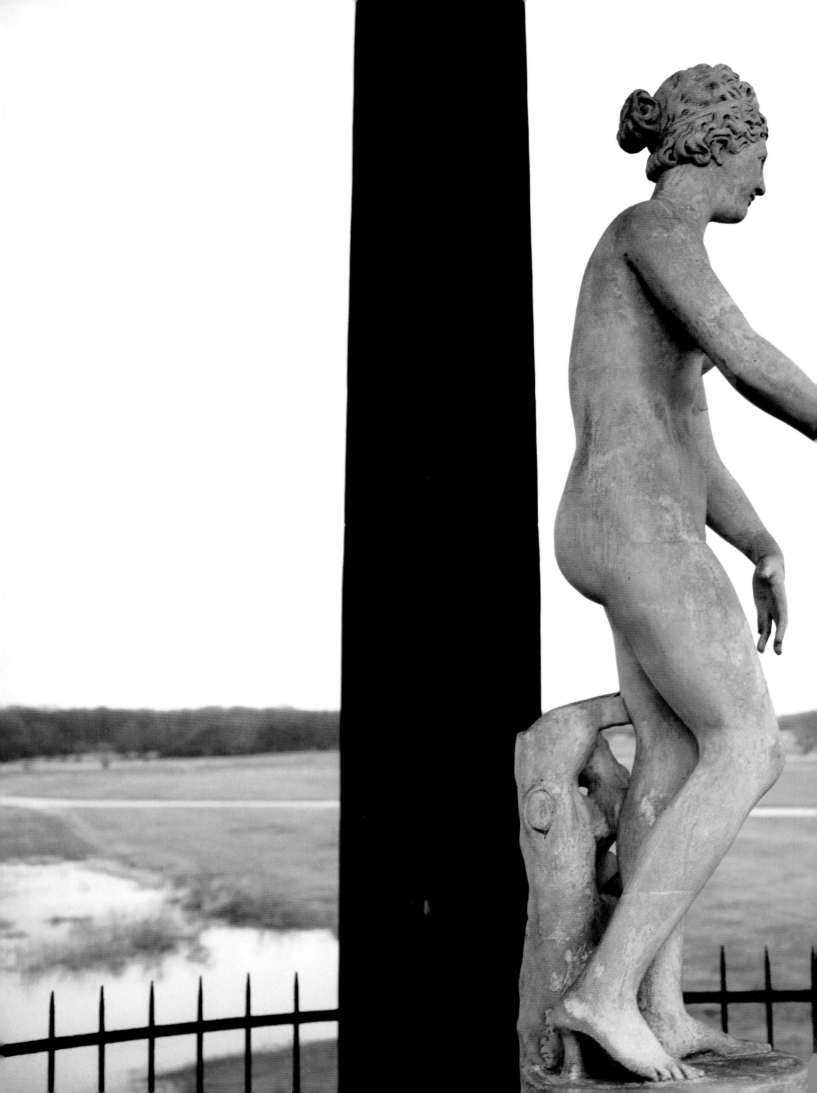

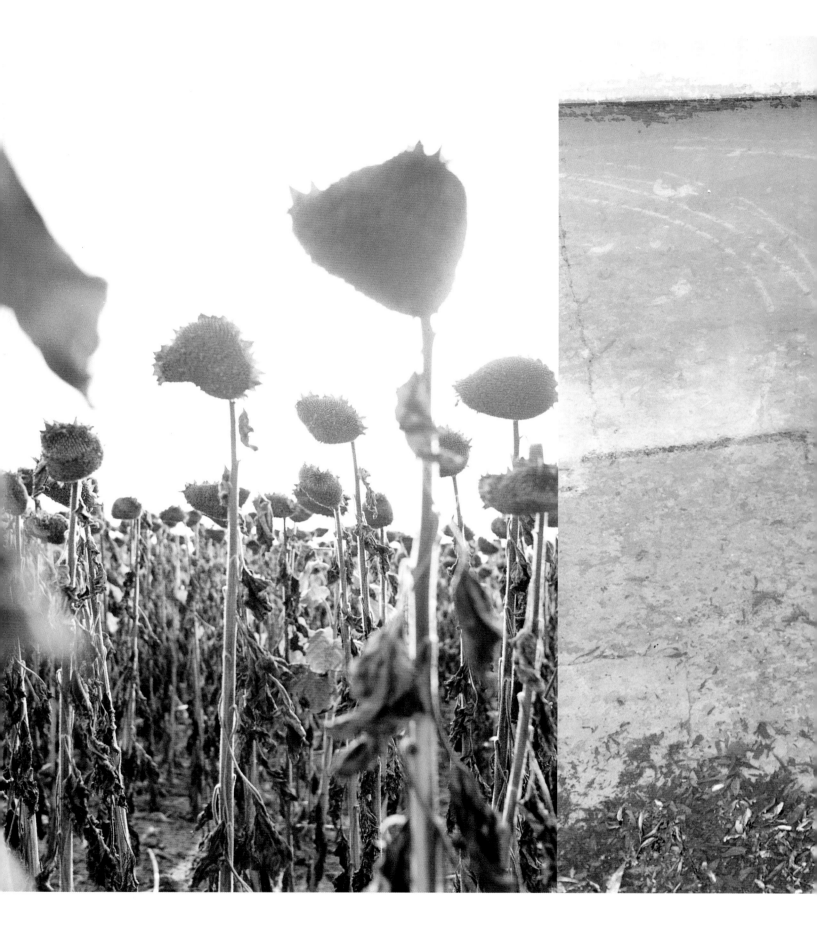

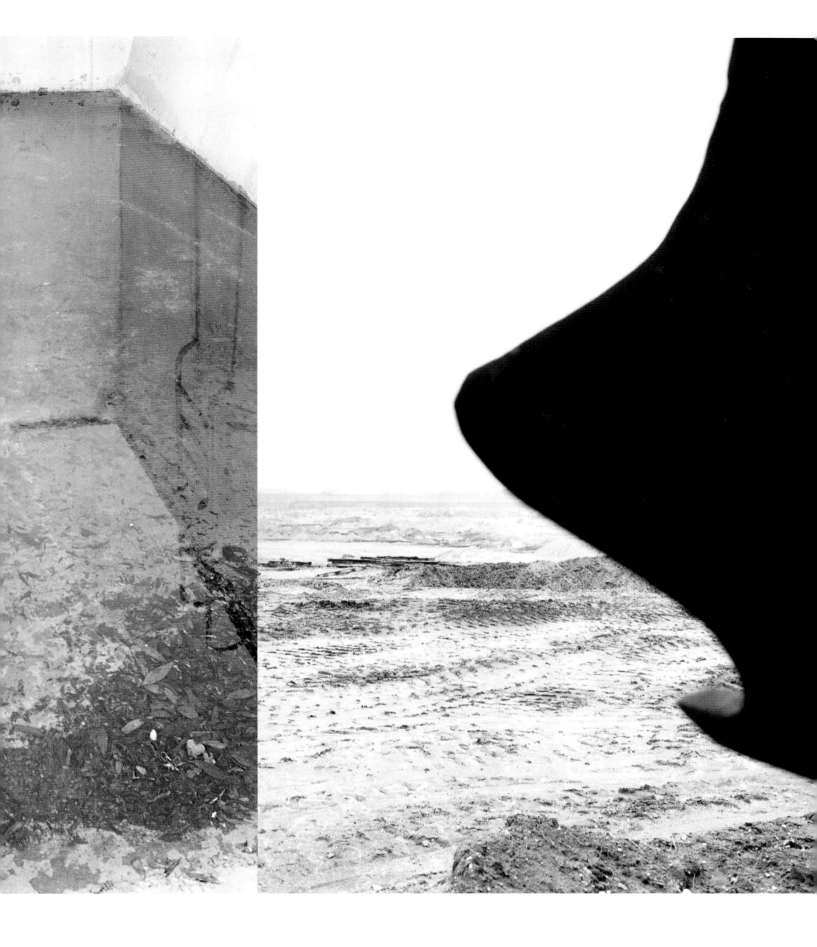

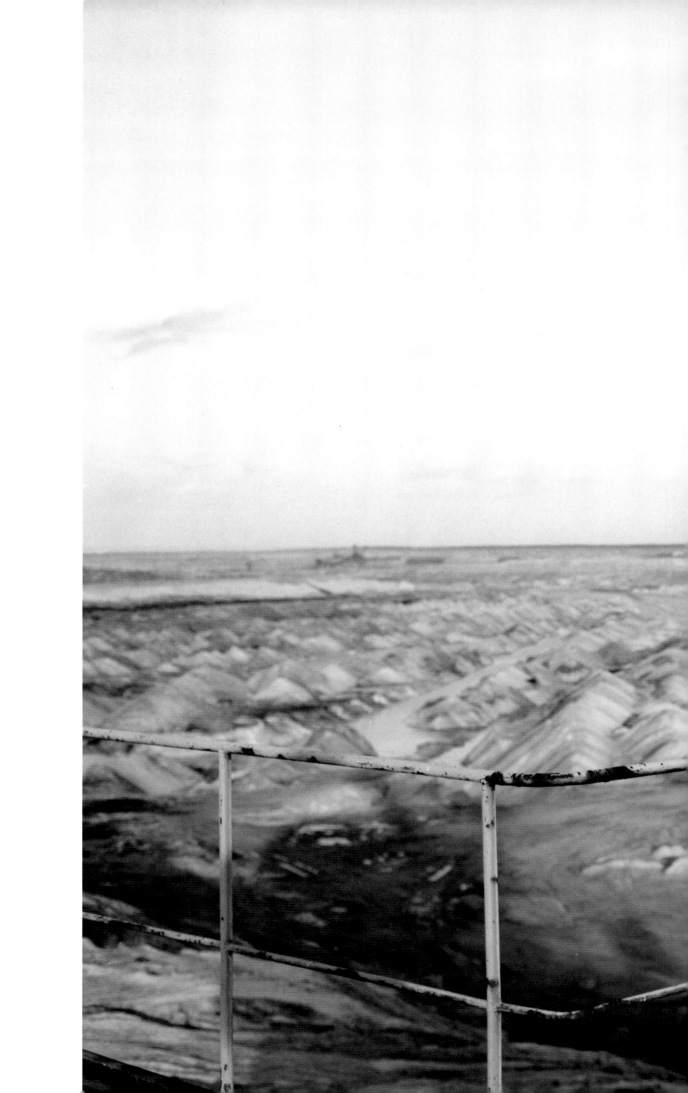

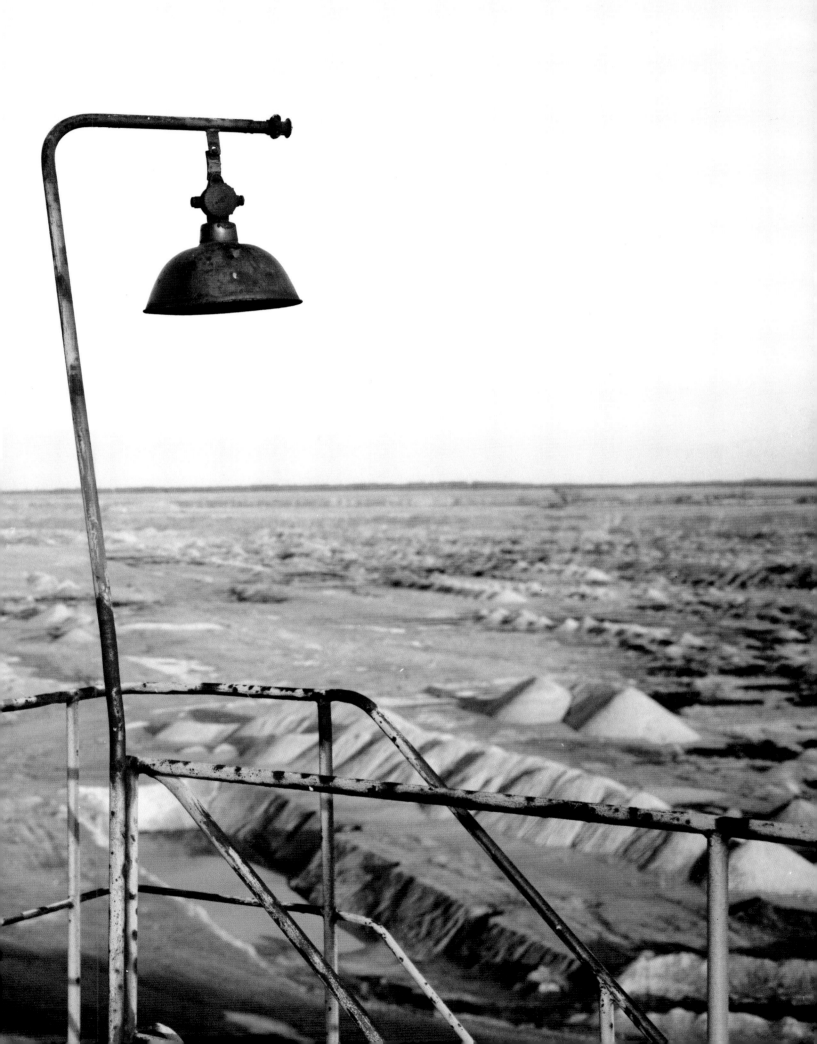

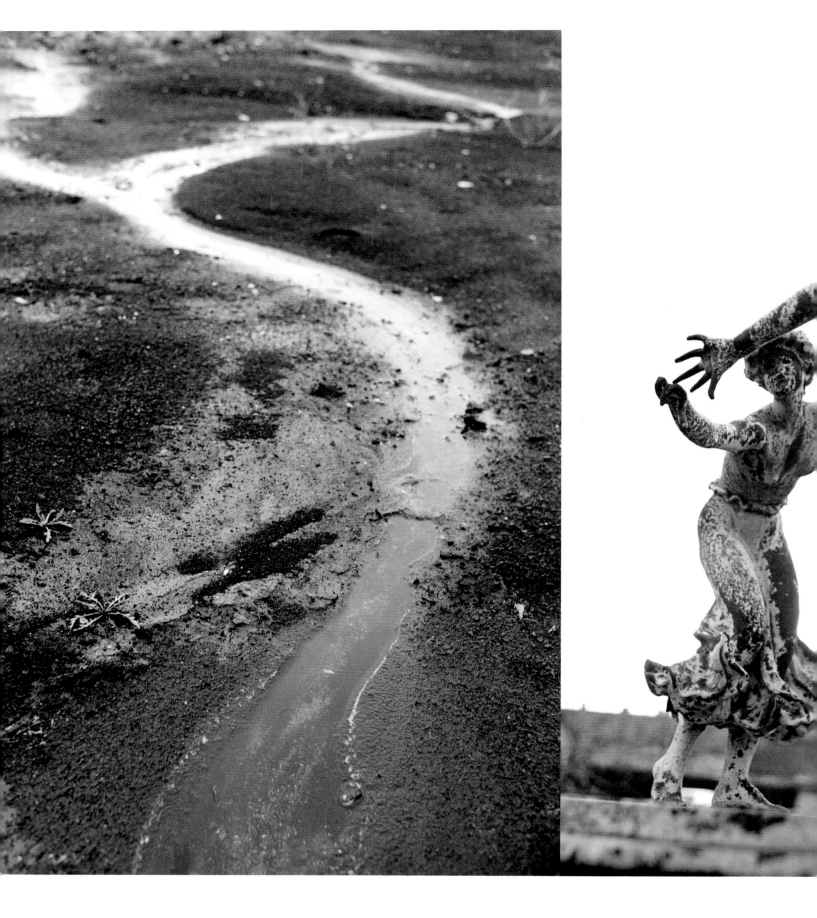

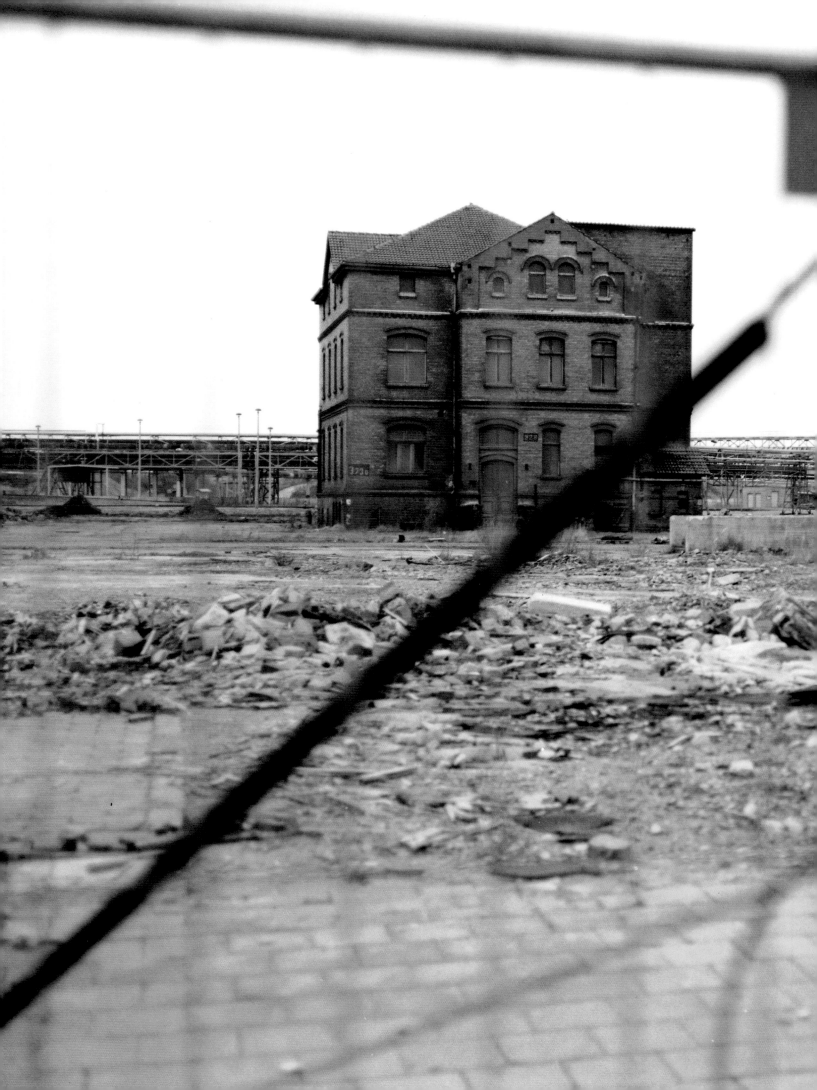

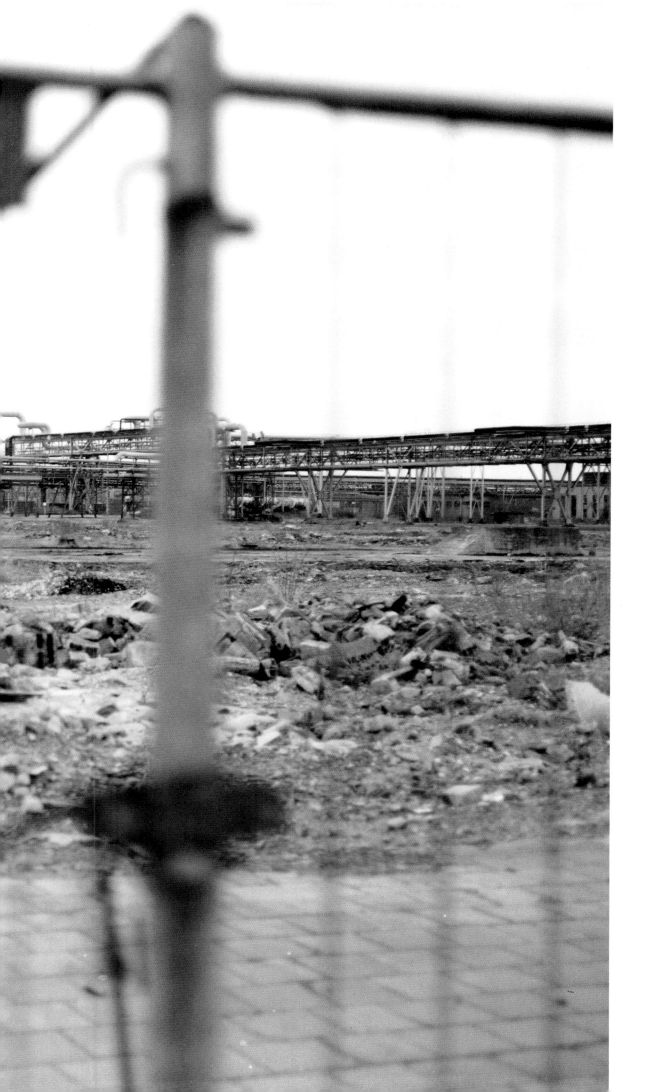

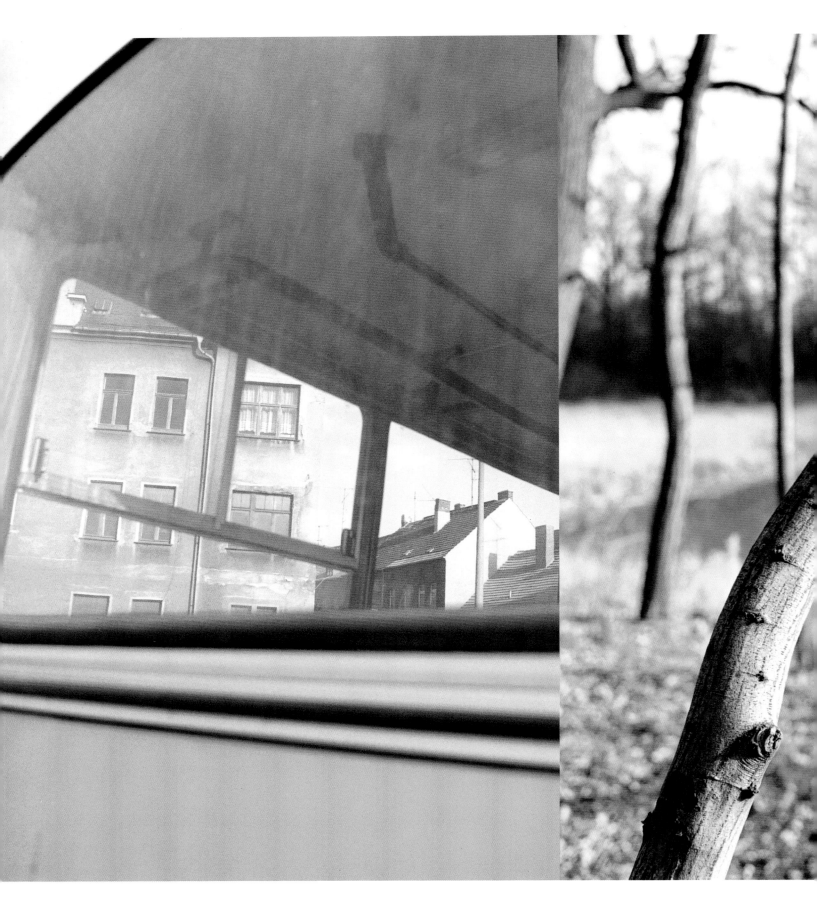

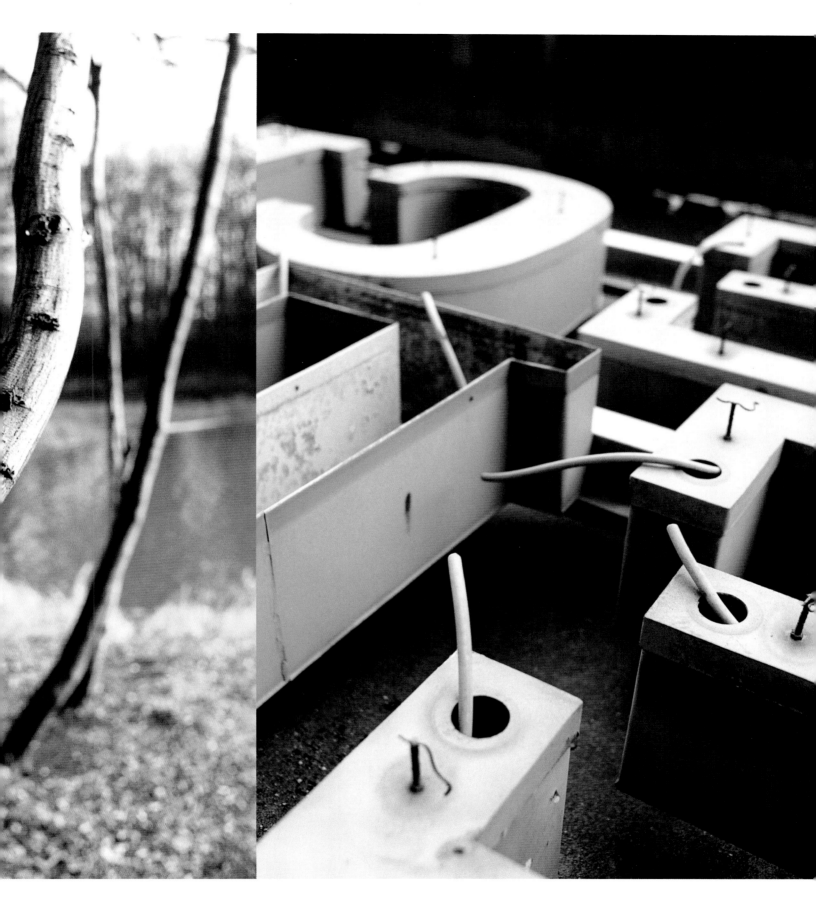

frederike hellwig

That is why I have dedicated a major portion of my photographic work to them and to their lives.

Illustrations: 1. Micki and Florian at the Club, Wuppertal, August 1992; 2. Tobias in Hamburg, April 1994; 3. Patricia and Katja in a chair, London, January 1994; 4. Theo in the Hotel Florian, Zurich, July 1994.

Freunde sind das Wichtigste im Leben. Deswegen ist ihnen und ihrem Leben ein großer Bestandteil meiner photographischen Arbeit gewidmet.

Abbildungen: 1. Micki und Florian im Club, Wuppertal, August 1994; 2. Tobias in Hamburg, April 1994; 3. Patricia und Katja im Sessel, London, Januar 1994; 4. Theo im Hotel Florian, Zürich, Juli 1994.

Les amis, c'est ce qu'il y a de plus important dans la vie. C'est la raison pour laquelle une grande partie de mon travail photographique leur est consacrée, à eux et à leur vie.

Illustrations: 1. Micki et Florian au Club, Wuppertal, août 1994; 2. Tobias à Hambourg, avril 1994; 3. Patricia et Katja dans le fauteuil, Londres, janvier 1994; 4. Theo à l'Hôtel Florian, Zurich, juillet 1994.

rederike Hellwig was born in Hamburg in 1968; 1988 Graduation from high school; 1989–1991 photography school in Munich; 1992–1994 photography course t the Bournemouth & Poole College of Art and Design; various assistant's jobs with fashion photographers in Hamburg and in London; 1994 began freelance vork for i.D., jetzt, Süddeutsche Zeitung Magazin, Elle, Face and Tempo; exhibitions: 1992 solo exhibition at the Lintas Advertising Agency in Hamburg; 1996 solo xhibition at the "Ausstellungsraum Balanstraße" (exhibition area Balanstrasse) in Munich. Frederike Hellwig lives in London.

rederike Hellwig, 1968 geboren in Hamburg; 1988 Abitur; 1989–1991 Photoschule in München; 1992–1994 Bournemouth & Poole College of Art & Design, :urs Photographie; verschiedene Assistenzen bei Modephotographen in Hamburg und London; seit 1994 freie Arbeiten für I.D., jetzt, Süddeutsche Zeitung Aagazin, Elle, Face und Tempo; Einzelausstellungen: 1992 Lintas Werbeagentur, Hamburg; 1996 im „Ausstellungsraum Balanstrasse", München. Frederike Iellwig lebt in London.

rederike Hellwig, née en 1968 à Hambourg; 1988 baccalauréat; 1989–1991 école de Photographie de Munich; 1992–1994 Bournemouth & Poole College of rt & Design, cours de photographie; assistante de divers photographes de mode à Hambourg et Londres; depuis 1994, travaille en freelance pour I.D., à pré- ent pour le Süddeutsche Zeitung Magazin, Elle, Face et Tempo; expositions: 1992 exposition personnelle à l'agence de publicité Lintas, Hambourg; 1996 ex- osition personnelle à l'«Ausstellungsraum Balanstrasse», Munich. Frederike Hellwig vit à Londres.

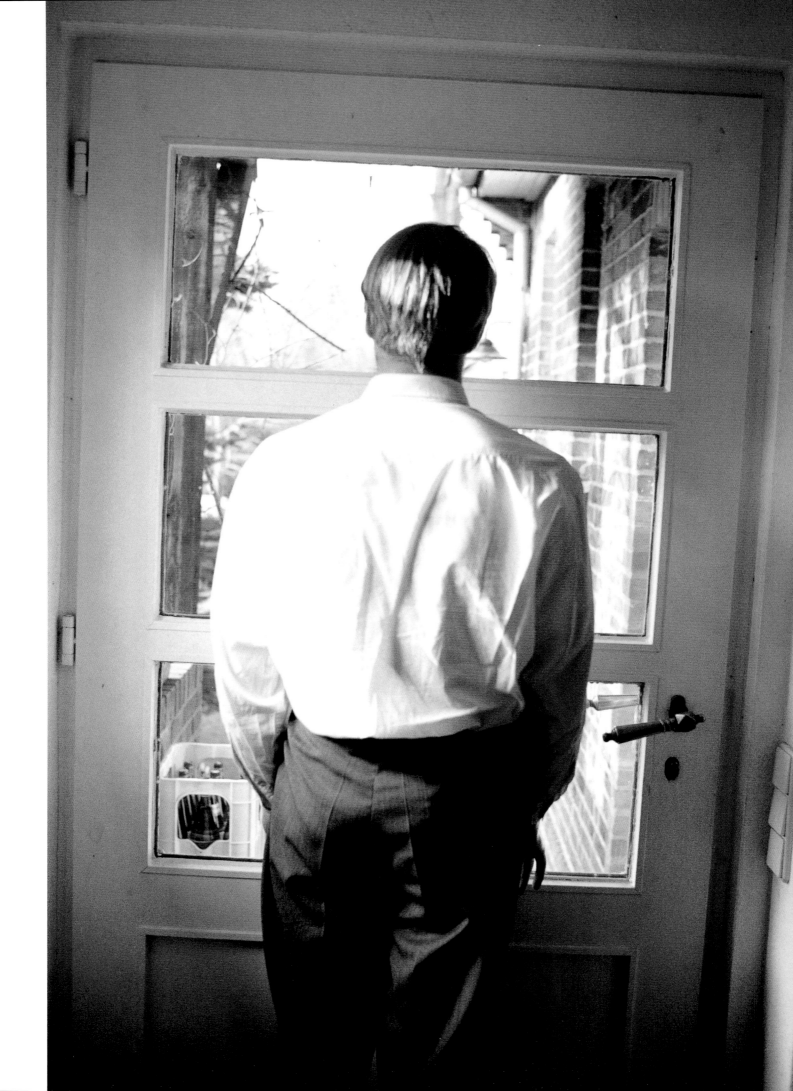

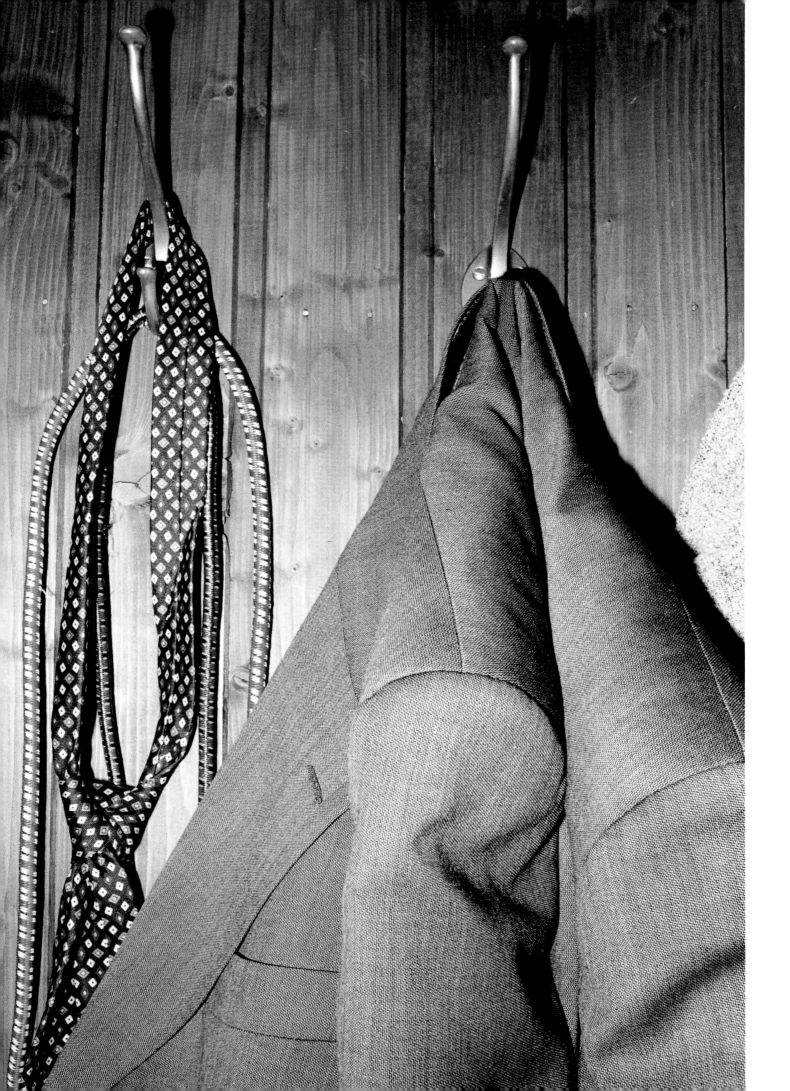

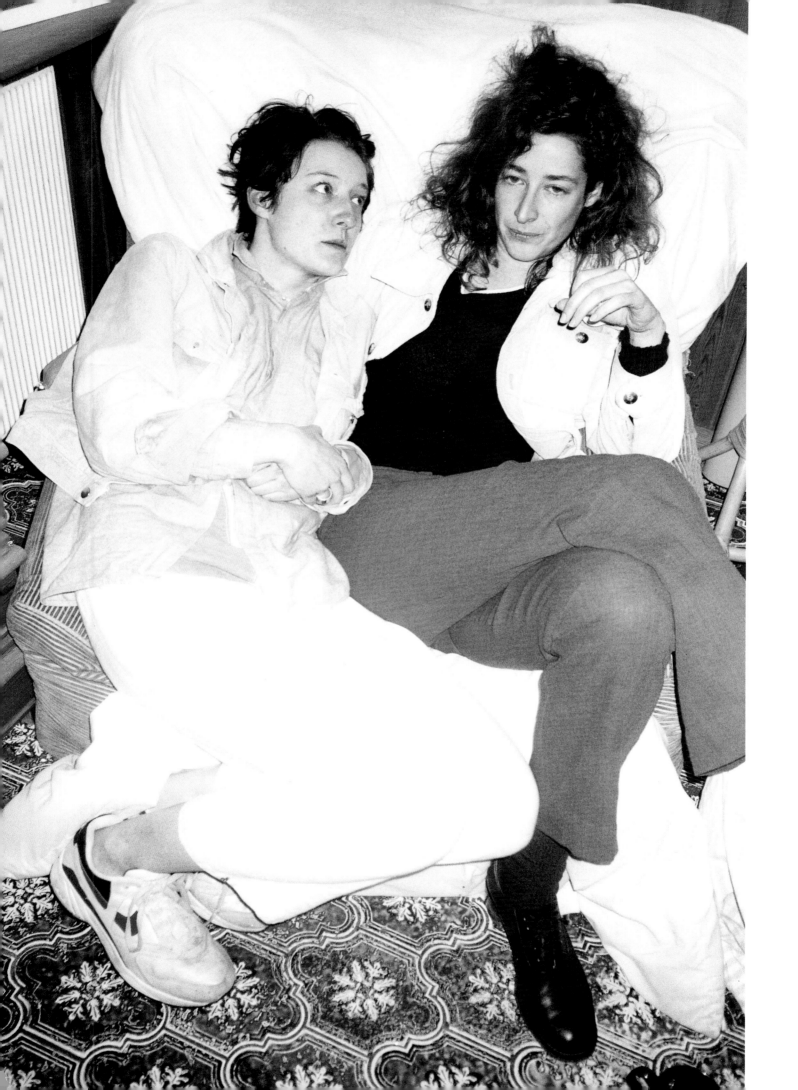

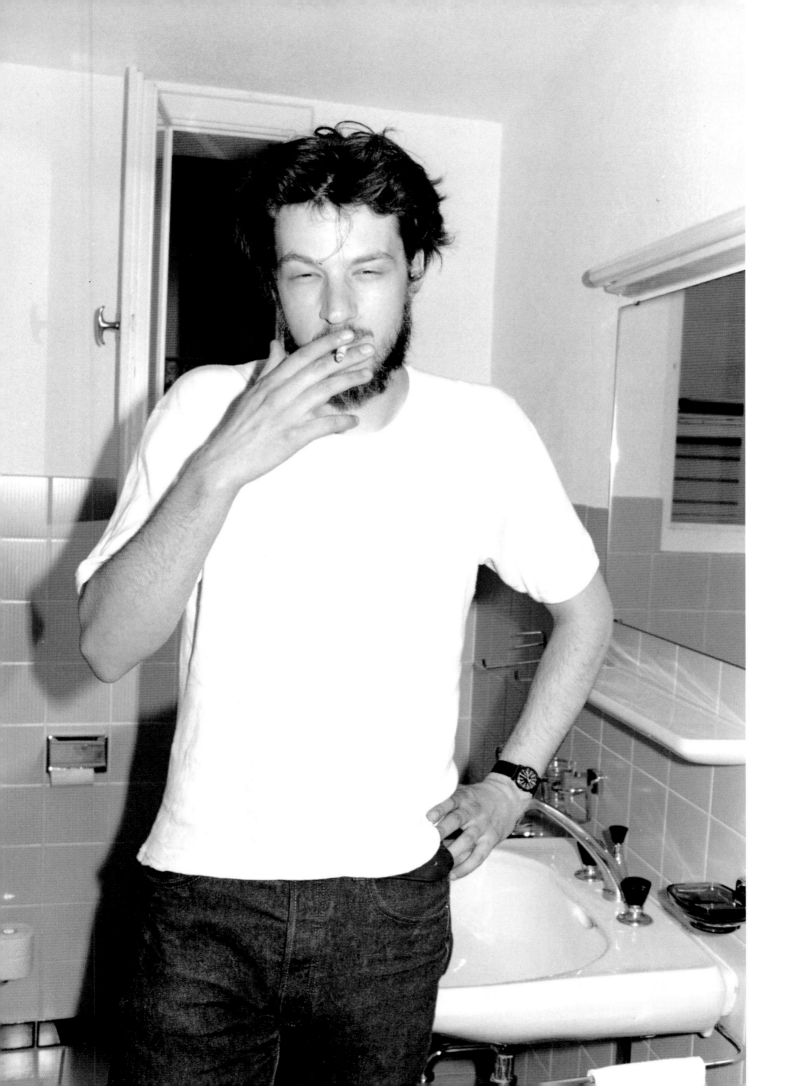

roman rahmacher

To get around the superficial banality of today's travel photography, photographic notes practically offer themselves as an alternative form of expression. In a positive sense, we are dealing with snapshot photography, in which it is acceptable that there are breaks and disturbances in its periphery. Perhaps this is the only way to get a little closer once again to an authenticity that has become largely diffused, and to operate beyond pigeonholed concepts, rounded perspectives or an aesthetic that is molded by the spirit of the times. Through this direct, in a sense reproducible photographic language an immediate connection is created between the observer and the subject. Enriched with fascination and an obvious respect for the unfamiliar, pictures are created that can be studied, whose manifold details with their curious discontinuities may reflect more truth than the centered linear perspectives of today's magazine photography.

Um den vordergründigen Abziehbildern heutiger Reisephotographie zu entgehen, bietet sich die photographische Notiz als alternative Sprachform geradezu an. In einem positiven Sinne handelt es sich hier um Snapshotphotographie, bei der man akzeptiert, daß an ihren Rändern Brüche und Störungen existieren. Vielleicht gelingt es nur so, noch einmal der weitgehend diffus gewordenen Authentizität wieder ein kleines Stück näher zu rücken und jenseits von rasterartigen Konzepten, gezirkelten Perspektiven oder einer vom Zeitgeist geprägten Ästhetik zu agieren. Durch diese direkte, in gewissem Sinne nachvollziehbare photographische Sprache entsteht ein unmittelbarer Draht zwischen Betrachter und Motiv. Angereichert mit Faszination und dem sichtbaren Respekt vor der Fremde entwickeln sich studierbare Bilder, in deren vielfältigen, mit seltsamen Brüchen ausstaffierten Details sich möglicherweise mehr Wahrheit spiegelt als in der zentrierten, linearen Perspektive heutiger Magazinphotographie.

Si l'on veut échapper aux décalcomanies qui envahissent aujourd'hui le devant de la scène de la photographie de voyage, la notice photographique se présente alors tout simplement comme un langage alternatif. Prise dans un sens positif, il s'agit ici d'une photographie instantanée dans laquelle on accepte la présence de fractures et de perturbations sur les bords. C'est peut-être la seule façon de parvenir à approcher d'un peu plus près, voire de retrouver cette authenticité dont on ne sait plus très bien ce qu'elle veut dire, et d'agir dans une direction qui va au-delà des concepts formatés, des perspectives parfaitement mesurées et d'une esthétique entièrement marquée par l'esprit de son temps. Un fil se tisse à partir de ce langage photographique direct et accessible, qui relie de façon immédiate le spectateur et le sujet. Enrichies par la fascination et le respect visible de l'étranger, des images se développent dont il se peut que la multiplicité des détails et le fait qu'ils soient affublés de rares brisures reflètent davantage de vérité que la perspective centrée et linéaire des photographies des magazines actuels.

Roman Rahmacher was born in Paderborn in 1960; 1984–1991 studied visual communication in the course of studies Photo/Film Design at the Bielefeld Technical College; 1991 dissertation, a photographic report of the Middle East; 1992 began working on freelance projects and assignments; exhibitions and publications (a selection): prize for young photojournalism, sponsored by Agfa and Bilderberg, Leverkusen; Phototage Herten; Photogalerie der Brotfabrik, Berlin; "Salon de Futura – De Fabriek", Rotterdam, and many others; publications in various print media, among them Die Zeit, Stern, Wendy, Wochenpost. Roman Rahmacher lives in Hamburg.

Roman Rahmacher, 1960 geboren in Paderborn; 1984–1991 Studium der Visuellen Kommunikation im Studiengang Photo/Film-Design, Fachhochschule Bielefeld; 1991 Diplomarbeit, Photoreportage aus dem Nahen Osten; seit 1992 Realisation von freien Projekten und Auftragsarbeiten; Ausstellungen und Publikationen (Auswahl): Preis für jungen Bildjournalismus, Agfa/Bilderberg, Leverkusen; Phototage Herten; Photogalerie in der Brotfabrik, Berlin; „Salon de Futura – De Fabriek" Rotterdam u.v.a.; Publikationen in diversen Printmedien (u.a. Die Zeit, Stern, Wendy, Wochenpost). Roman Rahmacher lebt in Hamburg.

Roman Rahmacher, né en 1960 à Paderborn; 1984–1991 études de communication visuelle dans le cursus Design Photo/Cinéma, Institut Universitaire de Technologie de Bielefeld; 1991 travail de fin d'études, reportage photo sur le Proche-Orient; depuis 1992 réalisation de projets individuels et de travaux de commande; choix d'expositions et de publications: prix du jeune photojournalisme, Agfa/Bilderberg, Leverkusen; Journées de la photographie de Herten; Photogalerie in der Brotfabrik, Berlin; «Salon de Futura – De Fabriek», Rotterdam, etc.; publications dans divers organes de presse (Die Zeit, Stern, Wendy, Wochenpost, etc.). Roman Rahmacher vit à Hambourg.

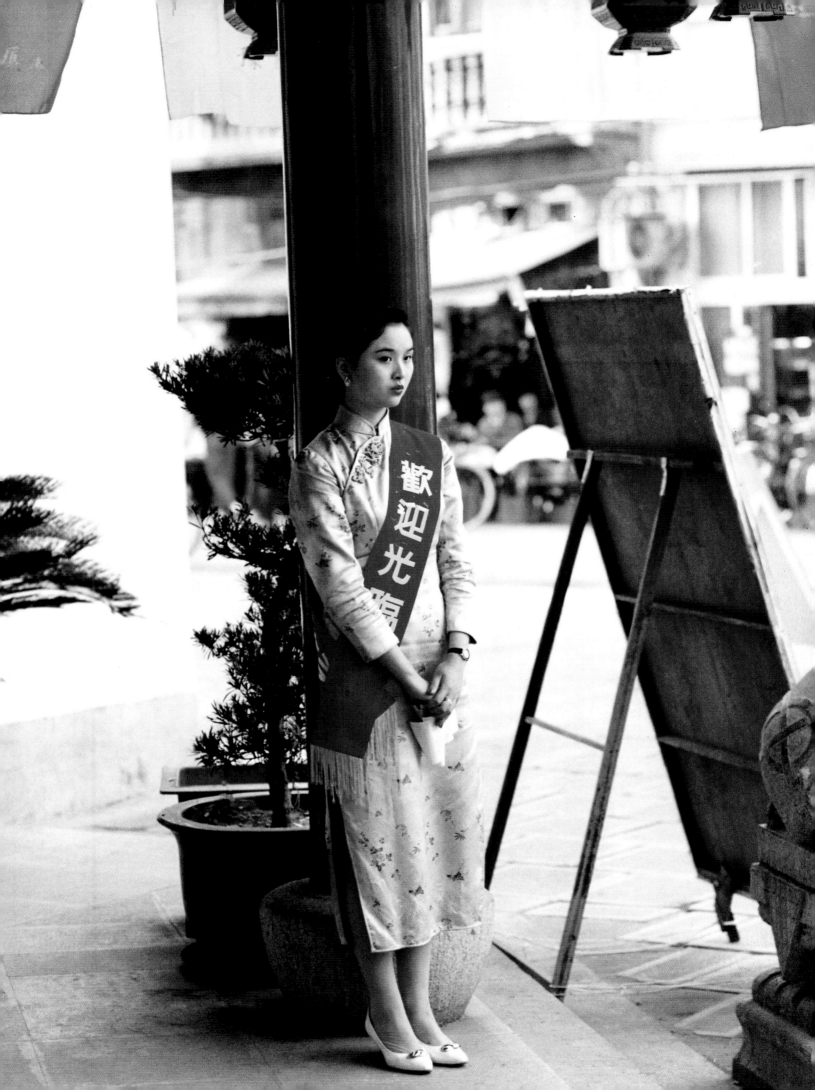

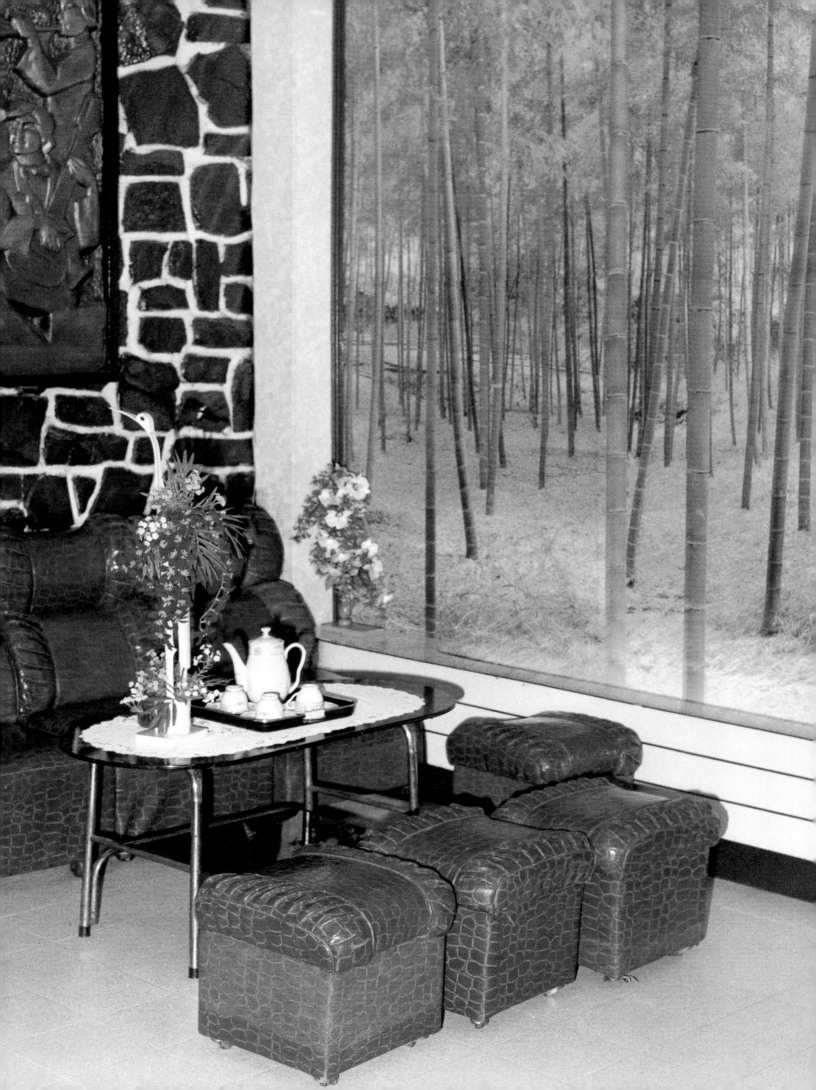

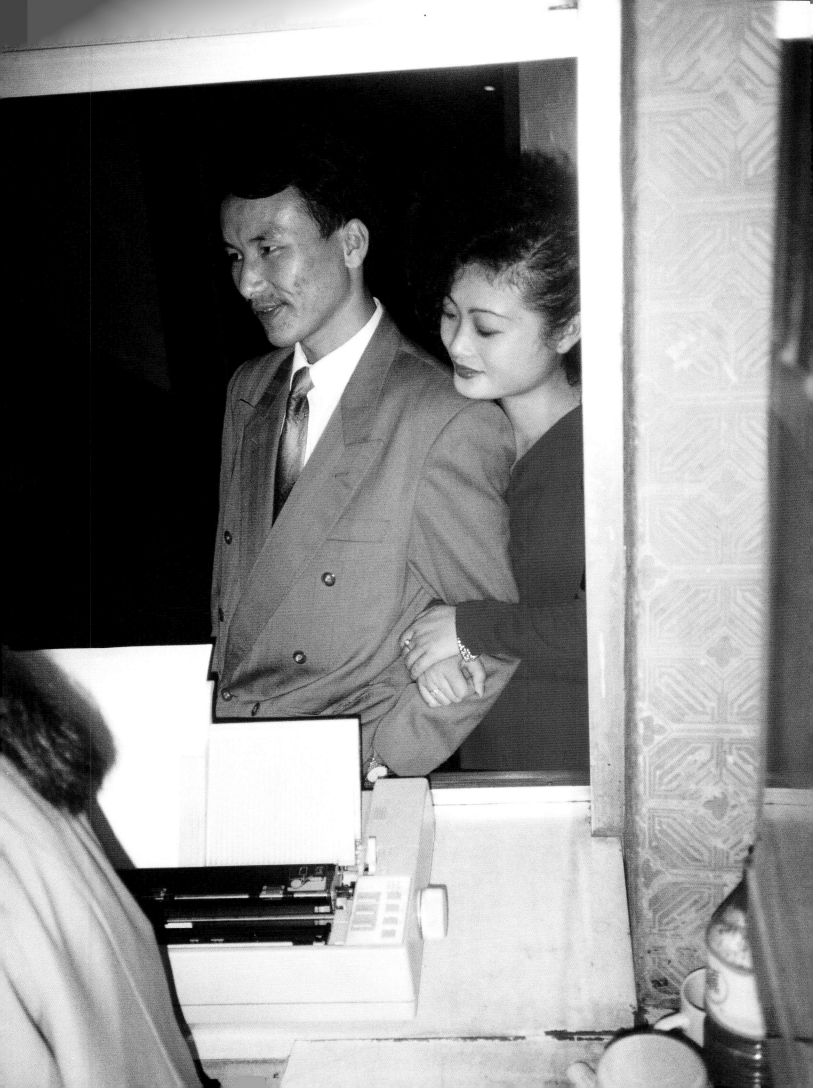

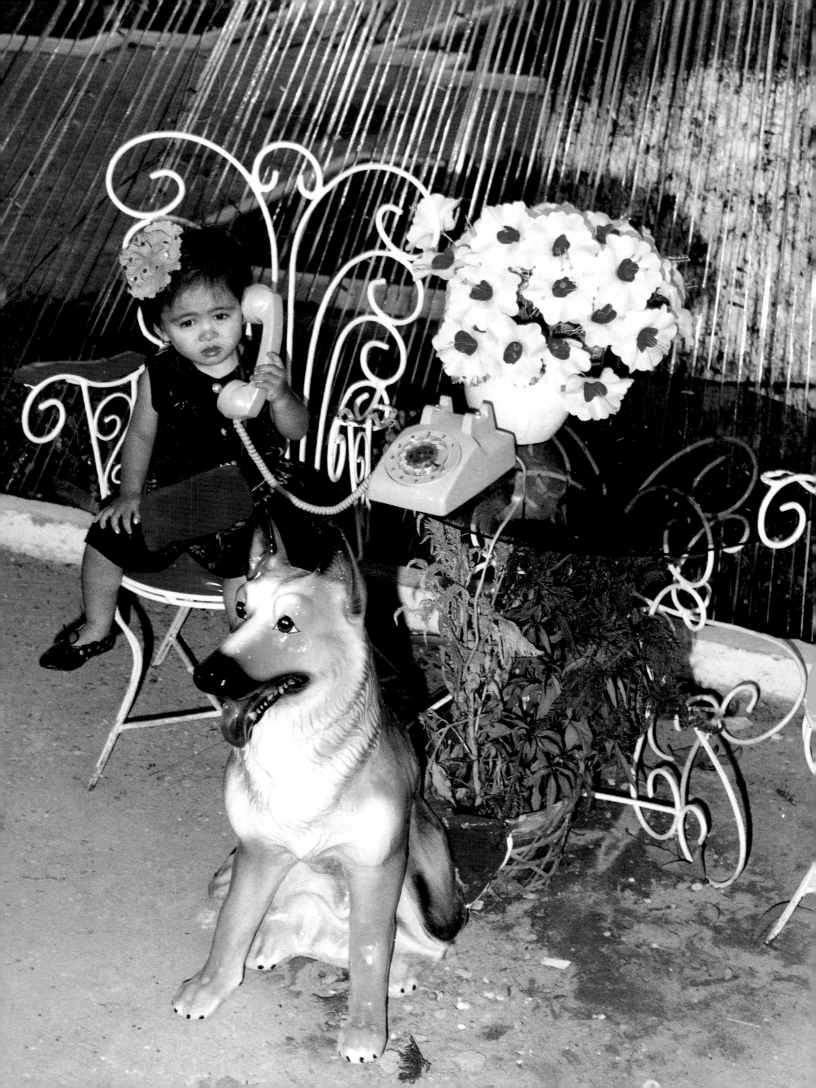

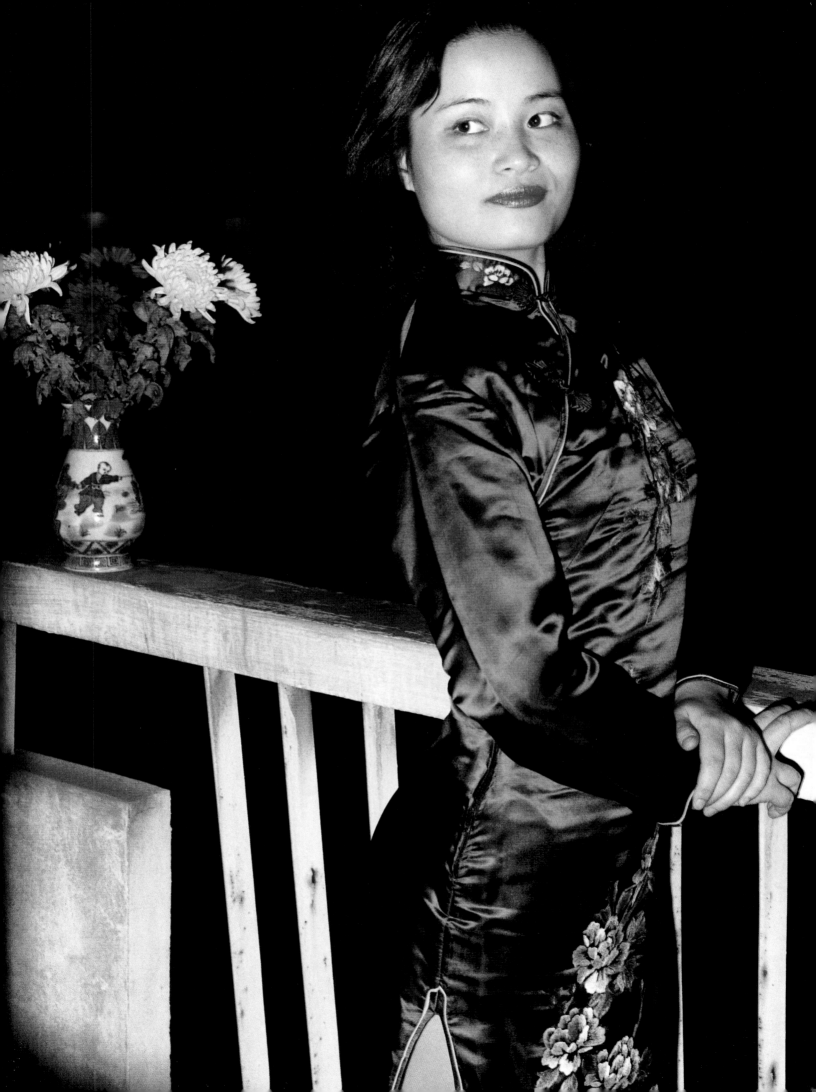

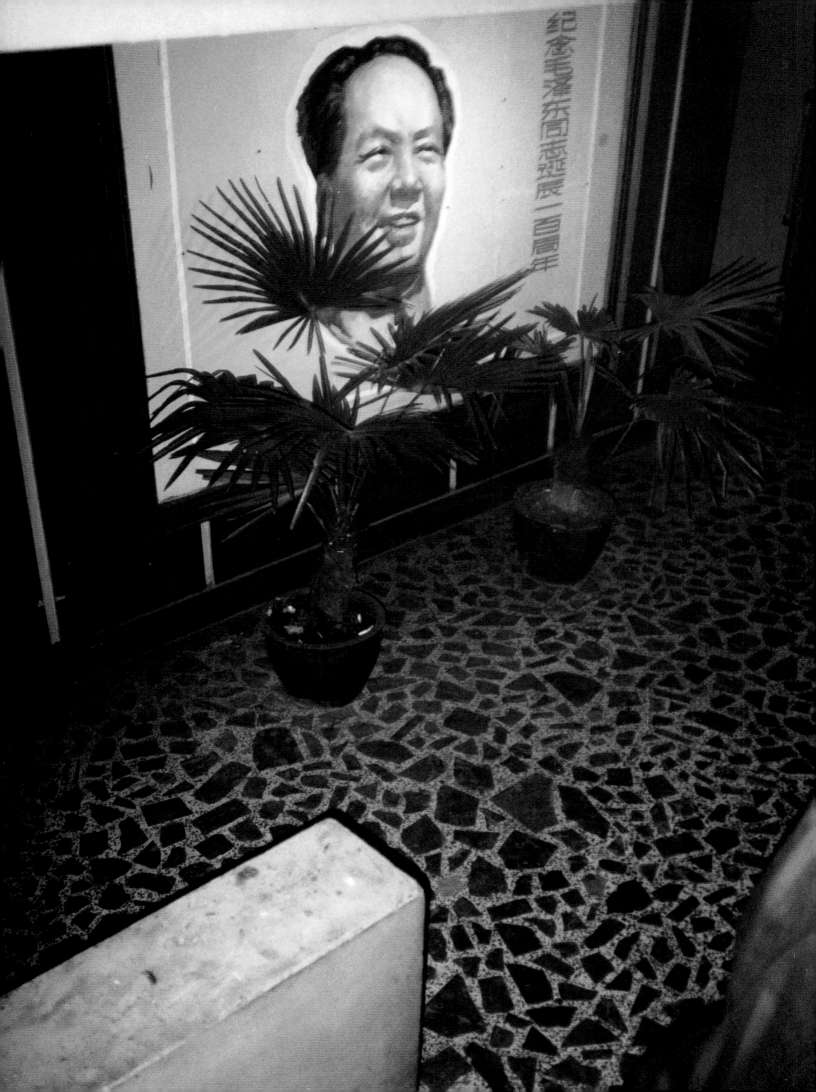

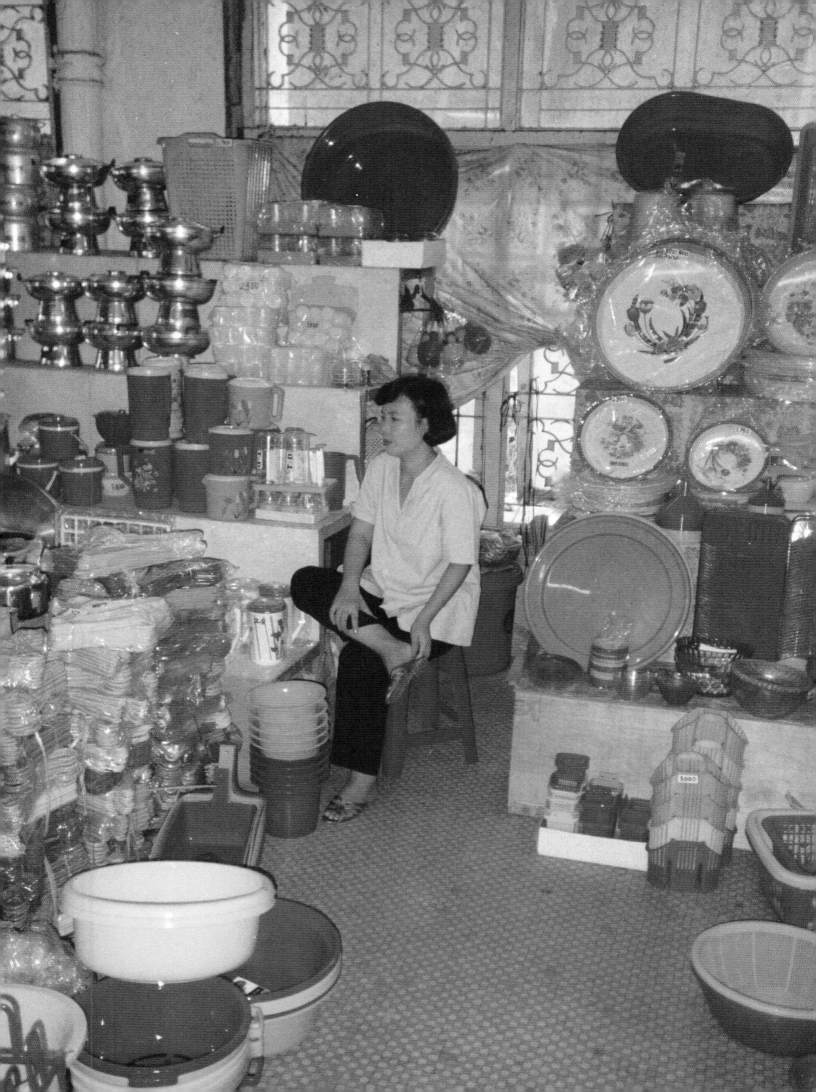

eva leitolf *German pictures – searching for evidence in Rostock, Thale, Solingen and Bielefeld*

From the 22nd to the 24th of August 1992, youths and neighbors in Rostock-Lichtenhagen threatened the central reception office for asylum seekers and the adjoining Vietnamese hostel without being hindered, setting the building on fire. The inhabitants survived because at the last moment they were able to break open a skylight. The police did not intervene for several hours, instead they deliberately withdrew. In Thale, a small town in the Harz region, on the 17th of October 1992 youths (among them two girls, 13 and 14 years old) attacked a Vietnamese hostel while some of them were invited there for dinner. In Solingen, on the 29th of May 1993 five Turkish girls lost their lives as a result of an arson attack on the house occupied by the Genç family. On the 20th of May 1994, youths tossed a Molotov cocktail into the home of Turkish workers, destroying an entire floor.

Illustrations: 1. Living room after the arson attack in Bielefeld-Senne in 1994; 2. Living room in Solingen in 1994; 3. Solingen in 1994; 4. On the day after the arson attack in Bielefeld-Senne, 1994; 5. Neighborhood in Bielefeld-Senne, 1994; 6. Writing desk, Solingen, 1994; 7. During the demonstration on the occasion of the anniversary of the arson attack, Solingen 1994; 8. Youth club in Thale, 1992; 9. Former location of the home of the Genç family on the anniversary of the arson attack in Solingen, 1994

Deutsche Bilder – eine Spurensuche in Rostock, Thale, Solingen und Bielefeld **Vom 22. bis 24. August 1992 bedrohten in Rostock-Lichtenhagen Jugendliche und Anwohner ungehindert die zentrale Aufnahmestelle für Asylsuchende und das angrenzende Vietnamesen-Wohnheim, das sie teilweise in Brand steckten. Die Bewohner überlebten, weil sie in letzter Minute eine Dachluke aufbrechen konnten. Mehrere Stunden lang hatte die Polizei nicht interveniert, sondern sich vielmehr ausdrücklich zurückgezogen. In Thale, einer Kleinstadt im Harz, überfielen Jugendliche (darunter ein 13- und ein 14-jähriges Mädchen) am 17. Oktober 1992 ein Vietnamesen-Wohnheim, während einige von ihnen dort zum Essen eingeladen waren. In Solingen kamen bei einem Brandanschlag auf das von der Familie Genç bewohnte Haus am 29. Mai 1993 fünf türkische Mädchen ums Leben. Am 20. Mai 1994 wurde in Bielefeld-Senne von Jugendlichen ein Molotowcocktail in ein Haus türkischer Arbeiter geworfen, der eine gesamte Etage zerstörte.**

Abbildungen: 1. Wohnraum nach Brandanschlag, Bielefeld-Senne, 1994; 2. Wohnzimmer, Solingen, 1994; 3. Solingen, 1994; 4. Am Tag nach dem Brandanschlag, Bielefeld-Senne, 1994; 5. Nachbarschaft, Bielefeld-Senne, 1994; 6. Schreibtisch, Solingen, 1994; 7. Während der Demonstration zum Jahrestag des Brandanschlags, Solingen 1994; 8. Jugendclub, Thale, 1992; 9. Ehemaliger Standort des Hauses der Familie Genç am Jahrestag des Brandanschlags in Solingen, 1994

Images d'Allemagne – sur les traces des événements de Rostock, Thale, Solingen et Bielefeld Du 22 au 24.8.1992, des adolescents et des riverains ont menacé sans être le moins du monde inquiétés, la centrale d'accueil des demandeurs d'asile de Rostock-Lichtenhagen, ainsi que le foyer viêtnamien voisin, auquel ils mirent en partie le feu. Les habitants n'ont survécu que parce qu'ils ont pu briser une lucarne à la dernière minute. Plusieurs heures ont passé sans que la police intervienne. Plus grave, celle-ci s'était expressément retirée. A Thale, une petite ville du Harz, des adolescents (parmi eux une fille de 13 ans et une autre de 14) ont attaqué le 17.10.92 un foyer de Viêtnamiens, alors que certains d'entre eux y avaient été invités à manger. A Solingen, cinq jeunes filles turques ont trouvé la mort, le 29.5.93, lors d'un incendie criminel dont la maison de la famille Genç fut l'objet. A Bielefeld-Senne, un cocktail Molotov fut jeté par des adolescents dans une maison d'ouvriers turcs le 20.5.94, et un étage entier fut détruit.

Illustrations: 1. Salle de séjour après l'incendie, Bielefeld-Senne, 1994; 2. Salle de séjour, Solingen, 1994; 3. Solingen, 1994; 4. Le lendemain de l'incendie, Bielefeld-Senne, 1994; 5. Voisinage, Bielefeld-Senne, 1994; 6. Bureau, Solingen, 1994; 7. Pendant la manifestation organisée le jour anniversaire de l'incendie, Solingen, 1994; 8. Club d'adolescents, Thale, 1992; 9. Ancien emplacement de la maison de la famille Genç le jour anniversaire de l'incendie de Solingen, 1994

va Leitolf was born in Würzburg in 1966; 1985–1986 studied philosophy at the Ludwig-Maximilian University in Munich; 1986–1994 studied communication design majoring in photojournalism under Professor Angela Neuke at the Essen Polytechnic University, graduating with distinction; 1995 began art studies at the California Institute of the Arts; 1990 began publishing in Süddeutsche Zeitung Magazine, Zeit magazine, Telegraph magazine, The New Yorker, and others; awards and grants: 1990 Kodak Blitz prize for up-and-coming young photographers; 1992 Kodak European Panorama Award for Young Professional Photography; 1993 Emma+ Agfa prize for woman photojournalists; 1994 induction into membership in the German Society for Photography; Scholarship of the Mathias-schorr Foundation for the creative arts; 1995 annual scholarship of the DAAD for the California Institute of Arts in the USA; invitation to the World Press Photo Joop Swart Masterclass in Amsterdam; promotion within the framework of the Visum youth program; induction into the Visum Archive in Hamburg; Kodak youth promotion prize for 1995; German photographic promotion prize 1995, Stuttgart; 1996 International Center for Photography Annual Infinity Award for Young Photographers, New York; Cal Arts Merit Scholarship, Valencia, CA, USA; group exhibitions: 1991 *Personas expuestas* (exposed persons), Goethe Institute, Caracas, Venezuela; 1993 Bilderberg and Agfa Prize for young photojournalism, Leverkusen and Herten; 1994 *Heimatkunde* (Local History), Internationale Photoszene Köln, Cologne; 3. Internationale Phototage Herten (Third International Photo Days in Herten); 1996 *Das Deutsche Auge* (The German Eye), Hamburg; Deutscher Photopreis 1995 (German Photographic Prize for 1995) exhibitions in the Fotografie Forum in Frankfurt and at the Rencontres Internationales de la Fotografie in Arles, France, and at photokina, Cologne *Nachkriegszeit* (Postwar period), Visum, Hamburg; Heisse Brühe (Hot Brew), Kunstverein Halle, Kunstver-in Aschaffenburg, Gotha Museum Gallery, Bad Herfeld, Kaufbeuren; solo exhibitions: 1995 *Deutsche Bilder* (German Pictures), Munich; 1996 Taking Stock, Cal Arts, Valencia, CA (USA). Eva Leitolf lives in Munich.

va Leitolf, 1966 geboren in Würzburg; 1985–1986 Philosophiestudium an der Ludwig-Maximilian Universität, München; 1986–1994 Studium Kommunikationsdesign an der Universität Gesamthochschule Essen mit Schwerpunkt Bildjournalistik bei Prof. Angela Neuke, Abschluß mit Auszeichnung; seit 1995 Kunststudium, California Institute of the Arts; seit 1990 Publikationen in Süddeutsche Zeitung Magazin, Zeit Magazin, Telegraph Magazine, The New Yorker, u.a.; Preise, Stipendien und Auszeichnungen: 1990 Kodak Blitz Nachwuchsförderpreis; 1992 Kodak European Panorama Award of Young Professional Photography; 1993 Emma+Agfa Preis für Photojournalistinnen; 1994 Berufung zum Mitglied der Deutschen Gesellschaft für Photographie; Stipendium der Mathias-Pschorr-Stiftung für bildende Kunst; 1995 DAAD-Jahresstipendium, California Institute of the Arts, USA; Einladung zur World Press Photo Joop Swart Masterclass, Amsterdam; Förderung im Rahmen des Visum Nachwuchsprogramms, Aufnahme in das Visum Archiv Hamburg; Kodak Nachwuchsförderpreis '95; Deutscher Photo-Förderpreis 1995, Stuttgart; 1996 ICP Annual Infinity Award 1996, „Young Photographer" (International Center of Photography, New York); Cal Arts Merit Fellowship; Gruppenausstellungen: 1991 *Personas expuestas*, Goethe-Institut, Caracas/Venezuela; 1993 Bilderberg und Agfa Preis für jungen Bildjournalismus, Leverkusen und Herten; 1994 *Heimatkunde*, Internationale Photoszene Köln 1994, Köln; 3. Internationale Phototage Herten; 1996 *Das Deutsche Auge*, Hamburg; Deutscher Photopreis 1995, Photographie Forum Frankfurt; Rencontres Internationales de la Photographie, Arles/Frankreich, photokina, Köln; *Nachkriegszeit*, Visum, Hamburg; *Heiße Brühe*, Hallescher Kunstverein, Kunstverein Aschaffenburg, Gothaer Museumsgalerie, Bad Hersfeld, Kaufbeuren; Einzelausstellungen: 1995 *Deutsche Bilder*, München; 1996 *Taking stock*, Cal Arts, Valencia/USA. Eva Leitolf lebt in München.

va Leitolf, née en 1966 à Würzburg; 1985–1986 études de philosophie à l'Université Ludwig-Maximilian de Munich; 1986–1994 études de design et de comucication, spécialisation photojournalisme, auprès du professeur Angela Neuke, diplôme avec mention, Universität Gesamthochschule de Essen; depuis 1995, études d'art, California Institute of the Arts; depuis 1990, publications dans le Süddeutsche Zeitung Magazin, Zeit Magazin, Telegraph Magazine, The New Yorker etc.; prix, bourses et récompenses: 1990 Kodak Blitz, prix d'encouragement aux jeunes photographes; 1992 Kodak European Panorama Award of Young Professional Photography; 1993 Emma+Agfa, prix décerné à des femmes photojournalistes; 1994 nommée membre de la Société Allemande de Photographie; bourse de la fondation Mathias Pschorr pour les arts plastiques; 1995 bourse d'un an du DAAD, California Institute of the Arts, USA; invitation à participer au World Press Photo Joop Swart Masterclass, Amsterdam; encouragement dans le cadre du programme Visum pour les jeunes photographes; entrée aux archives Visum à Hambourg; prix Kodak d'encouragement aux jeunes photographes 95; prix allemand d'encouragement à la photographie, 1995, Stuttgart; 1996 ICP Annual Infinity Award 1996, «Young Photographer» (International Center of Photography, New York); Cal Arts Merit Fellowship; expositions collectives: 1991 *Personas expuestas*, Goethe-Institut, Caracas (Venezuela); 1993 Prix Bilderberg et Agfa du jeune photojournalisme, Leverkusen et Herten; 1994 *Heimatkunde* (Nouvelles du pays), Internationale Photoszene Köln 1994, Cologne; 3e Journées Internationales de la Photographie de Herten; 1996 *Das Deutsche Auge* (L'œil allemand), Hambourg; Deutscher Photopreis 1995, Forum de la Photographie, Francfort; Rencontres Internationales de la Photographie, Arles (France), photokina, Cologne; *Nachkriegszeit* (Après-guerre), Visum, Hambourg; *Heisse Brühe* (Bouillon chaud), Hallescher Kunstverein, Kunstverein Aschaffenburg, Gothaer Museumsgalerie, Bad Hersfeld, Kaufbeuren; expositions personnelles: 1995 *Deutsche Bilder* (Images d'Allemagne), Munich; 1996 *Taking stock*, Cal Arts, Valencia (USA). Eva Leitolf vit à Munich.

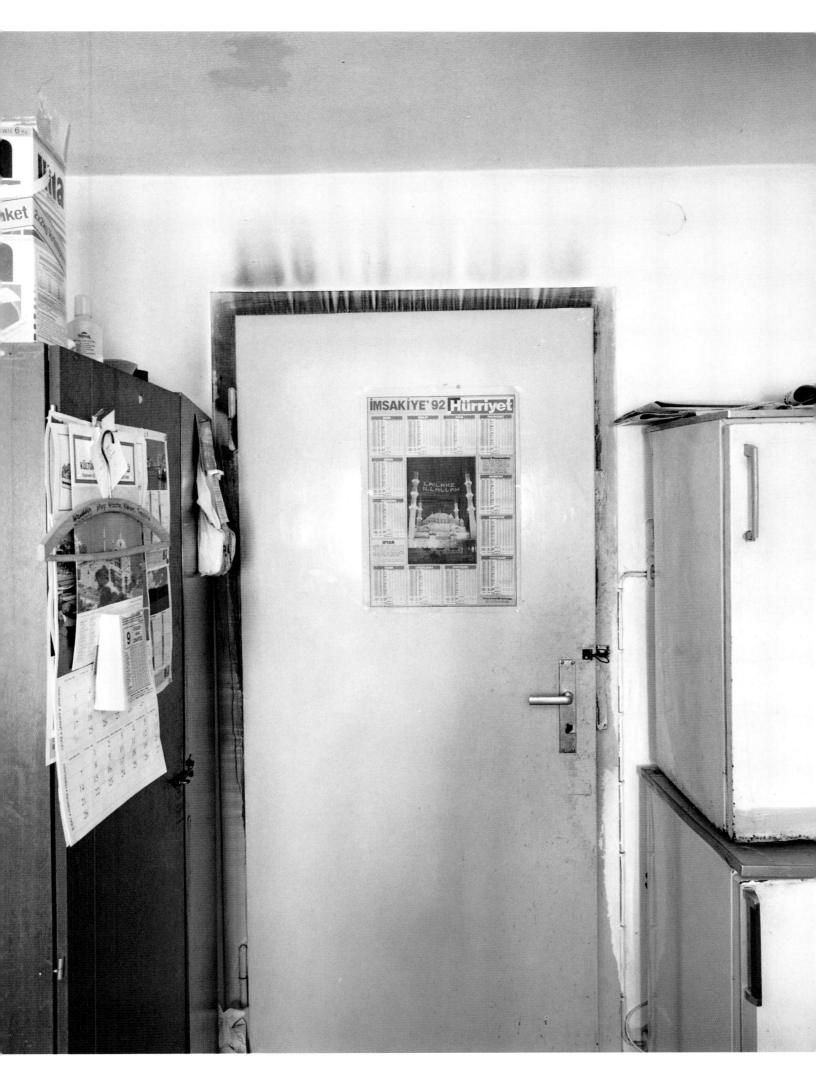

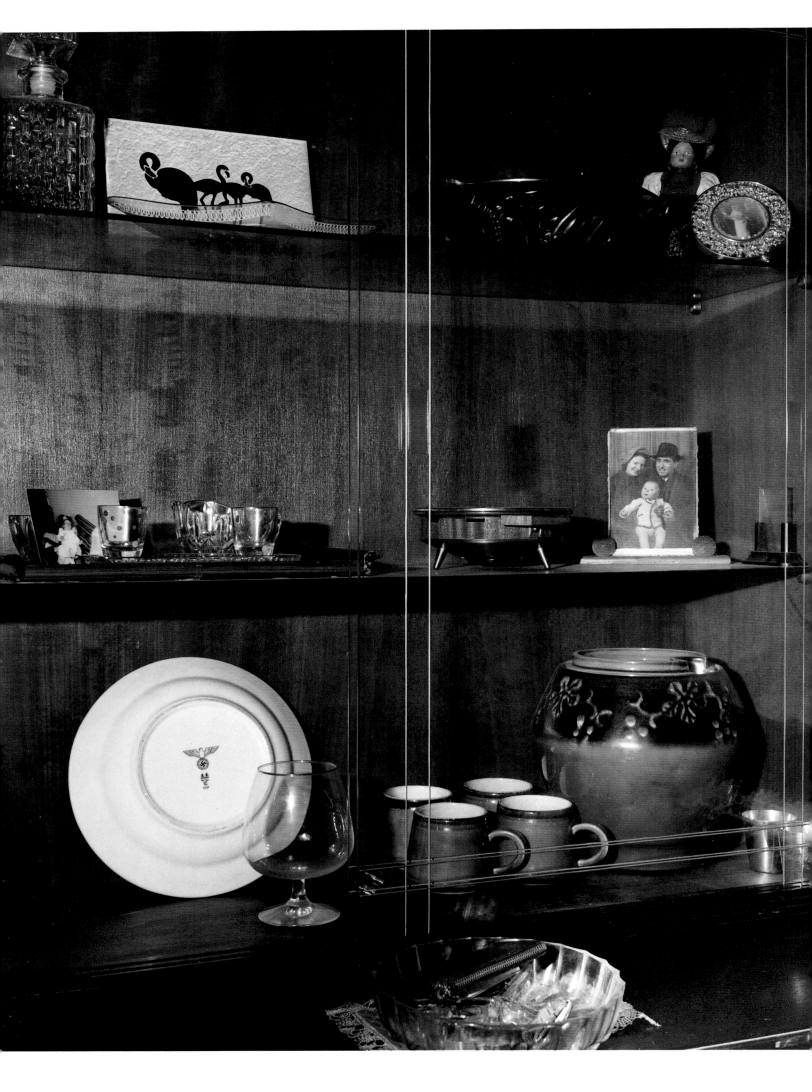

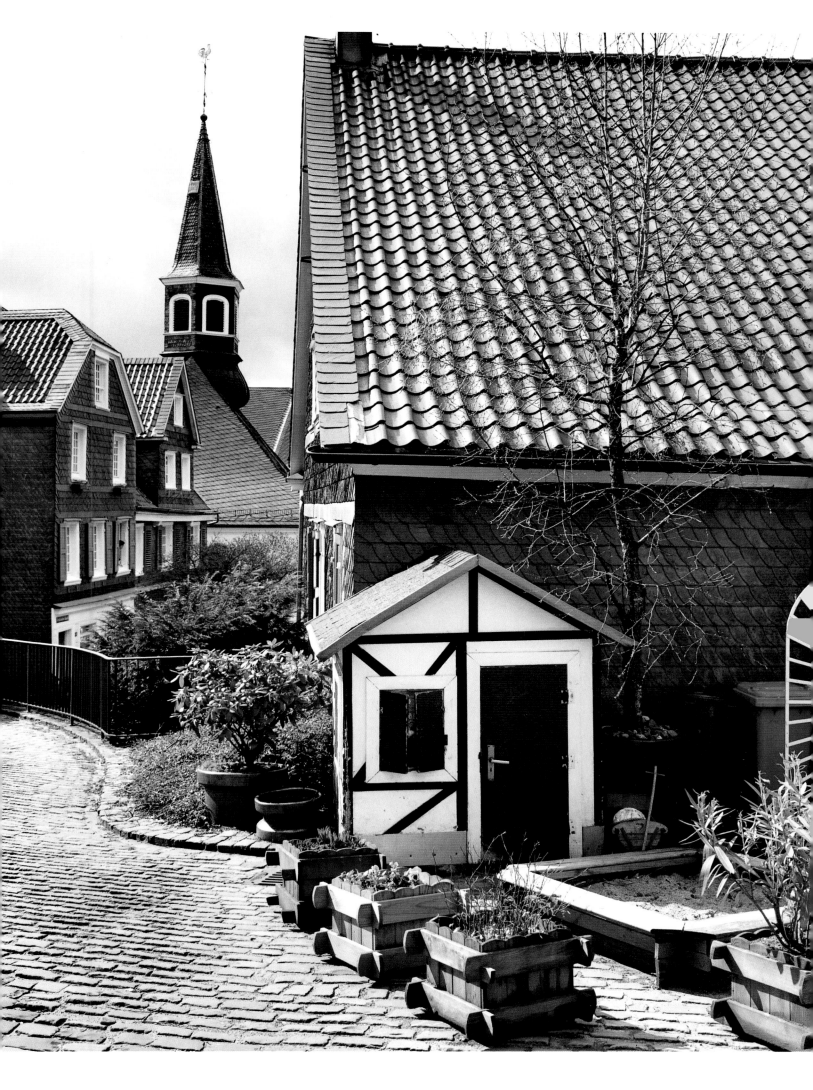

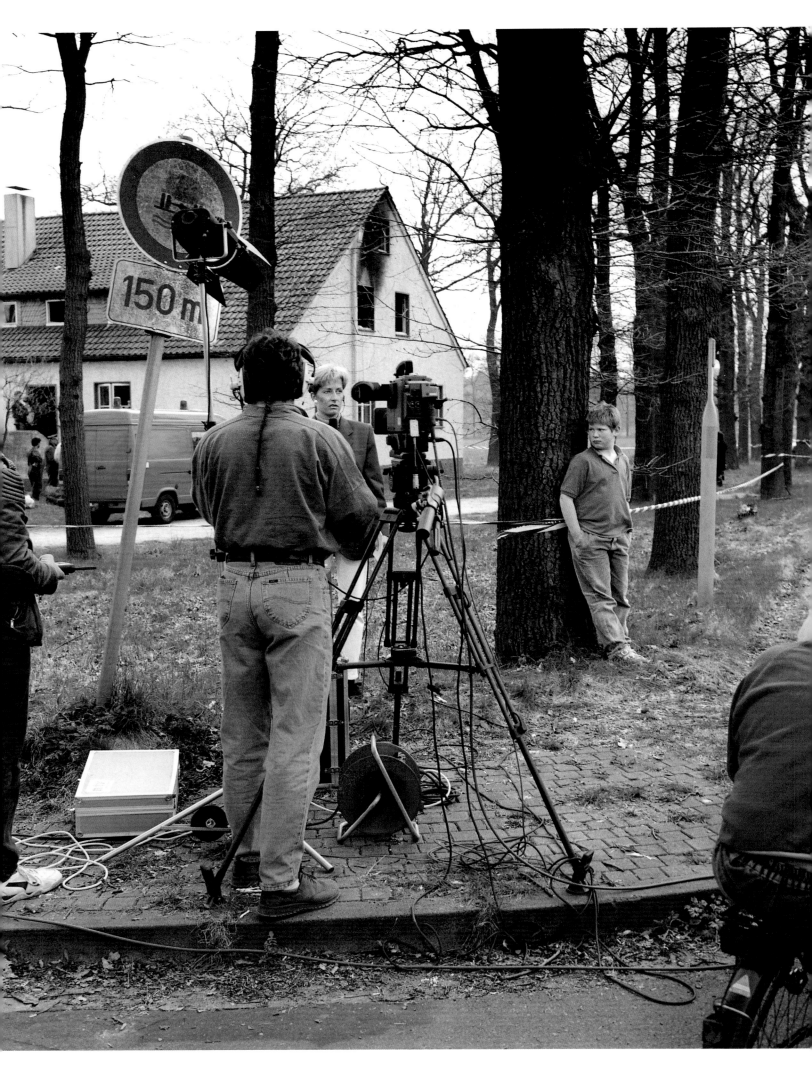

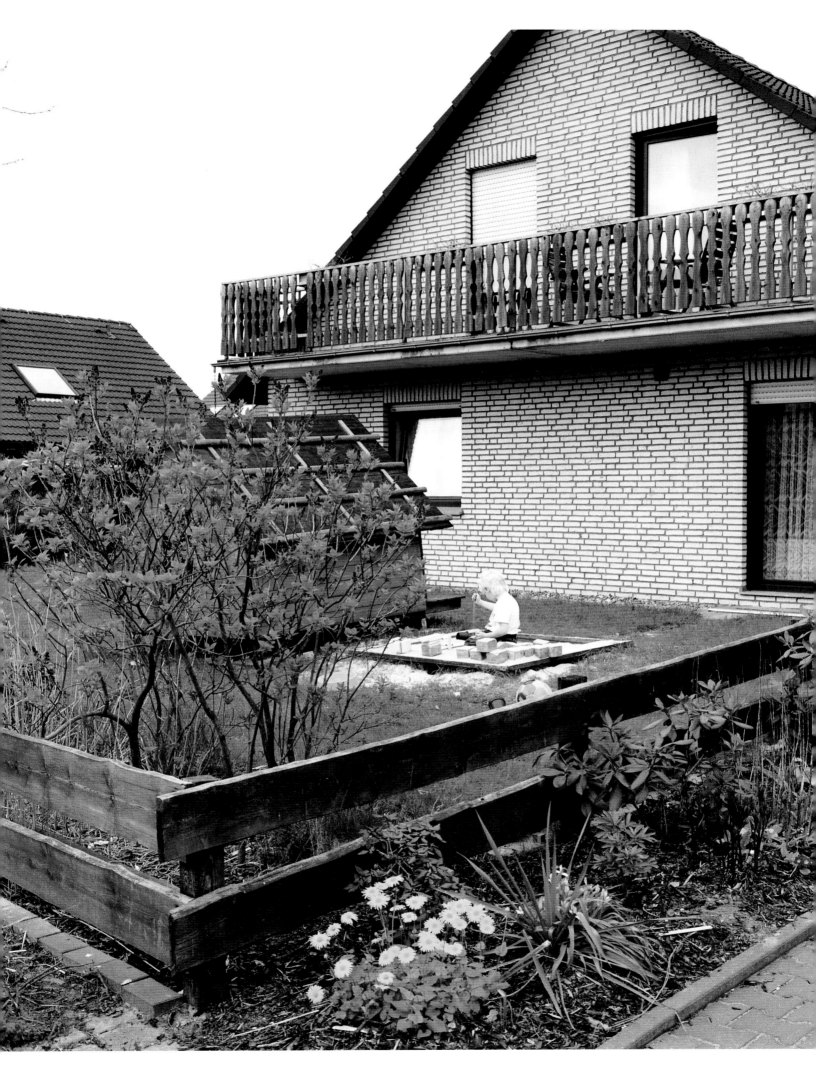

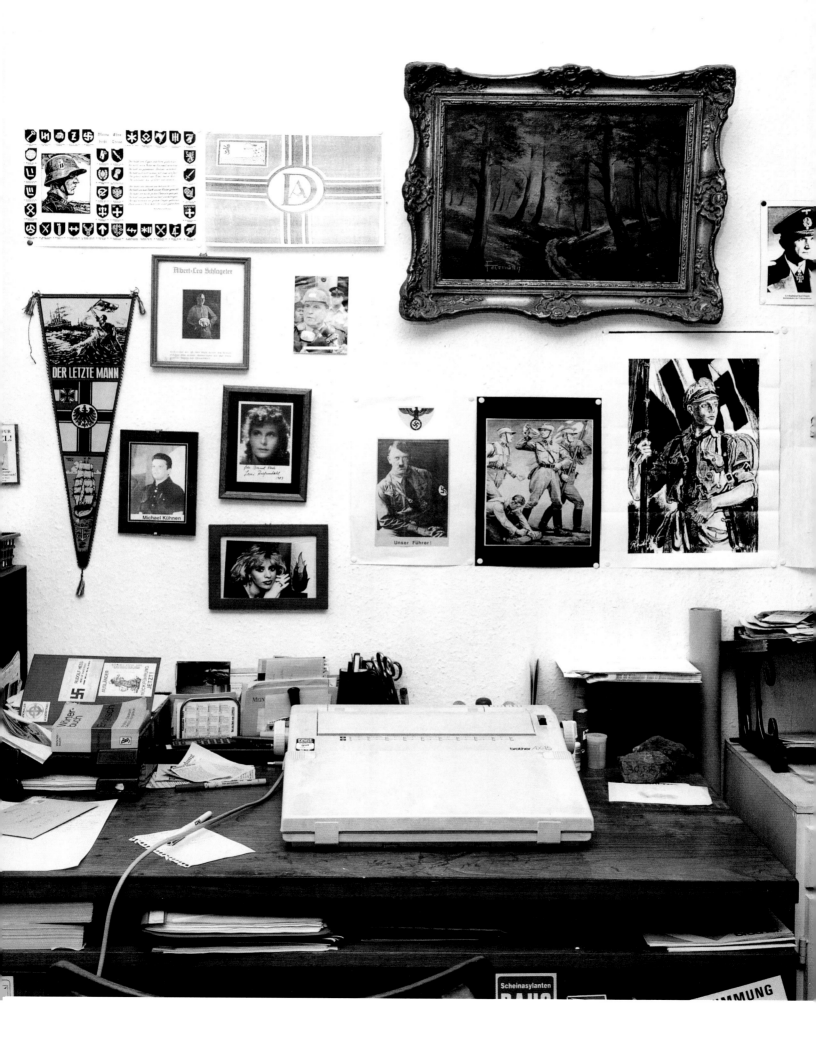

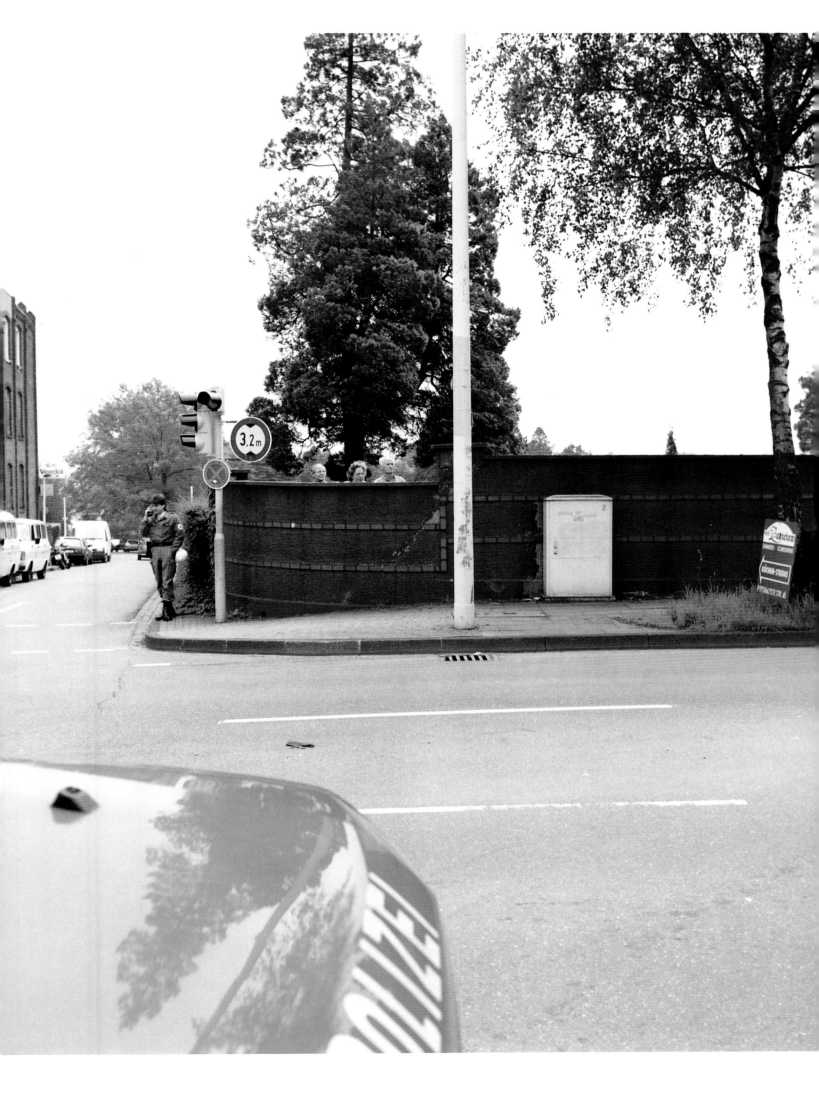

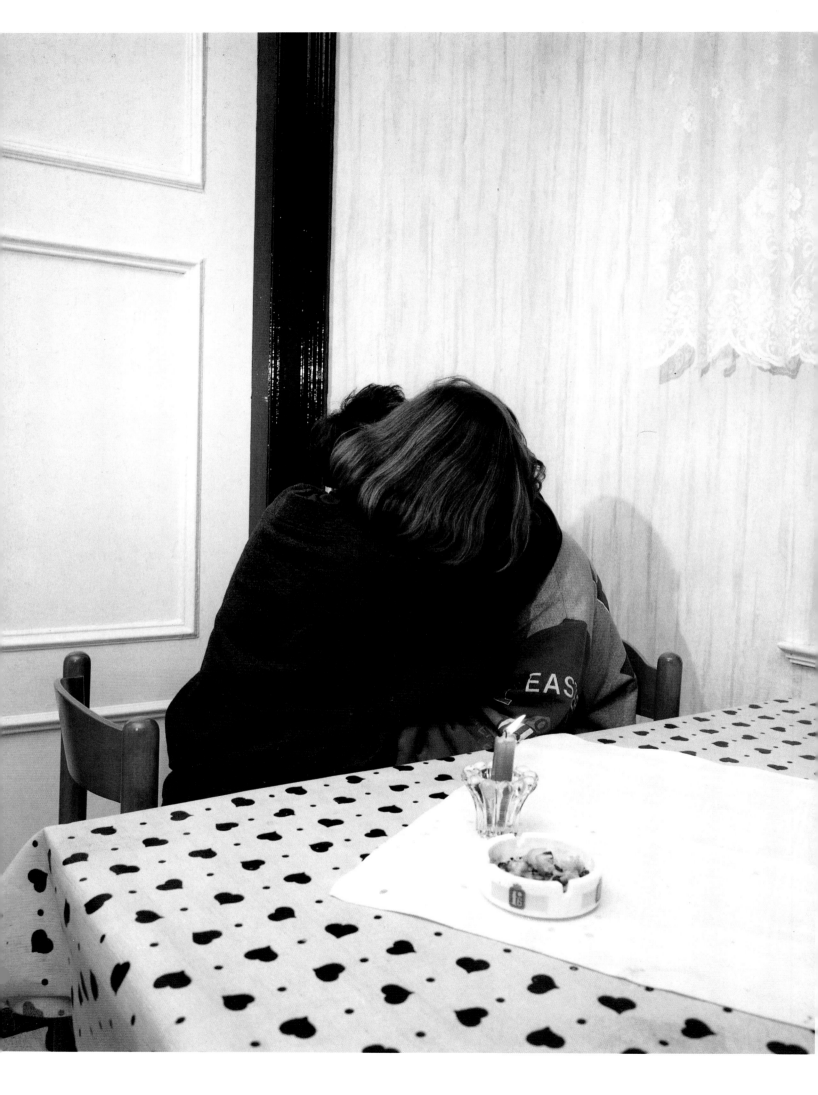

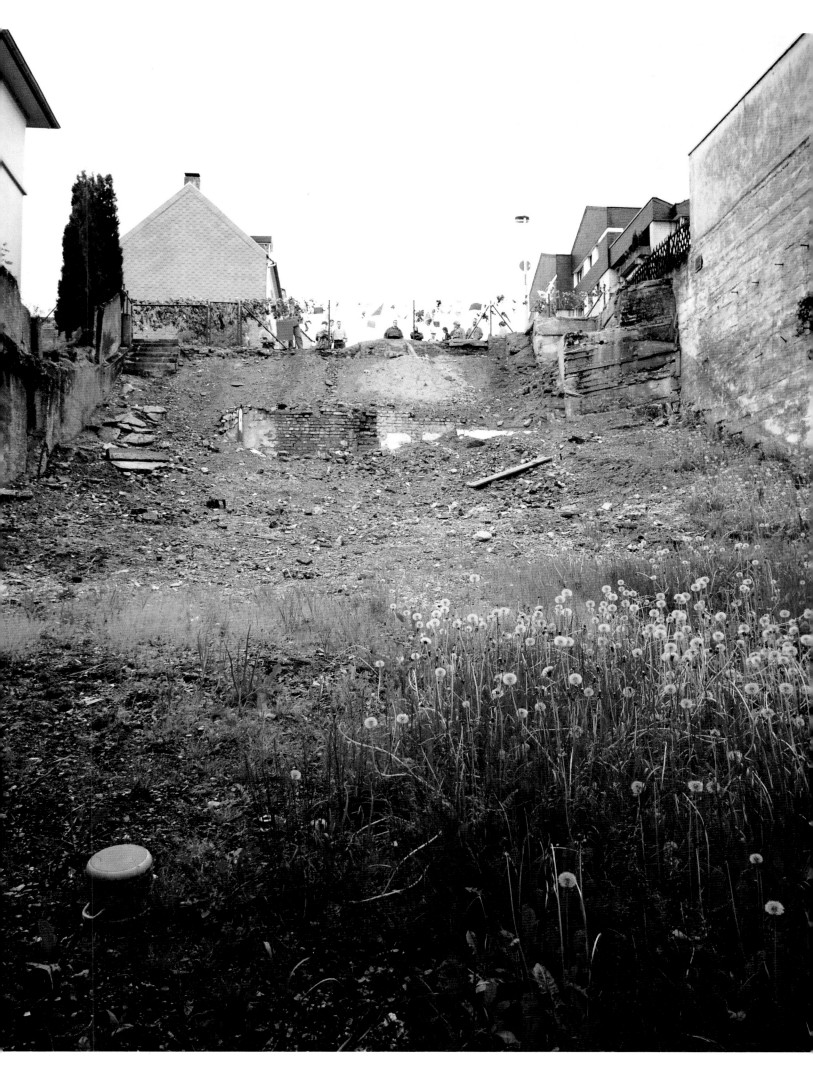

bert heinzlmeier

The subject is longing, people who are searching for something, travel, experience of the unfamiliar, scepticism about the familiar and real. Love and sex. Picture selection and groupings are guided by personal experiences. The aim is to describe a condition, to react to a complex world and media – created reality with an appropriate pictorial language. Everything is possible, and the individual picture no longer has any credibility. Relationships result from oppositeness, subjective information is generated from between the pictures.

Die Photos handeln von der Sehnsucht derer, die auf der Suche sind, vom Reisen, der Erfahrung des Fremden und der Skepsis gegenüber dem Vertrauten und Realen. Von Liebe und Sex. Die Bildauswahl und -kombinationen folgen persönlichen Erfahrungen. Es geht um Zustandsbeschreibungen und den Versuch, einer komplexen Welt und von Medien geschaffenen Realität eine adäquate Bildsprache entgegenzusetzen. Alles ist möglich, und dem Einzelbild wird kein Glaube mehr geschenkt. Zusammenhänge ergeben sich aus der Gegensätzlichkeit, die subjektive Information entsteht zwischen den Bildern.

Il est question ici de désir, du désir qui anime ceux qui sont en quête de quelque chose, question du voyage, de l'expérience de l'étranger, et de la méfiance envers le familier et le réel. Question d'amour et de sexe. Le choix des images et leur combinaison obéissent à des expériences personnelles. Il s'agit de décrire des états de choses et d'essayer d'opposer à la complexité d'un univers et d'une réalité créés par les médias, un langage photographique adéquat. Tout est possible, et l'image en soi, l'image individuelle n'a plus aucune crédibilité. De la confrontation naît un contexte, et c'est de l'espace entre les images que surgit l'information subjective.

Bert Heinzlmeier was born in Munich in 1968; after graduating from high school and community service, practical training in a photographic studio; 1990–1993 studied at the State College of Photodesign in Munich; 1993 began participating in exhibitions; 1994 began working as a freelance photographer for magazines; living in Asia since June 1996. Bert Heinzlmeier currently lives in Bangkok.

Bert Heinzlmeier, 1968 geboren in München; nach Abitur und Zivildienst erstes Praktikum in einem Photostudio; 1990–1993 Studium an der Staatlichen Fachakademie für Photodesign, München; seit 1993 Ausstellungsbeteiligungen; seit 1994 als freiberuflicher Photograph für Magazine tätig; seit Juni 1996 in Asien. Bert Heinzlmeier lebt zur Zeit in Bangkok.

Bert Heinzlmeier, né en 1968 à Munich; après le baccalauréat et le service civil, premier stage dans un studio photo; 1990–1993 études à l'Académie d'Etat de Photodesign de Munich; depuis 1993, participe à des expositions; depuis 1994, travaille en photographe freelance pour des magazines. Bert Heinzlmeier vit depuis juin 1996 en Asie et habite pour l'instant à Bangkok.

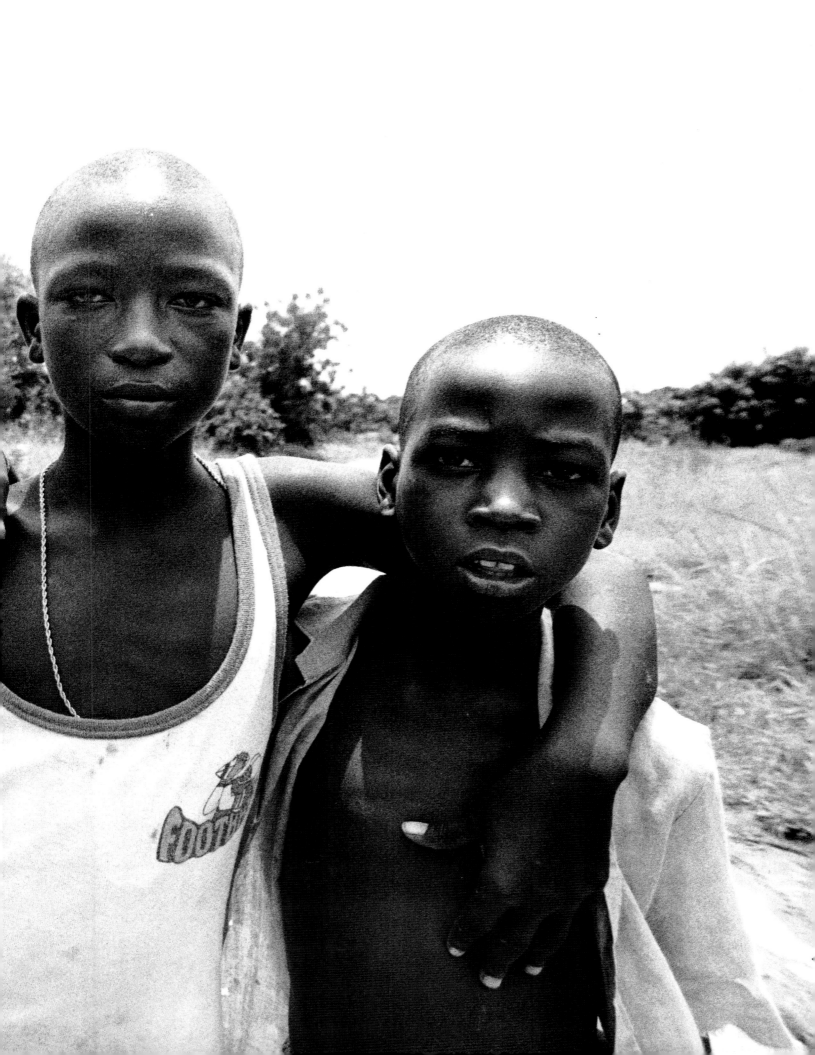

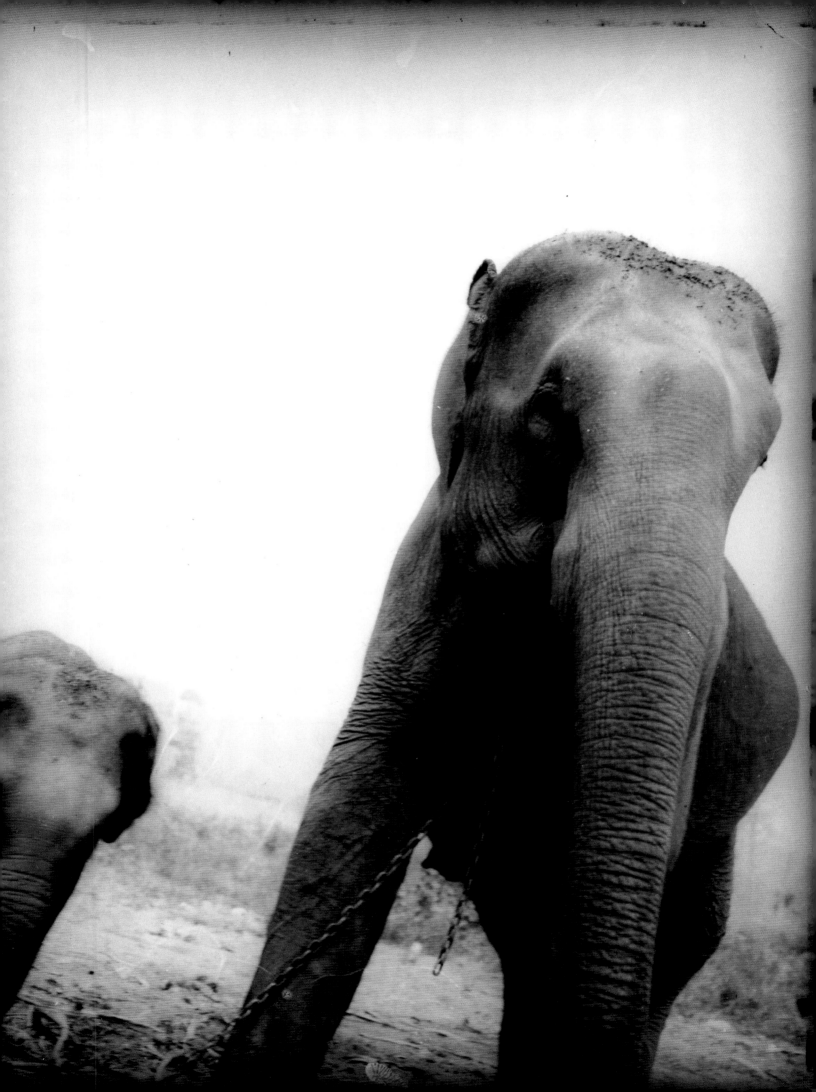

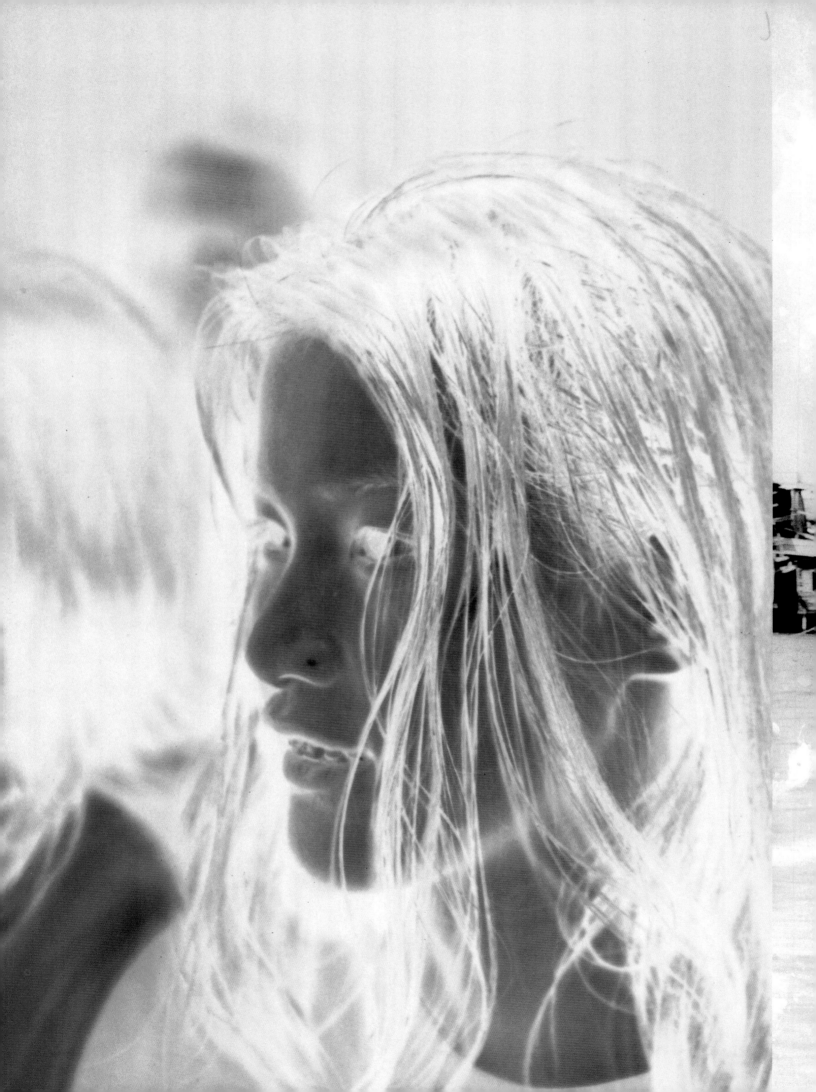

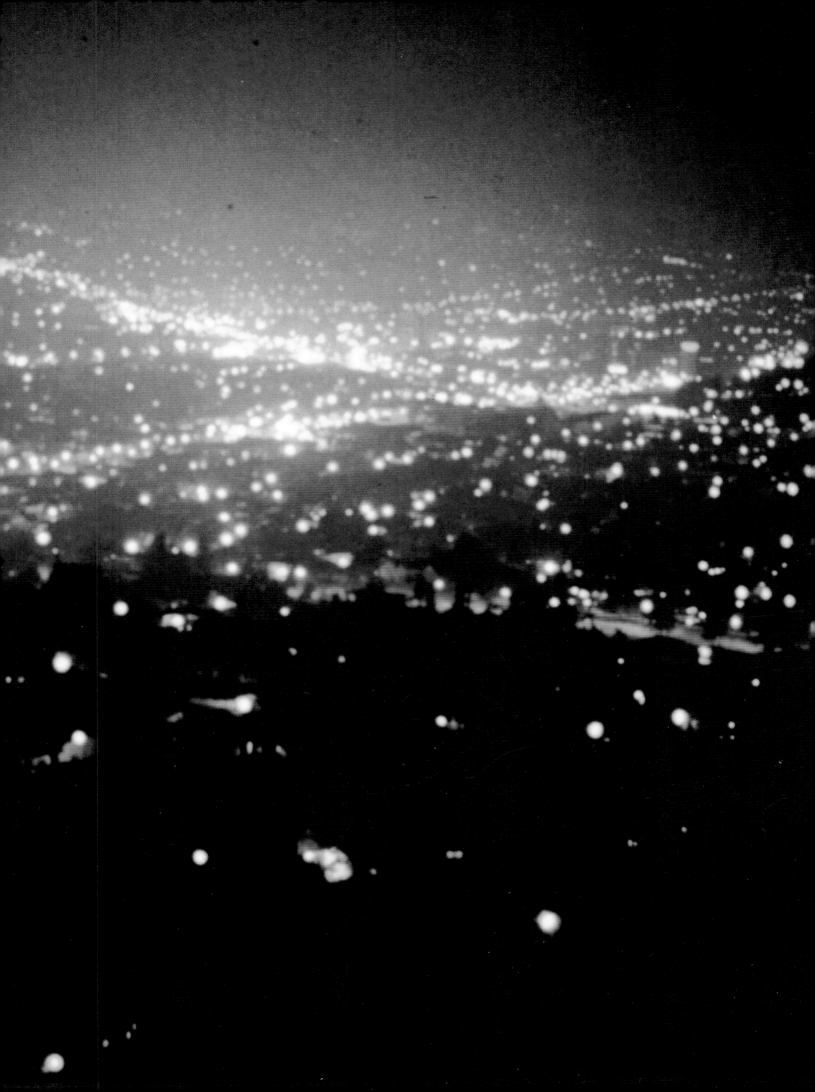

barbara müller

Because of the constantly changing organization of its structures a city offers ample opportunities and reasons for orientation. Photographs evolve from a process of searching and collecting which attempt to establish a relationship with urban factors, both by encoding and recognition, as well as by the interchangeability of images and signs. Picture complexes are assembled that are to be related to one another, whose components alternately contain parallels in substance and in visual impact, and whose density and dominance are to synthesize variety as well as simultaneity. Episodes between individual living spaces and public interfaces are intentional.

Eine Stadt bietet aufgrund sich stets verändernder Strukturen ausreichend Gelegenheit und Anlaß zur Orientierung. Aus einem Prozeß des Suchens und Sammelns resultieren Photographien, die gleichermaßen mittels Verschlüsselung und Wiedererkennung sowie Austauschbarkeit von Bildern und Zeichen einen Umgang mit urbanen Faktoren versuchen. Es entstehen aufeinander zu beziehende Bildkomplexe, deren Bestandteile mal inhaltliche, mal visuelle Parallelitäten aufweisen und deren unterschiedliche Dichte und Dominanz Vielfalt und Gleichzeitigkeit synthetisieren sollen. Episoden zwischen individuellem Lebensraum und öffentlichen Schnittstellen sind beabsichtigt.

La réorganisation constante des structures d'une ville fournit en abondance mobiles et matière à orientation. Aboutissement d'un processus de recherche et de collecte, des photographies voient le jour qui essaient d'entretenir un rapport avec les facteurs urbains, soit que les images et les signes soient parfaitement verrouillés et identifiables, soit, et ceci dans une mesure égale, qu'ils soient interchangeables. Il en résulte des complexes d'images qui sont à rapprocher les uns des autres, dont les composantes accusent des parallélismes tantôt d'ordre visuel, tantôt au niveau du contenu, et dont les différences de densité et de ton doivent synthétiser la diversité et la simultanéité. L'intersection entre espace de vie privée et interface publique, à laquelle se situent certains épisodes, est intentionnelle.

Barbara Müller was born in Remscheid in 1967; 1989–1995 studied photo design at the Bielefeld Technical College; 1992–1993 studied in Barcelona (Spain); exhibitions: 1991 *Pinhole*, Enschede, Netherlands; 1992 *Zwischenzeit* (Interim Time), Siegen; Saarbrücken; Bielefeld; 1993 Videotage (Video days) Salzgitter; 1995 project Z1, Rüdersdorf; International Photography Symposium, Ghent, Belgium; 1996 project Theatertage (Theater days), Rüdersdorf. Barbara Müller lives and works in Berlin.

Barbara Müller, 1967 geboren in Remscheid; 1989–1995 Studium Photodesign, Fachhochschule Bielefeld; 1992/93 Studienaufenthalt in Barcelona/Spanien; Ausstellungen: 1991 *Pinhole*, Enschede/Niederlande; 1992 *Zwischenzeit*, Siegen/Saarbrücken/Bielefeld; 1993 Videotage Salzgitter; 1995 Projektbegleitung Z1, Rüdersdorf; Internationales Photosymposium, Gent/Belgien; 1996 Projektbegleitung „Theatertage", Rüdersdorf. Barbara Müller lebt und arbeitet in Berlin.

Barbara Müller, née en 1967 à Remscheid; 1989–1995 études de photodesign, Institut Universitaire de Technologie de Bielefeld; 1992/93 séjour d'études à Barcelone (Espagne); expositions: 1991 *Pinhole*, Enschede (Pays-Bas); 1992 *Zwischenzeit* (Entre-temps), Siegen/Sarrebruck/Bielefeld; 1993 Journées de la Vidéo de Salzgitter; 1995 accompagnement du projet Z1, Rüdersdorf; Symposium International de Photographie, Gand (Belgique); 1996 accompagnement du projet des Journées du Théâtre, Rüdersdorf. Barbara Müller vit et travaille à Berlin.

After three months in windy and rainy London I am, at last, in Miami and I can't believe the feeling of palm trees, 37fk C (98fk F) at night and the colorful neor lights. The only person on the beach standing in the water with pants and sneakers, camcorder, camera, flash and telephoto lens is me, but that doesn't seer to bother anybody other than myself. Later, in a midsize Toyota in Los Angeles, the whole city is a living photograph through which I am driving and occasion ally stopping to take a picture – unnecessarily, because here everyone and everything photographs themselves all the time anyway. Then came the nighttim arrival in Las Vegas, an incredible sea of lights, incredible temperatures next morning. In contrast, the casinos with dingy carpets, flowery shirts and shorts or the strip, and the ugliest people in the world downtown. But this truth, if it is a truth at all, is of no interest to me, because all I am interested in is the possi bility of photographing a crystalline luminance. Crystal trash. I am fascinated by an obsessive, pyromaniacal picture production that creates sterile desire. I am interested in the striving for a perfect situation, in front of and behind the camera. Later, on the beach, I wonder why everyone is smiling at me so nicely and why apparently nobody considers me to be an annoying voyeur, and whether my work doesn't have something to do with America after all.

Flamingos Northwest　**Nach drei Monaten im windigen und regnerischen London endlich in Miami, und ich kann das Gefühl von Palmen, 37 Grad nachts und bunten Neonlichtern nicht glauben. Die einzige Person am Strand, die mit Hose und Turnschuhen, Camcorder, Kamera, Blitz und Teleobjektiv im Meer steht bin ich, aber das scheint niemanden zu stören außer mich selbst. Später mit einem Mittelklassetoyota in Los Angeles, die ganze Stadt ist ein lebendes Photo durch das ich fahre und gelegentlich aussteige, um ein Bild davon zu machen – unnötigerweise, da sich hier ohnehin alle und alles andauernd selbst photo graphieren. Dann Ankunft nachts in Las Vegas, unglaubliches Lichtermeer, unglaubliche Temperaturen am nächsten Morgen. Dagegen das Innere der Casino mit schäbigen Teppichen, Blumenhemden und Shorts am Strip und den häßlichsten Menschen der Welt Downtown. Aber diese Wahrheit, wenn sie überhaup eine ist, ist mir egal, weil mich nur die Möglichkeit interessiert, ein kristallines Leuchten aufzunehmen. Crystal trash. Mich fasziniert eine obsessive, pyroma nische Bildproduktion, die eine sterile Lust erzeugt. Mich interessiert das Streben nach einer perfekten Situation, vor und hinter der Kamera. Später am Strand wundere ich mich wieder, warum mich alle so nett anlächeln, und mich anscheinend keiner für einen lästigen Spanner hält, und ob meine Arbeit nicht doc etwas mit Amerika zu tun hat.**

Flamingos Northwest　Après trois mois passés à Londres dans le vent et la pluie, enfin Miami! Je n'arrive pas à croire à cette sensation que me procurent le palmiers, les 37 degrés la nuit et les néons de toutes les couleurs. La seule personne sur la plage à porter un pantalon et des chaussures de sport, et à barbo ter arnaché d'un camescope, d'un appareil-photo, d'un flash et d'un téléobjectif, c'est moi, mais cela ne semble déranger personne, à part moi. Plus tard, à Los Angeles, la ville tout entière est une photo vivante que je traverse au volant d'une Toyota de classe moyenne, dont je descends de temps en temps pour faire une photo – inutile, cette photo de la photo, puisque de toute façon tout et tous ici photographient eux-mêmes sans arrêt. Ensuite, arrivée de nuit à Las Ve gas, océan de lumières incroyable, températures incroyables le lendemain matin. Contraste, l'intérieur du casino et ses tapis élimés, les chemises à fleurs et le shorts au strip-tease et les gens les plus laids du monde downtown. Mais cette vérité, à supposer qu'elle en soit une, m'est précisément indifférente parce que seule m'intéresse la possibilité de photographier une luminescence cristalline. Crystal trash. Ce qui me fascine, c'est de produire de façon obsessionnelle, ur peu comme un pyromane, des images génératrices d'un plaisir stérile. Ce qui m'intéresse et ce à quoi j'aspire, c'est de créer une situation parfaite, devant e derrière l'appareil. Plus tard, sur la plage, je m'étonne à nouveau de ce que tous me sourient si gentiment, que personne apparemment ne me considère comm un voyeur importun, et je me demande si finalement, mon travail n'a pas quand même quelque chose à voir avec l'Amérique.

Werner Amann was born in 1969; 1989 studied art history and philosophy; 1990 German Youth Photography Prize; 1991 German Youth Photography Prize, began studying visual communication and photography and film design; 1994 Bubble Generator Happening, Dortmund; 1995 cooperated in organizing the YUPF (Young Urban Photographers Festival) in Bielefeld; Kodak Pixel Award; 1996 studied abroad in London; publications in fashion, sex and spirit-of-the-time magazines. Werner Amann lives in Dortmund.

Werner Amann, 1969 geboren; 1989 Studium der Kunstgeschichte und Philosophie; 1990 Preisträger, Deutscher Jugendphotopreis; 1991 Preisträger, Deutscher Jugendphotopreis, Studienbeginn Visuelle Kommunikation/Photo-Filmdesign; 1994 Bubble Generator Happening, Dortmund; 1995 Mitorganisation von YUPF (Young Urban Photographers Festival), Bielefeld; 1995 Preisträger Kodak Pixel Award; 1996 Auslandsstudium in London; Publikationen in Mode-, Sex- und Zeitgeistmagazinen. Werner Amann lebt in Dortmund.

Werner Amann, né en 1969; 1989 études d'histoire de l'art et de philosophie; 1990 lauréat du Prix de la Jeune Photographie Allemande; 1991 lauréat du Prix de la Jeune Photographie Allemande; commence des études de communication visuelle/design photo et cinéma; 1994 Bubble Generator Happening, Dortmund; 1995 coorganisation du YUPF (Young Urban Photographers Festival), Bielefeld; 1995 lauréat du Kodak Pixel Award; 1996 études à Londres; publications dans des magazines de mode, de charme et des magazines «branchés». Werner Amann vit à Dortmund.

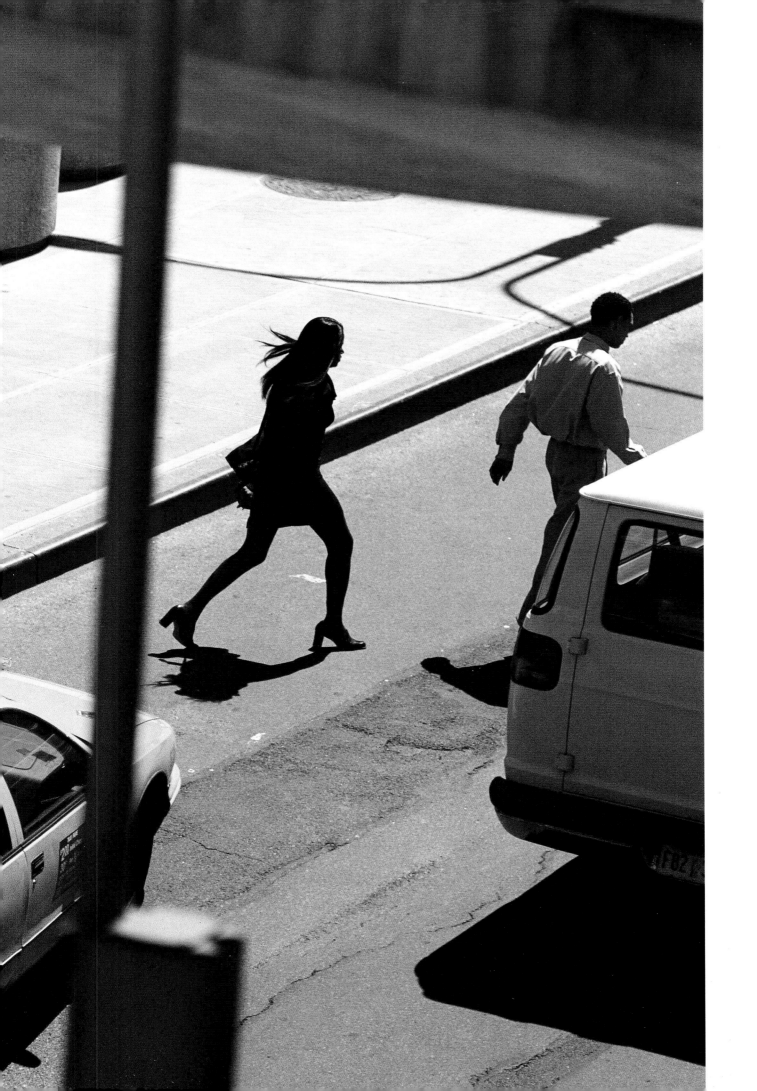

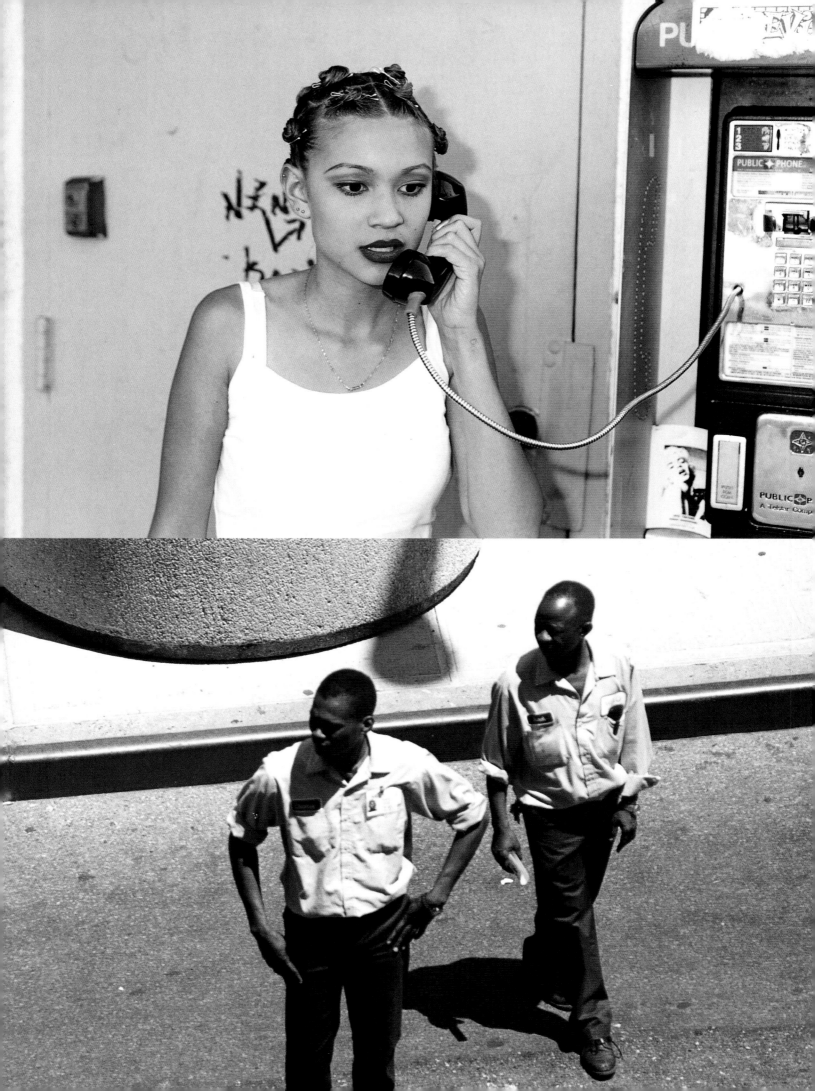

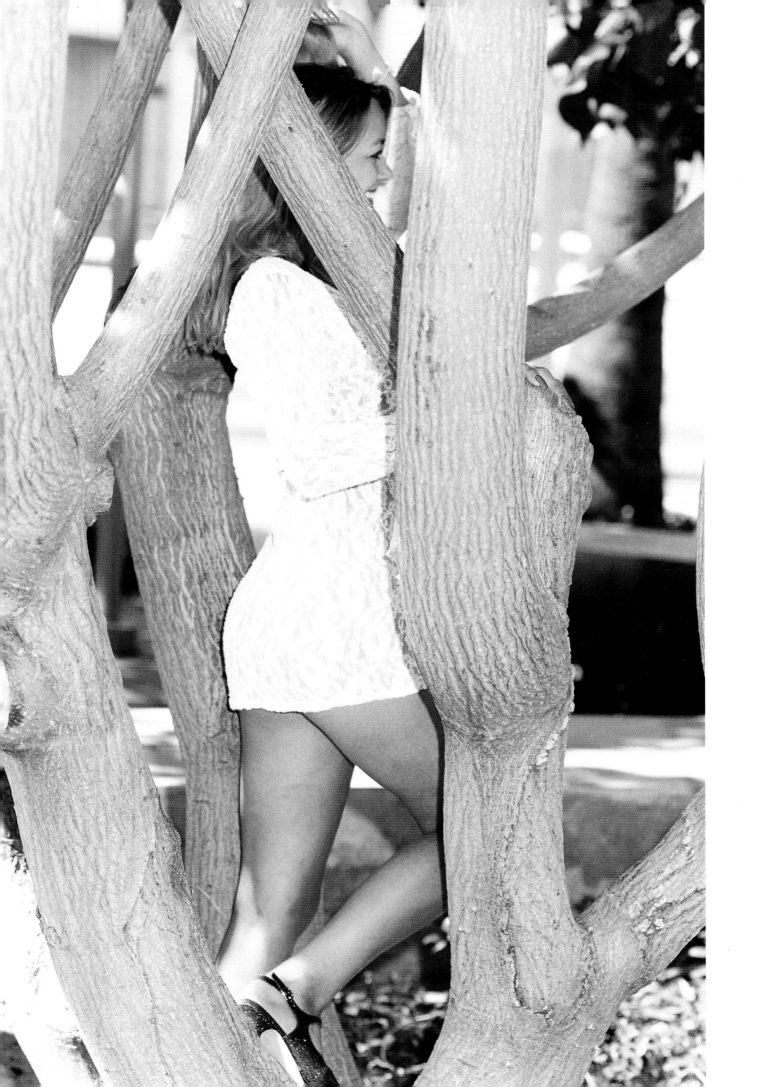

karin apollonia müller *The person who once fell from the sk[y]*

Here and there and here; where from, where to, how come. Man (or woman) is no longer at home in this world. Where we travel to, where we come from an[d] from where we depart. As the spirit of technology grows, man believes that he can find paradise far away in the distance. Yet he still faces the landscape lik[e] a stranger, seeing nothing except what he himself has created. He lacks the necessary familiar benchmarks that had once evolved from everyday life. I hav[e] learned from constant traveling that places and landscapes become interchangeable. A feeling develops of vacuum and of being lost. The task that I set my[-]self is the attempt to clarify the state of man in the landscape. The images are intended to address that which cannot be said. Because photography is a livin[g] force that contributes to the shaping of those traces for which there are no concepts.

Der Mensch, der einst vom Himmel fiel **Da und dort und da; von wo, wohin, woher. Der Mensch ist nicht mehr zu Hause auf der Welt. Wo man hinreist, w[ie] man her kommt und von wo man abreist. Mit dem Wachsen des technischen Geistes glaubt der Mensch, in der Ferne das Paradies zu finden. Und doch steh[t] er der Landschaft fremd gegenüber, weil er nichts erblickt, was er nicht selbst gestaltet hat. Ihm fehlt der notwendige Bezug, der sich einmal aus dem all[-] täglichen Leben ergeben hatte. Durch ständiges Reisen habe ich erkannt, daß Orte und Landschaften austauschbar werden. Es entsteht das Gefühl von Va[-] kuum und Verlorenheit. Die Aufgabe, die ich mir stelle, ist der Versuch, Befindlichkeiten des Menschen in der Landschaft sichtbar zu machen. die Bilder solle[n] das ansprechen, was nicht gesagt werden kann. Denn die Photographie ist eine lebendige Kraft, die zur Gestaltung der Spuren beiträgt, für die es keine Be[-] griffe gibt.**

L'homme qui était tombé du ciel Ici, là-bas, ici; d'où, vers où, à partir d'où. L'homme n'est plus chez lui dans le monde. Où qu'on aille, d'où qu'on vienne et d'o[ù] qu'on parte. Avec le développement de la technologie, l'homme croit pouvoir trouver le paradis dans des contrées lointaines. Et pourtant, son attitude face a[u] paysage, dans lequel il ne voit rien que ce qu'il a lui-même créé, est celle d'un étranger. Il lui manque ces liens nécessaires que tissait autrefois la vie quoti[-] dienne. A voyager constamment, je me suis rendu compte que les lieux et les paysages étaient interchangeables. Il en résulte un sentiment de vide, et la sen[-] sation d'être perdue. Aussi, je me propose d'essayer de rendre visibles les dispositions qui sont celles de l'homme au milieu du paysage. Les photos doivent par[-] ler de ce qui ne peut être dit. Car la photographie est une force vivante qui contribue à donner forme à des traces pour lesquelles il n'y a pas de mots.

Karin Apollonia Müller is the daughter of a captain and was born in Heidelberg in 1963; 1982 graduation from high school; 1984 began studying communication design, majoring in photography and film, at the Essen Polytechnic University; 1992 dissertation entitled *Deutsche Landschaften* (German Landscapes); began working as a freelance photojournalist; 1994 inducted into the German Society for Photography (DGPh); 1995 grant from the DAAD (German Academic Exchange Service); 1996 grant from the Friends of the Villa Aurora in Los Angeles; exhibitions and awards; 1989 *The Other Side of Photography,* Amsterdam; award from the Ministry of Education and Science; award from the Foreign Office; 1990 commendation by Kodak AG (Stuttgart), Young Photographers Award; 1991 Award for Young Photojournalism, Leverkusen; 2nd Prize for Photography as Art, Pforzheim; exhibition, 1st International Photo Days, Herten; commendation from Kodak AG (Stuttgart), dissertation grant; 1992 *Deutsche Landschaften* (German Landscapes), Essen; show of best graduate work in the State of North Rhine-Westphalia; 1993 *Mythos Tahiti, eher ein Begriff als ein Ort* (The Tahiti myth, a concept more than a place), solo exhibitions in Essen and in Pforzheim; Science Award for the best dissertation of 1992, Essen Polytechnic University; 2nd Prize at Emma, a competition for female photojournalists; 1995 Atomium, Kodak European Panorama of Young Photography, Arles, France. Karin Apollonia Müller lives in Weinheim.

Karin Apollonia Müller, 1963 geboren in Heidelberg als Kapitänstochter; 1982 Abitur; 1984 Aufnahme des Studiums Kommunikationsdesign, Schwerpunkte Photographie und Film, Universität Gesamthochschule Essen; 1992 Diplomarbeit *Deutsche Landschaften*; seit 1992 als freie Bildjournalistin tätig; 1994 Berufung zur Deutschen Gesellschaft für Photographie; 1995 DAAD Förderstipendium, Los Angeles; 1996 Förderstipendium der Freunde der Villa Aurora, Los Angeles; Ausstellungen und Preise: 1989 *The Other Side of Photography*, Amsterdam; Auszeichnung durch das Ministerium für Bildung und Wissenschaft; Auszeichnung durch das Auswärtige Amt; 1990 Anerkennung durch Kodak AG, Nachwuchsförderpreis; 1991 Preis für jungen Bildjournalismus, Leverkusen; 2. Preis für Photographie als Kunst, Pforzheim; Ausstellung, 1. Internationale Phototage, Herten; Anerkennung durch Kodak AG, Förderung der Diplomarbeit; 1992 *Deutsche Landschaften*, Essen, die besten Diplomarbeiten Nordrhein-Westfalen; 1993 *Mythos Tahiti, eher ein Begriff als ein Ort*, Einzelausstellung, Essen, Pforzheim; Wissenschaftspreis, Auszeichnung für die beste Diplomarbeit 1992, Universität Gesamthochschule Essen; 2. Preis bei Emma, Wettbewerb für Bildjournalistinnen; 1995 Atomium, Kodak European Panorama of Young Photography, Arles. Karin Apollonia Müller lebt in Weinheim.

Karin Apollonia Müller, née en 1963 à Heidelberg, fille de commandant; 1982 baccalauréat; 1984 études de design et de communication, spécialisation photographie et cinéma, Universität Gesamthochschule de Essen; 1992 travail de fin d'études *Deutsche Landschaften* (Paysages allemands); travaille depuis 1992 comme photojournaliste indépendante; 1994 nomination à la DGPH (Deutsche Gesellschaft für Photographie = Société Allemande de Photographie); 1995 bourse d'encouragement du DAAD, Los Angeles; 1996 bourse d'encouragement des Amis de la Villa Aurora, Los Angeles; expositions et prix: 1989 *The Other Side of Photography*, Amsterdam; récompense décernée par le ministère de la Formation et des Sciences; récompense décernée par le ministère des Affaires étrangères; 1990 reconnaissance par Kodak SA, prix d'encouragement aux jeunes photographes; 1991 prix du jeune photojournalisme, Leverkusen; 2e prix de «La photographie comme art», Pforzheim; exposition, 1ères Journées Internationales de la Photographie, Herten; reconnaissance par Kodak SA, soutien au travail de fin d'études; 1992 *Deutsche Landschaften*, Essen; exposition des meilleurs travaux de fin d'études de Rhenanie du Nord-Westphalie; 1993 *Mythos Tahiti, eher ein Begriff als ein Ort* (Le mythe de Tahiti, un concept plutôt qu'un lieu), exposition personnelle, Essen, Pforzheim; prix de la Recherche scientifique, récompense du meilleur travail de fin d'études 1992, Universität Gesamthochschule de Essen; 2e prix du concours des femmes photojournalistes Emma; 1995 Atomium, Kodak European Panorama of Young Photography, Arles. Karin Apollonia Müller vit à Weinheim.

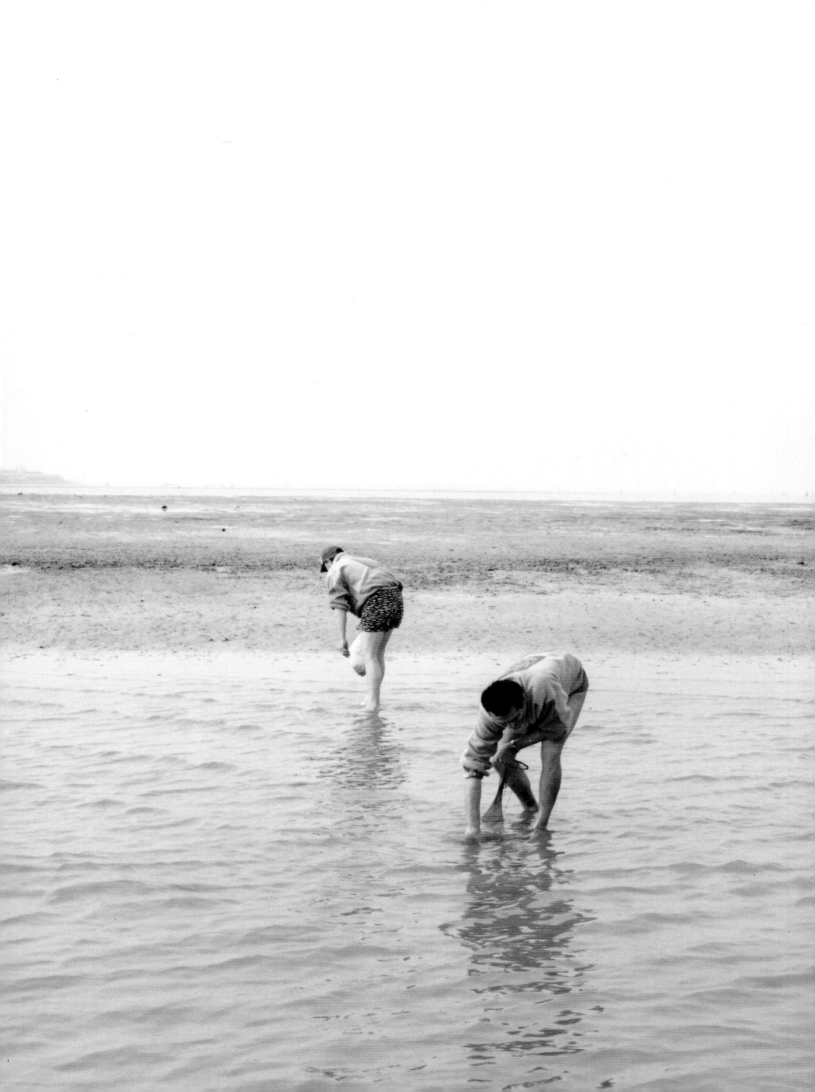

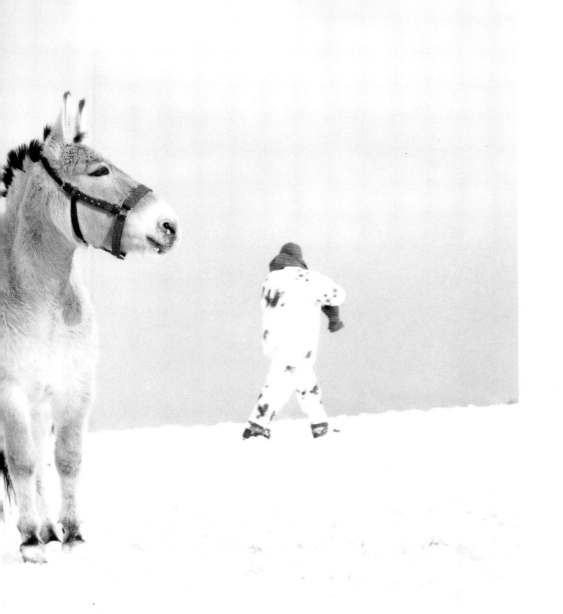

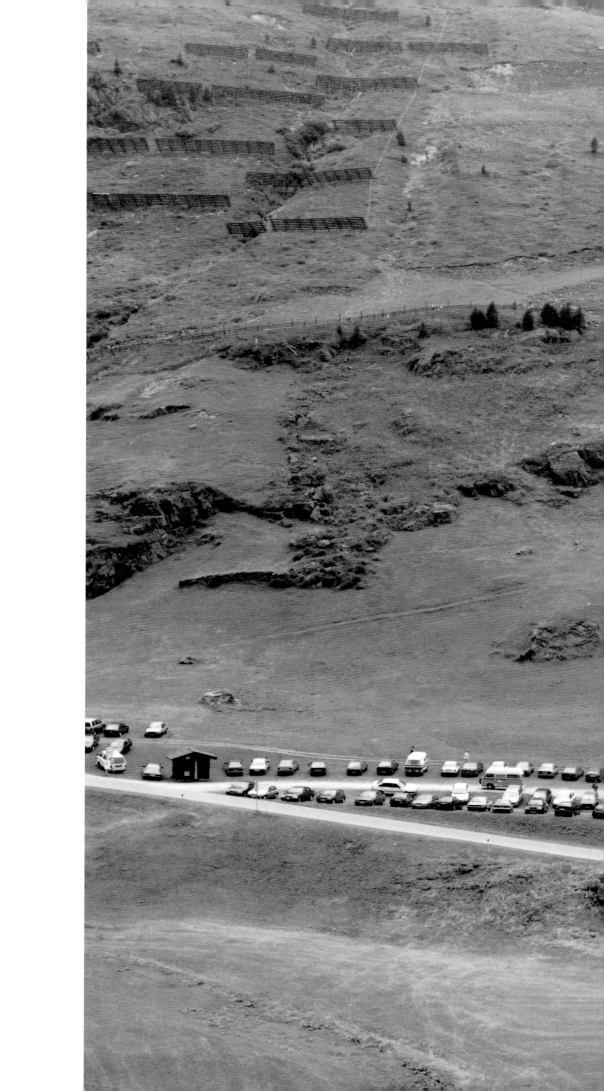

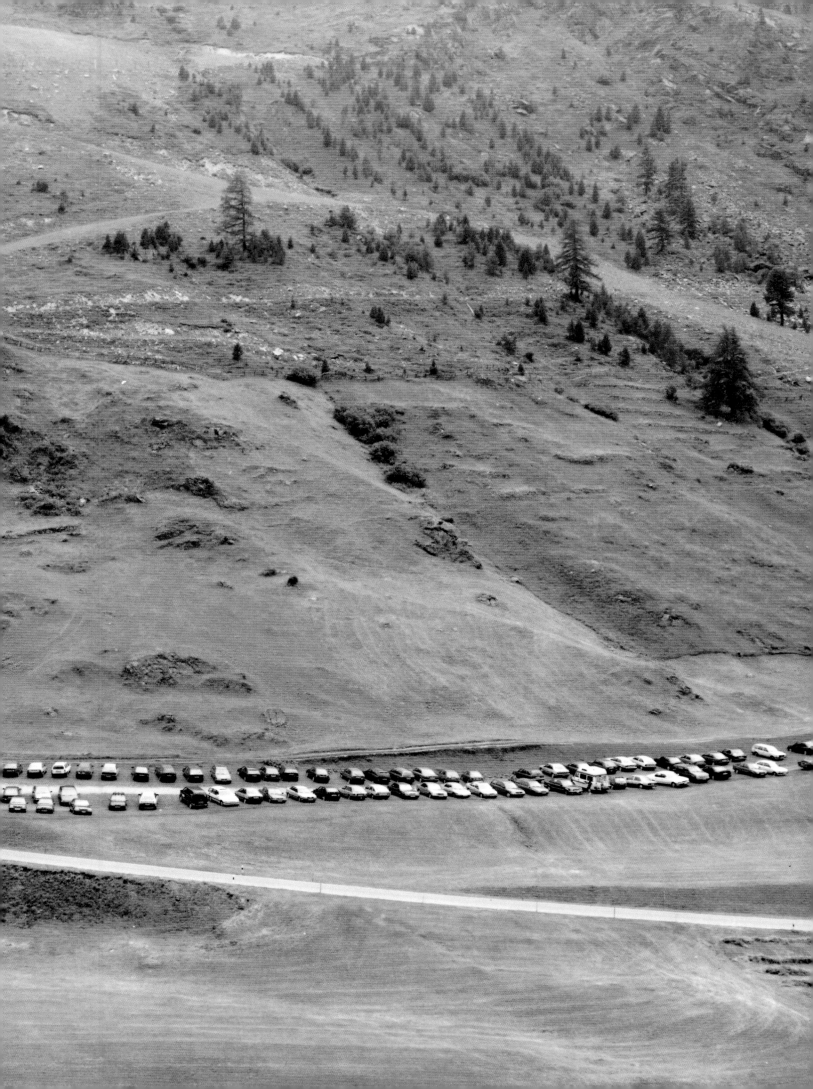

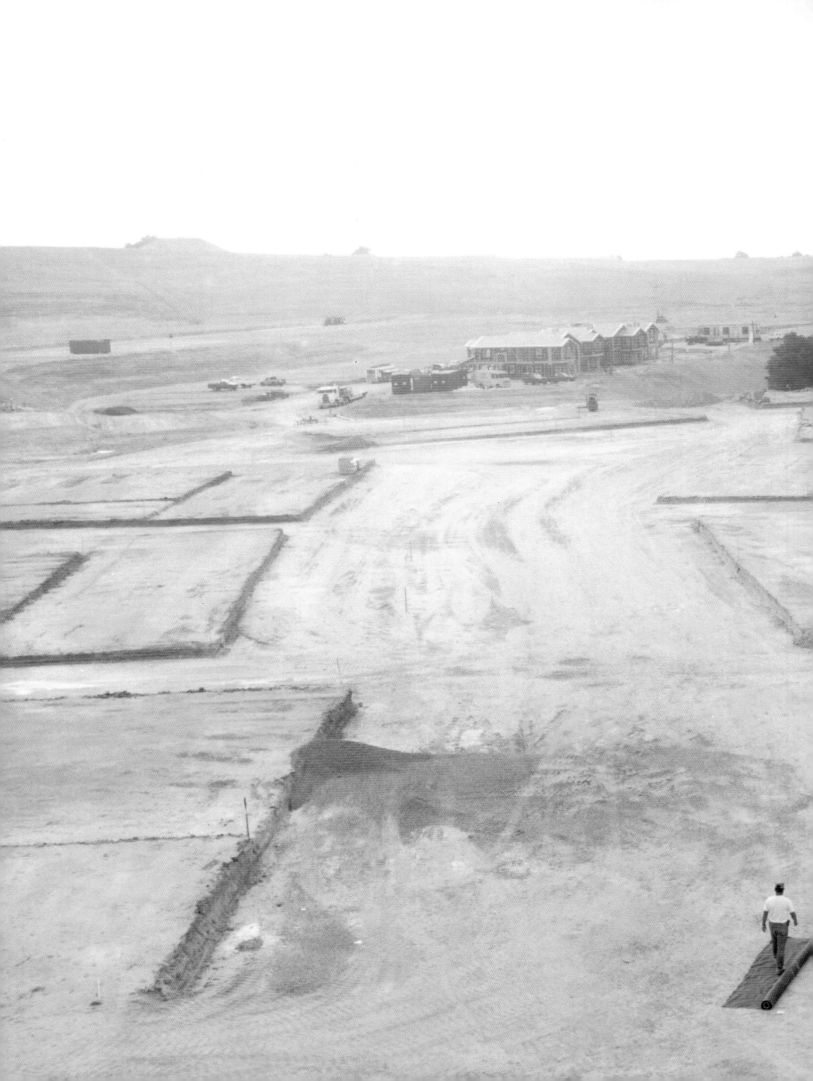

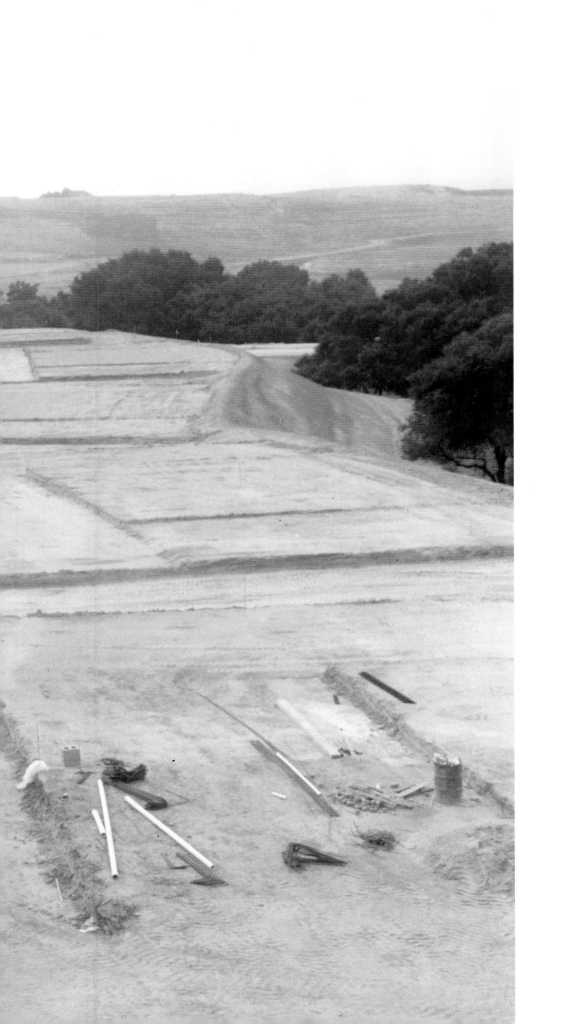

julia sörgel

Rasborka (Test of Strength) is a project started in 1995 to document the fate of German evacuees from Kazakhstan who had been resettled in the abandoned Soviet military barracks in Brandenburg. These evacuees are mostly German Mennonites, an evangelical religious community founded in the 16th century. Because they were persecuted at that time in Germany as sectarians, they gladly accepted an invitation by Catherine the Great and emigrated to Russia. The new settlers were granted great privileges by the Czarina and they settled down in the Ukraine and in the Volga region. These Mennonite communities managed to preserve their German identities into the thirties of the present century. In August 1941 they were given 12 hours to leave their elective homeland and they were deported to Siberia and to Kazakhstan as traitors. Even though they were discriminated against as Germans, the Soviet Union still remained something of a homeland to them. With the collapse of the Soviet Union at the end of the eighties, the Mennonites lost the right of Soviet citizens to be members of the Soviet Community of States regardless of their origin and nationality. In Kazakhstan too, where the Kazakhs themselves constitute only approximately 50% of the population, that country also began its ethnic cleansing. For these reasons, and for economic and perhaps also for patriotic reasons, some of the Mennonites opted to accept the invitation of the Brandenburg community to start a new life there. With this work I attempted to find an answer to the question whether a homeland is tied to a place or to the people. In my search for the homeland I encountered the familiar among the strange and the strange among the familiar – the feeling of homeland or of homelessness resides in the details and in the subjective perception of each individual.

Rasborka (Kraftprobe) ist ein 1995 entstandenes Projekt über das Schicksal deutscher Aussiedler aus Kasachstan, die sich auf einem verlassenen sowjetischen Militärgelände in Brandenburg angesiedelt haben. Es handelt sich bei ihnen überwiegend um Mennoniten, eine evangelische Religionsgemeinschaft, die im 16. Jahrhundert gegründet wurde. Da sie damals in Deutschland als Sektierer verfolgt wurden, wanderten sie auf Einladung Katharinas der Großen nach Rußland aus. Die Neusiedler bekamen von der Zarin viele Privilegien zugesprochen und wurden in der Ukraine und in der Wolgaregion ansässig. Bis in die dreißiger Jahre unseres Jahrhunderts konnten die mennonitischen Gemeinden ihre deutsche Identität bewahren. 1941 mußten sie innerhalb von zwölf Stunden ihre Wahlheimat verlassen und wurden als Verräter nach Sibirien und Kasachstan deportiert. Obwohl sie dort als Deutsche diskriminiert wurden, war die Sowjetunion doch immer so etwas wie eine Heimat. Bedingt durch den Zerfall der UdSSR Ende der achtziger Jahre verloren die Mennoniten den Anspruch, als Sowjetbürger ungeachtet ihrer Herkunft gleichwertiges Mitglied in der sowjetischen Völkergemeinschaft zu sein. Auch in Kasachstan, wo die Kasachen selbst nur etwa 50 Prozent der Bevölkerung stellen, wurden sie diskriminiert. Aus diesen, wirtschaftlichen und vielleicht auch patriotischen Gründen entschlossen sich einige, das Angebot der brandenburgischen Gemeinde anzunehmen und dort ein neues Leben zu beginnen. Ich versuchte, mit dem Projekt eine Antwort auf die Frage zu finden, ob Heimat orts- oder menschengebunden ist. Auf der Suche nach Heimat stieß ich auf das Vertraute im Fremden und auf das Fremde im Vertrauten – das Gefühl von Heimat bzw. Heimatlosigkeit liegt im Detail und in der subjektiven Wahrnehmung jedes Individuums.

Rasborka (Epreuve de force) est un projet qui a vu le jour en 1995 sur le sort de ces rapatriés allemands du Kazakhstan qui se sont installés dans le Brandebourg, sur un terrain abandonné par les forces soviétiques. Il s'agit essentiellement de mennonites allemands, une communauté religieuse évangélique fondée au 16e siècle. Ils étaient alors considérés en Allemagne comme une secte et faisaient l'objet de poursuites. Aussi s'empressèrent-ils d'accepter l'invitation de la Grande Catherine et d'émigrer en Russie. La tsarine accorda de grands privilèges aux nouveaux arrivants qui s'établirent en Ukraine et dans la région de la Volga. Jusque dans les années trente de ce siècle, les communautés mennonites purent conserver leur identité allemande. En août 1941, les mennonites durent, en l'espace de 12 heures, quitter leur patrie d'adoption, et ils furent déportés comme traîtres en Sibérie et au Kazakhstan. Même si, en tant qu'Allemands, ils y étaient sujets à discrimination, l'Union Soviétique continuait d'être pour eux une sorte de patrie. Avec l'effondrement de l'URSS à la fin des années quatre-vingt, les mennonites perdirent, sans considération d'origine ou de nationalité, le droit de se réclamer de la citoyenneté soviétique et d'être considérés comme membres à part entière de la communauté des peuples soviétiques. Même au Kazakhstan, où les Kazakhs ne représentent pourtant que quelque 50 pour cent de la population, on commence à pratiquer la purification ethnique. Pour toutes ces raisons, d'ordre économique mais peut-être aussi patriotique, certains se sont résolus à accepter l'offre du district de Brandebourg et d'y commencer une nouvelle vie. J'ai essayé dans ce projet d'apporter une réponse à la question de savoir si la notion de patrie était liée à un lieu ou à des gens. Au cours de cette recherche, j'ai rencontré du familier dans l'étranger et de l'étranger dans le familier. C'est en fait dans le détail et dans la subjectivité de la perception individuelle qu'il faut chercher le sentiment de patrie ou, le cas échéant, d'absence de patrie.

Julia Sörgel was born in Munich in 1970; 1989 high school graduation; 1990–1991 assistant to Herlinde Koelbl in Munich; 1991–1994 studied at the State College of Photodesign in Munich; 1994 Wüstenrot Foundation Young Documentary Photographers prize; 1995 began freelance work for periodicals and magazines. Julia Sörbel lives in Munich.

Julia Sörgel, 1970 geboren in München; 1989 Abitur; 1990–1991 Assistentin von Herlinde Koelbl, München; 1991–1994 Staatliche Fachakademie für Photodesign, München; 1994 Nachwuchsförderpreis für Dokumentarphotographie der Wüstenrot-Stiftung; seit 1995 freiberufliche Tätigkeit für Zeitschriften und Magazine. Julia Sörgel lebt in München.

Julia Sörgel, née en 1970 à Munich; 1989 Baccalauréat; 1990–1991 assistante de Herlinde Koelbl, Munich; 1991–1994 Académie d'Etat de Photodesign de Munich; 1994 prix d'encouragement aux jeunes photographes, photographie documentaire, de la fondation Wüstenrot; depuis 1995, travaille en freelance pour des revues et des magazines. Julia Sörgel vit à Munich.

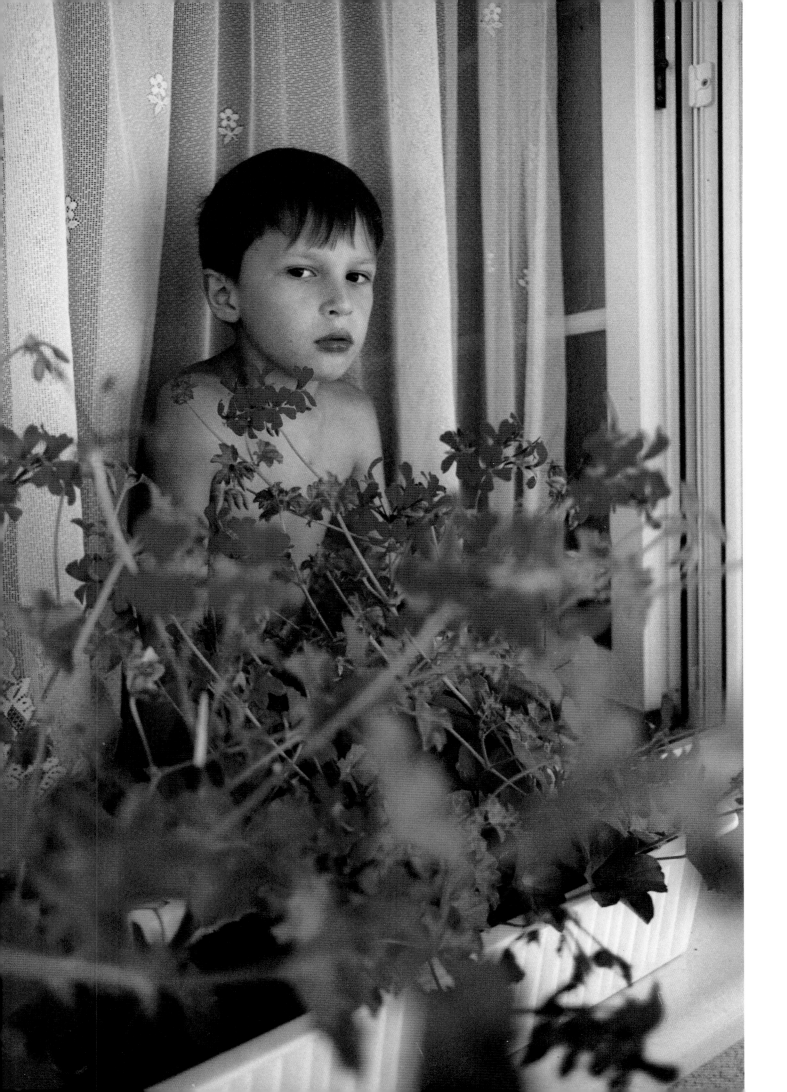

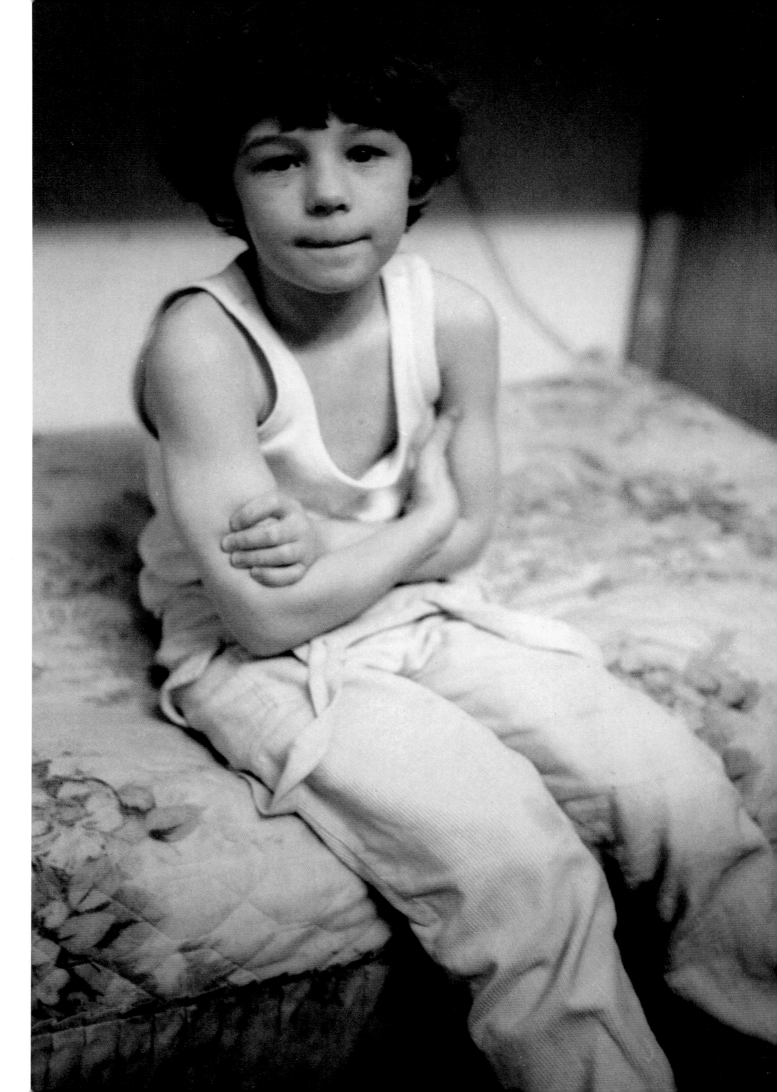

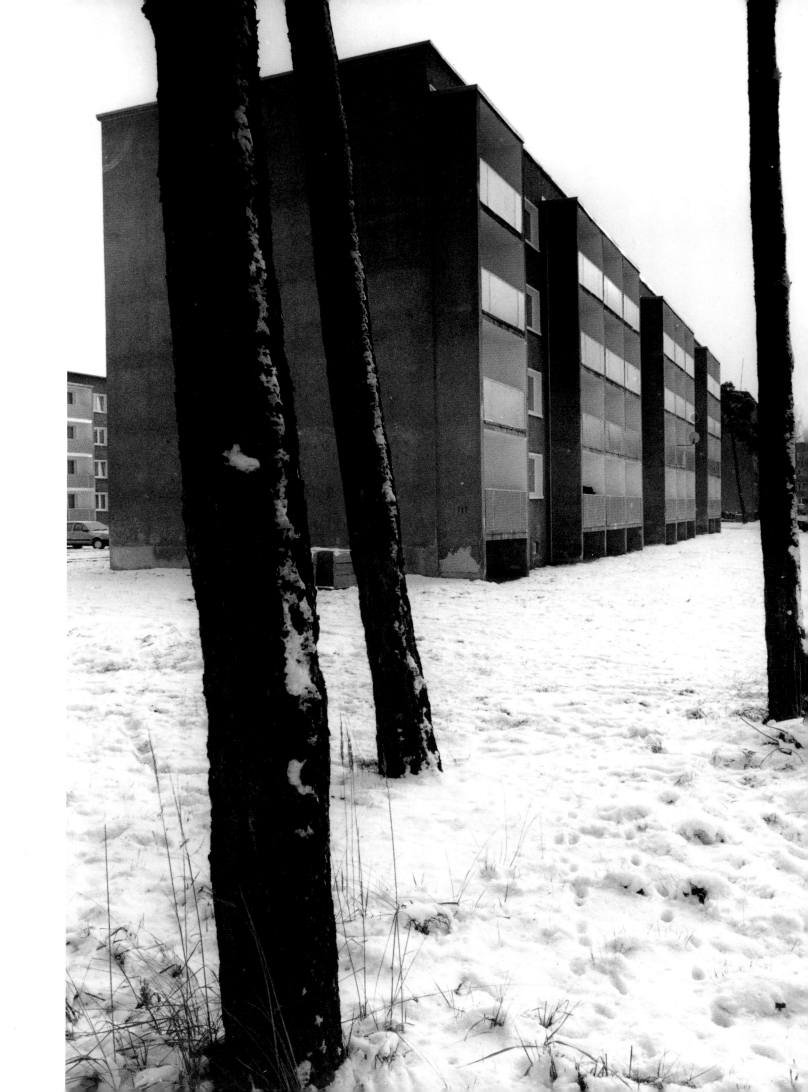

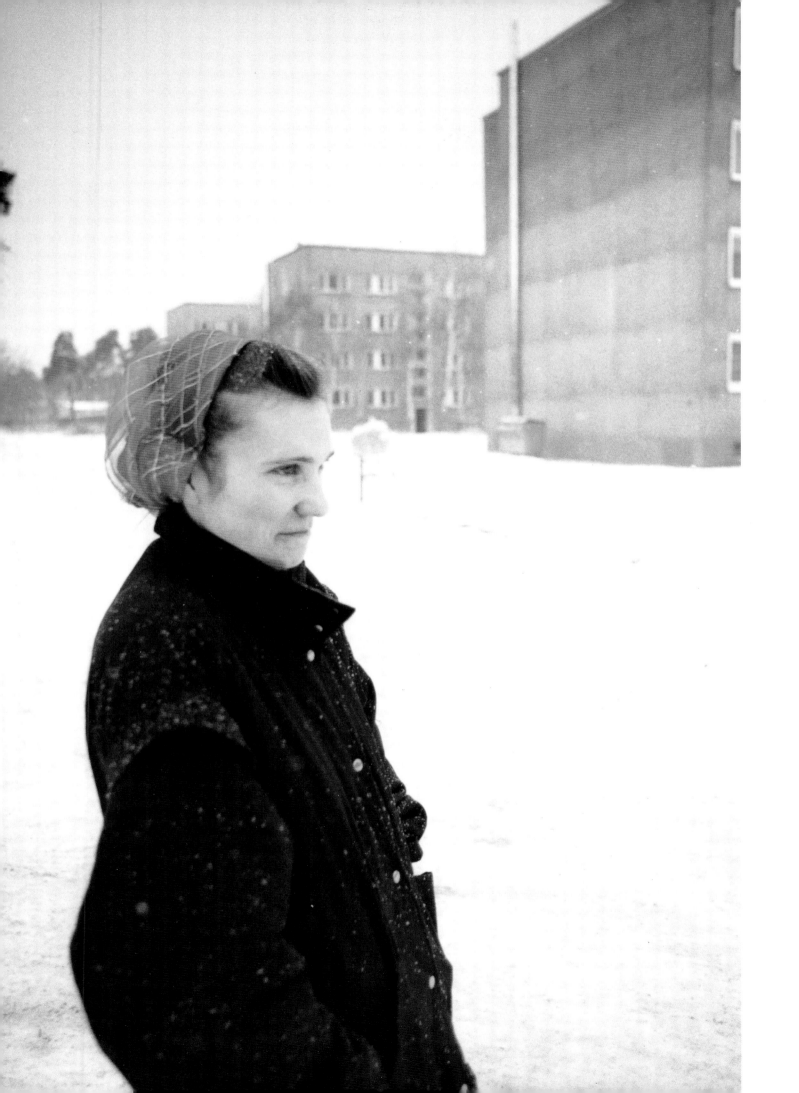

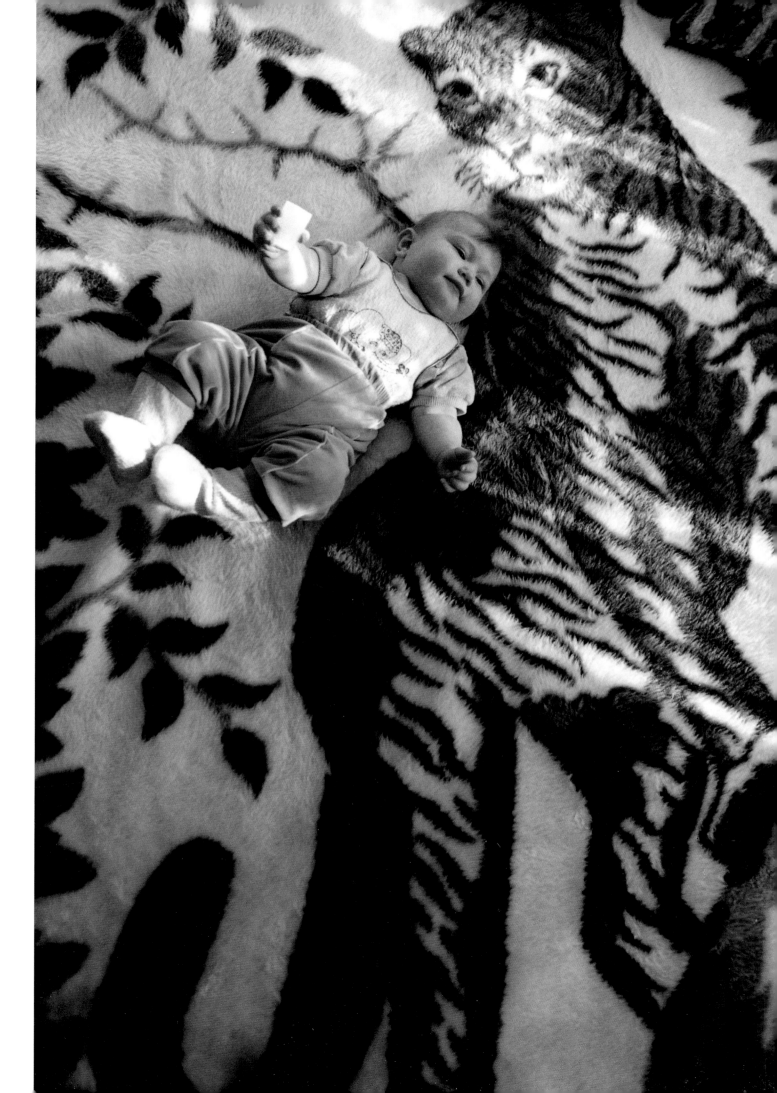

göran gnaudschun These pictures are part of the photo-book project *Longe – 44 Leningra[d]* which evolved from my existence as a photographer and a musician. For six years I was a guitarist in the folk-punk band *44 Leningrad*, and this made it poss[i]ble for me to describe an important part of my life from the inside, as it were, from my own admittedly subjective point of view. *Longe* means the every da[y] the chronological and geographical progression of a tour, but also the reciprocal training of band and public that evolves naturally in the quest for succes[s] *Longe* does not aspire to relate a story, but the everyday cycle of constantly changing yet always recurring basic feelings that I ascribed to the conditions an[d] to the people around me, to the band and to the public. Driving endless distances – unloading at the gig site – set-up – wait for the soundcheck – boredor[m] passed away with alcohol – soundcheck – wait some more – in spite of the familiar routine there is always some apprehension – the hall begins to fill up – a[n] other tuning – performance, usually good, sometimes poor – raucous crowds near the front of the stage – sweat runs over my eyes and my spectacles – en[c] cores – slowly recover – drink and celebrate – be celebrated – exhausted, fall asleep somewhere – wake up in the morning – bad taste in the mouth – recolle[c] tions fit together in bits and pieces – I am pleased that at least the film did not get torn in the camera – load the bus – drive, on to the next concert ...

Diese Bilder sind Teil des Photobuchprojektes *Longe – 44 Leningrad*, das aus meinem Leben als Photograph und Musiker entstanden ist. Ich war sechs Jahr[e] lang Gitarrist der Folk-Punk-Band *44 Leningrad*. Als Photograph konnte ich einen wichtigen Teil meines Lebens von innen heraus, aus meiner eigenen, beton[t] subjektiven Sicht beschreiben. *Longe* meint den Alltag, den zeitlichen und geografischen Ablauf einer Tournee, aber auch die wechselseitige Beeinflussun[g] zwischen Band und Publikum, die auf der Suche nach Erfolgserlebnissen fast zwangsläufig entsteht. *Longe* meint keine Geschichte, sondern den Alltag de[r] ständig wechselnden, aber immer wiederkehrenden Grundgefühle, die sich aus den Gegebenheiten und den Menschen um mich herum, aus Band und Pu[b] blikum, entwickelten. Fahren, endlos lange – ausladen am Auftrittsort – aufbauen – warten auf den Soundcheck – Langeweile, mit Alkohol bekämpft – So[und] undcheck – wieder warten – trotz Routine immer in leichter Anspannung – der Saal füllt sich – noch einmal Stimmen – Auftritt, meistens gut, manchmal mie[s] – pogende Meute am Bühnenrand – mir läuft der Schweiß über die Augen und die Brille – Zugaben – sich langsam erholen – trinken und feiern – sich feier[n] lassen – irgendwo ermattet einschlafen – morgens aufwachen – schlechter Geschmack im Mund – bruchstückhafte Erinnerungen – bin froh, daß wenigsten[s] der Film in der Kamera nicht gerissen ist – den Bus beladen – fahren, zum nächsten Konzert ...

Ces images sont extraites de mon projet d'album photographique *Longe – 44 Leningrad*, projet né de mon existence de photographe et de musicien. J'ai ét[é] pendant six ans guitariste du groupe folk-punk *44 Leningrad*, ce qui m'a permis de décrire de l'intérieur, à partir de ma propre subjectivité, de ma propre visio[n] des choses, ce qui a été une partie importante de ma vie. *Longe*, c'est le quotidien, le déroulement d'une tournée dans le temps et dans l'espace, mais aussi [le] dressage que s'imposent mutuellement le groupe et le public, et qu'implique presque obligatoirement la recherche du succès. *Longe*, ce n'est pas une histoir[e] mais le quotidien de ces sentiments fondamentaux qui changent sans cesse mais sans cesse reviennent, et qui sont liés pour moi à des faits et des gens d[e] mon entourage, que ce soit dans le groupe ou dans le public. La route, interminable – décharger à l'arrivée – monter le matériel – attendre la balance – l'ennu[i] que l'on trompe par l'alcool – balance – de nouveau attendre – toujours une légère tension malgré la routine – la salle se remplit – encore des voix – entrée e[n] scène, bien le plus souvent, parfois dégueulasse – meute déchaînée au bord de la scène – la sueur me dégouline sur les yeux et les lunettes – rappels – récu[] pérer lentement – boire et faire la fête – se laisser acclamer – s'endormir épuisé n'importe où – se réveiller le matin – un mauvais goût dans la bouche – le[s] souvenirs se remettent en place par petits bouts – suis content qu'au moins le film dans l'appareil ne soit pas déchiré – charger le bus – repartir, pour le pro[] chain concert ...

Göran Gnaudschun was born in Potsdam in 1971; 1987–1990 apprenticeship in hydraulic engineering; after community service came an unfinished course of study in construction engineering, followed by fruitful years of unemployment; 1994 student at the College of Graphic Design and Book Art in Leipzig; 1996 in June received a preliminary diploma with the book *Longe – 44 Leningrad*, followed by studies in the specialist course led by Professor Timm Rautert; exhibition in Heidelberg: *1994 Dai*. Göran Gnaudschun lives in Potsdam.

Göran Gnaudschun, 1971 geboren in Potsdam; 1987–1990 Lehre als Wasserbauer; nach dem Zivildienst und einem abgebrochenen Bauingenieursstudium fruchtbare Jahre der Arbeitslosigkeit; seit 1994 Student an der Hochschule für Grafik und Buchkunst Leipzig; im Juni 1996 Vordiplom mit dem Buch *Longe – 44 Leningrad*; seitdem in der Fachklasse Prof. Timm Rautert; Ausstellung: 1994 Dai, Heidelberg. Göran Gnaudschun lebt in Potsdam.

Göran Gnaudschun, né en 1971 à Potsdam; de 1987 à 1990 apprentissage de technicien hydraulique; après le service civil et l'interruption d'études d'ingénieur du génie civil, quelques années de chômage fertile; depuis 1994 étudiant à l'Ecole Supérieure de Graphisme et d'Art du Livre de Leipzig; en juin 1996 prédiplôme avec le livre *Longe – 44 Leningrad*; étudie depuis lors dans la classe du professeur Timm Rautert; exposition: 1994 Dai, Heidelberg. Göran Gnaudschun vit à Potsdam.

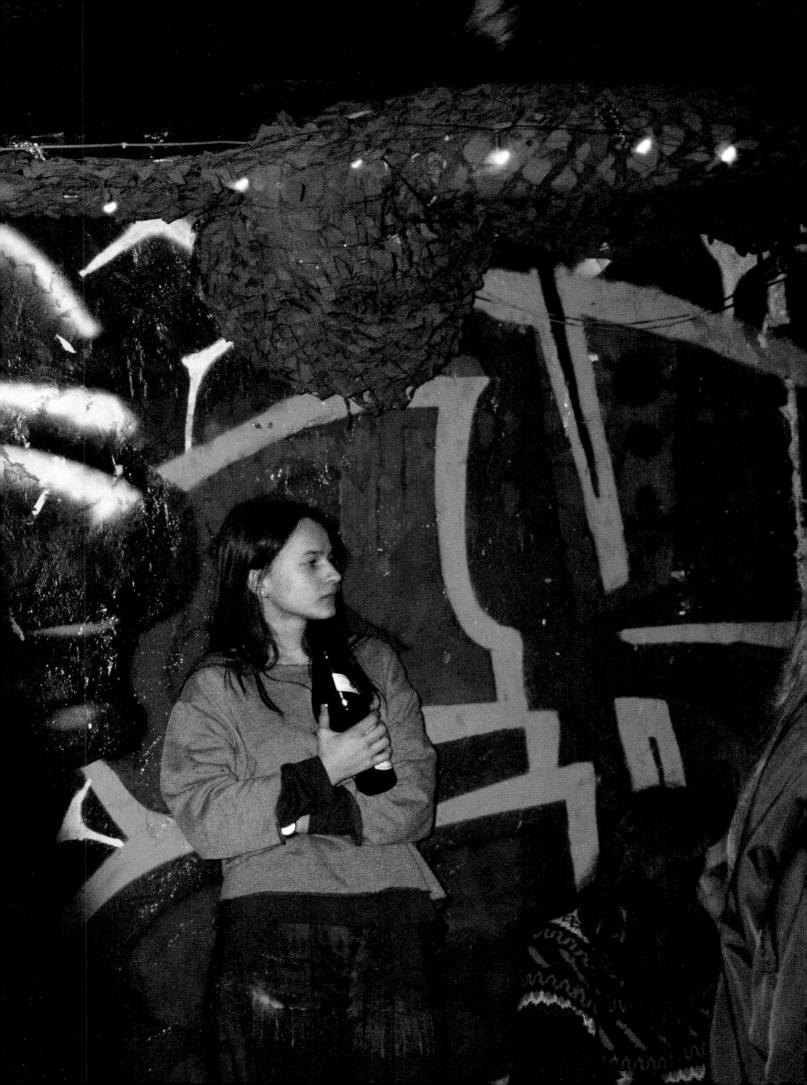

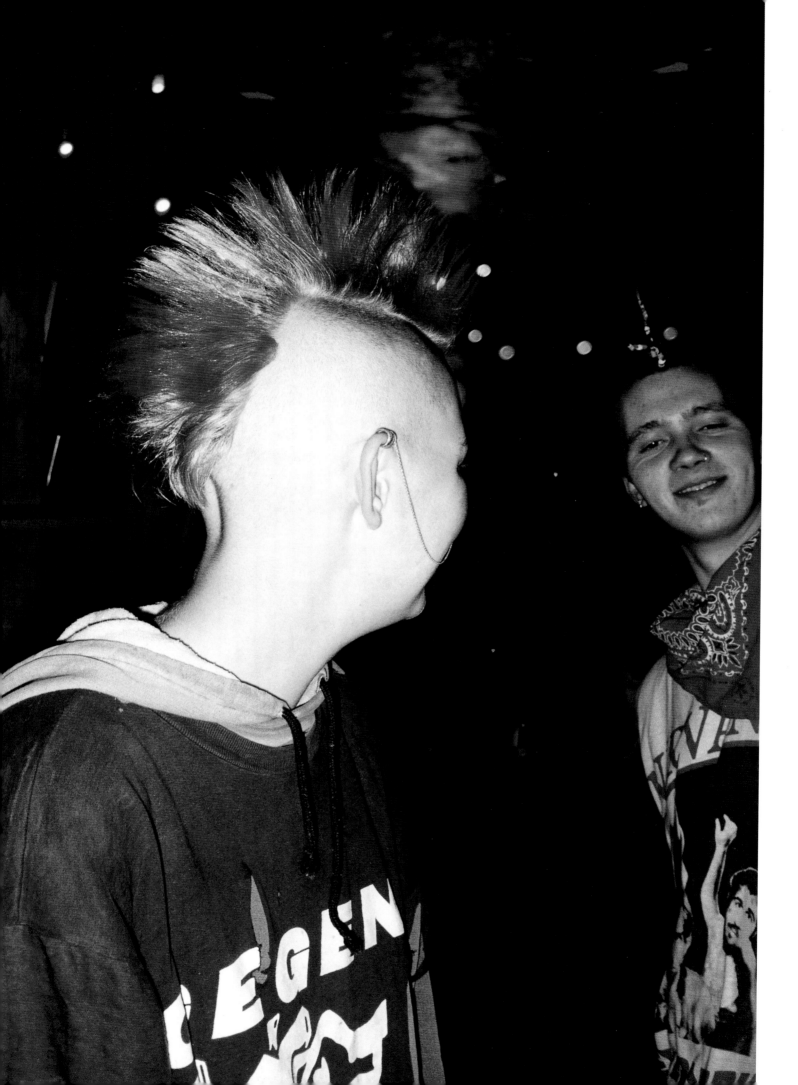

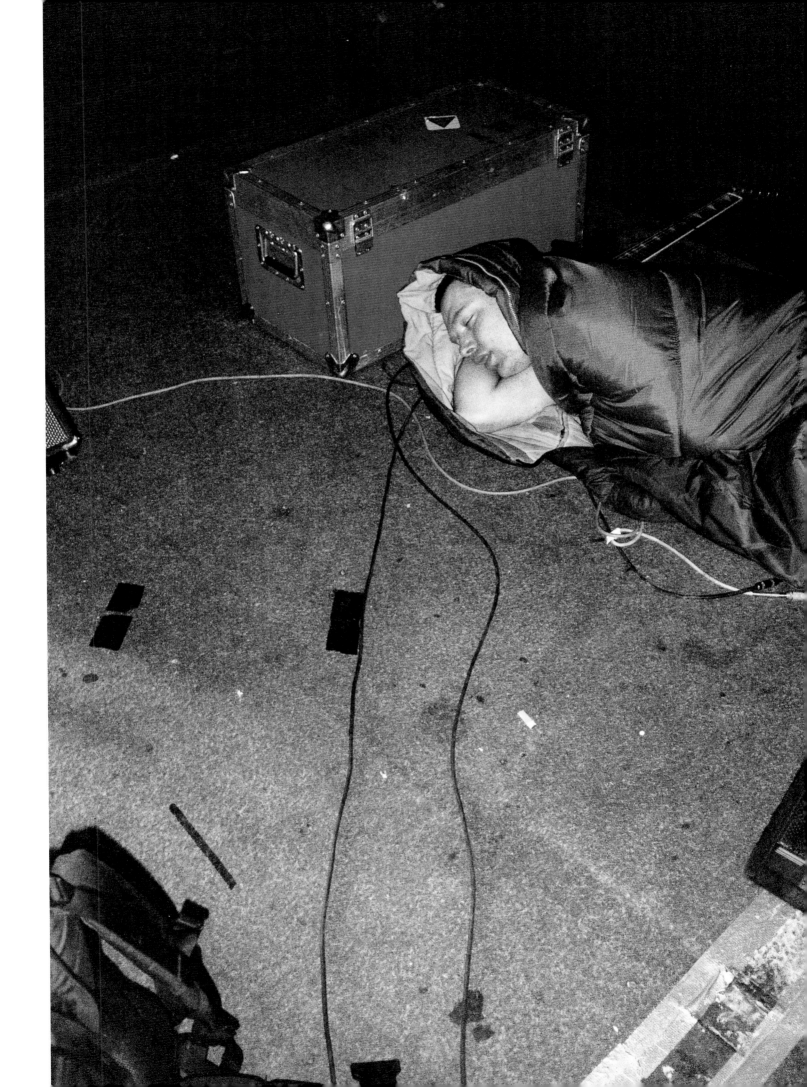

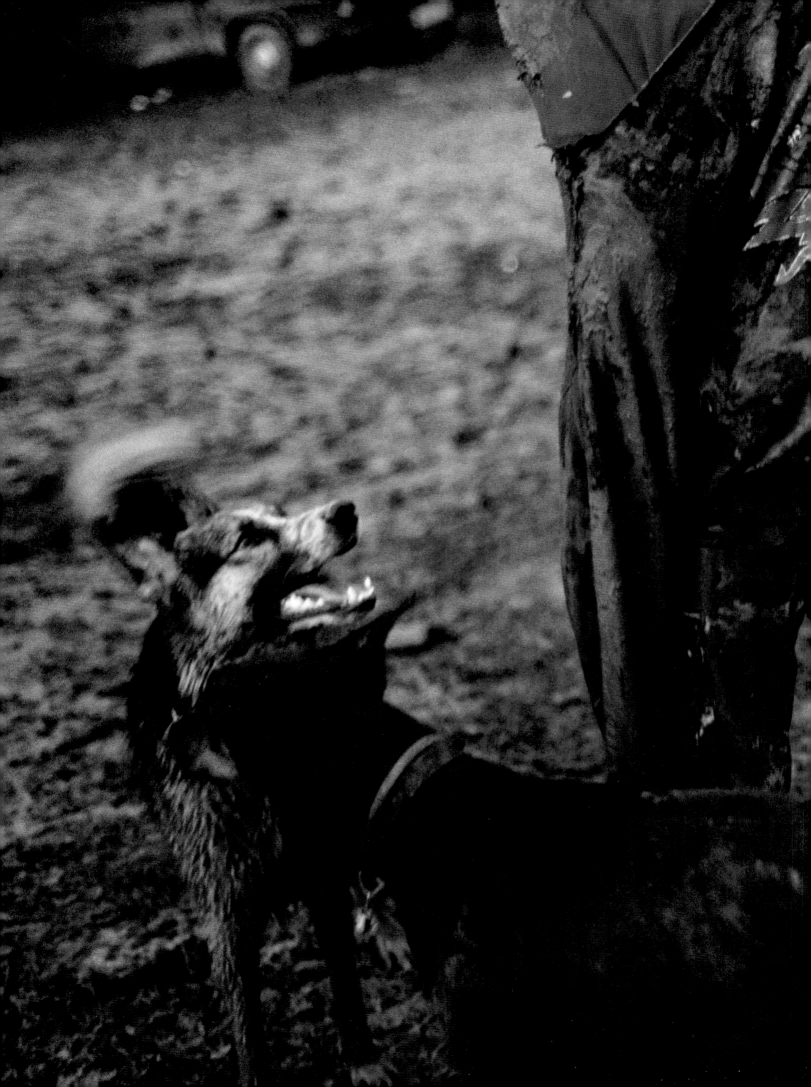

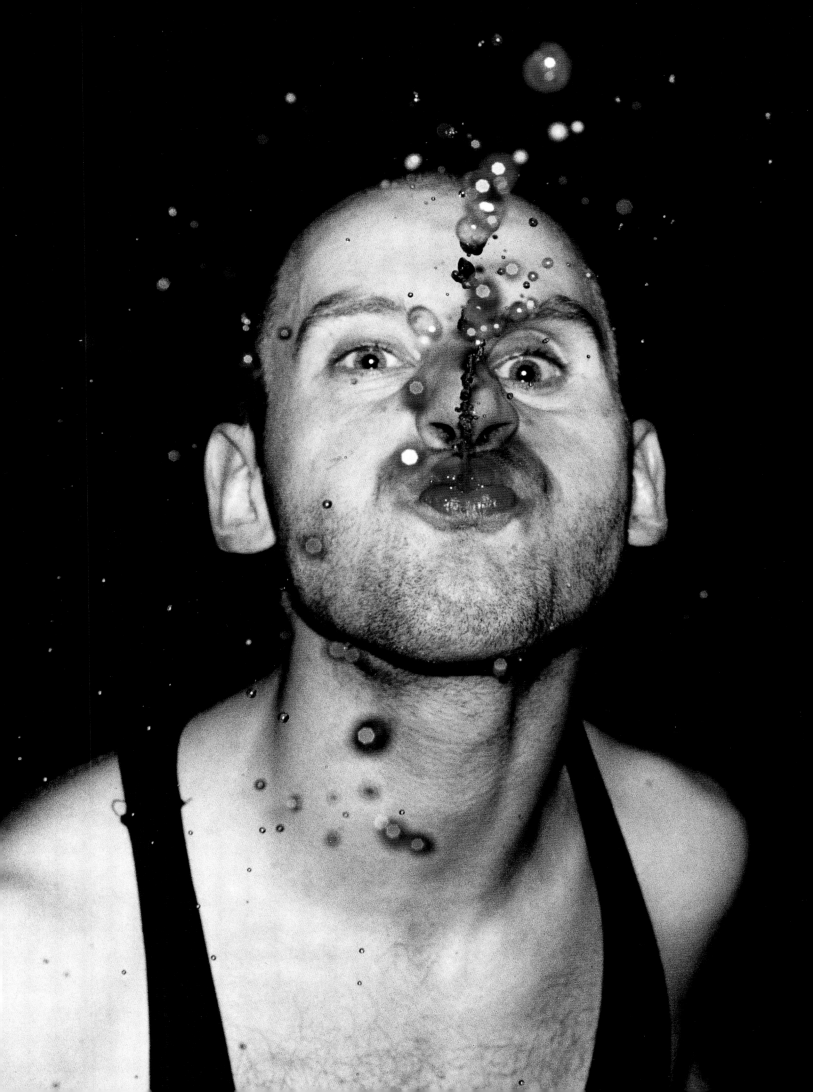

albrecht fuchs

For some time now I have been working mostly in portrait photography. The photographs selected for this book were made during the past two and a half years, both as assignments on my own initiative. Even though I did not specialize in a particular group of people, a uniform photographic approach created a serial connection between the individual portraits. It is unimportant whether my portrait features a close acquaintance or perhaps the president of the Federal Bank. I strive to depict the most diverse individuals in a largely neutral and balanced manner in order to leave room for the viewer to derive his or her own impression of the person.

Illustrations: 1. Bernard Yenelouis; 2. Helmut Schlesinger; 3. Tim Neuger and Burkhard Riemschneider; 4. Utako Koguchi; 5. Marcel Beyer; 6. Nakomis O'Brien 7. Elizabeth Peyton; 8. Johannes Wohnseifer

Seit längerer Zeit arbeite ich hauptsächlich im Bereich Porträtphotographie. Die für dieses Buch ausgewählten Photographien entstanden in den letzten zweieinhalb Jahren sowohl als Auftrags-, als auch als freie Arbeiten. Obwohl ich mich nicht auf eine bestimmte Personengruppe spezialisiert habe, ergibt sich durch eine gleiche photographische Herangehensweise zwischen den einzelnen Porträts ein serieller Zusammenhang. Ob ich in einem Porträt einen guten Bekannten oder etwa den Bundesbankpräsidenten zeige, ist unerheblich. Ich versuche, die unterschiedlichsten Personen weitgehend neutral und gleichwertig darzustellen und dem Betrachter Raum für ein eigenes Bild von der Person zu lassen.

Abbildungen: 1. Bernard Yenelouis; 2. Helmut Schlesinger; 3. Tim Neuger und Burkhard Riemschneider; 4. Utako Koguchi; 5. Marcel Beyer; 6. Nakomis O'Brien 7. Elizabeth Peyton; 8. Johannes Wohnseifer

Depuis un certain déjà, je travaille essentiellement dans le domaine du portrait. Les travaux sélectionnés pour cet ouvrage ont été réalisés au cours des deux dernières années – deux ans et demi exactement. Ce sont aussi bien des travaux personnels que des commandes. Bien que je ne me sois pas focalisé sur un groupe de gens précis, mon approche photographique, toujours la même, opère entre les portraits un rapprochement qui relève de la série. Que je fasse le portrait de quelqu'un que je connais bien ou du président de la Bundesbank par exemple, n'a aucune importance. J'essaie de représenter des personnes extrêmement différentes de la façon la plus neutre et la plus équilibrée possible, et de laisser ainsi au spectateur la possibilité de se faire sa propre image de la personne.

Illustrations: 1. Bernard Yenelouis; 2. Helmut Schlesinger; 3. Tim Neuger und Burkhard Riemschneider; 4. Utako Koguchi; 5. Marcel Beyer; 6. Nakomis O'Brien 7. Elizabeth Peyton; 8. Johannes Wohnseifer

Albrecht Fuchs was born in Bielefeld in 1964; 1986–1993 studied photography at the Essen Polytechnic University; 1991 began publishing in Frankfurter Allgemeine Zeitung, jetzt, New York Times Magazine, Süddeutsche Zeitung Magazin, Zeit Magazin; 1997 *O.I.F. – Portraits*, Tropen Verlag Cologne. Albrecht Fuchs lives in Cologne.

Albrecht Fuchs, 1964 geboren in Bielefeld; 1986–1993 Photographiestudium an der Universität Gesamthochschule Essen; seit 1991 Publikationen in Frankfurter Allgemeine Magazin, jetzt, New York Times Magazine, Süddeutsche Zeitung Magazin, Zeit Magazin; 1997 *O.I.F. – Porträts*, Tropen Verlag, Köln. Albrecht Fuchs lebt in Köln.

Albert Fuchs, né en 1964 à Bielefeld; 1986 à 1993 études de photographie à la Universität Gesamthochschule de Essen; depuis 1991 publications dans le Frankfurter Allgemeine Magazin, à présent dans le New York Times Magazine, le Süddeutsche Zeitung Magazin, le Zeit Magazin; 1997 *O.I.F. – Portraits*, éditions Tropen, Cologne. Albert Fuchs vit à Cologne.

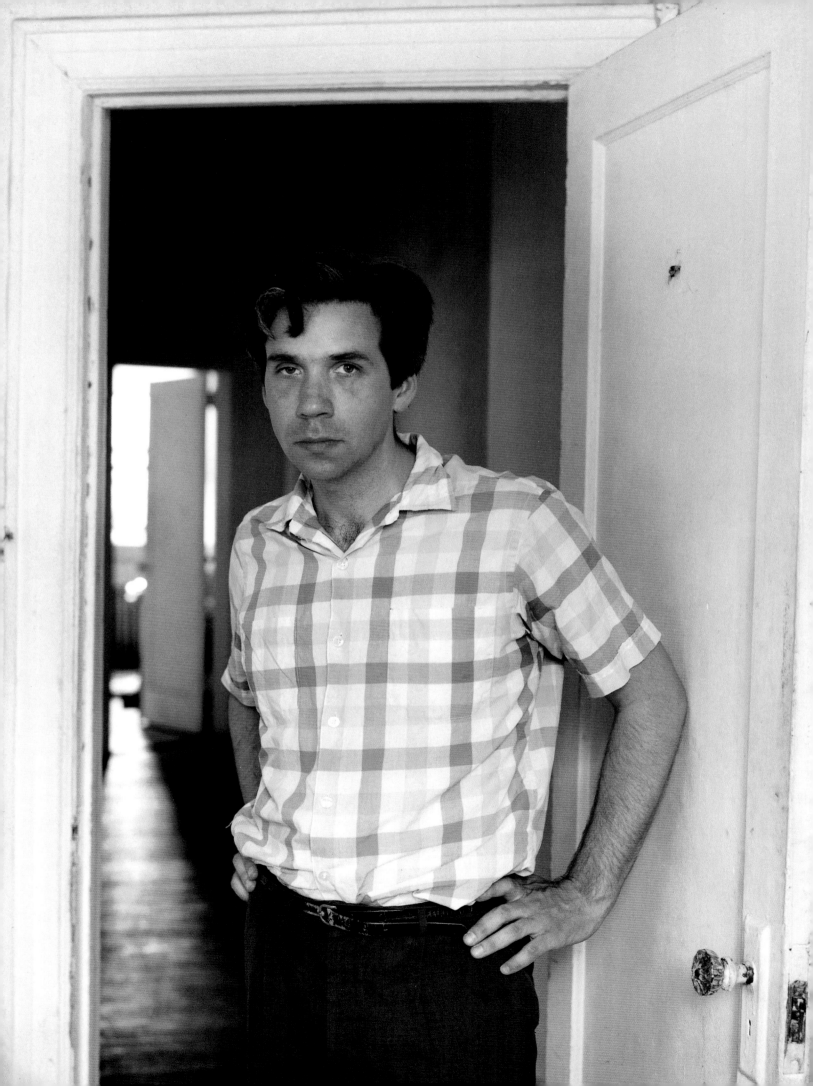

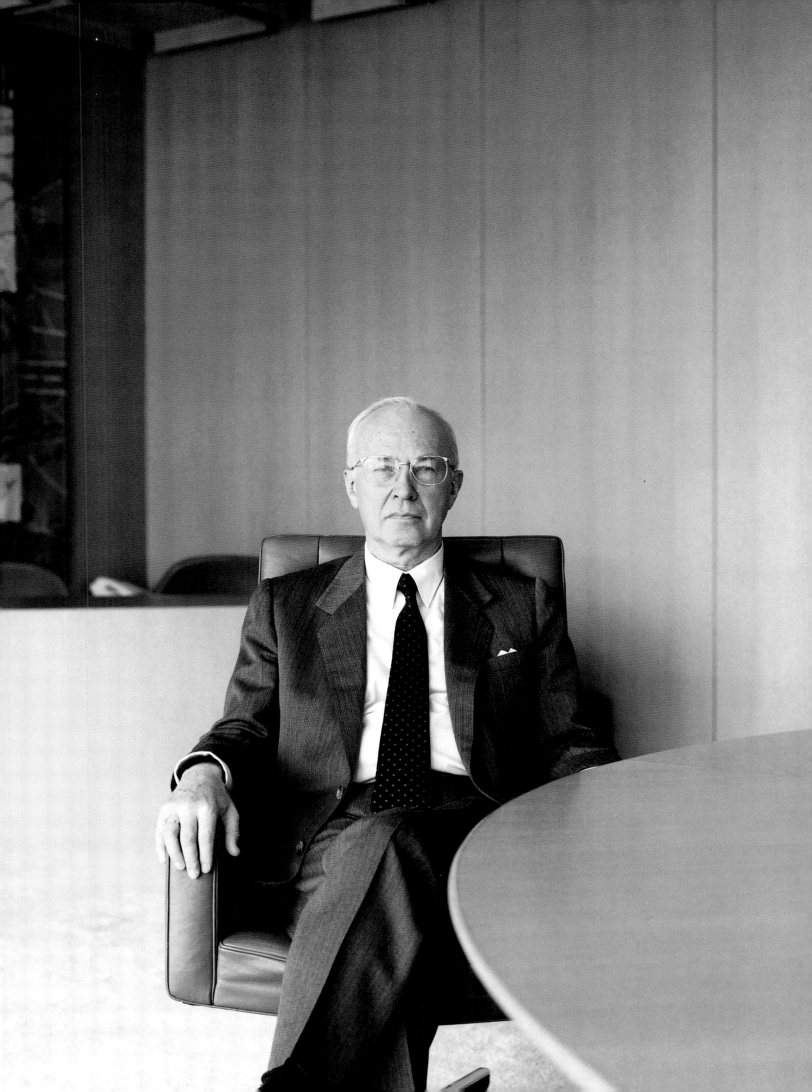

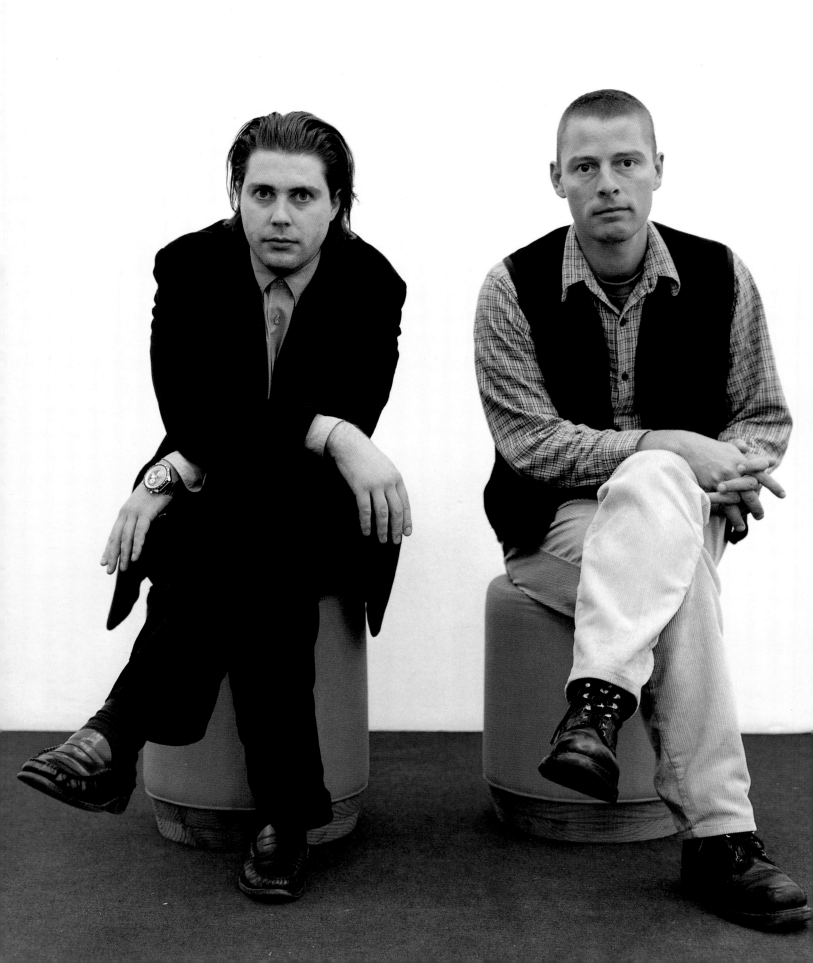

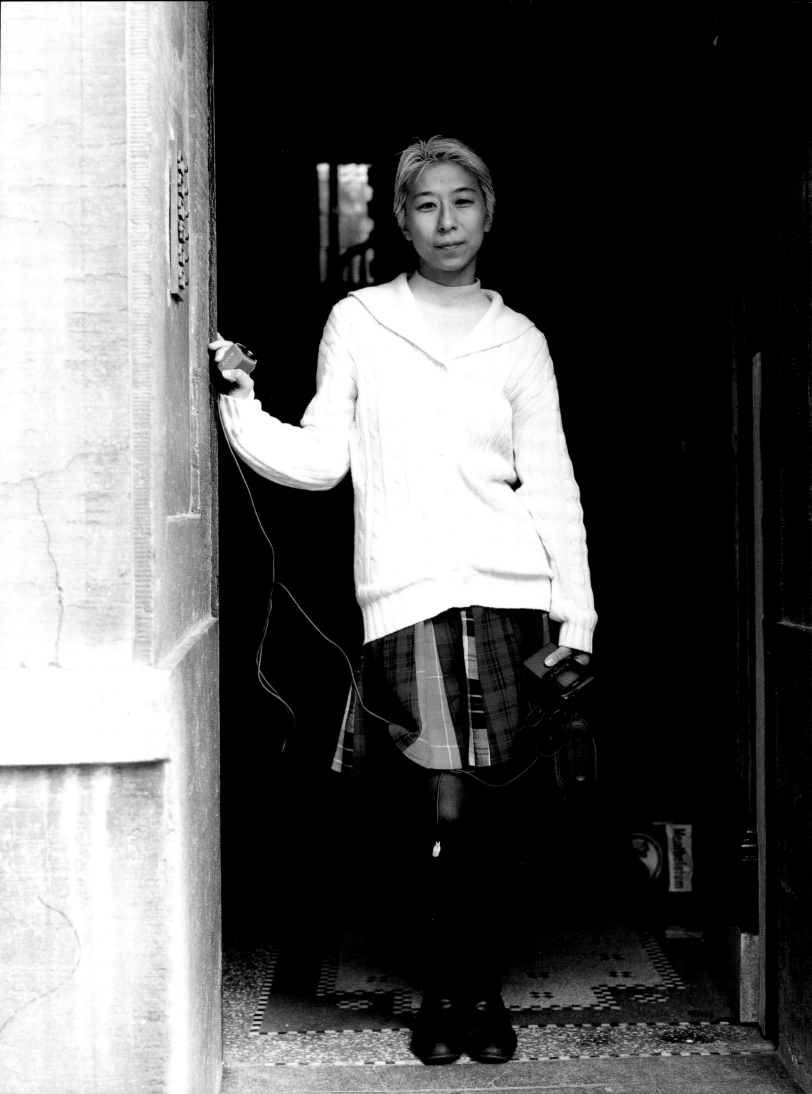

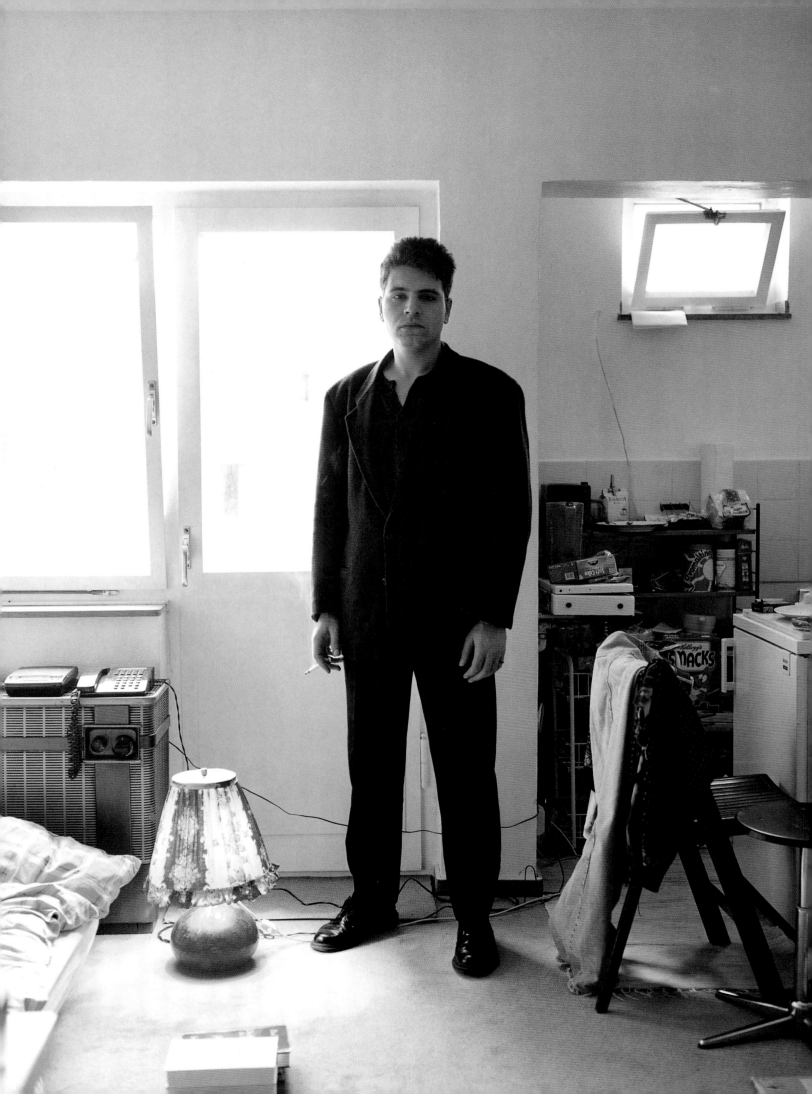

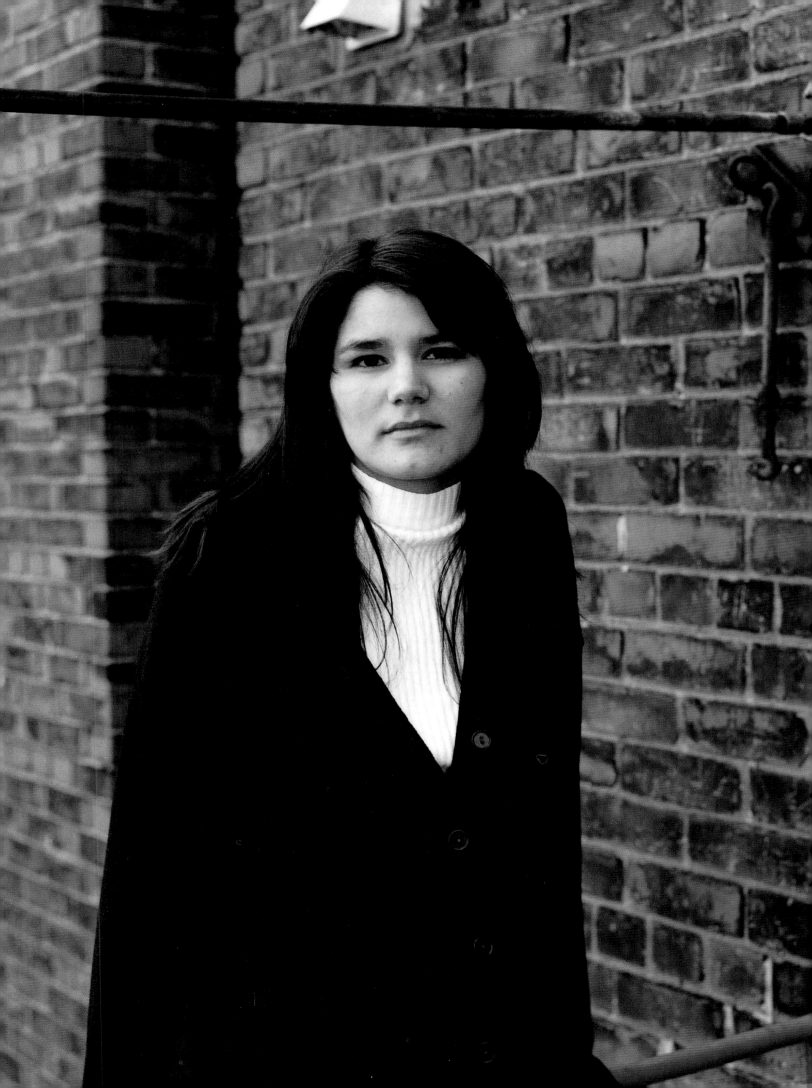

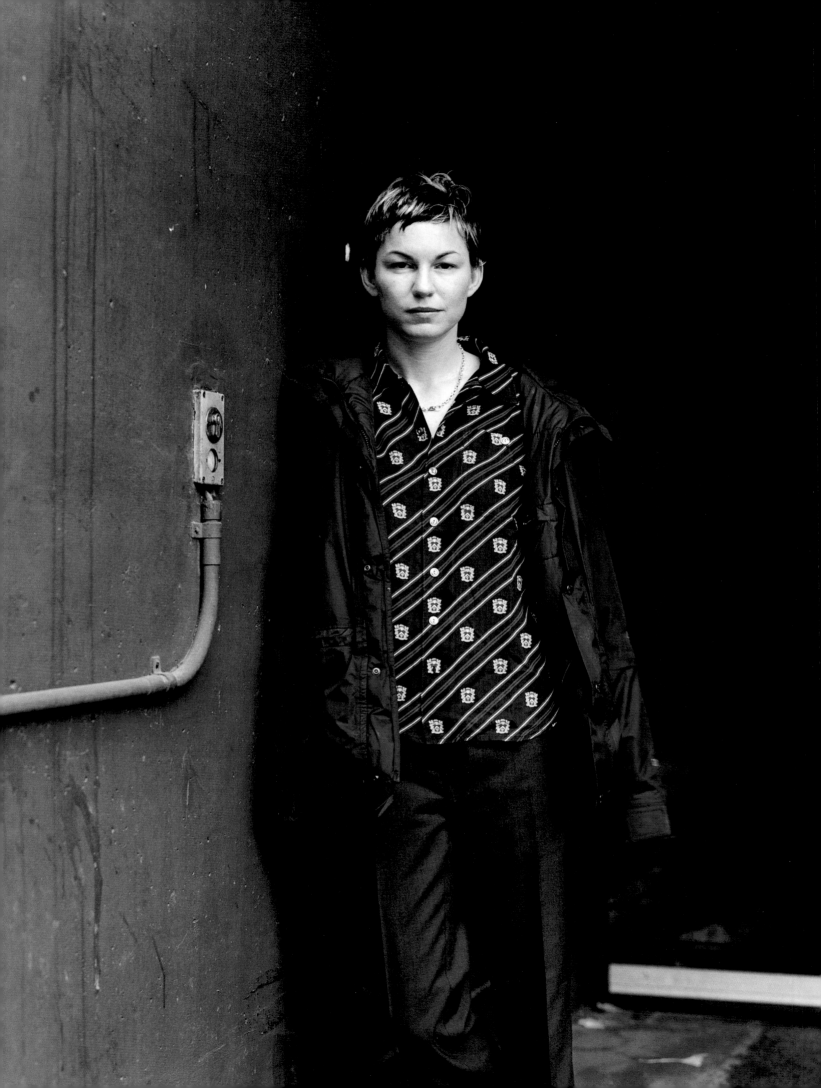

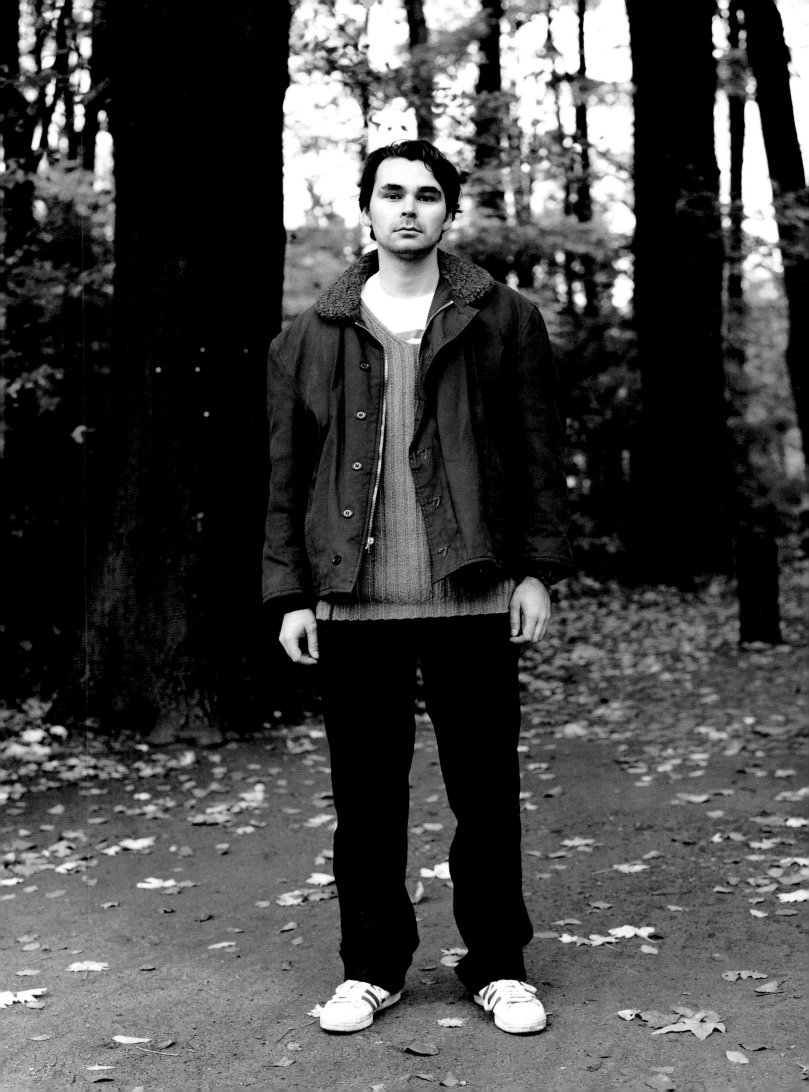

nina lüth I am fascinated by the strange or alien

I encounter it not by seeking the strangeness in it, but by juxtaposing it with what is familiar and everyday in it.

Es ist die Fremde, die mich fasziniert. Ich begegne ihr, indem ich nicht die Fremdheit in ihr suche, sondern ihr das entgegensetze, was an ihr vertraut und alltäglich erscheint.

C'est l'étranger qui me fascine. Je le rencontre lorsque ce n'est pas l'insolite que je recherche en lui, mais le contraire, ce qui à première vue apparaît comme familier et quotidien.

Nina Lüth was born in Bonn in 1971; 1990 high school graduation; 1991 began studying photography with Professor Jürgen Heinemann at Bielefeld Technical College; 1993 exhibition at the Tyler Gallery in Philadelphia, USA; co-founded the Camp Gallery Group in Bielefeld. Nina Lüth lives in Bielefeld.

Nina Lüth, 1971 geboren in Bonn; 1990 Abitur in Düsseldorf; seit 1991 Studium der Photographie, Fachhochschule Bielefeld bei Prof. Jürgen Heinemann; 1993 Ausstellung Tyler Gallery Philadelphia, USA; 1993 Mitbegründerin der Galeriegruppe Camp, Bielefeld. Nina Lüth lebt in Bielefeld.

Nina Lüth, née en 1971 à Bonn; 1990 baccalauréat à Düsseldorf; depuis 1991 études de photographie, Institut Universitaire de Technologie de Bielefeld, auprès du professeur Jürgen Heinemann; 1993 exposition Tyler Gallery, Philadelphie, USA; 1993 cofondatrice de la galerie coopérative Camp, Bielefeld. Nina Lüth vit à Bielefeld.

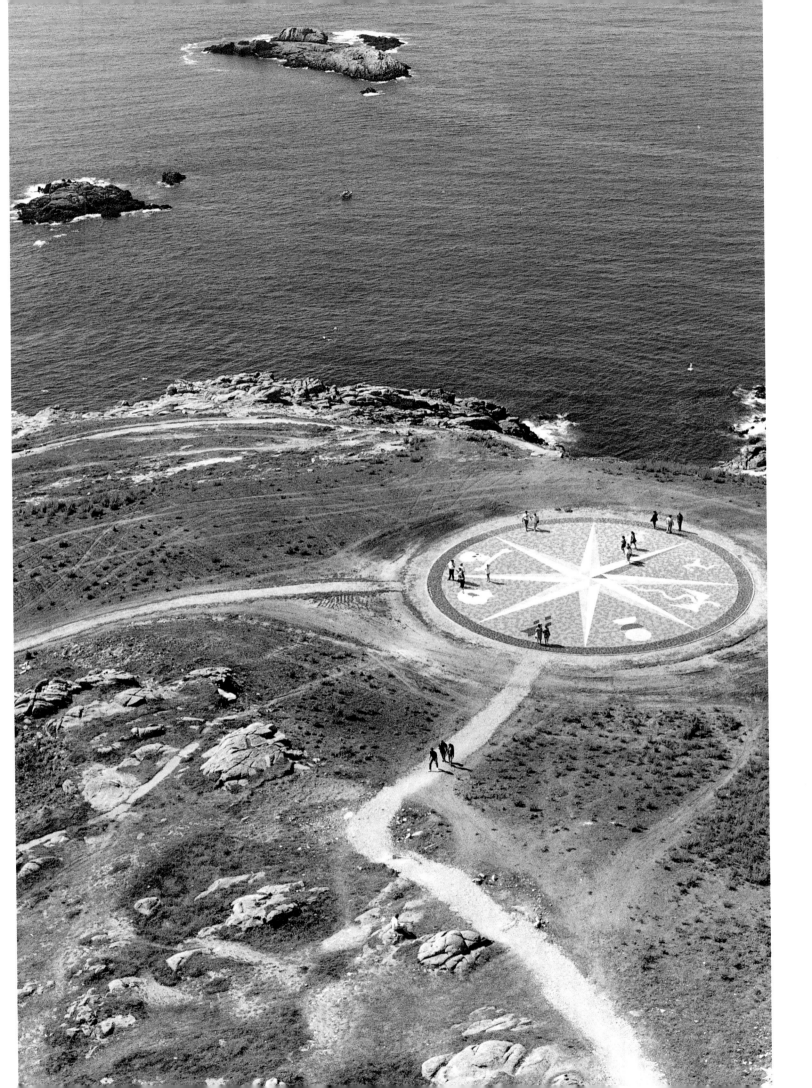

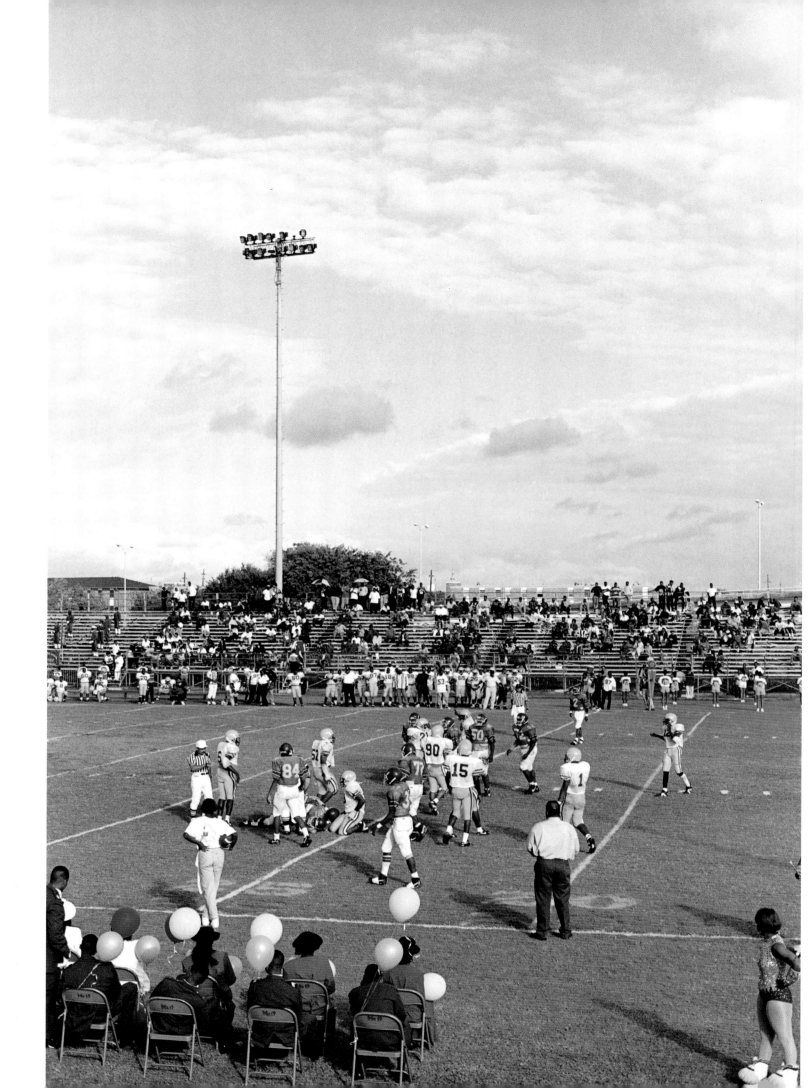

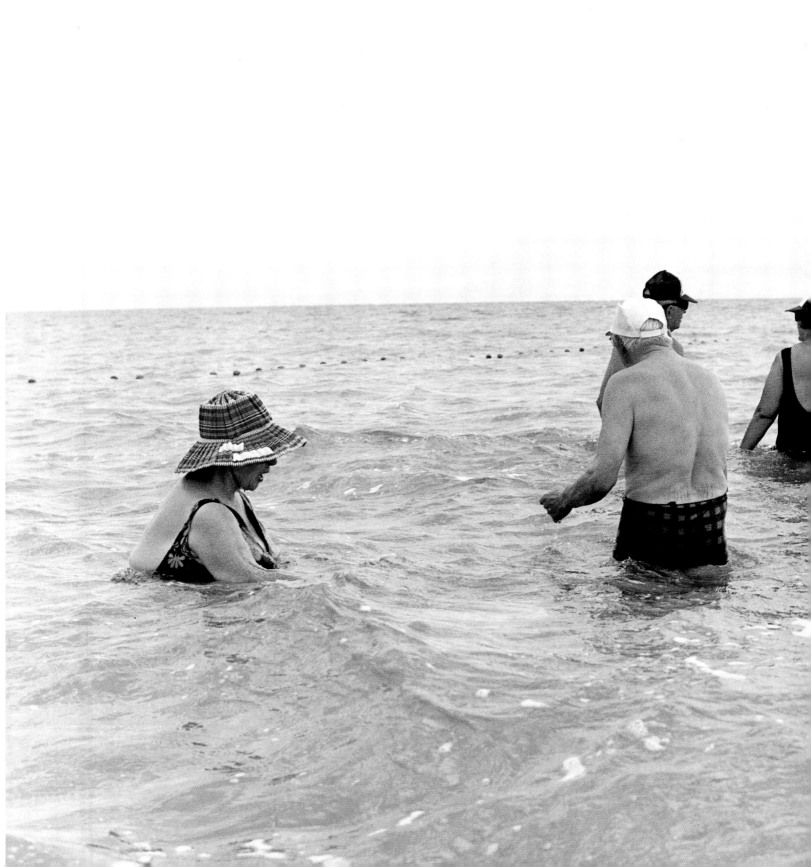

ulrike frömel *Pygmies – from the Greek "Pygmaios", "as long as a fist, dwarf-like*

This work was created in September 1996, when I spent some time with a Pygmy tribe in the Bundibuyo district in Western Uganda. I was fascinated by thi ethnic group of originally nomadic wild game hunters, who are considered to be particularly brave and who are feared by the local population. I and my Africa companion Teopista were received very warmly and affectionately. Since the local Pygmies were driven out of the woods, they sleep in simple huts built fo them. During the day, however, they remain with their clan, which molds their lives, staying in dome-shaped huts made of cane and large leaves near thei hunting grounds and assembly areas. The six families in all, with 38 members, are very proud of their young ones and their bravery. These pictures attempt t document and to describe the awareness of life of these people, who live so very differently from us.

Pygmäen – zu griech. Pygmaios „eine Faust lang, zwergenhaft" Die Arbeit ist im September 1996 entstanden, als ich einige Zeit mit einem Pygmäenstamm im Bundibuyo-Distrikt im Westen Ugandas verbrachte. Die als besonders tapfer geltende und von den Einheimischen gefürchtete Bevölkerungsgruppe – un sprünglich nomadisierende Jäger – hat mich fasziniert. Mit meiner afrikanischen Begleiterin Teopista wurde ich sehr warm und herzlich aufgenommen. Sei die in Bundibuyo ansässigen Pygmäen aus dem Wald vertrieben wurden, schlafen sie in einfachen, für sie erbauten Hütten. Tagsüber halten sie sich jedoch i der Sippe, von der ihr Leben geprägt ist, in Kuppelhütten aus Ruten und großen Blättern, nahe ihrem Jagd- und Sammelrevier, auf. Die insgesamt sechs Fa milien mit 38 Mitgliedern sind sehr stolz auf ihren Kleinwuchs und ihre Tapferkeit. In den Bildern wird versucht, das Lebensgefühl dieser so ganz anders le benden Menschen zu beschreiben.

Pygmées – du grec «Pygmaios», «haut d'une coudée, nain» Ce travail a vu le jour en septembre 1996, alors que je passais quelque temps dans une tribu pyg mée du district de Bundibuyo, à l'ouest de l'Ouganda. Cette catégorie de population (à l'origine des chasseurs non sédentaires) particulièrement réputée pou son courage et redoutée des indigènes, m'a fascinée. Accompagnée de Teopista, une Africaine, je reçus un accueil très chaleureux. Depuis que ces pygmées on été chassés de la forêt, ils dorment dans de simples huttes, construites spécialement pour eux. Mais la journée, ils se tiennent avec le clan, qui joue dans leu vie un rôle de premier plan, dans des huttes à coupole faites de baguettes et de larges feuilles, à proximité de leur réserve de chasse et de cueillette. Ces six fa milles en tout et pour tout, soit 38 membres, sont très fières de leur petite taille et de leur bravoure. J'ai essayé dans ces images documentaires de décrire l sentiment de vie qui anime ces gens dont la façon de vivre est tellement différente de la nôtre.

Ulrike Frömel was born in Munich in 1987; 1987 high school graduation; trained to become a photographer; one-year stay as an assistant in London; 1992–1995 studied at the College of Photodesign, Munich; 1996 began assignment work for, among others, Süddeutsche Zeitung Magazin, jetzt, Photomagazin; member of the Bilderberg Agency. Ulrike Frömel lives in Munich.

Ulrike Frömel, 1968 geboren in München; 1987 Abitur; Ausbildung zur Photographin, München; einjähriger Aufenthalt und Assistenz in London; 1992–1995 Studium an der Fachakademie für Photodesign, München; seit 1996 Auftragsarbeiten u.a. für Süddeutsche Zeitung Magazin, jetzt, Photomagazin; Mitglied der Agentur Bilderberg. Ulrike Frömel lebt in München.

Ulrike Frömel, née en 1968 à Munich; 1987 baccalauréat: formation de photographe, Munich; séjour d'un an et travail d'assistante à Londres; 1992–1995 études à l'Académie de Photodesign, Munich; depuis 1996 commandes, entre autres, du Süddeutsche Zeitung Magazin, jetzt, Photomagazin; membre de l'agence Bilderberg. Ulrike Frömel vit à Munich.

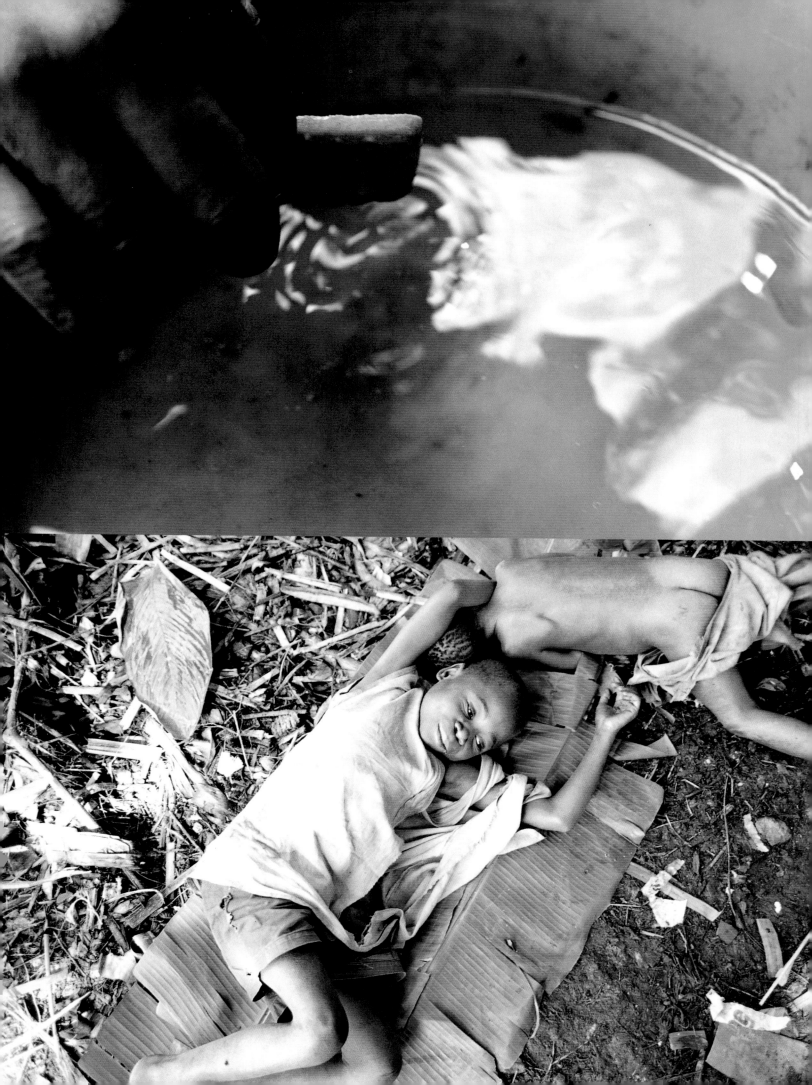

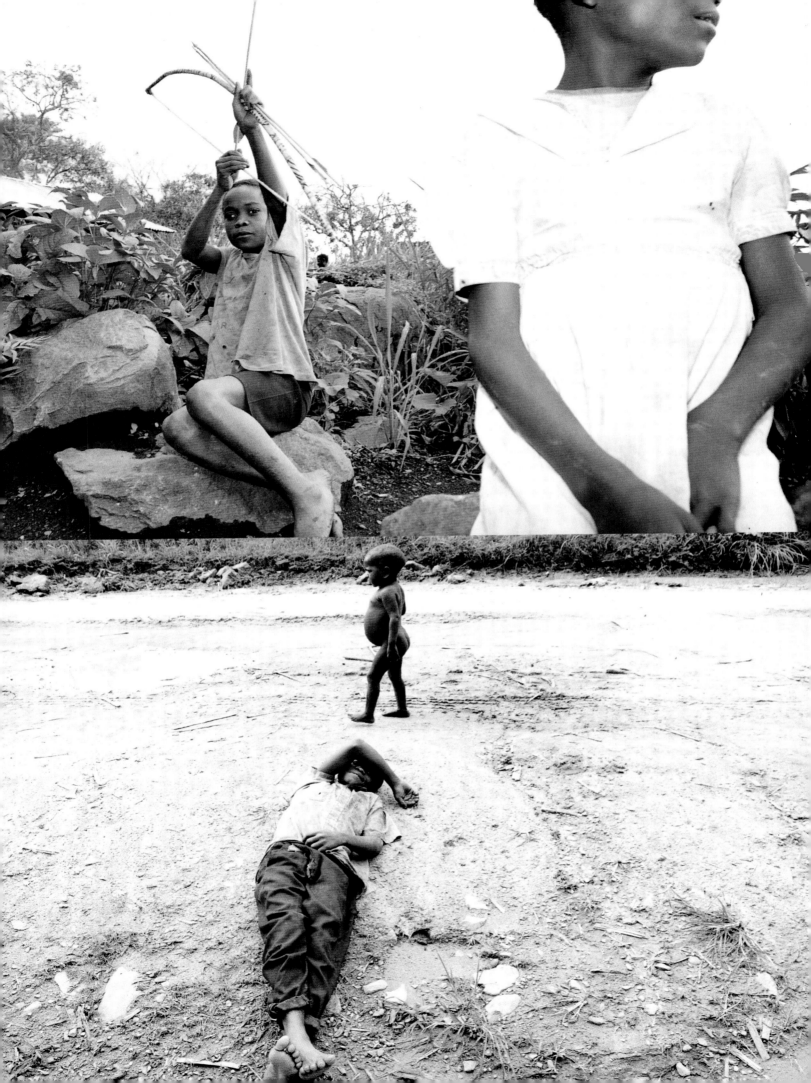

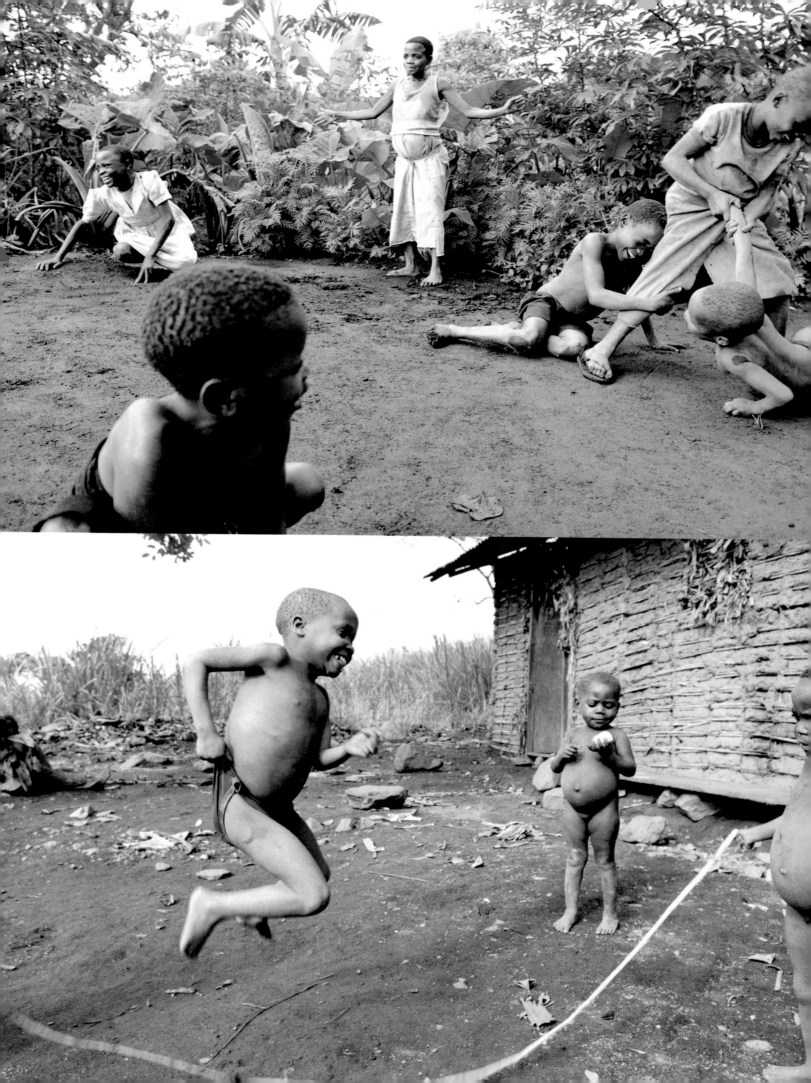

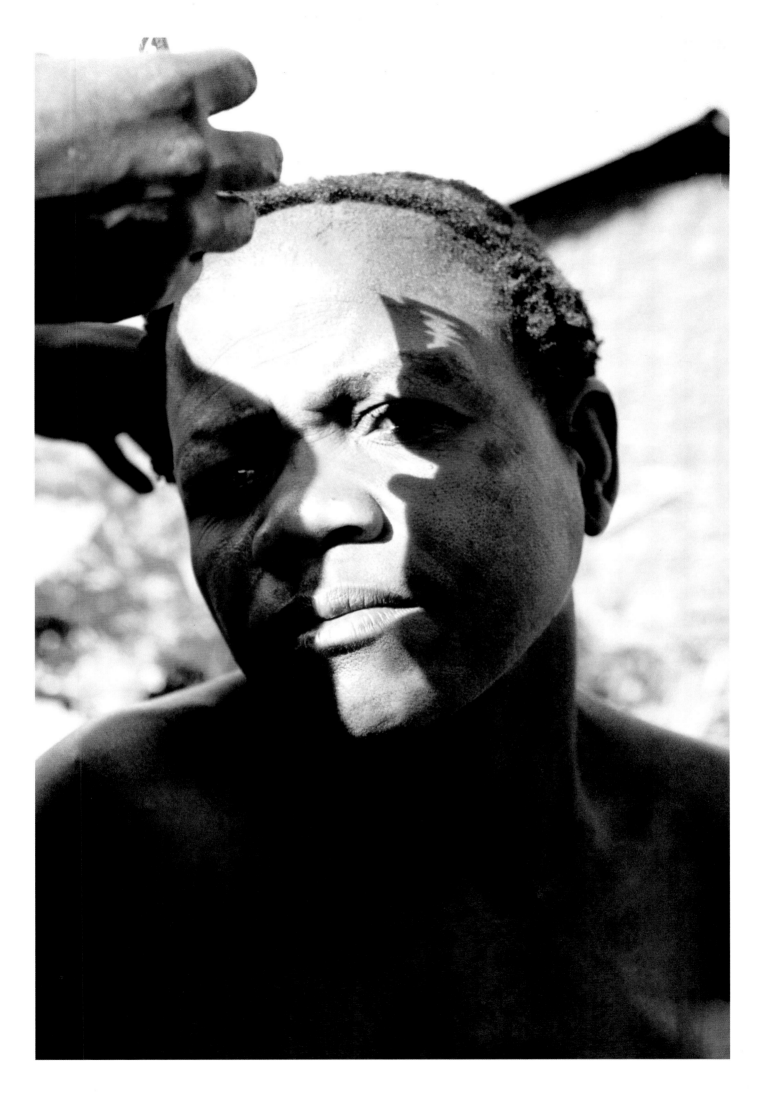

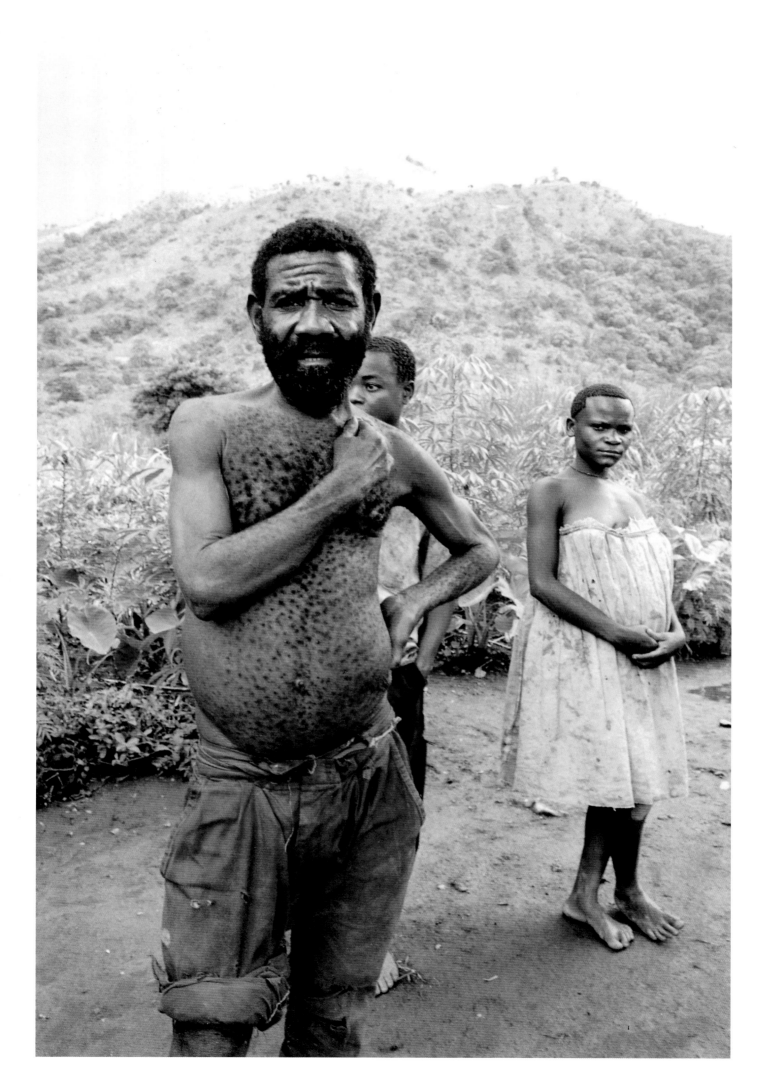

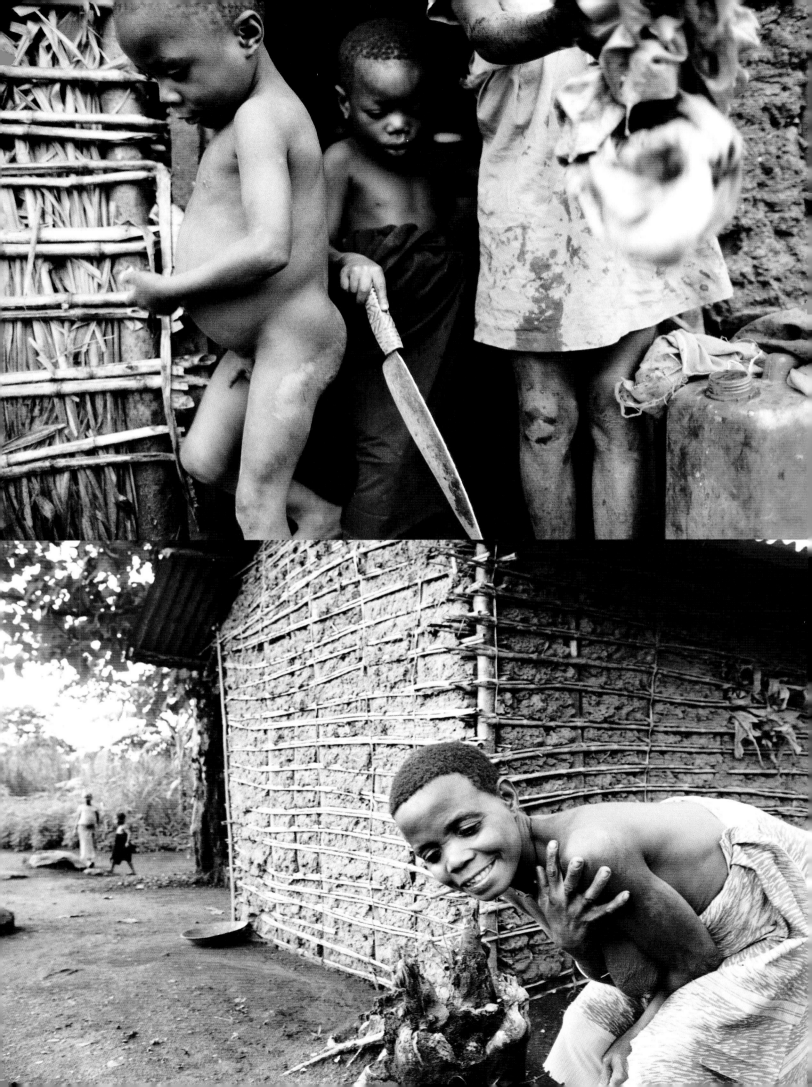

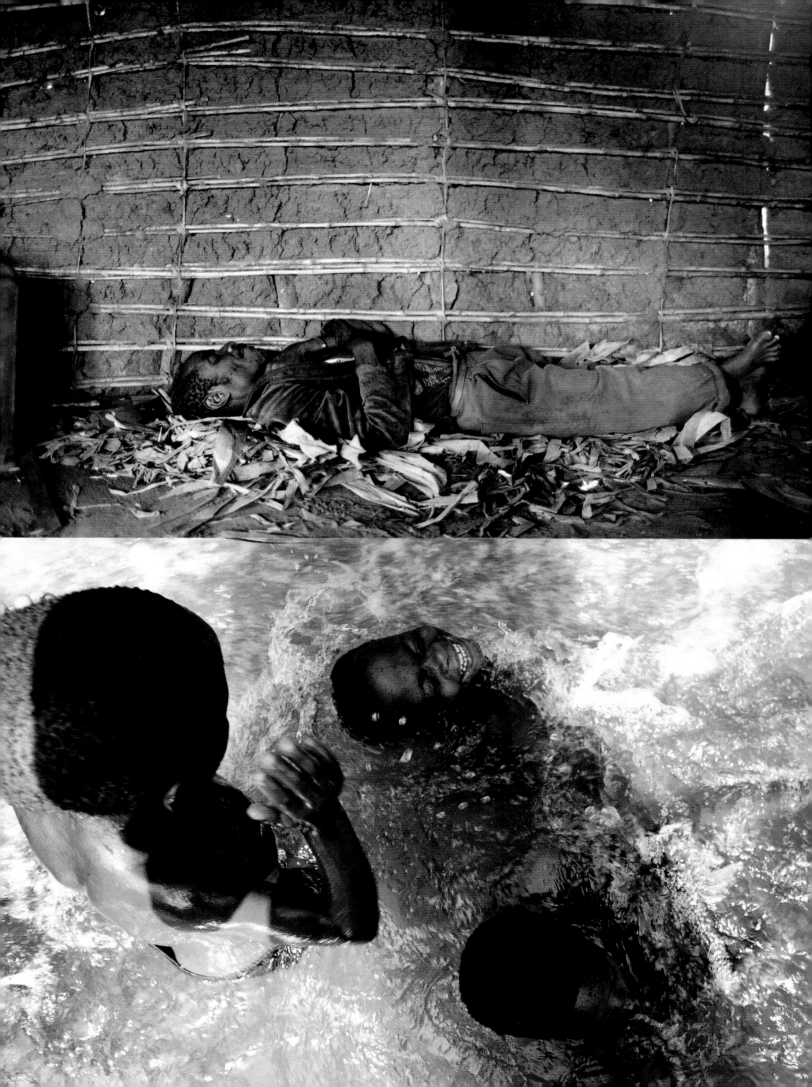

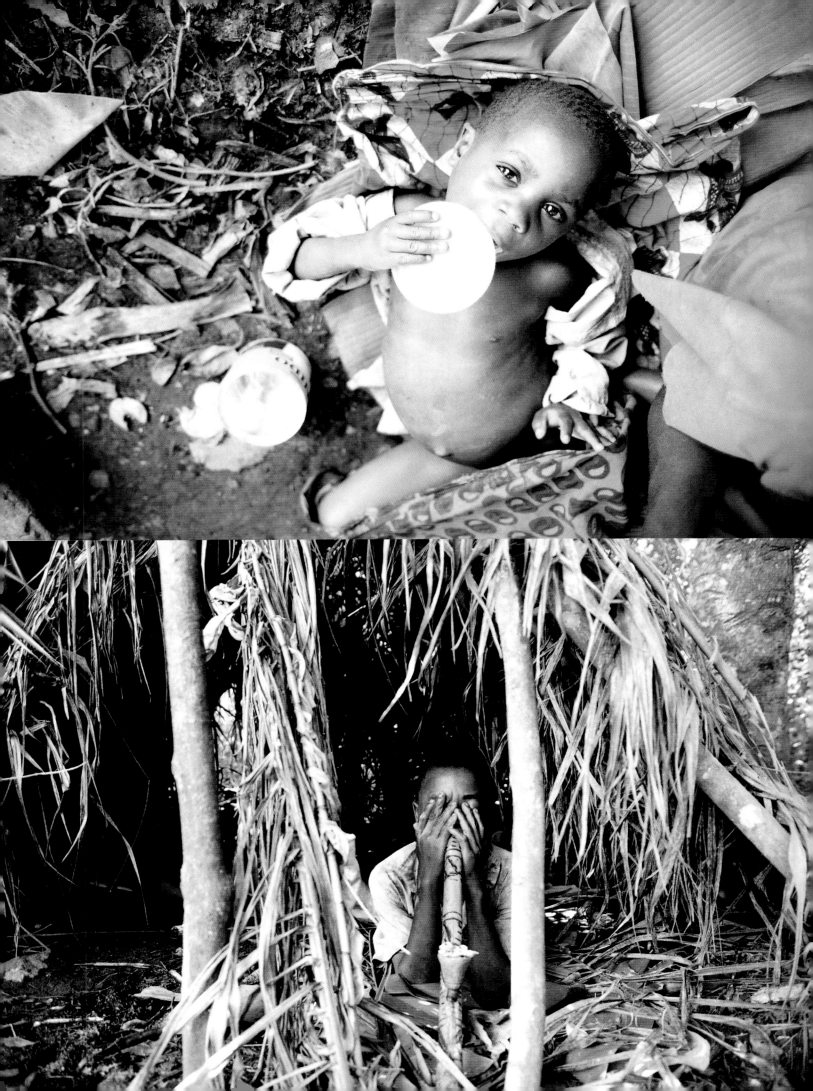

wolfgang stahr *Employees must wash their hands before returning to wor*

New York in particular, with its predominantly functional architecture and numerous public spaces, provides a background that can be regarded as the trad
tional expression of public city planning. In taking my photographs, I searched for situations in which urban life seemed to blend into an entity of architectur
and man, just like the architects of modernity would have wanted it. Most of the people shown in these portraits are between 20 and 35 years old. Their ex
ternal appearance corresponds, in a harmonious way, with the urban surroundings in which they find themselves – the place of work, recreational areas or pub
lic places. In spite of the radically different cultural backgrounds of these people, their styling and their external demeanor is based on the consensus of an ur
ban city culture. Perhaps this is where the bridge between city architecture and human façades is located. The cultivated form of human individuality, even i
its often artificial exaggeration, only rarely departs from the socially accepted framework and is always also molded by the space in which it manifests itsel
The core of this work consists of fragmented structures and isolated moments that illustrate the reciprocal relationship of the individual with the architectur
in the urban environment.

Employees must wash hands before returning to work Gerade New York mit seiner vorwiegend funktionalistischen Architektur und den zahlreichen öf
fentlichten Räumen liefert eine Kulisse, die als traditionelle Ausprägung von städtebaulich geplanter Öffentlichkeit betrachtet werden kann. Beim Photogra
phieren suchte ich Situationen, in denen sich das urbane Leben zu einer Einheit von Architektur und Mensch zu verdichten scheint, so wie es die Architekte
der Moderne gerne gehabt hätten. Die Mehrzahl der hier Porträtierten ist zwischen 20 und 35 Jahre alt. Ihre äußere Erscheinung korrespondiert auf harmo
nische Art mit dem urbanen Umfeld, in dem sie sich bewegen – dem Arbeitsplatz, Freizeitarealen oder öffentlichen Plätzen. Trotz der z.T. völlig unterschiedli
chen Kulturbereiche, aus denen die Menschen stammen, basiert ihr Styling, ihr äußeres Auftreten auf dem Konsens einer urbanen Stadtkultur. Hier liegt viel
leicht die Brücke zwischen städtischer Architektur und menschlicher Fassade. Die kultivierte Form menschlicher Individualität, auch in ihrer häufig
künstlichen Überzeichnung, verläßt nur noch selten den gesellschaftlich akzeptierten Rahmen und ist immer auch geprägt vom Raum, in dem sie sich insze
niert. Im Zentrum dieser Arbeit stehen fragmentierte Strukturen und isolierte Momente, die das Wechselverhältnis des Einzelnen mit der ihn umgebenden
Architektur im urbanen Umfeld verdeutlichen.

Employees must wash hands before returning to work New York, avec son architecture surtout fonctionnelle et ses nombreux espaces publics, livre juste
ment un décor dont on peut considérer qu'il porte les signes traditionnels d'une volonté de donner un caractère public à l'urbanisme. Je cherchais à photo
graphier des situations dans lesquelles la vie urbaine réunirait l'architecture et l'homme dans une sorte d'osmose, comme l'auraient souhaité les architecte
de la modernité. La plupart des gens dont j'ai fait ici les portraits ont entre 20 et 35 ans. Leur apparence extérieure s'harmonise parfaitement avec l'environ
nement urbain dans lequel ils se meuvent, le lieu de travail, les aires de loisirs ou les places publiques. En dépit de leur appartenance à des milieux socio-cul
turels totalement différents, le look, la présentation des gens, leurs manières reposent sur le consensus d'une culture urbaine. C'est peut-être là que se trou
verait la passerelle entre architecture urbaine et façade humaine. La forme cultivée de l'individualité humaine, même dans ses artifices souvent excessifs, ne
s'échappe que rarement du cadre accepté par la société, et elle porte toujours la marque de l'espace dans lequel elle se met en scène. Cette relation mimétique
que le particulier entretient avec l'environnement architectural du contexte urbain est au centre de mon travail, dans lequel elle se traduit par la présence de
fragments de structures et par la figuration d'instants particuliers, isolés de leur contexte.

Wolfgang Stahr was born in 1969; 1988 graduation from high school; 1991 began studying visual communication and photography and film design at the Bielefeld Technical College); 1993 co-founded the Camp Gallery Group for Photography; member of the Bildwerk Agency for photography until 1995; 1994 *Simcity – Simulation des öffentlichen Raumes* (Simcity – Simulation of Public Space): 15th Bielefeld Symposium on Photography and Media; 1995 the Camp Gallery Group participates in the organization of the Young Urban Photographers Festival (YUPF) in Bielefeld; 1996 graduation diploma of the Bielefeld Technical College; selected exhibitions: 1993 Award for Young Photojournalism, Leverkusen, Herten, Cologne (catalog); *Landläufig* – Contemporary Photography, Bielefeld, Berlin, Munich; 1994 *über die Aktualität unserer Städte* (About the Actuality of our Cities) – Contemporary Photography, Bielefeld, Kassel; 1995 Aenne-Biermann Award, Gera, Herten, Berlin (catalog); Ism'95: the 1st Tokyo International Photo Biennale, Tokyo (catalog); 1996 *Wunschmaschine. Das Bild der Zukunft* (Wish-machine. The image of the future), Dortmund, Düsseldorf (catalog). Wolfgang Stahr lives in Berlin.

Wolfgang Stahr, 1969 geboren; 1988 Abitur; 1991 Beginn des Studiums Visuelle Kommunikation/Photo-/Film-Design an der Fachhochschule Bielefeld; 1993 Mitbegründer der Galeriegruppe Camp Photographie, Mitglied bei Bildwerk – Agentur für Photographie (–1995); 1994 *Simcity – Simulation des Öffentlichen Raumes*, 15. Bielefelder Symposium über Photographie und Medien; 1995 Camp ist Mitorganisator des Young Urban Photographers Festival (YUPF), Bielefeld; 1996 Diplom an der Fachhochschule Bielefeld; Ausstellungen (Auswahl): 1993 Preis für jungen Bildjournalismus, Leverkusen, Herten, Köln (Katalog); *Landläufig* – Zeitgenössische Photographie, Bielefeld, Berlin, München; 1994 *Über die Aktualität unserer Städte*, Bielefeld, Kassel; 1995 Aenne-Biermann-Preis, Gera, Herten, Berlin, (Katalog); Ism '95: The 1st Tokyo International Photo-Biennale, Tokyo, (Katalog); 1996 *Wunschmaschine. Das Bild der Zukunft*, Dortmund, Düsseldorf (Katalog). Wolfgang Stahr lebt in Berlin.

Wolfgang Stahr, né en 1969; 1988 baccalauréat; 1991 entreprend des études de communication visuelle/Design photo et cinéma à l'Institut Universitaire de Technologie de Bielefeld; 1993 cofondateur de la galerie coopérative de photographie Camp – membre de l'agence de photographie Bildwerk (–1995); 1994 *Simcity – Simulation des Öffentlichen Raums* (Simcity – simulation de l'espace public); 15e symposium sur la photographie et les médias de Bielefeld; 1995 co-organisateur du Young Urban Photographers Festival (YUPF), Bielefeld; 1996 diplômé de l'Institut Universitaire de Technologie de Bielefeld; choix d'expositions : 1993 prix du jeune photojournalisme, Leverkusen, Herten, Cologne (catalogue); *Landläufig* (Courant) – Photographie contemporaine, Bielfeld, Berlin, Munich; 1994 *Über die Aktualität unserer Städte* (Sur l'actualité de nos villes), Bielefeld, Kassel; 1995 Prix Aenne Biermann, Gera, Herten, Berlin (catalogue); Ism '95: The 1st Tokyo International Photo-Biennale, Tokyo (catalogue); 1996 *Wunschmaschine, Das Bild der Zukunft* (Machine à rêves, l'image du futur), Dortmund, Düsseldorf (catalogue). Wolfgang Stahr vit à Berlin.

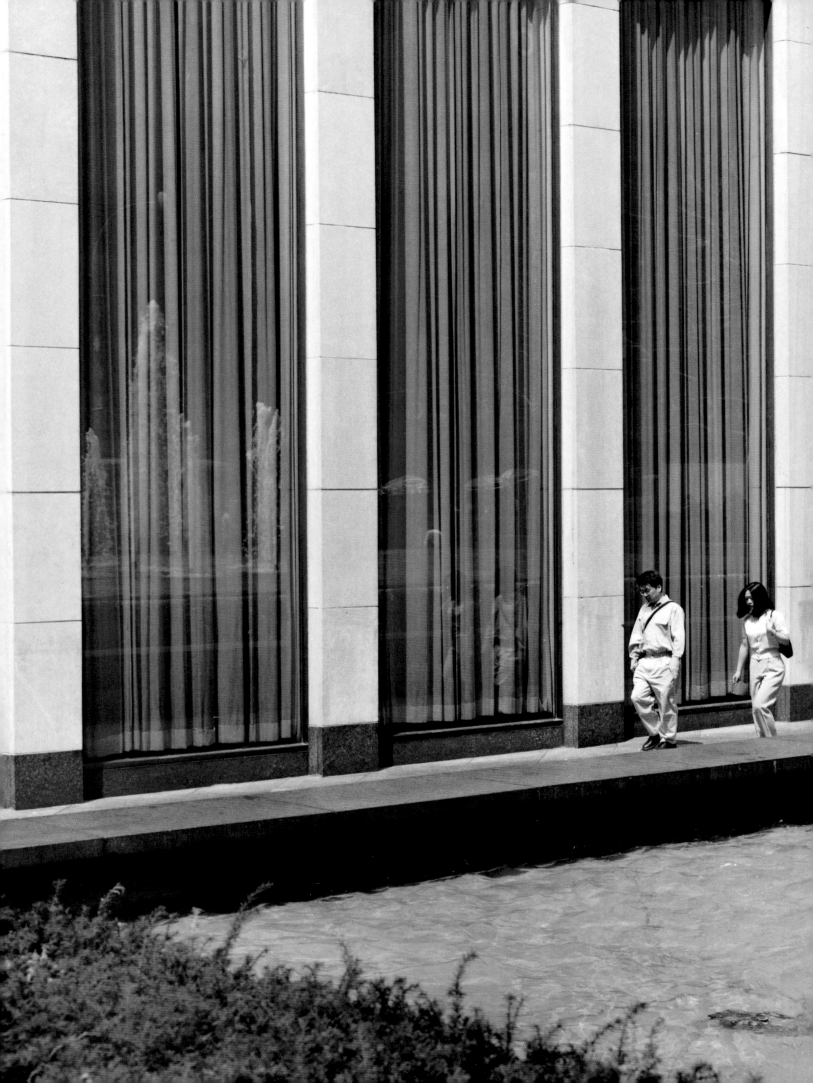

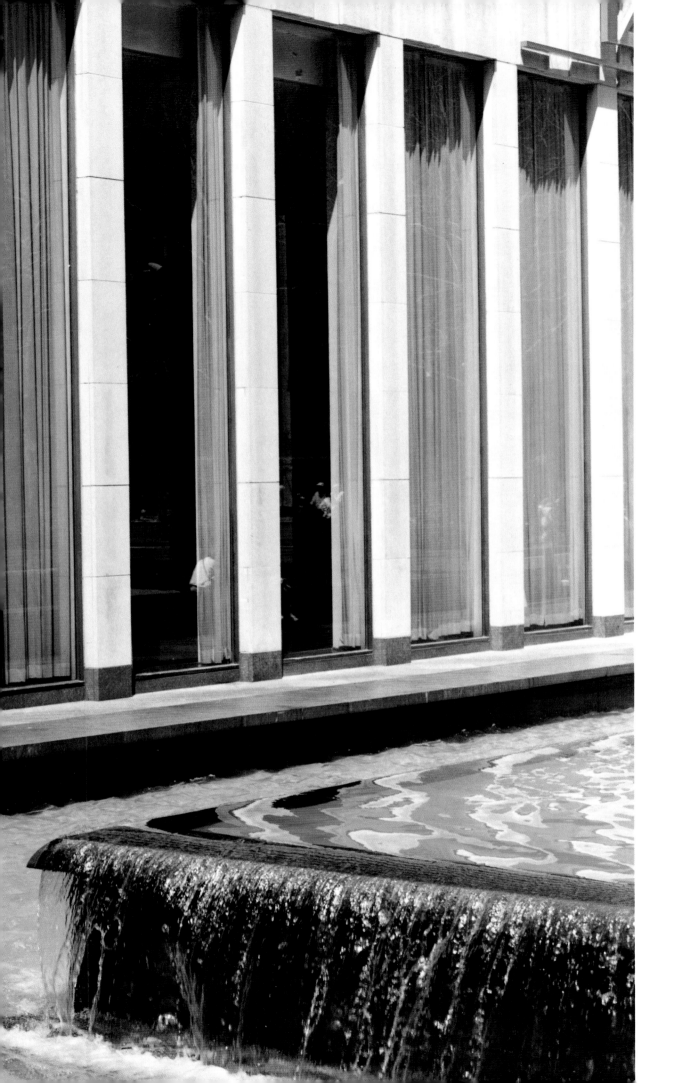

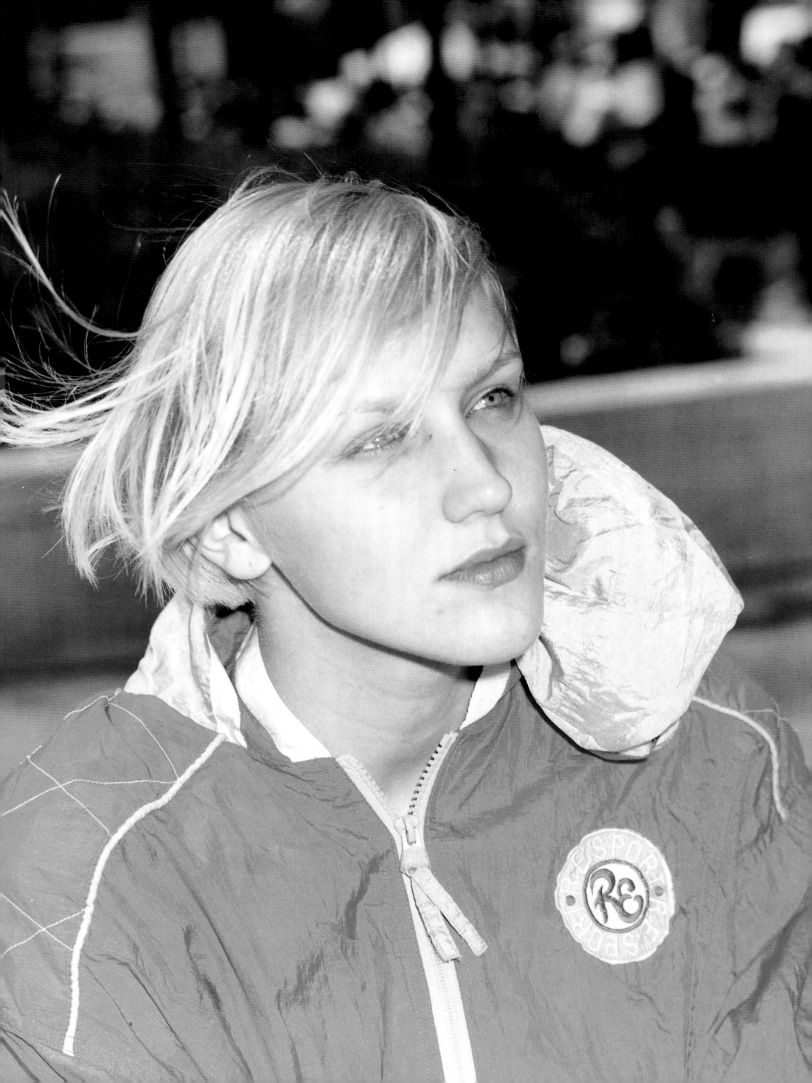

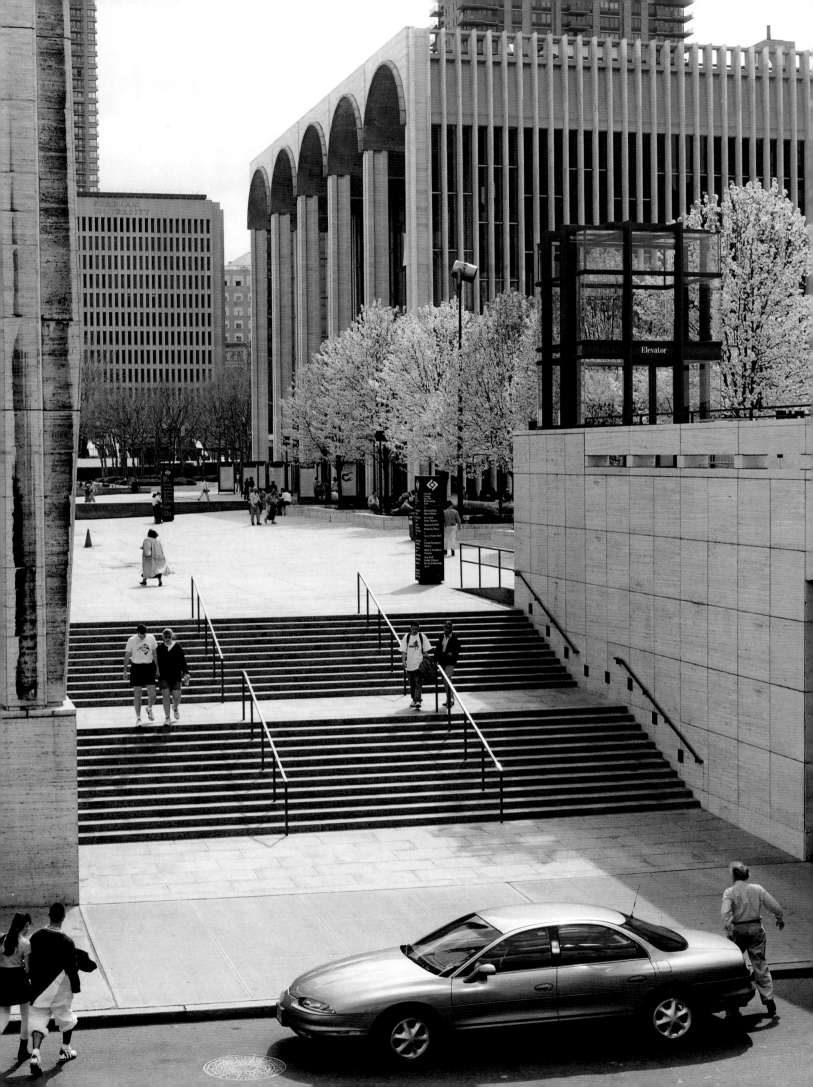

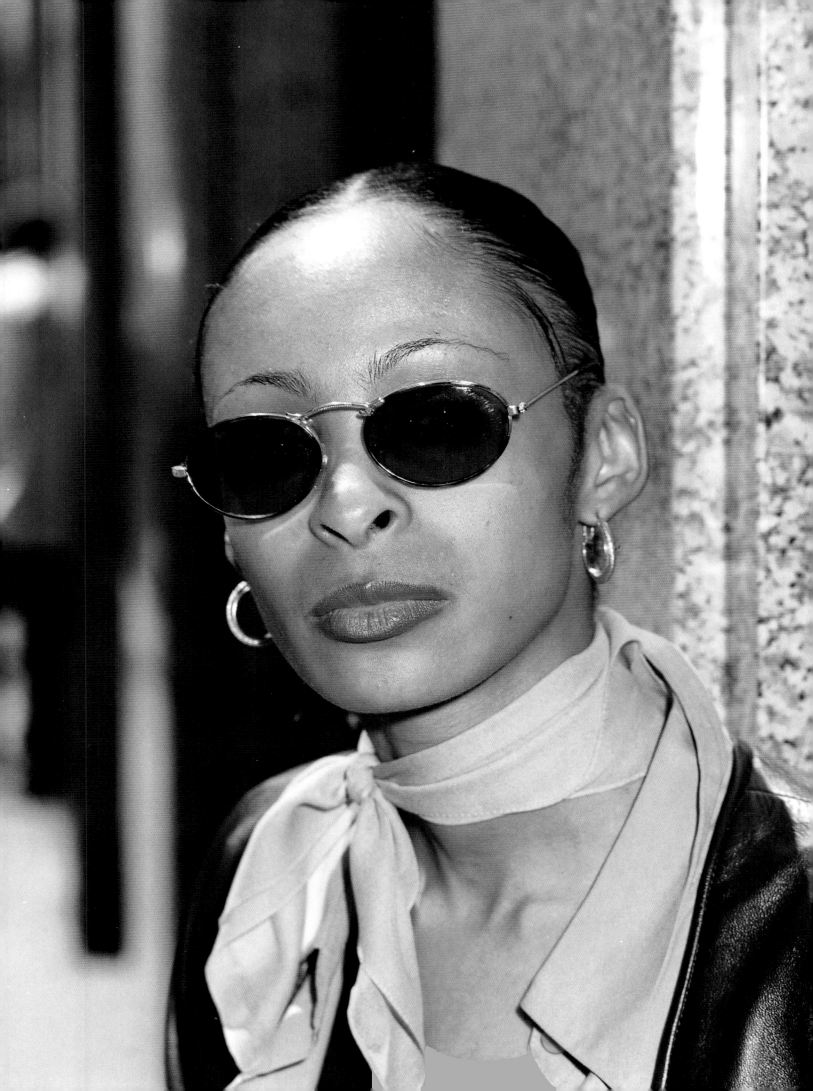

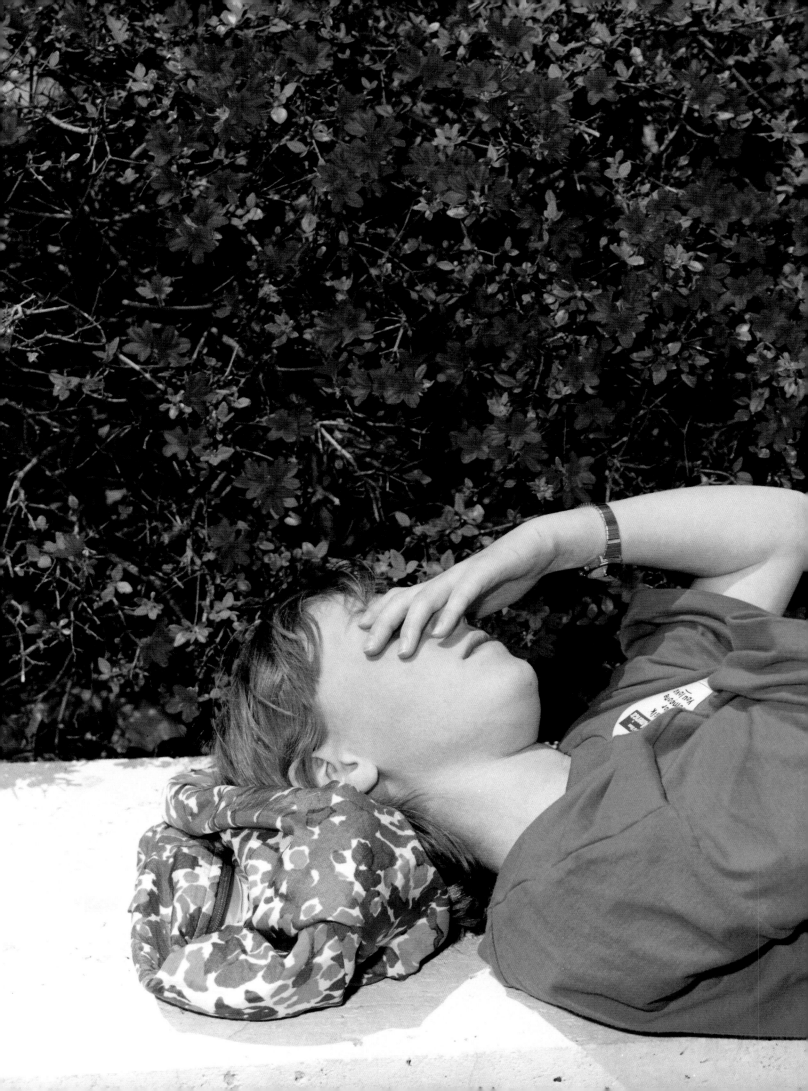

Special thanks to

Barbara,
Benedikt Taschen and Burkhard Riemschneider for their confidence,
Andreas Lebert, Christian Kämmerling and Ulf Poschardt,
Helfried Hagenberg and Heinz Augé,
Patrick, Studi, Dieter, Georg, Dirk, Cristopher, Florian and Rudi,
Eva and Claudia for their wonderful assistance,
my parents.

Thanks to all the photographers included in this book for their uncomplicated cooperation.
Thanks to all those photographers not included for their interest,
and with a sincere request for their unterstanding as regards the final selection
and compilation of this book. Every photograph submitted to me
had its own unique quality and deserved publication.
Good luck to all young photographers on their chosen path.

Front cover: © Wolfgang Bellwinkel: *Father and Son near Mostar*
 Outer flap: © Frederike Hellwig: *Tobias in Hamburg*, April 1994
 Inner flap: © Werner Amann

Back cover: © Roman Rahmacher
 Outer flap: © Eva Leitolf: *Solingen*, 1994
 Inner flap: © Ulrike Frömel

**This book was printed on 100% chlorine-free bleached paper
in accordance with the TCF standard.**

© 1997 Benedikt Taschen Verlag GmbH
Hohenzollernring 53, D–50672 Köln
© on the photographs rests with the photographers
© Preface: Ulf Erdmann Ziegler, Berlin
Edited by Markus Rasp, Munich
Text edited by Yvonne Havertz, Margrit ten Hoevel, Cologne
English translation by Christian Goodden, Bungay (text by Ulf Erdmann Ziegler)
and Rolf Fricke, Rochester (N.Y.)
French translation by Cathèrine Henry, Nancy

Printed in Italy
ISBN 3-8228-8181-3